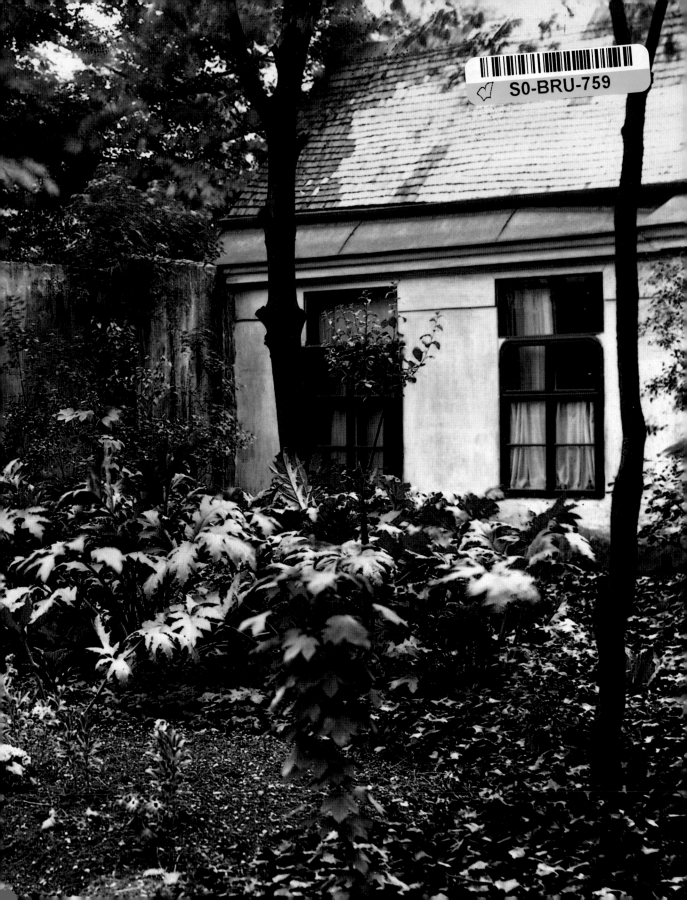

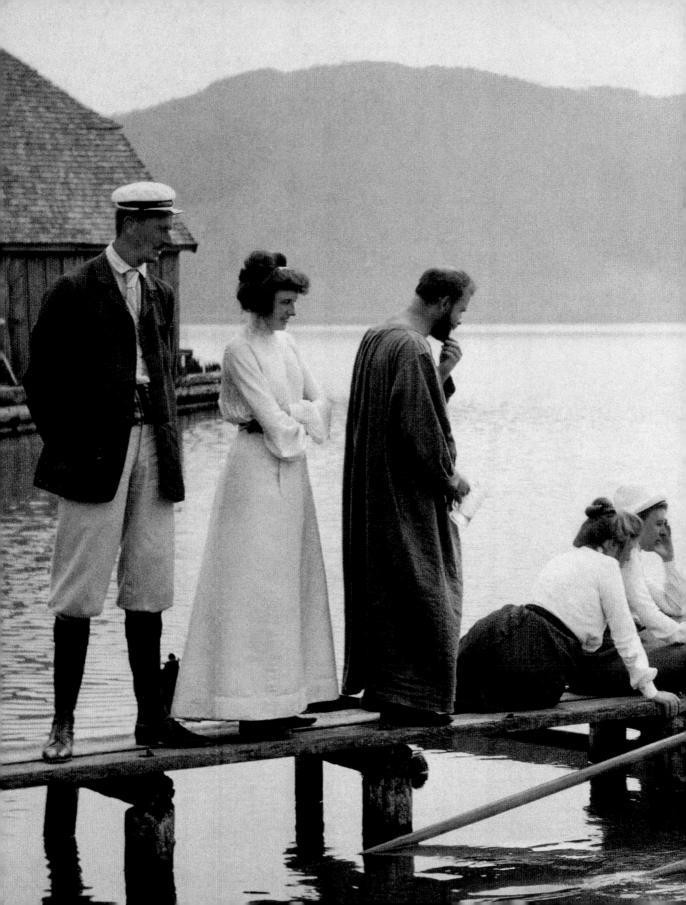

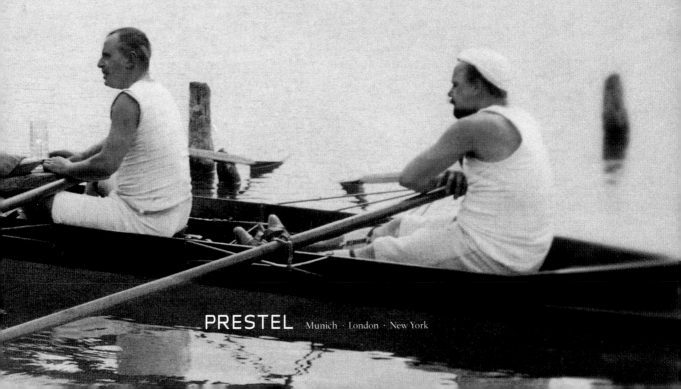

GUSTAV KLIMT
LANDSCAPES

Edited by Stephan Koja

With contributions by

Christian Huemer, Stephan Koja,

Peter Peer, Verena Perlhefter,

Carl E. Schorske, Erhard Stöbe,

and Anselm Wagner

PRESTEL Munich · London · New York

Photographic Credits

*Pictorial material has kindly been provided by the museums and collections
named in the captions, or has come from the Bildarchiv der Österreichischen
Galerie Belvedere, Vienna, the Fotostudio Otto, Vienna, the Verlag Galerie
Welz, Salzburg, from private collections, or from the following archives
(numbers refer to page numbers):*

Albertina / Klimt-Archiv: 199 top; Oskar Anrather, Salzburg: 16;
Austrian Archives, Vienna: title page, 6, 8, 10, 14—15, 26, 27, 29, 65,
69, 96 top, 98, 99, 128 bottom, 130 bottom, 204 top left, center, right,
214; Courtesy, Galerie St. Etienne, New York: 75; Historisches
Museum der Stadt Wien, Vienna: 193 top left, 195 right; Öster-
reichische Nationalbibliothek, Bildarchiv, Vienna: opening pages,
124 bottom, 125, 152, 154—155, 191 left, 193 bottom left, 196, 199 bot-
tom, 200 left, 200 second from top on right, 201 bottom right, 203
top right, 205 top center, 206, 208—209, endpapers; Verena Lobisser:
166 right; Alfred Weidinger: 47, 164, 165, 166 left. Additional repro-
ductions from *Die Eroberung der Landschaft, Semmering — Rax — Schneeberg,*
exh. cat., Niederösterreichische Landesausstellung Schloss Glog-
gnitz, (Vienna, 1992): 21, 23, 24; Heinrich Kulka, *Adolf Loos*
(Vienna, 1931): 23 bottom left; Christian M. Nebehay, *Gustav Klimt
Dokumentation* (Vienna, 1969): 96, 116, 191, 207; Christian M. Nebehay,
Das Skizzenbuch aus dem Besitz von Sonja Knips (Vienna, 1987): 195 left,
198 top; Eva Pusch / Mario Schwarz eds., *Architektur der Sommerfrische*
(St. Pölten, 1995): 23 top left

Front cover: *Schloss Kamer on the Attersee I*, 1908 (detail, plate 33)

Endpapers: Gustav Klimt in the garden outside his studio
in Josefstädterstrasse 21, Vienna VIII, *c.* 1910, photographed
by Moriz Nähr

Double pages at front of book:
Gustav Klimt, *Schönbrunn Park*, 1916 (detail, plate 47)

Emilie Flöge and Gustav Klimt (third from left) with friends on a
dock in Litzlberg on the Attersee, photographed probably in 1903

Back cover: *Farm Garden with Sunflowers, c.* 1907 (detail, plate 32)

The Library of Congress Cataloguing-in-Publication data is
available; British Library Cataloguing-in-Publication Data:
a catalogue record for this book is available from the British
Library; Deutsche Bibliothek holds a record of this publication
in the Deutsche Nationalbibliografie; detailed bibliographical
data can be found under: http://www.dnb.de

Prestel Verlag, Munich
A member of Verlagsgruppe Random House GmbH

Prestel Verlag
Neumarkter Strasse 28 · 81673 Munich
Tel. + 49 (0) 89 4136-0 · Fax + 49 (0) 89 4136-2335

Prestel Publishing Ltd.
14—17 Wells Street· London W1T 3PD
Tel. + 44 (0) 20 73 23-50 04 · Fax + 44 (0) 20 7323-0271

Prestel Publishing
900 Broadway, Suite 603 · New York, NY 10003
Tel. + 1 (2 12) 9 95-27 20 · Fax + 1 (2 12) 9 95-27 33

www.prestel.com

Translated from the German by: John Gabriel, Worpswede;
Rebecca Law, Vienna; and Robert McInnes, Vienna

Editorial direction: Christopher Wynne
Production: René Güttler
Cover Design: René Güttler, Claudia Weyh
Original design and layout: Cilly Klotz
Cartography: Anneli Nau, Munich
Color separations: Trevicolor, Dosson di Casier
Printing and binding: Druckerei Uhl GmbH & Co KG, Radolfzell

Verlagsgruppe Random House FSC®N001967
The FSC®-certified paper *Hello Fat Matt* produced
by mill Condat has been supplied by PaperlinX

ISBN 978-3-7913-3717-3

Gustav Klimt with friends having a snack at Gahberg—Hannerl Grögl (*far left*), Emilie Flöge
(*third from left*), Emma Bacher (*center*), Helene Klimt (*third from right*), Heinrich Böhler and
Gustav Klimt, 1908

Farmhouse with Birch Trees
(Young Birches), 1900
see plate 11

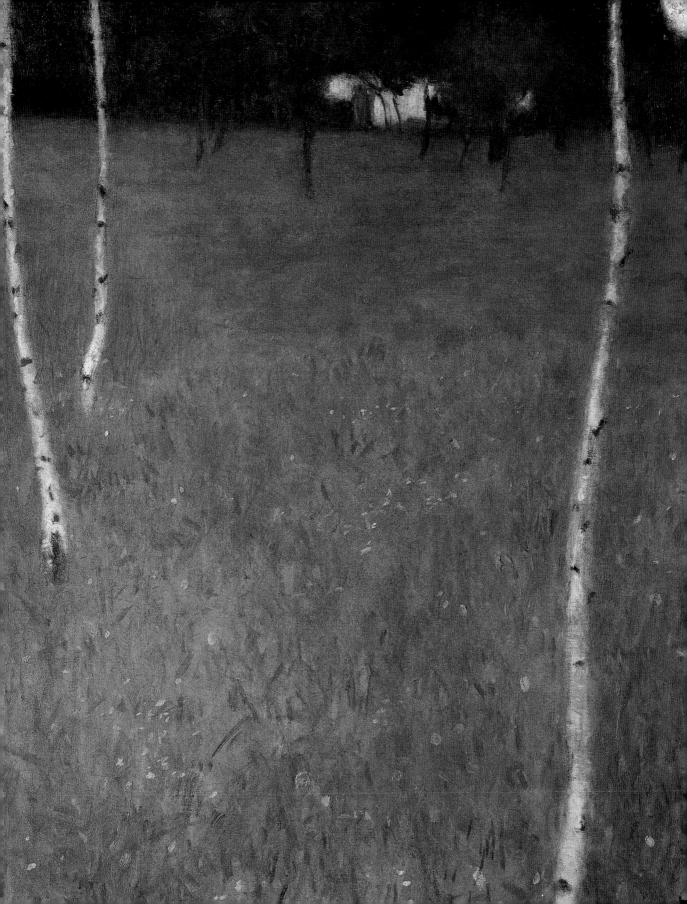

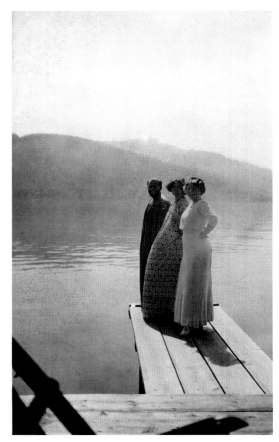

Gustav Klimt, Emilie Flöge and Helene Flöge with the light behind
them on a dock on Attersee, c. 1905

Introduction

Gustav Klimt: important cultural-political phenomenon of the years of artistic upheaval, farsighted patron of the young, public figure with the notion of changing the art of his time, painter of women, gifted portraitist—this is how Klimt is generally perceived. Comparatively little notice has been taken of his landscapes, although these comprise almost one half of the oeuvre of the last two decades of his life. At times, they were even capable of provoking. One critic, confronted with seventeen landscapes at the Klimt Retrospective Exhibition in the Secession in 1903, stated: "Klimt's landscapes should be in an exhibition on Mars or Neptune; thank God things look somewhat different on our planet"[1]—however, Klimt's monumental paintings drew the greatest attention.

Even today, Klimt's paintings exert a tremendous fascination. Generally speaking this is not due only to the subject matter, since allegorical and mythical representations no longer have a popular appeal, and the society ladies in his portraits are of little significance today. This fascination must, therefore, stem from the artist's pictorial language. And, his landscapes speak this language in a particularly precise manner. They lead us to very core of his art. Our eyes are directed at the essentials, the purely artistic, unobstructed by theme and content. It becomes apparent that, in these works, Klimt achieved his real greatness. Almost all of Klimt's landscapes which, not only in their content, exhibit a kind of escapism, were created during periods of relaxation. Klimt's life was characterized by a certain bipolarity: on the one hand, the increasing need for seclusion and privacy that he found in his studios and during the *Sommerfrische*, and, on the other hand, his public role, which the painter may not have striven for but which had been forced upon him as a result of his early successes.

Klimt painted his landscapes for his own personal pleasure and to earn money—they were not commissioned works, but intended for the free market. In these paintings, he dealt with purely artistic questions, and displayed more formal boldness than in his other work. It is no exaggeration to say that those who carefully study the landscapes will discover the complete Klimt, become intimate with his artistic sensibility and concerns, and discover the essence of Klimt's art: his coloristic brilliance, precisely detailed pictorial composition, omnipresent sensuality, controlled by the distancing from the object, and the rigid organization of the surface. Unlike his figural paintings, in which the person portrayed sometimes seems to disappear behind a mask of remoteness and decoration, or in the allegorical works, which are not completely free of formalistic attitude, Klimt finds his own individual language in his landscapes.

Klimt was a painter of subtleties. In his landscapes he was able to demonstrate his mastery—with his sensitivity and skill for the inner laws of the visual world, for melody and harmony, his pictures equal nature in their perfection. The landscapes appear withdrawn, lost in reverie, and timeless—in a pure state, pure presence. Standing motionless in eternity, with their immaculate glory, they have been compared to still lifes. It is precisely the solemnity of this tranquility which plays an important part in the impression created by these paintings.

Klimt's landscapes also demonstrate his stylistic development and method of painting in a particularly lucid way: his never-weakening openness for new artistic movements and the permanent assimilation of impulses, which were then adapted to his personal style. The landscapes make it obvious just how strongly Klimt absorbed inspiration from international artistic innovations, and how active the Secession's links with these were.

I would like to take this opportunity of mentioning three people, from a large number, who have played such a decisive role in making this project possible, and to whom I am particularly indebted: Franz Eder, who with never-ending patience and generosity supported my work in so many ways; my colleague Verena Traeger, for her constant attention to detail; and finally, especially my wife, for her loving and patient companionship in the preparation of this project. This book is dedicated to her.

Stephan Koja

1 Josef Lange, "Secession," in *Die Waage*, IV (1903), 612

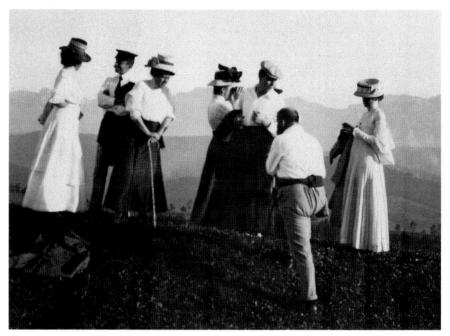

Gustav Klimt (with his back to the camera), Emilie Flöge, Hermann Flöge, and Helene Klimt with friends on an outing during the *Sommerfrische* to Gahberg, 1908

"Kultur" and "Natur"

Carl E. Schorske

For the cultural elite of Vienna, whose lives were closely linked to Gustav Klimt's creative output, the year was traditionally divided into two unequal parts. From autumn to spring, its members busied themselves in their quest for *Kultur*—a search to broaden the mind and refine the spirit, especially through the performing arts. In the summer months, they withdrew to *Natur*, to refresh the body and soul after the strains of work and play in the city. As the essays in this volume make clear, the nature to which families belonging to the *Bildung und Besitz* (culture and property) class turned was hardly *nature naturante*. Nor was it the utilitarian nature of the farmer or entrepreneur who prized it for its economic yield. In the late nineteenth century in particular, it was vacation country that was valued; a place to spend the *Sommerfrische*—a time of recreation for the families of officials and businessmen, and of undisturbed work and inspiration for intellectuals and artists.

The Salzkammergut was the most popular resort area for Viennese intellectuals, Klimt among them. In the last two decades of his life, he found not only a creative refuge in that region but also subject matter with which to express his mature vision of order and peace. For Klimt, the landscape—in its luminous utopian quietude—became a genre to complement his late portraits of wealthy female clients in highly crafted, hermetic, and aestheticized settings. His paintings of *Natur* and *Kultur*, the first without movement or people, the second without space or gesture, converged in a vision of "still life." With this emphasis on motionlessness in landscapes and on static artifice in portraiture, Klimt employed both genres for something otherwise expressed by the traditional genre for the inanimate: still life.

The essays in this publication illuminate Klimt's landscape painting in a rich variety of perspectives. Verena Perlhefter examines the changing view of nature that accom-

panied and conditioned new forms of contact between urban dwellers and the country: the rise of recreational travel, the development of spas and settled family vacation areas, in which the culture of the city was often replicated. Stephan Koja explores the place of landscape painting, focusing on Klimt's participation in the changing thought and outlook of his generation and his evolving compositional techniques. Christian Huemer analyzes the artist's changing role and function with respect to the historical shift of patronage from the state to the individual. He directs his attention to the artist's character and his leadership during the struggle for autonomy in art.

Peter Peer shows that, despite stylistic shifts and conceptual innovations, Klimt's work was deeply anchored in a strong Austrian landscape tradition. Klimt's modernist approach in some thematic and formal aspects appears as a continuation of his predecessors' work. Conversely, his predecessors can be seen as anticipating Klimt's modern vision.

Two further essays consider Klimt's landscape painting from a conceptual and technical point of view, as opposed to contextually—biographically, socially, or art historically. Anselm Wagner analyzes the late landscape paintings as products of the artist's quest for otherness, for an "elsewhere," a utopia. To purge the land of its disturbing, active character, Klimt came to approach it with a distant vision, in which its purity and its ideality could be expressed. Wagner shows how both contemporary aesthetic-theoretical concepts (Riegl and Wickhoff) and technical means for distancing and framing (telescopic and telephotographic techniques) were connected to Klimt's pursuit for the intellectual—namely, to project a vision of serenity and order that could transcend and neutralize the experience of discordant reality.

Erhard Stöbe demonstrates how Klimt achieved the painterly effect that conveyed his vision of a purified

nature. In the same way that Gustav Mahler composed with instrumental sonority, so Klimt composed with color. Through a careful examination of Klimt's materials and, where possible, his work process, Stöbe presents a view of an artist who increasingly mobilized the means of his craft to banish darkness from the landscape and to endow it with a warm, luminous texture. The surface of the canvas presents a decorative image of nature, a nature that often conceals its structure in flowers and leaves.

Although Klimt became a painter of Nature late in life, he won his spurs at a younger age as a painter of Culture. Graduating from the School of Arts and Crafts—which had only been founded shortly before—when the state was engaged in a vigorous policy of fostering high culture throughout the Empire, the enterprising Klimt and two college friends formed a partnership that won state commissions for architectural decoration, especially of provincial theaters. Within Vienna, they provided ceiling and spandrel paintings for two of the last monumental cultural buildings on the Ringstrasse: the Burgtheater and the Kunsthistorisches Museum. Here Klimt distinguished himself as a committed and eloquent exponent of the officially supported cultural values of the Austrian elite.

Two paintings in particular reveal the social and ideological context of that culture in the late 1880s, and the place that Klimt envisaged for the artist within it. Because these paintings stand in such radical contrast to the conditions and concept that governed Klimt's landscape paintings three decades later, they enable us to appreciate the drastic character of the shift from traditional to modern high culture and the bold, creative role that Klimt played in it, first as a public artist, later as a private one.

Nothing could be further from the static, visionary character of Klimt's peopleless landscapes than the animated, realistic representations of theatrical performances through the ages in his Burgtheater paintings. In a picture representing a performance of Shakespeare's *Romeo and Juliet,* Klimt's focus is wide. He includes not only the action on the stage, but also the engrossed Elizabethan spectators and their royal patroness, who found their mirror-images on the stage. Klimt also included images of himself, his artist-brother, and his father among the audience, and in this way, underlined their part in the Viennese cult of classical theater.

In 1887, the City Council commissioned Klimt to paint the audience in the old Burgtheater before it was demolished to make way for the new building. He portrayed more than one hundred individuals in this group portrait of Viennese society (see p. 192). Once again, with his characteristic social self-confidence, Klimt added a number of attractive women he knew to the the other figures in the audience. He had little problem depicting himself and his middle-class friends among the ruling upper classes pursuing their cultural activities! The coveted Emperor's Prize, awarded to Klimt for this painting in 1890, was an acknowledgement from his imperial patrons for their satisfaction with his achievement at a time when the Ringstrasse had reached the zenith of its cultural importance.

These early *Kultur* paintings serve us well as a backdrop for understanding by contrast the late *Natur* paintings. They show us Klimt during his "Age of Innocence," when artist, royal patron, and elite society were united in devotion to historical culture. It was a kind of Paradise soon to be lost in a cultural revolution in which Klimt played a powerful leading part. Between the two kinds of paintings, alpha and omega of his artistic work, lay Klimt's struggle to develop a new culture with his generation, to develop a new form of art to express its values, and a new community of artists and patrons to sustain it. The exertions of such an ambitious mission to replace the old official culture drove Klimt ever more toward "art for art's sake" on the one hand, and toward abstract applied art for wealthy clients on the other. Three outstanding events mark the reciprocal strengthening of these tendencies: the founding of the Vienna Secession in 1897–98, the Beethoven Exhibition in 1902, and the *Kunstschau* in 1908.

Klimt was the acknowledged leader of the Secession movement that was to redefine the Austrian art of a new age. He provided powerful symbols: Theseus liberating youth from the ogre of commercialism and tradition (see p. 146); *Nuda Veritas,* who holds up her mirror to show modern man his true face (see p. 148); and many graphic designs to herald the emergence of a new, modern culture. Although visual artists led the movement, the Secession's organ *Ver Sacrum* was edited by Max Burckhardt, a sophisticated upholder of Nietzsche's teachings, legal reformer, and director responsible for the modernization of the Burgtheater. He strove to include contributions in *Ver Sacrum* from representatives of other art forms associated with *Die Jungen,* notably from the field of literature, such as Hermann Bahr, Hugo von Hofmannsthal, and even Rainer Maria Rilke. The pursuit of truth—an aim initially as prominent in the new modernist camp as the pursuit of beauty—included the exploration of the world of instinct. Here too Klimt led the way, with prolific, often explicit, representations of erotic experience. In the execu-

tion of the last state commission in connection with the Ringstrasse—depicting representations of the faculties in the new building of the university—Klimt's identification with the philosophical teachings of Nietzsche and Schopenhauer clashed head-on with the scientific and rationalistic morals of the academy. Angered and, in the end, deeply traumatized by the rejection of his visionary talents, Klimt broke away from the political authority and state patronage, never to return.

In the Beethoven Exhibition of 1902, the Secession proclaimed the autonomy and authority of the artist as never before. Klimt provided its central ideology in a great frieze devoted to the Ninth Symphony and Schiller's "Ode to Joy." He portrayed the artist as the redeemer of man in his struggle for happiness. Klimt relocated the message of the "Ode to Joy" from politics—the celebration of the brotherhood of humankind—to sex; for in the frieze a kiss suggests little of Schiller's universal fraternity, but rather the erotic fulfillment that stands at the end of the pursuit of happiness. Above all, the collaborators in the Beethoven show expressed the self-validating claim of the artist as Promethean culture-maker (see pp. 149, 198, 199). In their *Gesamtkunstwerk* for Beethoven they had built a temple in which to worship their own kind.

If the Beethoven show heralded the artist as autonomous creator and redeemer, the next important landmark exhibition of the artists associated with Klimt, the Kunstschau of 1908, had less an exalted and more a practical objective: to demonstrate through *Wohnkultur* the way in which art could penetrate and enhance daily life. The artist's function would be not to convey modern truth, as in Klimt's Secession productions or in his university paintings, but to permeate daily life with beauty. The Kunstschau exhibited the ripe fruits of a long collaboration between the fine and applied artists of Vienna: a model house, ceramics, a garden with sculpture, a theater, even a model cemetery. Fine arts, far from being excluded, were central to the exhibition's idea. With a spacious Klimt Hall at its very center (see p. 203), a critic could rightly describe the show as "a festive garment wrapped around Klimt." A number of portraits and landscapes, painted during the years of traumatic recoil following the reaction to his faculty paintings, were exhibited for the first time.

Klimt himself opened the Kunstschau with an unusual address. Its declared objective was to form a link between the artist and the public. In this respect, it would be considerably more beneficial to create works that strove to meet the requirements for major public projects. But as long as political and economic matters had the upper hand in the public eye, the exhibition remained the only means to achieve this objective. Do we not hear in these plaints the echoes of Klimt's Paradise Lost, of the Ringstrasse years when state, public and artist were united in fostering a shared high culture? This kind of exhibition, Klimt said, would provide a new bond between artist and public, by furthering through its displays William Morris's idea that "even the smallest object, properly crafted, tends to increase beauty on earth, and that … the progress of culture is based on the penetration of all life with artistic intentions." Klimt envisaged the creation of a new social formation committed to artistic culture. He called it a *Künstlerschaft*, "an ideal art-community of those who create and those who enjoy."

"Art is art and life is life," wrote Peter Altenberg, "but to live life artistically, that is the art of life." Altenberg's concept comported well with the aesthetic ideal embraced by the modernist sector of Austria's wealthy elite. The Kunstschau provided concrete models for such a high lifestyle, while Klimt's idea of a *Künstlerschaft* offered an identity to aspirants and potential patrons wealthy enough to embrace the life beautiful. At the heart of the undertaking was the collaboration of artist and designer-craftsman. Klimt himself, always a believer in collective enterprise, engaged in such practical projects as Josef Hoffmann's Stoclet Palais in Brussels. Admittedly, he too insisted on the distinction between the artist and the craftsman, even when they collaborated. Yet if the craftsman received inspiration from Klimt as artist, the reverse was also true. The decorative design components in Klimt's mature portraits became as salient as the human subjects. Framed in their fantasized ornamental setting, Klimt's women seem to exist in a pure transcendent house of beauty, an aesthete's enclosed space, bracketing out the common life of the world.

Despite all his efforts to present it as an event marking the start of a new cooperation, the Kunstschau showed how Gustav Klimt—the public painter for a public culture—had indeed become a private painter for an elite private culture, despite his long and creative struggle for modernism. Within this context, the utopian character of his landscape painting seems doubly meaningful—as part of an aestheticist turn and as the re-emergence of an Austrian tradition.

Nature seen as pure landscape permits the artist's eye to select. As in Klimt's paintings, dissonances can be eliminated and the sun be made to shine on an ordered and colorful world. It is thus a scene of culture's triumph, for nature is soon made to bloom as in a magic garden, soon

to serve as a model of an ideal of peace and order, the "Rosenhaus," that is achievable only in art.

Perhaps Austrian tradition resonates here too. Klimt's house-and-garden images of nature and the buildings that man has placed in it call to mind Adalbert Stifter's classic work, *Nachsommer* (1857). Its central figure, a bureaucrat defeated in his struggles against immorality and discord in the capital, withdraws to the country to a house of perfect order. Active craftsmanship sustains the beauty of the interior and its well-preserved furnishings. Outside, the gardener's art has dressed the house with roses, nurtured by careful pruning to a life of beauty. Is it not the same with Klimt's ever-blooming hillsides and with his bright and warm but mildly melancholic, well-ordered distant visions? Do not his highly crafted later portrait-settings and his decorative, bon-bon colored symbolic paintings echo the interiors of the "Rosenhaus," where art and craft together created a serene Biedermeier ideal of beautiful static order that life in the world of power had failed to provide?

Gustav Klimt (in smock), Emilie Flöge (to the right of Klimt) with friends on a dock in Litzlberg am Attersee (on the left, in the background, Litzlberg Island can be seen), probably 1903

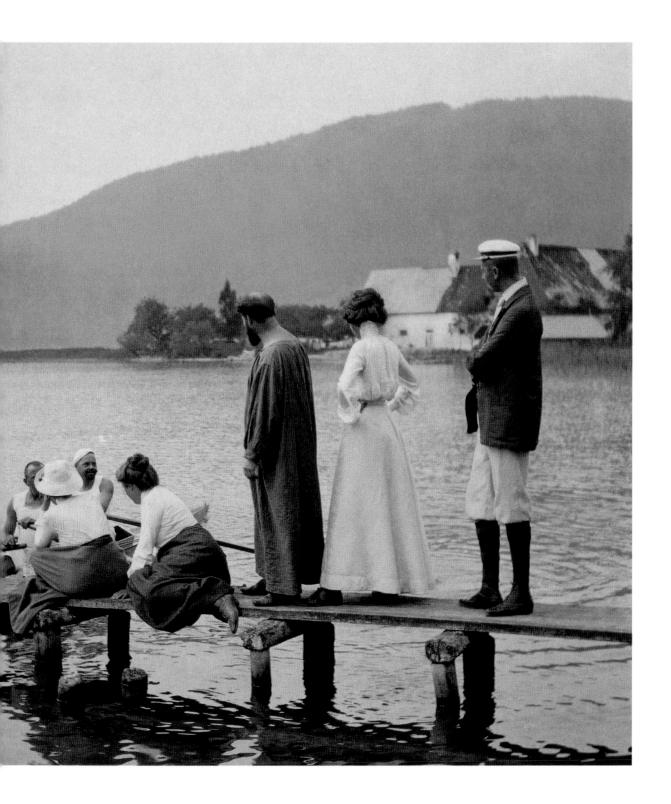

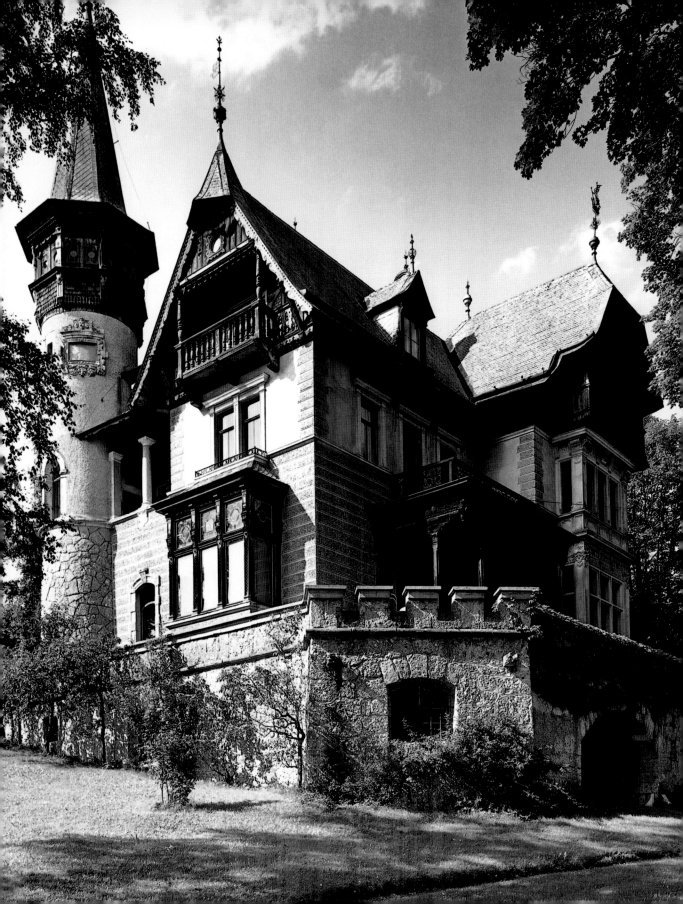

"It is such a wonderful feeling to be in the countryside."[1]
The Phenomenon of the Austrian *Sommerfrische*

Verena Perlhefter

"Nature as a landscape is the fruit and product of a theoretical spirit"[2]

Those who live in the country are completely at home with nature; nature is a part of everyday life: the forest provides wood; the earth, fields; and the water, fish. There is no specific reason to go into the open countryside and to abandon oneself to its observation. The landscape only becomes nature for the person who goes out into it to experience its feeling of the "all-embracing," its omnipresence in free, relishing observation:[3]

> When, while the lovely valley teems with vapor around me, and the meridian sun strikes the upper surface of the impenetrable foliage of my trees, and but a few stray gleams steal into the inner sanctuary, I throw myself down among the tall grass by the trickling stream; and as I lie close to the earth, a thousand unknown plants are noticed by me: when I hear the buzz of the little world among the stalks, and grow familiar with the countless indescribable forms of the insects and flies, then I feel the presence of the Almighty, who formed us in his own image, and the breath of that universal love which bears and sustains us.[4]

The fields, the river, the mountains are not "landscape" of their own accord; they only become so when one confronts them, for no practical reason, in order to feel at one with nature. Those aspects that appeared useful or useless and were rejected as being hostile were transported into greatness, sublimity, and beauty—transferred aesthetically into a landscape.[5]

Until the middle of the eighteenth century, most travelers were principally interested in the human world, in the artistic and historic monuments of bygone times, in the civilization of foreign peoples. Nature, untouched and uncultivated by man, appeared intimidating, unaesthetic, dangerous: "Any kind of landscape or view is imperfect without those human figures which bestow it with liveliness," expressed Dr. Johnson on his journey to the Hebrides with James Boswell.[6] Before the nineteenth century, the category of landscape painting also enjoyed less esteem in Europe than the treatment of religious, historical, or mythological themes or portraiture. During his first period of office (1769–90) as president of the Royal Academy, Sir Joshua Reynolds laid down a set of academic principles that envisioned landscape painting as the depiction of an idealized, perfect nature, as the manifestation of beauty; these directives were accepted by artists for many years.[7] Exceptions were made by a few landscape painters in the seventeenth century, such as Claude Lorrain, who used idealized landscapes to deliver a moral message,[8] Nicolas Poussin, who imbued them with a classical grandeur, or Salvator Rosa, who created wild and exalted scenes. But by the eighteenth century, classical landscape painting had degenerated into a "routine, vacuous stylistic hull."[9] Correspondingly, it was cultivated fields, houses, villages, fences, or trees that finally made a landscape beautiful—both through their diversity and also as a witness of human settlement.[10] Mountains were seen as dangerous and repulsive, symbols for the fall from grace. Ruins of a world torn asunder, they surrounded the valley regions, cultivated by man, like a hostile arena.[11] A description of a Swiss alpine crossing, dating from 1765/67, describes the perils awaiting the traveler: "abysses," "the clamor of vultures and other birds of prey," the "chill of this savage wilderness."[12]

Approximately one hundred years later, the very same mountain world evoked quite different impressions: "One has to have stood up there oneself in order to have a notion of all the magnificence and grandeur and then

these hours will be counted among the most beautiful and unforgettable in one's life."[13] The philosophers and poets of the second half of the eighteenth century contributed to this change in man's attitude to untouched nature. In particular, Jean-Jacques Rousseau's description of the "noble savage" and the idealization of "primitive peoples" (such as the native Americans and the original inhabitants of the Pacific islands) resulted in simplicity being associated with virtue and the natural landscape being held in greater esteem. The psychic assimilation of experiences in the mountains with religious metaphors ("the beauty and grandeur of creation," "preaches the word of God") transferred these into an enchantment with nature. The idea of exaltation aestheticized terror: mountains now produced feelings of dread but, at the same time, veneration.

Painters as Precursors and Beneficiaries of Tourism: "Landscape Painting Increases the Desire to Travel"[14]

In his treatise *A Philosophical Enquiry into the Origin of Our Ideas of the Sublime and Beautiful* (1757), Edmund Burke draws attention to those properties and qualities which cumulate in the feeling of sublimity: enormity, infinity, light, and also the color black. He saw the terror produced by the sublime as absolutely combined with a sensation of pleasure (once the sources of that terror are identified as mere emulation), resulting in a "delightful horror,"[15] as is the case with art. Hugh Blair, in his *Lectures on Rhetoric and Belles Lettres* (1783), described those emotions which ennoble the human spirit and result in sublime feelings: "Not the merry landscape, the meadow of flowers, … but venerable mountain peaks, the lonely lake, the primeval forest and the waterfall, which plunges over boulders."[16] It took country folk a long time to understand "why a stranger would travel more than a hundred miles just to look at their hideous mountains."[17]

At the beginning of the nineteenth century, Romanticism propagated the importance of those emotions that landscapes evoked — the more picturesque the landscape, the more stirring the subsequent emotions. Individual pleasure could be obtained from impressive outlooks and

Charles Jacque, *Shepherdess and Sheep at the Forest Edge*, undated, private collection

views. These views, however, had to be organized and arranged into individual landscape scenes in order to not overwhelm through their sheer overabundance.[18] Through a continuous change of their "point of view" travelers learned to identify individual scenes: the terrifying ravine, the enchanting valley, the threatening, snow-covered mountain peaks. Painters placed these landscapes in the correct dimension: easily approachable (the valley, the tranquil river) or better admired from a distance (the mountains, the stormy ocean). They populated their pictures with "aborigines," melancholy fishermen, adventurous hunters, and pretty dairymaids — if necessary, attired in saucily torn garments. Alpine lakes, because of their mirroring and color-changing effects, were particularly in demand as components of paintings, whereas they had been regarded simply as utilities into the nineteenth century. It is reported that, in 1804, Chateaubriand described the Riviera as "dreary."[19]

Usually, travel reports paved the way for tourism in attractive regions, followed by artists who discovered new panoramas or satisfied the demand for pictures of popular destinations.[20]

In the 1830s and 1840s, a relatively independent group of artists had come together in the small village of Barbizon in the forests around Fontainebleau in France: the painters Camille Corot, Charles-François Daubigny, Jules Dupré, Jean-François Millet, Théodore Rousseau, and Gustave Courbet came here for brief or lengthy periods and dedicated themselves to the study of nature and its ever-changing appearance. In the beginning, sketches made in the open-air were regarded as preliminary work for paintings produced later in the studio. With time, however, it became more accepted that a work produced directly in front of the object *en plein air* was more authentic than a studio painting. Admittedly, it was left to the next generation — the Impressionists — to uncompromisingly produce their works directly in natural surroundings.[21]

In the 1830s plans were made to develop the forest of Fontainebleau according to the designs of C.F. Denencourt; in 1839 a topographic guide with five itineraries and recommended viewpoints was published. The railroad line

Poster for the Melun
railway line to Barbizon,
color lithograph,
Musée Municipal de
l'École de Barbizon

As in Europe, painters contributed to the popularity of various regions through their work. The tragedy of the Willey family, who were wiped out by a landslide in the White Mountains of New Hampshire, initiated a kind of "catastrophe tourism" which, however, soon turned the region into a popular vacation destination.[26] Similarly, the paintings of Winslow Homer helped popularize the Adirondack Mountains in upstate New York.[27] Newport, in Rhode Island, was already starting to develop into a bathing resort for wealthy New Yorkers when Kensett visited it for the first time in 1852 and, as a result, painted many pictures of the town and its surroundings.[28] When

between Paris and Lyon was opened in 1849, providing a comfortable and speedy journey from the capital, which in turn led to an enormous increase in the number of tourists. Denencourt's guide was even published in English. On the one hand, the forest's popularity with tourists saved it from logging by profit-seekers, but on the other hand, the idyll which the painters had treasured so much was destroyed, caused to a large extent by the popular depictions they themselves had produced.[22]

Around the middle of the nineteenth century, painters and writers often spent their summers on the Normandy coast, where the cost of living was lower than in Paris. In their paintings and articles, these intellectuals—such as Alphonse Karr, Eugène Le Poittevin, Gustave Courbet, Jean Baptiste Isabey, and Eugène Boudin—promoted these relatively undiscovered villages and contributed to their increasing popularity. Claude Monet's famous paintings of Étretat were created at a time when the area was already a well-known, popular seaside resort.[23]

When Thomas Cole and, later, John Frederick Kensett, Jasper Cropsey, Frederick Edwin Church, and Sanford Gifford started traveling to the Hudson River valley in the 1820s in search of motifs, several travel guides for the region and the Catskill Mountains were already in circulation; tourism had slowly started to penetrate from New York.[24] For these painters, the wilderness had not merely lost its terror: it had become the embodiment of the authentic American, the warrant of divine selection. This notion of the untouched wilderness as "God's own country" became the unifying thought which bound the nation of immigrants together. It was interpreted as a specific characteristic of the still-young nation, a geographic substitute for a scanty history lacking in historical monuments [25] and, therefore, as a central concept of the American identity.

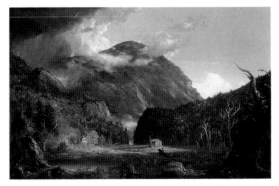

Thomas Cole, *A View of the Mountain Pass Called the Notch of the White Mountains (Crawford Notch)*, 1839. Andrew W. Mellon Fund, National Gallery of Art, Washington

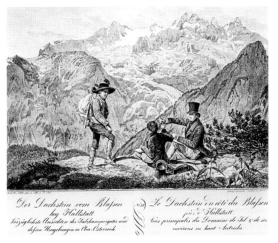

Jakob Alt, *Der Dachstein vom Blassen bey Hallstatt*, "Popular views of the Salzkammergut in Upper Austria" (the artist with his son, Rudolf, and a mountain guide, resting), 1833, lithograph, Albertina, Vienna

Cole, Church, Fitz Hugh Lane, and Alvan Fisher visited Mount Desert Island in Maine, between 1830 and 1860, they discovered an untouched landscape. By 1880, however, there were already paved roads, summer houses, a yacht harbor, and even a railroad to the main viewpoints.[29]

The scenic beauty of the Salzkammergut and the Hudson River valley were both "discovered" at approximately the same time. The German naturalist Alexander von Humboldt compared the Salzkammergut with Switzerland[30] and, on their tours and journeys, painters such as Thomas Ender, Franz Steinfeld, Ferdinand Georg Waldmüller, and Rudolf von Alt portrayed its beauties. The German painter Jakob Alt declared the lake landscape, which he traveled extensively between 1823 and 1825, to be his second spiritual home.[31] In 1825, Friedrich Gauermann hiked through the Salzkammergut for the first time, where he "spent two days in Aussee making oil sketches, eight days were reserved for Hallstadt where I busily painted by the lake and the Strub forest brook."[32] The image to be painted was depicted from the observer's point of view, and there were hardly any compositional changes. Baroque

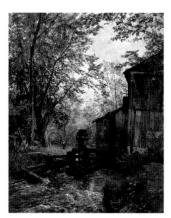

Emil Jakob Schindler, *Sawmill near Goisern*, 1883. Österreichische Galerie Belvedere, Vienna

schemata were overcome; however, the severity in the treatment of the material still stood in the way of a realistic landscape perception.[33]

Emil Jakob Schindler, like the artists of Barbizon, was also fascinated by the idea of the atmospheric, untouched experience of nature. He disapproved of heroic elements and stressed the poetic-narrative aspects of nature—consequently, he christened his artistic concept "poetic realism."[34] For years, during the 1860s and 1870s, he spent his summers in Goisern, along with his family and students, where he was fascinated by the mountainous landscape which provided the basis for his recurring motif, the mill.

Another artist who spent his summers in the countryside was Hans Ranzoni, the longtime president of the Viennese Künstlerhaus. Once, when he was seated behind his easel in the open air, he heard a peasant woman say: "That would be something for my lad. He's not really healthy, and actually a bit silly, but at least he'd be out of doors!"[35]

It was only a small step from these contrived landscapes to seeing nature as a backdrop, as pleasant surroundings,

as a piece of decoration (with a window as the frame): "nature [is] like a theater: it presents its plays as best it can and [the person] watches and applauds when nature has satisfied him."[36]

Sommerfrische: "As far as nature is concerned, I'm happy with the chives in my soup"[37]

The phenomenon of *Sommerfrische* is not easily explained: in the Grimm Brothers' German dictionary it is defined as a recreational period, spent by a city dweller in the country during the summer.[38] The *Sommerfrische* could also be an apartment in the country. The verb "to *sommerfrisch*" was an expression that supposedly originated in the southern Tyrol, because the citizens of Bolzano were accustomed to "look for freshness" in order to escape from the hot days of summer in the cooler atmosphere of the surrounding mountains.[39] Even in medieval times "the summer heat in the formerly swampy woods of the Adige" forced "the inhabitants to seek out more pleasant locations."[40] In his German-Italian dictionary of 1693, Matthias Kramer translated the Italian word *refrigeria* as cool refreshment in the shade[41] and noted that the population of Merano and Bolzano had derived the German word *Sommerfrische* from the Italian expressions *fresco* and *frescura*.[42] In his book *Alpenreisen* (Journeys through the Alps) of 1849, Johann Georg Kohl wrote: "The people here [on Lake Garda] call both the period they spend in the country as well as the country house itself *frescura* (freshness)."[43] Another opinion concerning the origin of this expression harks back to the time when shepherds would graze their flocks on alpine pastures. At the turn of the last century, the term for this period, in Tyrolean dialect, was still *sommerfrist*.[44]

The common aspect of the various etymological attempts to explain *Sommerfrische* is that it deals with an extended summer sojourn in a rural environment, as opposed to cultural travel undertaken to become acquainted with antiquity and the classical period, with foreign countries and cultures. Cultural travel was not intended as a source of recreation; its goal was rather to see "as many museums and objects of interest as possible, guided

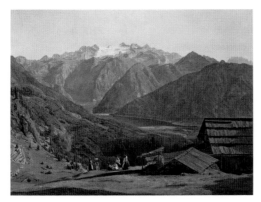

Ferdinand Georg Waldmüller, *View of the Dachstein with Lake Hallstatt from Hütteneckalm*, 1838, Historisches Museum der Stadt Wien, Vienna

View from the spa building in Semmering, photographed in 1991

more by the standards of Baedeker than one's own interests and feelings."[45] *Sommerfrische*, on the other hand, provided a possibility for remaining in one place; it offered both the continuity and repetition of the familiar.[46]

The sojourns undertaken by the aristocracy to their country estates during the sowing, growing, and harvesting periods can be seen as precursors of the *Sommerfrische*. They mostly sought proximity to the court only during the winter months. In the period prior to the revolution of 1848, the bourgeoisie typically left the cities in the summer months in order to avoid the annual typhoid and dysentery epidemics and to relax in the surroundings of Vienna—at first on Sundays and holidays, later for longer periods often combined with a stay at a health resort. Women and children profited most from these bourgeois summer arrangements because successful businessmen,

civil servants, and tradesmen saw it as a sign of their consolidated financial situation to send their families to the country and to visit them on the weekends.[47] The summer trip to the country became popular among the less-well-to-do classes at a later date—their restricted financial circumstances only permitted day excursions.[48]

The poor condition of the transportation network limited the location of these resorts to the immediate vicinity of Vienna. In 1852 Franz Grillparzer reported on a trip to Bad Tatzmannsdorf (about two hours from Vienna by train): "Several unfortunate incidents prolonged my journey. In Ödenburg, Doctor Reinwald awaited me, however, in a condition which appeared to prevent any continuation. He was afflicted with nausea and vomiting and any other person would have been unable to move from the spot. In spite of this, we departed from Ödenburg after the meal—where I was seated alone. The second misfortune occurred when one of his own horses, which was waiting for us as a relay about half way to Güns, became lame from inactivity. In spite of this, we traveled on with the lame horse and arrived in Güns on Wednesday evening. On the next day, the horse could not move and I had to spend the entire day in Güns (I believe one calls it *ennui*). Finally, we left the place at 4 a.m. and arrived here at around 11 a.m."[49]

The extension of the railroad network in the 1860s and 1870s permitted those seeking recreation to venture deep into the Salzkammergut, the Semmering and Rax mountain areas, as well as reach the Carinthian lakes.[50] In Germany, the bathing resorts on the Baltic and North Seas experienced a boom through summer visitors and, in the United States, the coastal towns of New England were discovered as places to spend a summer vacation. In his drama *Das weite Land*, Arthur Schnitzler outlines this development in a scene in which the hotel porter responds to a guest complaining about the tiring journey: "In three years, at the latest, we will have a railroad here, Herr von Kreindl. The Director of our hotel is leaving for Vienna shortly to discuss this matter with the Minister."[51]

The introduction of statutory holiday privileges for the working population also contributed to the increased numbers enjoying the *Sommerfrische*: this vacation right was granted to commercial workers in 1910, followed in 1914 by government employees.[52] In winter, visits were made to the springlike Riviera or Lake Garda; in the spring, to Italy or France; and in early summer possibly a few weeks by the sea. The *Sommerfrische* was a time to recuperate from these journeys and to spend an extended period of time in one place—and that at a time of ever-increasing mobility.[53]

For the masses, the choice of a particular place to enjoy the *Sommerfrische* depended less on health or educational considerations and more on the regular visits of crowned heads of state: "Among the reasons for choosing a specific vacation resort, health reasons—if they played any role at all—were given, by and large, low priority."[54] Ischl profited particularly from the "supreme" predilection of Franz Joseph I, and it was noted that "the Emperor also took the waters and he had a truly robust constitution."[55] Archduke Karl made Reichenau a center of attraction; Napoleon III, Biarritz; and Queen Victoria, the Isle of Wight. Less elegant summer spas with simpler accoutrements sprung up in the vicinity of these noble resorts. Due to their lower prices they were frequented by the middle class (minor civil servants and master tradesmen).[56]

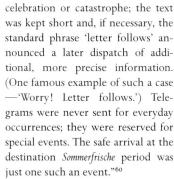

Swiss-style country house, side elevation, in Andrew Jackson Downing, *The Architecture of Country Houses* (New York, 1850)

Summer visitors took the city along with them into the countryside and accelerated the transfer of the Viennese way of life into the originally rural regions. Nature, in its cultivated and domesticated form was preferred, within a social framework and a well-developed infrastructure—in contrast to the mountaineers who sought out untouched summits.[57] Taken to an extreme, some people on their *Sommerfrische* expected to find good restaurants, interesting company, and coffeehouses stocking all the most important newspapers—"and we just have to put up with a bit of fresh air."[58]

At the end of the nineteenth century, just as at the beginning, the *Sommerfrische* period involved an extended sojourn with family and the majority of the domestic staff in one's own villa or other accommodation, rented for the summer months. The "season" in the city—with its social and cultural activities such as the opera and theater, concerts and balls—lasted from late autumn until spring; June to September was spent in the countryside. Rosa Albach-Retty described setting out for the *Sommerfrische* period: "Every year, in the last week in June, holiday fever broke out. Then Anna, together with the cook and the parlor maid, retrieved the large trunks and baskets from the attic, packed part of our china service, silver cutlery, glasses and dishes, as well as my husband's hunting rifle, and made sure that everything was delivered in time to the West Train Station. This was to be certain that when we arrived punctually on July 2 in St. Gilgen everything was ready to be unpacked. In those days we traveled for

the *Sommerfrische* period with the whole kit and caboodle and, of course, with the domestic servants. This was called 'menagieren.'"[59] "Certain customs formed an integral part of the institution of the *Sommerfrische*; among them, the arrival telegram... The telegram informed the *paterfamilias*, who had remained behind in the city, of the happy completion of the journey and always began with the words 'Arrived safe and sound.' Telegrams in those days still conjured up a sense of excitement. Whether announcing a celebration or catastrophe; the text was kept short and, if necessary, the standard phrase 'letter follows' announced a later dispatch of additional, more precise information. (One famous example of such a case —'Worry! Letter follows.') Telegrams were never sent for everyday occurrences; they were reserved for special events. The safe arrival at the destination *Sommerfrische* period was just one such an event."[60]

During the week, the head of the family attended to his affairs in the city and only visited on the weekends. This routine led to the Monday morning train to Vienna from Reichenau am Semmering (also a very popular *Sommerfrische* destination for Viennese society) being christened the "Busserlzug" ("kiss train") because so many fathers were kissed farewell by their families on the platform. They would then see each other again on the following Friday.[61]

Rental accommodations usually consisted of rooms, or entire floors, in guesthouses, hotels, or farms. Hugo von Hofmannsthal described one such type of frugal accommodation: "It is a tiny farmhouse, the so-called dining room is such that the children can never eat with us at table. They eat by themselves, outside in summer and, when it rains, in the roomy, farmhouse kitchen. When it rains, and recently it poured, there is no possibility for a guest to retire, there is only one miniscule bedroom, a so-called study is located in another outlying farmhouse."[62]

The ever-increasing demand for accommodation led to a lively construction boom: the new summer villas were mostly patterned on the "Swiss Chalet,"[63] a style which, after the 1850s, overran all the newly discovered rural recreational areas. The "Swiss Style" was widely variable in its basic architectonic concept—the term merely indicated a completely arbitrary reception of the most varied decorative elements and their application in all wooden (or wood-like) components, which were greatly facilitated

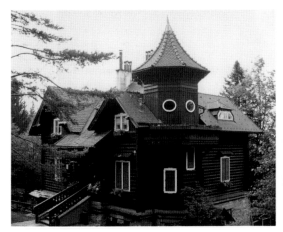

Villa Kreuzberg, Breitenstein

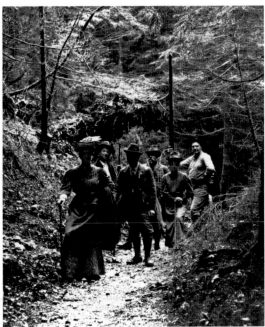

The Teiber family on an excursion from Thalhof to Lackerboden, 1905, plate photograph, photo: Heinrich Teiber jr.

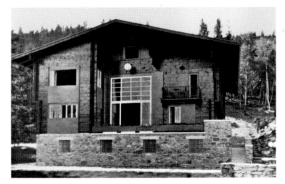

Landhaus Khuner, Payerbach near Vienna, photographed in 1930

by mechanical reproduction. A building counted as "rural" and in harmony with the non-urban environment if the gables, rafters, shutters, balconies, and verandas bore ornamental woodwork fashioned with a fretsaw.[64] These summer residences picked up the thread of the English country house tradition and attempted to satisfy the demands for comfort, coziness, reserved seclusion, and calm at the same time as capturing the panorama through look-outs, verandas, and oriels. In his book *The Architecture of Country Houses*, published in New York in 1850, Andrew Jackson Downing wrote: "The appropriate place for a country house in the Swiss style is in an audacious, mountainous environment, on the slopes, or at the foot, of a wooded hill or in a wild, picturesque valley. In such an environment, this form of architecture assumes sense and relevancy and appeals to all, whereas, on the plains,

surrounded by green meadows it would appear affected and ridiculous."[65] The houses should "at any case, be appropriate to knickerbockers."[66] The surrounding mountains became a kind of theatrical backdrop and provided those relaxing on the verandas and balconies with a harmonious panorama. Seen from this perspective, nature was no longer exalted and threatening, as in classical romantic aesthetics, but peaceful—an assemblage of pretty knickknacks.[67]

On the other hand, Adolf Loos, who designed the Villa Khuner on the Semmering in 1930, wanted not to imitate and falsify this "country style" but to integrate technical improvements (such as central heating, permitting larger windows) into the existing traditions. "The Viennese attorney who talks to the farmers in a yokel dialect should be wiped out.... Do not build quaintly. Leave that to the country folk, the mountains and the sun. The person who dresses cutely is not cute but a tomfool. The farmer does not dress picturesquely—he is picturesque."[68] For these reasons, "the childish attempt of our architects over the past forty years, to accommodate nature by using steep roofs, alcoves and other rustic 'yodeling' has flopped ignominiously."[69] Loos was concerned with sincerity in his

relationship to nature and the landscape: "Urbanites must once again find a connection with nature. Not as day-trippers or summer guests, because that leads to the most gruesome product of our time: the Bad Ischl dirndl."[70]

The standards for observing nature were set down and popularized in the nineteenth century; poets minted expressions such as "wildly romantic" and "wonderfully mellow"; one was expected to exclaim "magnificent!" from the right vantage point and not to talk loudly on lonely forest paths but to relish the silence.[71] "'Nature' had been discovered.... One felt indebted to this discovery, which consisted of nothing more than the fact that one word which had previously meant 'composition or condition' (our forefathers understood it as such) was now invested with a vague—even aesthetic—content: which any decent person has to evaluate as positive. This is exhibited and even regulated—in rural regions, people tap each other on the shoulder to draw the other's attention to the beauties of nature. If somebody said that this spinach-green sublimity, up hill and down dale, gave him a nauseating feel, he would be regarded as wicked."[72]

Usually, the enjoyment of nature during the *Sommerfrische* was restricted to observing it from the comfort of the balconies and terraces. Walks and hikes in the mountains were undertaken, but no one ever left the marked paths, with their benches for taking a rest and admiring the picturesque views. Solitude in the out-of-doors could inspire artistic activity: "In short, I cannot hold back, I must go to the country! I have to write twenty plays!"[73] Alma Mahler described how this was in the case of Gustav Mahler: "Mahler's pattern of life never changed in the entire six years. In summer, he got up every day between six and half past six. As soon as he awoke he rang for the cook, who immediately prepared breakfast and carried it up the slick, steep path to his study house. This was located in the middle of a wood about sixty meters above the villa; the cook was not allowed to use the regular path because he could not bear to see her—or anyone else—before starting work, and so she had to climb up the slippery gravel path every morning carrying all the dishes."[74]

The physical exercise that resulted from a mountain ascent could also provide a change from the everyday existence behind a desk or in front of the easel. In August 1889, Arthur Schnitzler wrote to a lady friend: "Two lines, my sweetest, from these sacred heights—I am writing these

Fashionable ladies' boot for mountain hikes, 1873, Deutsches Schuh- und Ledermuseum, Offenbach

lines from the Hütteneckalm—countless meters above sea level (at least, I have never counted them)—in my holy solitude—snow vis-à-vis (but far away). This is already my second summit today because, exactly two hours ago, I was on the Predigerstuhl."[75] The different perception of nature—on the one hand, a provider of views for the guests and, on the other hand, the basis for the farmers' livelihood—was not always overlooked; Peter Altenberg once asked to whom the beauty of the Alps belonged: "the hillbilly who cultivates it or me, who experiences it?"[76]

This meditation on the relationship between the local inhabitants and tourists could also lead to pronounced criticism of the subservient variety of tourism, as described by Karl Kraus (himself, a passionate *Sommerfrischler*): "The Austrian countenance, so often conjured up by our feature writers, is actually the visage of a sweating hotelier, busying himself everywhere, incessantly genuflecting in front of empty tables and always trying to liven up the place by reorganizing the bread-rolls.... The children should be trained to compensate for the surliness of bad inn habits, trains which arrive late or in a swinish condition, expensive automobiles, and wretched telephone calls through their very own intrusiveness. Because the Alps are ours. The Swiss also have a domain and have developed into a united people of hoteliers.... No other country worries so much about tourism as Austria, the others wait patiently and without fuss to see what the summer will bring. In England, Germany, and France everyone thinks that it is more important to take care of the locals than strangers, because these tourists will come of their own accord when the locals are taken care of."[77]

The cultural activities consisted mainly of spa concerts and theater productions, and the performers really had to make an effort to satisfy their demanding guests. Singers and actors who were on their *Sommerfrische* themselves performed on these occasions, among them the famous actor Alexander Girardi. His wife reported from a journey to Holland: "If Girardi had had his way, he would have walked barefoot back to Ischl immediately after our arrival in Scheveningen."[78] In 1893, the premiere of the one-act play *Farewell Supper*, from Schnitzler's "Anatol" cycle, took place in the theater in Bad Ischl.

Taking part in cultural activities was considered a sign of refinement; one was seen in public enjoying more demanding entertainment. Even though people were busy

cultivating their social contacts, nobody was forced to communicate—contacts with others served mainly to increase one's own social prestige. For this reason, many *Sommerfrische* regions and spas published a weekly guest list with information on the names and accommodations of the new arrivals. In summer 1891, Hugo von Hofmannsthal expressed his dissatisfaction with the other guests in Bad Fusch: "I really find it a pity that I have so many new ties with me, there is nobody here to appreciate them. The lady who sits next to me at dinner is a dried out canoness from Saxony, her chambermaid, however, is called Selma. And then there's this old Polish Lieutenant Marshall, a terribly conventional figure, he sits around blustering ... gluttonous, tells yarns, took part in a campaign ... disgusting.... And, as some sort of compensation, the daughters of a soap boiler from Graz sit opposite me; absolutely blond, absolutely clean."[79] The summer guests avoided all-too-close contacts with the local population; these contacts were restricted principally to "greetings when (they) met during a walk and the promise to help if anyone needed a position in the city; the children from the city, however, played with the farmers' children."[80]

The clothing—particularly that of the men—showed a strong propensity for local, traditional influences. They wore loden jackets and leather trousers—and the Emperor, when he was in Ischl, only sported hunting gear. This masquerading in local costumes also led to ridicule: "On the banks [of the Attersee] live people with loden jackets and naked knees, and, if they would stay silent, you would never know that they came from Berlin."[81] The ladies usually chose less cumbersome materials than in the city; the designs, however, were just as uncomfortable: a parasol protected them from the dreaded tan, long excursions into the mountains were undertaken in long skirts, corsets, booties, and thin stockings. In 1891, Viscountess Harburton founded the English "Rational Dress Society," organized to adapt female clothing to the more practical male equivalent for sporting activities such as cycling, swimming, tennis, and mountaineering. A few years later, it was possible to wear culottes; the corset, however, was still *de rigeur*.[82] An exception to these strict constraints was offered by the "reform dresses," designed by Emilie Flöge for her salon and very popular in intellectual circles. They hung down from the shoulders like loose

The Emperor Franz Joseph I leaving the Imperial Villa in Bad Ischl, 1905

sacks, without corsets, and offered room for deep breathing, independent thinking, and movement (see p. 26).

"The Salzkammergut is an ideal landscape conceived by the Creator for his own pleasure"[83]

The historical area of the Salzkammergut consists of the Styrian Aussee region and the Upper-Austrian Traun valley from Hallstatt over Ischl to Ebensee. Today the area around Traunsee, Mondsee, and Wolfgangsee are also included. For centuries, the Salzkammergut enjoyed privileges in connection with salt extraction and trade and was administered directly by the Imperial Chambers in Vienna. In the middle of the nineteenth century these privileges slowly diminished—the salt, however, remained a major industrial factor as well as being used as brine for medicinal bath purposes.

The interest in spas and climatic resorts had increased since the Age of Enlightenment, when much emphasis was placed on hygiene and health services. After the middle of the eighteenth century numerous treatises were published on the benefits of mineral spas and, at the same time, the first seaside resorts were established in England. Both bathing and drinking sea water were recommended, although bathing meant splashing around more than actually swimming. The main season for this was originally winter.[84] Those who were not able to travel to the sea still did not have to forego its healing properties—the saline bath produced the same results. In 1803 the first saline bath establishment was opened near Magdeburg.[85]

The saline doctors of the Salzkammergut had recognized the alleviating properties of the medicinal brine bath, but it was only when the Viennese doctor Franz de Paula Wirer sent the first spa guests to Ischl that it, along with Gmunden and Aussee, became recognized as health resorts,[86] slowly integrating the surrounding communities into the sphere of the summer guests.

Dr. Wirer's connections to the court in Vienna led to more and more members of the aristocracy and upper class being included in the guest lists of the various resorts. When the Archduke Franz Karl and his wife Sophie, who until that time had remained childless, took the waters in Ischl, the little town became famous due to the births of the "salt princes" Franz Joseph, Ferdinand Maximilian,

and Karl Ludwig. Franz Joseph I returned every year with his parents and later with his wife Elisabeth, and spent, as Emperor, sixty summers in Ischl. He had been given a villa there as a wedding present and transformed it into a summer residence. In the summer of 1914—the last which the Emperor spent in Ischl—he signed the ultimatum to Serbia on July 23 and on July 28 the manifesto "To My Peoples," which marked the beginning of World War I.

There was no end to the flow of summer guests — poets, composers, actors, and singers came to the resorts, among them Nikolaus Lenau, Giacomo Meyerbeer, Johannes Brahms, Anton Bruckner, Johann Strauss, Arnold Schönberg, Maria Jeritza, Leo Slezak, Olga Wisinger-Florian, Carl Moll, and Adalbert Stifter. Peter Altenberg spent a total of twenty-three summers in Gmunden, his "home village of the soul."[87] Sigmund Freud spent many summers in the Aussee region and reported, in his *Traumdeutung* (Interpretation of Dreams) of 1900, of two wish-fulfillment dreams with a connection to Hallstatt and Aussee. His small daughter had a dream about Aussee: "Just as sincere is another dream which the scenic beauties of Aussee aroused in my young daughter who was only three and a quarter years old at the time. She had traveled across the lake for the first time and the passage went by too quickly for her. She did not want to leave the boat at the landing stage and wept bitterly. On the following morning she told me: Last night I was on the lake again. Let us hope that she was more happy with the duration of that journey."[88]

from 1908 to 1912, resided in the Villa Oleander in Kammerl near Kammer on Attersee. In 1913 they spent the summer on Lake Garda with only a few days on Attersee visiting Emilie's brother Hermann in the Villa Paulick in Seewalchen. From 1914 to 1916, the Flöges returned to Attersee, living in the Villa Brauner in Weissenbach; Klimt, however, took lodgings in a secluded forester's house (plates 48, 49).[91]

Usually, Emilie traveled ahead with the family, while Klimt continued to work in Vienna and followed later. He often sent postcards to Attersee detailing his impending arrival or the situation in Vienna: "I have already packed quite a lot—it just has to be put in the crates"(July 9, 1907);[92] "We will seek out some walk.... Just imagine, the first time on Litzlberg and being able to enjoy it alone." (July 8, 1908).[93] In 1910 his work on the frieze for the Palais Stoclet in Brussels forced him to remain longer than usual in Vienna: "Looking at this stupid work for Brussels, I should stay here the whole summer" (July 26, 1910).[94] "I will just leave on Friday—and will try to take care of this 'dirty work' for Brussels while in the country" (July 27, 1910).[95] "Unfortunately, I will have to busy myself in the country with Stoclet, which really peeves me" (July 28, 1910).[96] Some less serious greetings from this summer have also been preserved: "I have just read that two waiters drowned near Attersee—watch out! Anybody who tells jokes in the boat should be hit on the head with an oar!" (July 24, 1910).[97] When he inspected the completed *Stoclet Frieze* four years later, the working summer at

"The Attersee is the Lake of Heaven"[89]

In 1897, Gustav Klimt spent his first extended summer country holiday with the Flöge family, in Fieberbrunn in Tyrol. The summer of 1898 was spent in St. Agatha near Bad Goisern and, in 1899, the Flöge family and Klimt visited Golling, where a picturesque waterfall attracted many visitors and a spa offered relief for those suffering from gout.[90] Gustav's brother Ernst had been married to Helene Flöge and, after Ernst's early death, Gustav became the guardian of their small daughter Helene. Klimt had a close relationship with his sister-in-law's sister Emilie Flöge. This intimate connection to the entire family led to the *Sommerfrische* period being spent together in the Salzkammergut.

Starting in 1900, the Flöges and Klimt were permanent summer guests at Attersee. They stayed in the guest wing of the brewery in Litzlberg near Seewalchen until 1907 and,

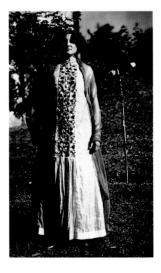

Emilie Flöge in a "reform dress" in the garden at Villa Oleander in Kammerl am Attersee, c. 1910, lumière autochrome plate by Friedrich Walker

Taking a break with friends on Gahberg near Weyregg am Attersee (in the foreground: Emilie Flöge and Helene Klimt), 1908

large poplar with a storm welling up. Sometimes, instead of this evening painting session, I go bowling in a neighboring village; not very often though. Then twilight falls, supper, then early to bed and early to rise the next morning. Sometimes I interrupt this routine to do a little rowing to tone up my muscles a bit. This is the way my days go by, so far two weeks have passed and the shorter half of the holiday is already over. Then one is glad to return to Vienna.... The weather here is very unpredictable—really not hot and often interrupted by rain—I am prepared for all eventualities with my work—and that is really very pleasant."[99]

Klimt was an enthusiastic swimmer and rower,[100] and he sought relaxation on extended walks. "I am doing a lot of walking in the open air."[101] Sweet idleness was also intended to bring the desired relaxation: "During the first few days here I didn't start to work immediately, as I had planned, I let a few days just drift by."[102] "Today I must seriously think about beginning to work—I'm really looking forward to it because just doing nothing becomes boring after a while, even though when I do nothing I still think fiercely, thinking day and night, artistic and non-artistic thoughts, the genuine, complete relaxation which would really do me so much good—that just doesn't exist."[103]

The locals called Klimt "Waldschrat" (Forest Demon) because he was usually on his way, alone in the forest, loaded down with his painting utensils.[104] If he were disturbed while painting he was not very amenable, as can be taken from this report by a vacationer: "It was around the turn of the century. We were at our favorite *Sommerfrische* on Attersee, a small, quiet village between Attersee and Litzlberg.... Once there was a period of bad weather, with cold, inclement weather and rain. In spite of that, we went walking, usually along almost deserted roads. In Litzlberg—the village lies across the lake from Kammer—we saw a man in a large meadow in front of an easel, in spite of the drizzle and cold, painting an apple tree, with photographic accuracy. We went closer, the grownups said a few friendly words but the genius remained cantankerously silent. It was surprising that somebody chose such simple motifs, at a time when others looked for particularly impressive scenes of the area.... It was only later that we discovered that the unknown painter was Gustav Klimt."[105]

Klimt brought work with him from Vienna (such as the already mentioned draft for the *Stoclet Frieze*) or created

Attersee was a romantic memory; the draft for the frieze had been stretched out on a wall of the summer house, and Emilie had occasionally helped him with the work.[98] In a letter, Klimt described his daily schedule as follows:

You want to know about my timetable—how I divide my day—well, it is very simple and quite routine. I get up early in the morning, usually around 6 a.m., sometimes earlier sometimes later. If I get up and the weather is fine I go into the nearby forest. I am painting a small beech grove, mixed with a few conifers. This takes until about 8 a.m. Then there's breakfast and after that a swim in the lake—I'm careful about it though. Then I paint for a while: if there's sunshine, a picture of the lake; if it's overcast, I work on a landscape through the window of my room. Sometimes I neglect this morning painting and, instead, study my Japanese books—outdoors. Then it's noon, after lunch I take a short nap or read—until the afternoon snack. Before, or after, the snack a second swim in the lake, not always, but usually. After the snack, back to painting. This time a

new ones on the spot. He chose the scenes using a viewfinder as he described in a letter to Mizzi Zimmermann: "With a viewfinder, that is a hole cut into a piece of cardboard, I looked for motifs for landscapes I wanted to paint and found many or — if you prefer — few."[106] Sometimes he completed these paintings in his studio in Vienna, sometimes during the *Sommerfrische*, as can be seen in letters sent to Vienna: "I have five paintings in progress here, a sixth canvas is still blank, maybe I will bring this one home in the same condition. I think I will be able to finish the other five. One lake painting, a bull in a stable, a swamp, a large poplar and, in addition, some young birches; those are the motifs of the paintings. My appetite for work has, unfortunately, diminished radically with the progress on the pictures."[107]

The weather had an influence not only on the progress of work but also on Klimt's temper: "Today, a fine day at last—apart from this today, rain, rain and more rain. It's exasperating. My holiday is almost over and I haven't been able to do anything outdoors to speak of—the last fourteen days are now upon me—and I am really annoyed that I will bring so few completed works with me.... If only the good weather would hold, that would immediately improve my spirits, but it almost looks like it's going to get bad again. It can just go to hell; on overcast days I am definitely in the worst mood."[108]

The two World Wars brought about the demise of the classical Austrian *Sommerfrische*. The summer guests were either impoverished or in exile. Short breaks, long distance travel, and mass tourism led to present-day guests having a sentimental picture of the *Sommerfrische* as if in an operetta, nostalgically located in the fin-de-siècle — the Salzkammergut as "an empty image turned into a cliché."[109]

1 Therese Nickl and Heinrich Schnitzler, eds., *Hugo von Hofmannsthal, Arthur Schnitzler: Briefwechsel* (Frankfurt am Main, 1964), 241.
2 Joachim Ritter, *Landschaft: Zur Funktion des Ästhetischen in der modernen Gesellschaft* (Münster, 1963), 13.
3 Ibid.; cf. Simon Schama, *Landscape and Memory* (New York, 1995), 10.
4 Johann Wolfgang von Goethe, *Die Leiden des jungen Werther*, *1774, 1. Buch, 10. Mai*, ed. Hans Christoph Buch (Berlin, 1982), 47. Translation from *The Harvard Classics Shelf of Fiction*, 1917.
5 Ritter, *Landschaft*, 18.
6 *Boswell's Journal of a Tour to the Hebrides with Samuel Johnson*, ed. Frederick A. Pottle and Charles H. Bennett (New York, 1936), 331.

7 Joseph D. Ketner and Michael Tammenga, eds., *The Beautiful, the Sublime and the Picturesque: British Influences on American Landscape Painting* (St. Louis, Mo., 1984), 13.
8 Ibid.
9 Peter Peer, "Die Schule von Barbizon und die österreichische Landschaftsmalerei," in *Unter freiem Himmel: Die Schule von Barbizon und ihre Wirkung auf die österreichische Landschaftsmalerei*, ed. Christa Steinle and Gudrun Danzer (Graz, 2000), 55.
10 Cf. Lynne Withey, *Grand Tours and Cook's Tours: A History of Leisure Travel, 1750 to 1915* (New York, 1997), 38f.
11 Hanns Haas, "Die Eroberung der Berge," in *Weltbühne und Naturkulisse: Zwei Jahrhunderte Salzburg-Tourismus*, ed. Hanns Haas, Robert Hoffmann, and Kurt Luger (Salzburg, 1994), 29f.
12 Christian Cay Lorenz Hirschfeld, cited from Ritter, *Landschaft*, 18.
13 Travel account by Ch. Aeby, dated 1851, cited from *Berner Oberland* as reprinted in *Merian* 15, no. 7 (1962): 74f.
14 Alexander von Humboldt, *Kosmos: Die physikalische Beschreibung des Universums* (Stuttgart and Tübingen, 1845–62), 7:191.
15 Edmund Burke, *A Philosophical Enquiry into the Origin of Our Ideas of the Sublime and Beautiful*, ed. J. T. Boulton (London, 1958), 134.
16 Cited from Ketner and Tammenga, *The Beautiful*, 24.
17 Eugen Guido Lammer, *Jungborn: Bergfahrten und Höhengedanken eines einsamen Pfadsuchers* (Munich, 1923), 47.
18 Haas, "Eroberung," 34.
19 Cf. Wolfgang Kos and Elke Krasny, eds., *Schreibtisch mit Aussicht: Österreichische Schriftsteller auf Sommerfrische* (Vienna, 1995), 141. After day trips it became fashionable, around 1870, to live directly on the lakefront.
20 Cf. Peer, "Barbizon," 58. See also Ketner and Tammenga, *The Beautiful*, 22.
21 Peer, "Barbizon," 60.
22 Cf. Christoph Heilmann, "Barbizon—Wege zur Natur," in *Corot, Courbet und die Maler von Barbizon*, ed. Christoph Heilmann, Michael Clarke, and John Sillevis (Munich, 1996), 10.
23 Robert L. Herbert, *Monet on the Normandy Coast: Tourism and Painting* (New Haven, 1994), 6.
24 Cf. Kevin J. Avery, "Selling the Sublime and the Beautiful: New York Landscape Painting and Tourism," in *Art and the Empire City: New York 1825–1861*, ed. Catherine Hoover Voorsanger and John K. Howat (New York, 2000), 111ff.
25 Cf. Stephan Koja, "Introduction," in *America: The New World in 19th-Century Painting*, ed. Stephan Koja (Munich/London/New York, 1999), 10.
26 Cf. Eric Purchase, *Out of Nowhere: Disaster and Tourism in the White Mountains* (Baltimore, 1999), 69ff.
27 Francis Murphy, *The Book of Nature: American Painters and the Natural Sublime* (New York, 1983), 41.
28 Avery, "Sublime," 119.
29 John Wilmerding, *The Artist's Mount Desert: American Painters on the Maine Coast* (Princeton, 1994), 16f. Occasionally, painters and photographers made an area popular, even earlier than travel reports. For example, in 1871, the artist Thomas Moran, accompanied an expedition into the then almost unknown Yellowstone region in Wyoming. His paintings, which familiarized a wide audience with the spectacular scenery and attracted tourists, were, in addition to the photographs of William Henry Jackson, exceedingly important for the government's decision to declare the area the first national park in 1872. Cf. Robert Hughes, *American Visions: The Epic History of Art in America* (New York, 1997), 198f.
30 Cited from Edwin Zellweker, *Bad Ischl: Werden-Wesen-Wandlung* (Vienna, 1951), 56.
31 Uwe Schögl, "Entzückend, das Salzkammergut," in *Kunst im Salzkammergut II*, ed. Künstlergilde Salzkammergut (Vienna, 1998), 17.
32 Cited from Ulrike Jenni, *Friedrich Gauermann 1807–1862* (Vienna, 1987), 41.
33 Peer, "Barbizon," 60.
34 Cf. ibid., 72f.
35 Gottfried Heindl, *Das Salzkammergut und seine Gäste: Die Geschichte einer Sommerfrische* (Vienna, 1993), 133.
36 Otto Friedländer, *Der letzte Glanz der Märchenstadt* (Vienna and Munich, 1969), 232.
37 Rudi Thomas, cited from Friedrich Torberg, *Die Tante Jolesch oder der Untergang des Abendlandes in Anekdoten* (Munich, 1975), 83.

38 Jacob und Wilhelm Grimm, *Deutsches Wörterbuch* (Leipzig, 1905), 16:1526f.

39 Angelika Pozdena-Tomberger, "Die historische Entwicklung des Fremdenverkehrs im allgemeinen und die Entwicklung einzelner Fremdenverkehrsorte im ehemaligen österreichischen Küstenland," in *Sommerfrische: Aspekte eines Phänomens*, ed. Willibald Rosner (Studien und Forschungen aus dem Niederösterreichischen Institut für Landeskunde, Bd. 20) (Vienna, 1994), 42.

40 Otto Stolz, "Das Wort 'Sommerfrische'," in *Archiv für das Studium der neueren Sprachen* 86, vol. 159 (N. p., 1931), 176f. In addition, Stolz was of the opinion that the old name Oberbozen indicated that this area previously had a connection to the city and that there were summer settlements there. Ferdinand Raimund supposedly made this known in Vienna when he found Bolzano (or Bozen) half-deserted due to the heat and went up to Oberbozen, where he dubbed the colony of quaint country houses "Sommerfrische."

41 Matthias Kramer, *Neu ausgefertigtes herrlich-grosses und allgemeines italiänisch-teutsches Sprach- und Wörterbuch* (Nuremberg, 1693), 938.

42 Ibid., 438.

43 Johann Georg Kohl, *Alpenreisen, 3 Theile* (Dresden-Leipzig, 1849–51), part 2, 219.

44 Elard Hugo Meyer, *Deutsche Volkskunde* (Strasbourg, 1898), 146.

45 Hanns Haas, "Die Sommerfrische—Ort der Bürgerlichkeit," in *Durch Arbeit, Besitz, Wissen und Gerechtigkeit: Bürgertum in der Habsburgermonarchie II*, ed. Hannes Stekl et al. (Vienna, 1992), 364.

46 Kos and Krasny, *Schreibtisch*, 9.

47 Brigitte Rigele, "Mit der Stadt aufs Land: Die Anfänge der Sommerfrische in den Wiener Vororten," in *Wiener Geschichtsblätter Beiheft 2* (Vienna, 1994), 5. Cf. Peter Csendes, "Erwachen heitere Empfindungen bei der Ankunft auf dem Lande, Landpartie und Tourismus im Biedermeier," in *Bürgersinn und Aufbegehren: Biedermeier und Vormärz in Wien 1815–1848*, cat., 109th Special Exhibition of the Historical Museum of the City of Vienna (Vienna, 1987), 471.

48 Sonja Herzog, *Bürgerliche Freizeit: Eine Analyse autobiographischer Texte*, thesis. (Vienna, 1998), 41.

49 Letter to Katharina Fröhlich, dated July 16, 1852; cited from Kos and Krasny, *Schreibtisch*, 24.

50 Pozdena-Tomberger, "Entwicklung des Fremdenverkehrs," 42.

51 Arthur Schnitzler, "Das weite Land" (1910), act 3. In *Meisterdramen* (Frankfurt am Main, 1955), 339.

52 Ernst Bruckmüller, *Sozialgeschichte Österreichs* (Vienna, 1985), 396f.

53 Kos and Krasny, *Schreibtisch*, 15.

54 Torberg, *Tante Jolesch*, 22f.

55 Peter Müller, *Die Ringstrassengesellschaft* (Vienna, 1984), 56.

56 Pozdena-Tomberger, "Entwicklung des Fremdenverkehrs," 39.

57 Kos and Krasny, *Schreibtisch*, 12.

58 Torberg, *Tante Jolesch*, 84.

59 Rosa Albach-Retty, cited from Heindl, *Salzkammergut*, 11f.

60 Torberg, *Tante Jolesch*, 83.

61 Hans Högl, "Aspekte des Urlaubs am Bauernhof und die Sommerfrische," in Rosner, *Sommerfrische*, 81.

62 Hugo von Hofmannsthal to Alfred von Nostiz, cited from Heindl, *Salzkammergut*, 14.

63 Cf. Andrew Jackson Downing, *The Architecture of Country Houses* (New York, 1850), 123. The "Swiss Style" was very popular in Anglo-Saxon countries because it was believed that this method of construction united purpose, material, climate, and national character. See also Mario Schwarz, "Die Architektur der Sommerfrische: Heimatliche Aspekte eines internationalen Stilphänomens," in *Architektur der Sommerfrische*, ed. Eva Pusch and Mario Schwarz (St. Pölten, 1995), 77.

64 Monika Oberhammer, *Sommervillen im Salzkammergut: Die spezifische Sommerfrischearchitektur des Salzkammerguts* (Salzburg, 1983), 32.

65 Downing, *Country Houses*, 124.

66 Emanuel von Seidl, *Mein Landhaus* (Darmstadt, 1910), 47.

67 Wolfgang Kos, "Das Malerische und das Touristische: Über die Bildwürdigkeit von Motiven—Landschaftsmoden im 19. Jahrhundert," in *Faszination Landschaft: Österreichische Landschaftsmaler auf Reisen*, exh. cat. (Salzburg, 1995), 19.

68 Adolf Loos, "Regeln für den, der in den Bergen baut, Jahrbuch der Schwarzwald'schen Schulanstalten," in *Trotzdem 1900–1930*, ed. Adolf Opel (Vienna 1982), 120.

69 Adolf Loos, "Heimatkunst," text of a lecture given November 20, 1912, in the Akademischen Architektenverein Wien; in *Trotzdem 1900–1930*, 127.

70 Adolf Loos, "Stadt und Land," *Neues 8-Uhr Blatt*, October 12, 1918.

71 Cf. Kos and Krasny, *Schreibtisch*, 73.

72 Heimito von Doderer, *Die Strudlhofstiege oder Melzer und die Tiefe der Jahre* (Munich, 1951), 228.

73 Moritz Gottlieb Saphir, *Humoristische Schriften in zwei Bänden*, vol. 1 (Berlin, n. d.), 178.

74 Alma Mahler-Werfel – Gustav *Mahler. Erinnerungen an Gustav Mahler. Briefe an Alma Mahler*, ed. Donald Mitchell, (Frankfurt am Main, 1971), 71.

75 Arthur Schnitzler, *Briefe 1875–1912*, ed. Therese Nickl and Heinrich Schnitzler (Frankfurt am Main, 1981), 48.

76 Kos and Krasny, *Schreibtisch*, 183.

77 Karl Kraus, "Pfleget den Fremdenverkehr," *Die Fackel*, April 1, 1913.

78 Cited from Zellweker, *Bad Ischl*, 139.

79 Letter to Richard Beer-Hofmann, dated July 9, 1891, cited from Kos and Krasny, *Schreibtisch*, 176.

80 Cf. Kos and Krasny, *Schreibtisch*, 183.

81 Daniel Spitzer, cited from Heindl, *Salzkammergut*, 128.

82 Kate Mulvey and Melissa Richards, *Decades of Beauty: The Changing Image of Women: 1890s–1990s* (London, 1998), 24.

83 Franz Lipp, cited from Heindl, *Salzkammergut*, 139.

84 John Urry, *The Tourist Gaze: Leisure Travel in Contemporary Society* (London 1990), 17.

85 Oberhammer, *Sommervillen*, 11.

86 Ibid.

87 Peter Altenberg, *Mein Lebensabend* (Berlin, 1919), 237.

88 Sigmund Freud, *Die Traumdeutung* (Leipzig and Vienna, 1900), cited from the Frankfurt am Main edition, 1982, 114.

89 Franz Karl Ginzkey, cited from Heindl, *Salzkammergut*, 141.

90 Cf. Christian Nebehay, *Gustav Klimt Dokumentation* (Vienna, 1969), 494.

91 Cf. ibid., 440.

92 Flöge Estate, Cat. A, no. 76, cited from Wolfgang Georg Fischer, *Gustav Klimt und Emilie Flöge: Genie und Talent, Freundschaft und Besessenheit* (Vienna, 1987), 162.

93 Ibid., no. 102.

94 Ibid., no. 258.

95 Ibid., no. 260.

96 Ibid., no. 265.

97 Ibid., no. 252.

98 Cf. Fischer, *Klimt und Flöge*, 163.

99 Letter to Marie Zimmermann dated August 1903, cited from Christian M. Nebehay, "Gustav Klimt schreibt an eine Liebe," in *Klimt-Studien: Mitteilungen der Österreichischen Galerie Belvedere* 22/23, nos. 66/67 (1978): 109f. The date was corrected to 1902 in Alfred Weidinger, "Neues zu den Landschaftsbildern Gustav Klimts" (diploma thesis, Salzburg, 1992), 82f.

100 Cf. Nebehay, *Dokumentation*, 440.

101 Letter to Marie Zimmermann, dated August 1903, cited from Nebehay, "Klimt," 109.

102 Ibid., 108.

103 Ibid., 109.

104 Weidinger, "Landschaftsbildern," 16 and 34.

105 Renate Vergeiner and Alfred Weidinger, "Gustav und Emilie: Bekanntschaft und Aufenthalte am Attersee," in *Inselräume: Teschner, Klimt & Flöge am Attersee*, exh. cat. (Vienna, 1988), 9.

106 Letter to Marie Zimmermann, dated August 1903, cited from Nebehay, "Klimt," 108f.

107 Letter to Marie Zimmermann, dated July 3, 1900, cited from ibid., 105f.

108 Letter to Marie Zimmermann, dated August 1903, cited from ibid., 110f.

109 Schögl, *Entzückend*, 9.

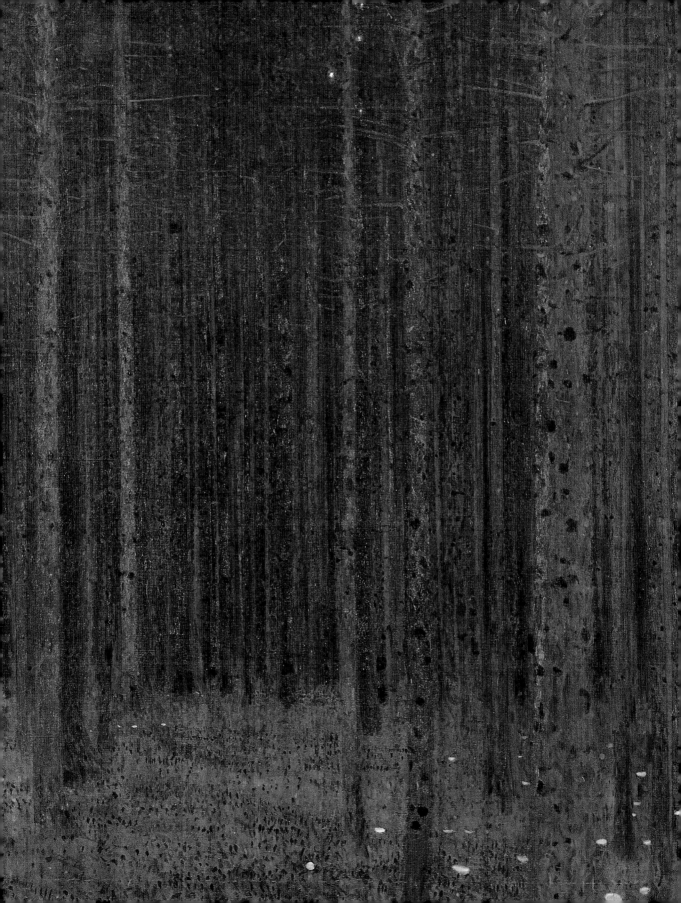

"Absolutely engulfed in the Beauty of Illusion"

Gustav Klimt, *Two Girls with Oleander*, c. 1890/92.
Wadsworth Atheneum, Hartford, Connecticut

Stephan Koja

Around 1890–92, Gustav Klimt painted *Two Girls with Olean-der*, a charming portrayal of two young girls; one breaks off a twig of blossoms from the oleander while the other looks on. This all takes place in front of a marble pillar, rising up behind the two girls. Of course, iconographic influences of Sir Lawrence Alma-Tadema or Fernand Khnopff cannot be overlooked, and the model for the head of the girl in the foreground has also been identified—a portrait bust of *Isabella of Aragon* (1488) by Francesco Laurana in the Kunsthistorisches Museum in Vienna. Laurana was the Italian Renaissance artist whose sculptural portraits with their indifferent, somewhat mysterious glances, were extremely popular in the Symbolist painting of the time.[1] The painting also has a lot to do with Klimt's conviction that woman was a noble specimen, a precious product of nature. Moreover, it is composed in a most refined manner; the tree, standing in front of a sinister, dark, imponderable background—undomesticated nature—creates a kind of cavity inclining toward the two girls. One twig actually seems to be kissing the forehead of the girl in the front. In paintings of this kind, an ideal, sophisticated past is described—a golden age of culture.

But what the painting really shows is that nature has to be cultivated, that it only achieves its greatest beauty through the influence of a regulating spirit. It takes the intervention of the artist to disclose the deeper harmony and perfection that preserves the natural model from transience. Here, Klimt plays with the contrast between tender, naturally portrayed skin and the meticulously depicted plant, opposed to the cold, rigid stone, the opposite of the organic and crystalline, as he often did in his later works. In particular, the clear division into two almost equal halves thematizes the difference between nature and culture: on the left, untamed nature in the form of the unpruned oleander shrub; on the right, culture which, as we have often been shown, has refined

nature to even greater perfection. This applies to the acanthus, nature transformed to an ornament, sublimated in architectural forms, just as it does to the two neatly-dressed girls. It applies particularly to how a person picks flowers; the binding of a perfect bouquet refining them to even greater beauty. This leads us directly to the core of Klimt's struggle for artistic form, which is especially apparent in his landscapes: elevation through stylization. In this case, we are reminded of Nietzsche's conviction "that the existence of the world is only justified as an aesthetic phenomenon."[2] The work of art, with its balancing harmony, is necessary to give meaning to life and the world.[3]

Klimt's landscapes make a clear statement about his artistic concerns, as they can be approached less distractedly. They do not describe famous or influential personalities, love and longing, sickness or death. However, they illustrate, even more pointedly, Klimt's understanding of art and of his self-conception as an artist.

In 1891, at the same time as Klimt was painting his *Two Girls with Oleander*, Hermann Bahr published *Das Ende des Naturalismus* (The End of Naturalism). This does not appear to be a coincidence—Bahr can be counted as one of Klimt's best and, intellectually, most influential friends, who often exchanged opinions with him, and who was granted frequent access to the painter's studio during the period of controversy over the faculty paintings. Bahr wrote, with great conviction (and not completely without ceremoniousness): "The dominance of naturalism is over, its role is finished, its magic has been broken. The rank and file of the unknowing, who trot along behind developments and who only perceive a question, when it has long been dealt with, maybe still talk about it. But, the avant-garde of learning, the cognoscenti, the conquerors of new values have turned away…. They want to get away from naturalism, to proceed beyond naturalism."[4]

He elaborates on what the "new" comprises: "To create things for oneself, instead of copying from others; to search for the hidden, instead of accepting what is apparent; and to express precisely those things where we feel, and know, differently from reality."[5]

Klimt in the Tradition of Symbolism

In order to understand the cultural environment from which these words emerged, it is necessary to bear in mind that the development of the modernists in Vienna proceeded differently than in Western Europe; the search for a new form of expression took a different path. "Art of the mind," not Impressionism or its successors, was of interest. One perceived this new form of art as a counter-movement to the superficial naturalism and empty pathos of Historicism. The goal was to discover the secrets behind physical appearances, the deeper meaning beneath the visible world.[6] For this reason, landscape painting in Austria—in spite of its considerable quality and public acceptance—never achieved the subversive strength necessary to overcome the hierarchy of genres, which it did in France. (Rather, the logical, further development of this "art of the mind" in Vienna led to the Expressionism of Oskar Kokoschka and Egon Schiele). In France, the development ran in a diametrically opposed direction. French painting was principally rejuvenated through landscape painting; through its professed simplicity and naturalness, the direct approach to the landscape—the motif—without the preparatory, intermediate stage of sketching. Courbet's use of the palette knife as an intuitive, sometimes uncontrolled medium must be seen under this aspect.

The veracity which the painters of the Barbizon School, Courbet, or, later, the Impressionists demanded—veracity vis-à-vis the phenomena of nature and, also, in their choice of means of expression—finally led to a reassessment of all values. This was a revolt against tradition, an assault on the institutions. A revolution from below, from the landscape.[7]

Gustav Klimt, *The Actor Josef Lewinsky as Carlos in "Clavigo,"* 1895, Österreichische Galerie Belvedere, Vienna

This was not the case in Austria and not the case with Klimt. In Austria, public discussion was not concerned with "temperaments" but with "ideas." Even Klimt seemed still to think in terms of the old hierarchy of genres. In spite of a comparatively large portion of landscape paintings in his entire oeuvre—more than sixty landscapes among the more than 220 works known to us, and their numerically major importance in exhibitions of the time—they played a subordinate role in Klimt's way of thinking (and, until today, in the thoughts of a large section of the public interested in art). In the pure sense of the word, they were predetermined for the "free market." It is also astounding just how thoroughly Klimt himself differentiated between his landscapes and figural paintings. We ascertain that "in the remaining works—the allegorical paintings— the landscape plays almost no role, whereas, on the other hand, narrative content can scarcely be discovered in the landscapes."[8]

Klimt was particularly susceptible to the response coming from France—Symbolism. The interest in visions, dreams, hallucinations, ecstasy, the whole scope of boundless, uncontrolled fantasies and the resulting metamorphoses appealed particularly to his way of thinking. Objects in the paintings were invested with referential character, could be saturated with symbolic meaning, or represent states of mind.

Klimt, who saw himself increasingly as a spearhead of the modernists,[9] wanted to go even further. Influenced by Franz von Stuck, Fernand Khnopff, and Jan Toorop, and, initially, drawing technically on Whistler, he attempted to develop an individual form of Symbolism. Already in *The Actor Josef Lewinsky as Carlos in "Clavigo"* (above), his allegory of the art of acting indicates human and, at the same time, feminine aspects: youth and age, charm and ugliness, mercy and malice. In *Love* (see p. 194), life-threatening powers, such as time and its associate decay, and female figures personifying "evil" powers force their way into the painting and hover, threateningly like storm clouds, behind the lovers, oblivious in their happiness. Klimt's pictorial cosmos increasingly became a world of ideas,

nurtured by his personal experiences, placing the power of Eros in the foreground and from which he developed his own programmatic paintings. It was a search for the psychic and libidinal, a search for his own self, or, as Carl E. Schorske formulated, "the quest for a new life-orientation in visual form."[10]

The works in which Klimt programmatically displayed his concept were the ceiling paintings for the Vienna University, the faculty paintings, which he worked on for many years after receiving the commission in 1894 and which were presented to the public in 1900 (*Philosophy*, see p. 151), 1901 (*Medicine*, see p. 197), and 1903 (*Jurisprudence*, see p. 159). The rationality of science and the clarity of reason were not portrayed in these works. Instead, dark forces, imponderabilities were shown. The multitude of uncontrollable moments with which human existence is confronted—such as man's powerlessness faced with aging, sickness or death—were depicted, and also the inseparable, powerful human impulses, the potency of the libido and subconscious. Klimt displays the citizen of his time as "a slumbering being… embarrassingly aware that he is controlled by instincts and not by principles,"[11] to use Hofmannsthal's words. Nature is uncontrollable, omnipresent, and overpowering. A region is displayed, removed from the compass of human reason and civilization. In no way did this meet the expectations of the professors of the university who, given the stipulated theme *The Victory of Light over Darkness*, expected a dazzling glorification of science, its conquest of darkness and ignorance, and its capabilities of controlling nature.

Klimt, however, wanted to go beyond the purely optical impression, not only in his figural works but also in his landscapes, and create an "art of the mind." In this respect, Klimt was part of a Central European movement.

Natural Lyricism

Here, the search for a spiritual idiom, a visualization of the intellectual, also found its expression in landscape painting. Here, we are not dealing with heroic mountain paintings but with a counter-movement against the "noble art" of idealism. For a long time, artists had been forced by tradition to alter nature stylistically, instead of showing it from an objective viewpoint. Refinement, elevation with an intellectual spiritual content, was the goal. Now, an artistic sensibility started to be felt in Central Europe, searching for nature itself, the objective world as subject matter. A form of natural lyricism developed in

Germany and Austria toward the end of the nineteenth century, which spread out and found its crystallization points in certain centers. Painters, including the group around Otto Modersohn in Worpswede, around Adolf Hoelzel and Ludwig Dill in Dachau near Munich, and the Emil Jakob Schindler circle in Bad Goisern in the Salzkammergut (later in Plankenberg in the Tullnerfeld area near Vienna) were all proponents of this style (see pp. 20, 50, 54, 174f.).

The landscape now became a medium of feeling, a parable for inner emotions. One attempted to give a spiritual answer to forms of terrain, trees or celestial phenomena, within the scope of traditional forms of expression. It is not merely by chance that Emil Jakob Schindler talks about "poetic realism." The term "atmospheric realists" was coined for Schindler and the painters in his circle. "Atmosphere" (*Stimmung*) takes on a role of central importance in the theoretical discourse of the period and becomes the declared goal of landscape painting.[12] Not only the "atmospheric realists" but also the Secessionists were lastingly affected. Painters, including Josef Maria Auchentaller, Wilhelm Bernatzik, Adolf Böhm, and Carl Moll, created landscapes in this spirit. At the Seventh Secession Exhibition in spring 1900, they showed, along with Klimt, numerous landscape paintings emphasizing the atmospheric.

Klimt's early landscapes were created in this environment. He showed himself as being very receptive to the lyrical aspects of a landscape, for the art of intent listening to inner emotions, to dark forebodings; his pictorial way of thinking was particularly suited to the symbolism of natural forms and their internal melancholy.

Klimt's initial stage as a landscape painter is, however, overshadowed by the troubles and excitement connected with the foundation of the Secession, and, particularly with the monumental commission for the paintings for the Vienna University. The contention over his faculty paintings, which soon occurred, and the political and cultural controversy of the period made him look for a less delicate subject—from both the ideological and political point of view. His increasing turn to portraits in these years can also be interpreted from this standpoint. In addition, he was faced with the increasingly troublesome necessity of earning money since, as Alma Schindler noted in her diary in May 1899 after talking to Klimt, four women in his immediate family, in addition to his mother, relied on his financial support.[13]

Almost all of Klimt's landscapes were created during his summer sojourns in the country. We know that Klimt

spent his summer holiday in 1897 with the Flöge family in Fieberbrunn in Tyrol. The following summer was spent in St. Agatha near Bad Goisern, where Schindler had summered for several seasons, and which offered a multitude of pictorial motifs. During this stay, he painted the view of an orchard, *After the Rain* (plate 6). In 1899 the Flöges and Klimt visited Golling, where he painted *A Morning by the Pond, Orchard in the Evening* and *Cows in a Stall* (plates 8, 7 and see p. 61). After 1900, the summers were spent on the Attersee, initially in Litzlberg, from 1908 in Kammer and, after 1914, in Weissenbach. With only a few exceptions, the artist's entire landscape output was created around Attersee.

Prince Eugen, *The Forest*, 1892, Göteborgs Konstmuseum

The motifs of these works, which were produced shortly before and around the turn of the century, were particularly suited to this matter: swamps, forest interiors, solitary looming poplars, and dreamy orchards (plates 9f.). These undramatic, completely balanced, unruffled compositions depict the peaceful existence of nature and permit one to sink into its quiet murmuring, which is only perceptible to the sensitive. One senses the growing of nature, the incessant chain of fertility, a continuous creation, blossoming and passing. The series of paintings from within the forest (plates 16f.) describe one of the artist's experiences, which the viewer should endeavor to imagine in the same manner. The suggestive strength of the sophisticated coloring produces a feeling of coolness and muted light—the daylight of the sky can only be glimpsed sporadically, and filtered, through the dense trunks and branches. The tree trunks solemnly encircle the observer—like a cathedral.

This was a popular theme of the period throughout Europe—one only has to consider the forest paintings of Albijn van den Abeele, Ferdinand Hodler, Fernand Khnopff, Piet Mondrian, Prince Eugen and Antonín Slavíček[14] (*above* and p. 66). An entire group of "forest fir motifs" was displayed at the Thirteenth Exhibition of the Secession in 1902, which permitted a comparison with Klimt's painting of a forest interior.

Edouard Hannon, *Forest Glade*, 1897, heliogravure, Museum für Kunst und Gewerbe, Hamburg

This also applies to the photography of the period, which tried to measure itself against painting (*below*). Occasionally, the connection between photography and Klimt's work goes further than a similarity typical of the age. Compare, for example, photographs such as Hugo Henneberg's *Beech Wood in Autumn* from 1898 (*opposite*) with Klimt's *Beech Forest II* from 1903 (plate 18).[15]

The fascination with water and its symbolism also played a central role in the perceptional world of Symbolist art. The depiction of swamps and ponds had even become something of an international fashion. Among many other examples, one thinks of Khnopff's *Silent Water: The Pond at Ménil* (see p. 36), which was exhibited at the First Secession Exhibition in 1898 and was reproduced in *Ver Sacrum* in the following December, or of the many other paintings by Austrian artists such as Wilhelm Bernatzik (see p. 36), Marie Egner, or Carl Moll.

Pictures, including *A Morning by the Pond, The Swamp,* and the two existing Attersee paintings (plates 8, 9, 12, 13), the later *Pond at Schloss Kammer on the Attersee* (plate 37), and the views of Schloss Kammer and Lake Garda (plates 33–46), indicate the importance of this theme in Klimt's oeuvre. Precisely these motifs were predestined to give expression to sinister forebodings, and to show "that painting has something to do with thinking, dreaming, and writing poetry," that it is capable of opening "submerged, overgrown trapdoors of the soul."[16] In Symbolism, pools and peaceful ponds—water in general— stood for the regenerative power of organic life. Even in ancient Greece water meant "the 'female' bearer of all organic life."[17] In addition, in his paintings *Fish Blood, Water Serpents (The Women Friends), Moving Water, Goldfishes,* and *Nixes,* Klimt shows the intimate connection between the fertility of water and women[18] (see p. 201).

High horizons are beneficial for contemplating nature. This enables the viewer to experience the meadow or forest floor as more significant and with an increased intensity (plates 11, 20, 21, 27, 29). Both the atmospheric Austrian

Hugo Henneberg, *Beech Wood in Autumn*, *c.* 1898, photograph, Staatliche Museen zu Berlin, Preussischer Kulturbesitz

Heinrich Kühn, *Landscape*, 1897, three-color gum bichromate print, Museum Folkwang, Essen

In Klimt's paintings of swamps and water surfaces, the lasting influence of Monet's work before and around the turn of the century is apparent. Monet, who at the time was already attempting to liberate the area of a painting from its confining boundaries and to construct the painting as an organized area, as a detail of a possibly much larger entity, not only influenced Klimt compositionally but also technically. Short, vivid brushstrokes in various tones dominate the Attersee paintings and are substantially responsible for the liveliness. The combination of brushstrokes of the most varied shades produces a realistic and lively overall color and, at the same time, provides an equivalent for the numerous colored reflexes on the surface of the water.[20]

painting and the photography of the period used similar stylistic methods—consider the work of Heinrich Kühn (*above* and p. 167). This was implemented particularly radically in the Attersee paintings (plates 12, 13), in which the area of water, with its plethora of sophisticated toning, lies before us, filling almost the entire surface of the painting and thus creating the atmosphere of a summer lake where the reflexes of light and color appear to be at arm's length.

Klimt paid close attention to the artistic life of the rest of Europe. He quickly incorporated stimuli that appeared important for his work in his personal style. In a similar way, the confrontation of European artists with Japanese woodcuts inspired them to more flatness, linearity, daring overlapping, and an increase in fine details—elements which can be observed in almost all of these landscapes. His primary model, Khnopff, is evident in the aesthetics of Klimt's pond paintings. Whistler's work played a decisive role in Klimt's liberation from the conventions of Historicism and helped him to find his individual style. In several early landscapes we can see those moving areas of filmy color—breathing, flowing—similar to those used by Klimt for his *Portrait of Sonja Knips* (see p. 37), a painting that is particularly close to his landscapes. This is not only due to the fact that a garden landscape forms the background of the painting, but also because of its square format, which Klimt used after 1899 exclusively for his landscape paintings.[19] As in the landscapes, this painting is also cropped at the sides. Behind the sitter we can see only a diffused landscape area without a genuine horizon—it appears to be drawn closer to her.

The Identity Crisis

When Klimt presented the first of the faculty paintings, *Philosophy* (see p. 151), the Seventh Secession Exhibition in 1900 it was received with great disapproval, particularly from the professors. Eighty-seven professors signed a protest against the ceiling painting and, a short time later, the conservative press began attacking Klimt. The confrontation became harsher with the exhibition of *Medicine* (see p. 197) one year later because the politicians joined the opposition, and the Ministry of Education began to distance itself from Klimt.

Ostensibly, the depiction of naked, even pregnant, women was found to be shameless. The real reason for the rejection, however, was Klimt's attack on the scientific view of positivism and the dominant political liberalism of the epoch.[21]

Klimt was badly hurt by this rebuff. The lack of understanding for his work and the ensuing public polemic resulted in self-doubts concerning his role as an artist. He, who was so used to success, and always saw himself as a public figure with a mission as an innovator of art propagating the repressed world of the libido, with the dark forces of Eros against the societal consensus of his time, suddenly found himself forced to leave the public arena. Klimt, like Sigmund Freud, who was made to suffer from the massive criticism of his theories (as well as from anti-Semitic attacks), began to withdraw into a private world.

Schorske views the conflict over the faculty paintings, and Klimt's rejection, as the impetus for a personal crisis in the life of the artist and for the change in his style that occurred after the turn of the century.[22] In Schorske's opinion, this change became apparent in the third of the paintings, *Jurisprudence* (see p. 159), whose aggressive message can be seen in relation to his wounded artistic ego. Contrary to the original draft, which does not depict justice in an ambivalent fashion, Klimt radically reworked the final version showing the individual at the mercy of the barbarity of punishment. Above all, Schorske sees an indication of Klimt's withdrawal into private life: "The very mode of the indictment,

Wilhelm Bernatzik, *Pond, c.* 1900, Österreichische Galerie Belvedere, Vienna

with its stress on the individual sufferer, involved a shift from public ethos to private pathos."[23]

In these years of dispute, culminating in Klimt repurchasing the three faculty paintings in 1905, the artist struggled to find a new orientation for his role as a modern painter, vacillating between revolt and wounded solitude. The result was that he still openly attacked his critics in some works, such as *Goldfishes* of 1901/02 (which he originally intended to call *To My Critics*) and *Jurisprudence*, but, basically sought to redefine his artistic self-conception. As early as 1902 *The Beethoven Frieze* (see pp. 149, 198f.) demonstrates a noticeable further development in which the artist gives an escapist response. In this, the viewer, exactly in agreement with the intentions of the Secession to provide alleviation from the severity of modern life through the transformation of life into art, is presented

with a utopian refuge of absolute happiness. "Where politics had brought defeat and suffering, art provided escape and comfort."[24]

Consequently, Klimt withdrew completely from public activities and placed the center of his artistic work in the private sphere: portraits of high-society women—the majority from the milieu of the well-to-do Jewish bourgeoisie—a commission for the decoration of a private house, and the landscapes, which form a considerable portion of the output of his last fifteen years.

It is also possible that Klimt realized that this formulation was not suited to his particular talent. In spite of his proclaiming the freedom of art and the resulting emotional struggle, it cannot be denied that these pictures not only reproduce a very personal attitude to the theme, but also a strangely half-baked one. As can be seen in the numerous preparatory sketches, the various pictorial elements of threatening, swelling towers of humanity. were continually taking on new forms without achieving a precise final structure. Even if it was Klimt's idea to depict a feeling of foreboding in view of the eternal cycle of nature, which mankind is powerlessly at the mercy of and, therefore, to dissolve the determinability of time and space, Karl Kraus's criticism can be regarded as being very precise: "A non-philosophical painter might be able to paint Philosophy; but he has to allegorize it, as it is painted in the philosophical heads of his time."[25] When he saw *Medicine*, Kraus made fun of the painting "in which a chaotic entanglement of suffering bodies symbolically

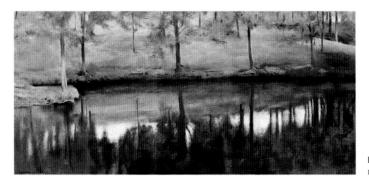

Fernand Khnopff, *Silent Water. The Pond at Ménil,* 1894, Österreichische Galerie Belvedere, Vienna

depicts the conditions in the General Hospital."[26] The professors' criticism, in their first petition against *Philosophy*, was concerned with the fact that "ambiguous thoughts were expressed through ambiguous forms."[27] It is no accident that, in this context, one is reminded of Rodin's long-lasting struggle with the composition of his *Gate of Hell.*

It would seem that this crisis was not only the result of wounded pride, due to the lack of public recognition, but also an identity crisis—and Klimt's response was an inner immigration. It was a distancing from the world and also a distancing from the motif. This applied also to his solitary work in his studios. The choice of his accommodations on the Attersee shows even more clearly Klimt's tendency to reclusiveness. After an initial sojourn in the merry atmosphere of the brewery guesthouse in Litzlberg, the Flöges and Klimt decided, a few years later, to move to the more peaceful Villa Oleander in Kammerl at the north end of the lake; finally, Klimt spent his last three summers in remote Weissenbach at the opposite end of the lake, living alone in the local forester's house, while the Flöge family lived in the Villa Brauner. Klimt really knew how to stage his seclusion. He repeatedly stressed that he needed peace,[28] and that particularly when working he needed absolute quiet and concentration.

This is also how his contemporaries saw things. An anonymous article in a Viennese daily newspaper, published after 1918, described the reclusive lifestyle of the master as "an almost pathological sensitivity of avoiding the public."[29] On February 14, 1918, eight days after Klimt's death, Bahr wrote to the writer Josef Redlich: "By the way, one only now feels, I only now feel completely, just how wonderful his life was in the last six or seven years, after he had withdrawn completely. This withdrawal is an essential aspect of an exemplary Austrian existence."[30]

Klimt was searching for a new style, and an "aesthetic distancing"[31] was a major component of this. His former pictorial style—with its organic, soft, misty forms—became increasingly replaced by the contrast between organic and geometrically abstract elements. The artist wanted to provide his paintings with their intrinsic dignity through the emphasis on decorative elements (which, at the time, had a positive connotation). The depiction should be timeless, elevated to another dimension of reality. The organic represented corporal aspects, the abstract-ornamental, the intellectual.[32] At the same time, natural activities of the psychic or physical world of experience, which had previously been dealt with in an open manner, were transported into a realm of stylization—of symbols.[33] It is interesting to note that the "dialectic of organic

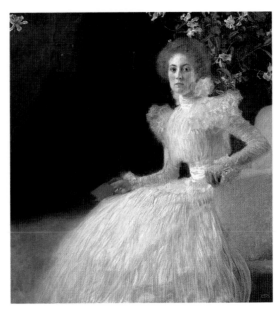

Gustav Klimt, *Portrait of Sonja Knips*, 1898, Österreichische Galerie Belvedere, Vienna

and crystalline, arabesque and geometric, had recently been analyzed by Alois Riegl, based on the history of ornaments, as the foundation of pictorial composition."[34]

The background plays a predominant role in portraits such as those of *Margarethe Stonborough-Wittgenstein* or *Fritza Riedler* (see pp. 202, 38), where the meticulously detailed, refined heads and hands are restrained within an austere, geometric pattern, in tranquil areas. In an increased form, the geometric design of the dress in *Adele Bloch-Bauer I* (see p. 203), takes prevalence over the figure. By placing the persons portrayed in an imaginary (ornamental) space, they are deprived of all feeling and, therefore, of all human experience of suffering and finiteness, elevated into the abstraction of the pure, beautiful form. In 1903, his confrontation with the mosaics in Ravenna and the hieratic aura of this art also played a major role in the even more consistent frontality of Klimt's figures; he consciously strove for this ecclesiastic aspect and renounced the effect of shadows.

We can observe something similar in the landscape paintings. In addition to the two-dimensionally drawn, and preciously conceived *Golden Apple Tree* (plate 23), there is a tendency toward the auratic—particularly through the frontality of the depicted objects, which achieves an ever-increasing importance. After the turn of the century,

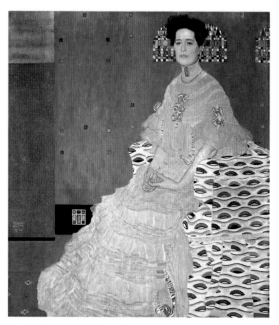

Gustav Klimt, *Fritza Riedler*, 1906,
Österreichische Galerie Belvedere, Vienna

and after 1903 under the influence of the artisans of the "Wiener Werkstätte," the Secessionists, in general, adopted a severe, linear, geometric style, which Klimt followed, in his own way.

In this stage of new orientation, Klimt greedily absorbed all the inspiration offered to him through the art of Jan Toorop, Charles Mackintosh, George Minne or Ferdinand Hodler (who all exhibited in the Secession between 1900 and 1904). He was particularly impressed by the simplicity of the monumentality and the elegant linearity in the works of these artists. Critics and art-writers, such as Hermann Bahr, Max Eisler, Hans Tietze, and Berta Zuckerkandl emphasized Klimt's incessant interest and receptiveness for new artistic impulses.[35]

The Teachings of France

Klimt's study of late French Impressionism and its consequences was particularly important for his landscapes. His early landscapes, up to *Pine Forest II* (plate 17), were still painted under the influence of the "atmospheric landscape," until he discovered Pointillism and began to place more importance on the effect produced by painting media. Klimt had many opportunities—in the Künstlerhaus, Secession, or the Miethke Gallery—of studying the French art of his time and of the previous generation. In addition, Klimt himself was jointly responsible for the themes of the Secession Exhibitions and the works shown there. The members of the Secession also kept up to date through their intense reading of contemporary art journals including *The Studio*, *La Revue blanche* and *Gil Blas*.

At the turn of the century, a series of retrospective exhibitions dedicated to those Post-Impressionist artists who were already accepted as major figures, was held in Paris: 1900 Seurat, one year later van Gogh, 1903 Gauguin. The rediscovery of Cézanne started in 1900, and Vienna was aware of these happenings. Klimt made his first attempts at Pointillism around 1900, following the exhibition of paintings by Théo van Rysselberghe in Vienna in January 1899, the city's first confrontation with Neo-Impressionism. In March 1900 works by Paul Signac and Giovanni Segantini (*opposite*) were shown in the Secession.

Klimt adapted the style, within a short time, into a dazzling mesh of colored spots, which, however, always maintained a material function (flowers, leaves, dry foliage on the ground), with an extremely sophisticated interaction of colors. This very personally interpreted form of Pointillism was not used to reproduce the flickering effects of light or the illusion of illumination but to express the liveliness, richness, and variety of tones and nuances that covered his paintings like a precious oriental carpet. At the same time, he could create a feeling of perspective, without counteracting the intended flatness, through the specific use of colored speckles and short strokes. (The ambiguity of nearness and distance, flatness and depth have always been among Klimt's essential means of expression). These speckles of color took on an increasingly ornamental function, structuring and dividing the surface. The trees in the landscapes are always part of a decorative area, however, individually and precisely delineated (plates 25, 26, 29) . In a discussion on the 1903 *Klimt Exhibition* in the Secession, Ludwig Hevesi coined the term "trout speckles" in connection with the painting *Tall Poplars II* (plate 24).[36]

Besides Seurat, whose pleading for pure color obviously led to a lightening of Klimt's palette, the Nabis played a special, trendsetting role in Klimt's future work.

The Nabis had assimilated the learning of the foregoing generation and put it into practice. Paul Sérusier gave this group of painters around Denis, Vuillard, Bonnard, Roussel, Maillol, among others, who followed Stéphane Mallarmé's motto "foretell, suggest, there lies the dream…," the name Nabis (The Enlightened). Richard Wagner's

Georges Seurat, *Sunday Afternoon on the Island of La Grande Jatte*, 1884, The Art Institute of Chicago. This picture was shown at the Impressionism exhibition 1903 at the Vienna Secession.

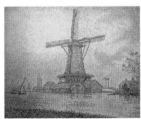

Paul Signac, *Edam Mill*, 1898, private collection. The picture was exhibited in March 1900 at the Secession in Vienna.

Giovanni Segantini, *The Evil Mothers*, 1894, Österreichische Galerie Belvedere, Vienna. The picture was bought in 1901 by the Secession and later donated to the state for the founding of the "Moderne Galerie."

symbolism found interested acceptance in these circles as well: in poetry, the "harmony" of a word was discussed just as Paul Gauguin had spoken of "the sound of colors." The object was to transfer the sentiment resulting from a natural phenomenon into a valid, permanent language through the organization and composition of a painting. Denis formulated the absolute radicality of these thoughts in his portentous statement: "One has to remember that a painting, before it becomes a battle-horse, a naked woman, or any other kind of anecdote, is, from its nature, a surface covered with colors arranged in a specific man-

Pierre Bonnard, *La Revue blanche*, 1894, lithograph, Deutsches Plakatmuseum, Essen

ner."[37] Denis was convinced "that every condition of our sensitivity has its source in an object harmony, capable of translating this." In this way, he proved that the Nabis had drawn on the consequences of their precursors: Seurat's emphasis on pure color, Gauguin's conviction on the power of expression of color in large, self-contained areas, Cézanne's search for underlying structures, van Gogh's

intensifying of the expression-bearing line, the immediacy of expression in his brushstroke and coloring.

In their journal *La Revue blanche* (*left*), which was founded in 1891 and for which Bonnard, Denis, Ranson, Sérusier, Toulouse-Lautrec, Valloton, Vuillard, and others provided illustrations, contributions were made not only by the French symbolists, but also by Ibsen, Strindberg, Hamsun, Wilde, Bakunin, Gorki and the Austrian writer Peter Altenberg who had close contacts with the Secessionists.

Twelve paintings by Bonnard, as well as works by Vuillard and Denis were displayed at the exhibition *The Development of Impressionism in Painting and Sculpture*, which was held in the Secession from January 17 to March 1, 1903. Here, Klimt found exactly what he had been looking for. In contrast to the Central European art of Symbolism, these works did not seek to present ideas in a painting, to stylize nature, to search for natural allegories in it in order to demonstrate these ideas, but to distill a pure form, complete harmony from the experience of nature, and to organize this within the autonomous space of a painting.[38]

The answer given by these painters was a revelation for him. Klimt began to distance himself from objects and to abstract them. Figures and landscapes were depicted without emotion and, at the same time, were more static in composition and form.

After several years of using magnificent golden decorations in his figural paintings (see pp. 68, 197, 198, 201, 203, 205, plate 23), the *Stoclet Frieze* and, strangely enough, in *Golden Apple Tree*—Klimt left this path after 1908, most probably because he himself recognized it as an endpoint. He had pushed the contrast between naturalism and geometric patterns, physicality and abstraction—up to the inclusion of non-painting materials—to the very limits without being able to amplify his message through all this richness.

39

The 1909 *International Art Exhibition* where works by Bonnard, Denis, Gauguin, van Gogh, Munch, Valloton, Vuillard, and also Matisse and Vlaminck were shown, as well as a trip to Paris which he undertook in the same year, must have suggested French solutions to him. In the following years, from 1909 to 1917, he created numerous landscapes—more than one half of his entire output in the field. In his late landscapes, Klimt concerned himself with Cubism, the *Fauves's* unchecked use of color, and in particular with the expressive lines in Schiele's work. The draughtsmanship quality in Klimt's pictures became more pronounced again with, at the same time, more confident brushstrokes, carried by a sonorous brilliance and by a solemn gravity in the coloring.

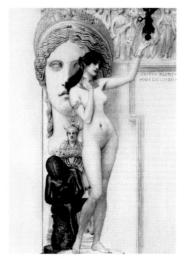

Gustav Klimt, *Allegory of Sculpture*, 1888/89, watercolor and gold, Österreichisches Museum für Angewandte Kunst, Vienna

Gustav Klimt, Master of Composition

As Hermann Bahr formulated, each Klimt painting "is an 'artistic entirety'; that means: when one color relates to another color, one line to another line, and the colors to the lines, and all measurements stand in such a fixed relationship to each other that it is impossible to imagine the painting without any single element without immediately destroying it,"[39] it is indicative of the clear structural principles of Klimt's landscapes and his manifest attempt—from the very beginning—to obtain a clear balance between the elements of the painting, going as far as adapting his view of the motif accordingly.

This applies particularly to the Attersee paintings, one of which was mentioned above by Bahr. Anselm Wagner showed that, in the *Island in the Attersee* (plate 13), only a cropped, almost "simplified" rectangular form of the island is capable of maintaining the "floating balance" to the surface of the water.[40]

The impression of a rigorously implemented order is underlined by the exclusive use of square formats for these landscapes.[41] Klimt usually harnessed the elements of his paintings within a strict, orthogonal structure, in a texture of horizontal and vertical surfaces. In *Island in the Attersee* Klimt can already be seen thinking in rectangular zones.

Upon closer observation, this procedure can be seen as a compositional principle pervading the entire work. It was already implemented in early works, such as the *Allegory of Sculpture (left)*, or *Two Girls with Oleander* (see p. 31), or the sketch for the poster for the First Secession Exhibition (see p. 146). It can be identified as a peaceful horizontal base line in landscapes (plates 25, 35, 36, 44, 51) as well as in the portraits of *Margarethe Stonborough-Wittgenstein* and *Adele Bloch-Bauer I*, and in allegorical paintings including the *Stoclet Frieze* (see pp. 68, 202, 203, 205). It is also apparent as vertical zones, such as in the gold-speckled rectangular field parallel to the left edge of the portrait of *Fritza Riedler* (see p. 38) or, as a structural principle, in the *Farmhouse with Birch Trees*, *Tall Poplars I*, *Tall Poplars II*, and *Orchard with Roses* (plates 11, 10, 24, 43). This attribute is particularly impressive in *Park* (plate 35), where the entire surface seems to be formed entirely from rectangles of different colors (and therefore, of different values).

Klimt's knowledge of the works of van Gogh or the Nabis may have further fortified this tectonic form. There

Gustav Klimt, viewfinder, 1903, drawing in a letter to Marie Zimmermann, Albertina, Vienna

can be no doubt that Klimt had studied van Gogh's *The Plain near Auvers-sur-Oise* (see p. 200), with its construction of horizontal color zones and its resolute emphasis on the plane. This painting was presented to the Austrian State by the artists of the Secession, in 1903, to persuade the government to found a gallery for modern art (now the Österreichische Galerie Belvedere).

Klimt not only took over a simplification of form from the Nabis but also the method of working with large areas of color on a decorative framework, upon which compli-

cated individual figures or playful arabesques were placed. These areas provided stability to the painting. This orthogonal structural framework permitted Klimt to organize the objects in his paintings from an ornamental viewpoint, as in *Farm Garden with Sunflowers*, *Schloss Kammer I*, or *Villa on the Attersee* (plates 32, 33, 49). This is often accompanied by an asymmetric construction and an excentric layout of the masses, as in the already mentioned Attersee paintings, in *Pear Tree* or *Park* (plates 12, 13, 25, 35).

It comes as no surprise that, in this connection, parallels can be drawn with Piet Mondrian.[42] Mondrian's work concentrates on the transformation of a natural model through the interaction between colors, areas and the relationship between their tension and size, and the resulting rhythm. Ultimately, however, Mondrian was concerned with the shedding of the natural and the individual as, in his eyes, the composition of a painting was the actual reality, and that real abstraction, real harmony could only be achieved through the expulsion of all materiality.

Over the years, the zonal separation in Klimt's work became more defined, the paintings developed from the internal logic of colored areas. Hevesi wrote (with a certain pathos): "Back to the planar, everything! No more spatial structure, but candidly admitted surface covering…. No illusionary perspectives, but the sincere renouncement of visual pleasures."[43] Comparisons of landscapes such as *Villa on the Attersee* and portraits, including those of *Mäda Primavesi* and *Adele Bloch-Bauer II* (plate 49, p. 205 and *above*), make it strikingly apparent how a related construction principle based on colored areas gains predominance—something that Mark Rothko, many years later, made the exclusive theme of his paintings.

Thinking in layers, sometimes completely parallel, takes the place of spatiality. This is achieved through the overlapping of segments of a painting—albeit with extreme discretion—which merely contrast slightly with each other and often even appear to be intertwined. The dissolution of objects into areas, and the uniformity of the spots of color used, led to this sought-after flatness. This permitted Klimt to produce a feeling of spatiality without relinquishing flatness.

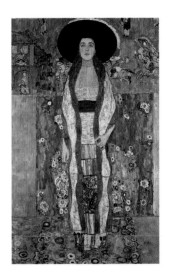

Gustav Klimt, *Adele Bloch-Bauer II*, 1912,
Private collection

Klimt once wrote home: "Arrived safely. Forgot my opera glasses—absolutely necessary. Helene should bring them. Greetings Gustav."[44] Klimt could not get by without these aids. There was a simple, practical reason for the use of a telescope or opera glasses. Klimt wanted to achieve what the French had demonstrated to him: not the simple reproduction of a landscape but its representation through an artistic equivalent—and the conception of a painting as a colored surface. Binoculars and telescopes logically helped him to achieve this. Distant objects could be drawn closer and, at the same time, compressed and flattened. The non-illusionary effect of his paintings increased. This also explains his use of a viewfinder—the landscape as a *painting* is what was being sought.[45] Through this, those photographs which show Klimt standing with a telescope on a tripod or binoculars in his hand, achieve their full significance (see pp. 6, 98, 165).

Alongside consistent compositional schemata one repeatedly discovers contrapuntal concepts—sometimes a dazzlingly colored flower bed as a base out of which the overwhelming *The Sunflower* (plate 31) can tower just as easily as the embracing couple in *The Kiss* (see p. 68); sometimes the triangular composition of *Farm Garden*, similarly depicted in both *Baby* and the portrait of *Amalie Zuckerkandl* (see p. 42); sometimes the pyramidal construction of *The Sunflower* and *Elisabeth Bachofen-Echt*, which, slightly transformed with colorful zinnias and poppies in the foreground, is found again in the towering dahlia plant of *Farm Garden* and which, in the landscape paintings, takes on anthropomorphous characteristics (plates 30, 31).

Wavy shapes and outlines pervade the entire oeuvre. As early as 1897, in *Tragedy*, the gentle swaying—the vegetal quality—of the contours is completely developed. This is incorporated sometimes vertically, sometimes horizontally and occasionally takes an anthropomorphous form.

In *Garden Landscape* as in *Forest Slope in Unterach* or *Villa on the Attersee* (plates 28, 58, 49), we discover the wavy lines of the hills and meadows which resemble reclining female figures. One is reminded of the lines by Heinrich von Kleist: "The landscape lay before us like a fifteen-year-old maiden." It is the same competitive sway of curves and waves found in the flying angelic figures of *The Beethoven*

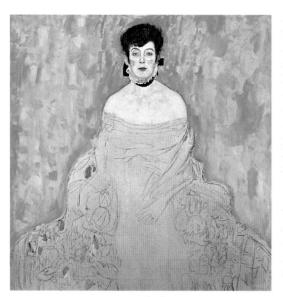

Gustav Klimt, *Amalie Zuckerkandl*, 1917/18, Österreichische Galerie
Belvedere, Vienna

Frieze, Water Serpents I, the garments of *Emilie Flöge, Adele
Bloch-Bauer II, Eugenia Primavesi,* or the contours of the bodies
of *The Women Friends* (plates 28, 49, 58 and pp. 44, 149, 199,
201, 207).[46]

Almost as a confirmation that he was in possession of a
multitude of basic design forms, from which he developed
all his portrayals, are Klimt's signets for the elaborate
collection of collotype facsimile reproductions of his
paintings, which appeared, in five individual portfolios,
between 1908 and 1914[47] and which, at the same time, pro-
vide a condensation of his compositional ideas (see p. 43).[48]
We find here signets demonstrating the typical spatial
division and the resulting tension (as in *Tall Poplars I* and
Sonja Knips); some which make inserts from the left and the
right recognizable as structural elements, as objects with
a different direction (signet for *Schloss Kammer II*), pyrami-
dal constructions (signet for *Jurisprudence*), waviness (signets
for *Nuda Veritas, Fruit Trees*), or anthropomorphous, as re-
peatedly shown in the rose bushes of several paintings
(signet for *The Three Ages of Woman;* see pp. 43, 68, 70, plates
26, 43).

Klimt's Colorism

Delacroix had already discovered that local colors, mixed
on the palette, appeared less brilliant when viewed at a

distance from the canvas, than the objects themselves.
However, when one separated this local color into several
adjacent colors, and placed these next to each other using
short brushstrokes, one could achieve a greater vibrancy.
Delacroix was the first to construct a painting with the
exclusive use of small strokes of color. The impact of
colors could be increased by placing them calculatedly
next to each other—something which he demonstrated
particularly impressively in his floral still lifes (*below*). The
Impressionists and Neo-Impressionists developed these
ideas further, taking advantage of the modern writings on
color theory by Eugène Chevreul and Charles Blanc, who
had investigated the effects of complementary contrasts.
The realization that mixing complementary colors re-
sulted in gray, but placing them next to each other pro-
duced a glowing effect and a vibrant pulsation, caused a
revolution in the coloration of French painting. At the
same time, this showed, beyond a doubt, the impor-
tance—and soon the preeminence—of the color mate-
rial, of the expressive content of the color, over its mimetic
function. These ideas were the subject of great interest in
France but in Vienna one only began to deal with them
after French paintings were shown in exhibitions.

Chevreul's theoretical works on color, *La loi du contraste
simultané des couleurs* and *Les couleurs,* had not only been trans-
lated into German by Friedrich Jännicke in 1878, but had
also been introduced into Central European scholarship,
as he brought them into relationship with other color the-
ories from own traditions[49] (see p. 44). Klimt was one of
the very few Austrian painters to recognize the dormant
potential of these French experiences and to take advan-
tage of them for his own work.[50] He used contrasting
complementary colors in the way that Goethe had
defined them in his color circle (closely related to
Delacroix's color triangle) and in the way that they were
important for the French Impressionists and Symbolists,

Eugène
Delacroix,
*Still-Life with
Flowers,* 1834,
Öster-
reichische
Galerie
Belvedere,
Vienna

particularly for van Gogh: red-green, blue-orange, yellow-violet. He specifically selected the flowers for his paintings following these methods and obtained prominent media for the tonal values, which he contrasted with each other (cf. *Farm Garden with Sunflowers, Poppy Field, Villa on the Attersee, Forester's House in Weissenbach on the Attersee*—going as far as the flowering plants in the windows!—or the floral zones in *The Kiss* (plates 32, 29, 49, 48, and p. 68).

Klimt also made fruitful use of this knowledge in the organization of his surfaces out of spots of color and short brushstrokes. Here, his preferred color was *chromoxyd feurig*, that blue-green which the French also treasured and which he diversified, through the changing relationship to its neighboring colors in yellow, red, or violet tones, more toward green, gray, or brown, without affecting vivacity or luminosity. When he wanted to define neutral zones or evoke spatial depth in his paintings he could resort to an optically produced gray (from a mixture of *chromoxyd feurig* and violet, among other possibilities), which deprived the painting of none of its general luminosity and festive colorfulness.

Klimt's coloration was generally dry, bright, subtle, very well balanced, and without extreme contrasts. In complete accord with French aesthetics, he varnished none of his paintings in order to preserve their coloring. Today, paintings that were subsequently varnished make us realize just how little they, with their coloring, exaggerated contrast, and severity, reflect Klimt's sensitivity to colors. In this way *Park* (plate 35) has lost much of its original, subtle atmosphere. The painting *Garden Landscape* (plate 28), which so impressively displays the procedure of Klimt's technique, seems, after its later varnishing, as less finished than it probably originally appeared. The too-intense contrasts lead to the light grounding being too strongly perceived.

A painting such as the *Pear Tree* (plate 25) makes the method Klimt used for the colorist construction of his paintings apparent: as in many of his paintings, it is still so bare that one could continue working on it. In the upper left quarter, the picture appears to be further developed—with sophisticated blue, violet, and mauve tones within a great deal of green,

Signets from
Das Werk Gustav Klimts,
(Vienna, 1914)

*Helene Klimt
Tall Poplars I
Nuda Veritas
Jurisprudence
Fruit Trees
The Three Ages
of Woman
Schloss Kammer
on the Attersee II*

whereas, in the lower left and middle, much of this colorist refinement seems to be missing. The upper left area, therefore, shows what he intended to achieve: to balance the contrasts and create a soft, gossamer-like chromaticism.

Klimt's particular strength lay in the nuances, the sensitivity of his palette, the ability to evoke tones in which everything is perfect, which surprise and delight the eye in such a way that the viewer experiences an immediate feeling of bliss. To achieve such an intensity, he had to extract the dazzling colors from the local color but then attune them to the inner harmony of the painting—to its tones and chords. This increasingly developed into a formation originating in color. Klimt knew, only too well, that the impression made by this tonal harmony increased according to the tranquility of the construction of the painting and its colored areas. The tones and chords permitted this harmony to create a colorist atmosphere, even before the viewer's interest in details was awoken.

If colors were intended to be predominant there could, consequently, be no emphasis on light and shadow. Lighting does not govern Klimt's landscapes; the colors glow from within themselves, and light flows out of the core of the color. When shadows are shown, as on some roofs, they are so consolidated that they become an individual area of color, almost a distinct part of the painting.[51]

In Klimt's later portraits, we observe that the landscape increasingly invades the space of the sitter, such as in the portraits of *Elisabeth Bachofen-Echt* or *Mäda Primavesi* (see p. 205). Here, the "carpet pattern," with its landscape contractions, refers to the young girl's world of experience: to the ocean and its waves, on which she stands with fish, mussels, water plants, water birds; but also to a bulldog (she owned) and, behind her, a pond with water lilies.[52]

All this is so ornamentally construed that there is an oscillation between the decoration and the depicted object. His entire experience in the observation of the floral world comes to fruition in his posthumous portrait of *Ria Munk* (see p. 44). The painting was prepared in

Fundamentals of the chromatic circle according to Chevreul (*left*), and Goethe (*right*). Hand-colored book illustrations, in Chevreul-Jännicke, *Farbenharmonie* (Stuttgart, 1878)

several sketches taking the coloration into exact consideration. One of the loveliest examples, however, is the portrait of *Eugenia Mäda Primavesi* (*below*). In addition to the ornamental area behind her head, the border to the right and left of her garment and the dress itself are all in full blossom. The pulsation in grand, supple lines is seen, once again, in her dress and silhouette. As in the landscapes, the construction of the composition out of colored areas is treated in a particularly bold and resolute way. The surface of the painting is developed out of the tension between orthogonal severity and curving lines, with a distinct pictorial arrangement and a decisive stroke. In his late work, Klimt arrives at his individual style. He no longer jumps from corporeality and geometric abstraction but celebrates color.

Nature as the Starting Point

In photographs of Emilie Flöge taken in the orchard of the inn in Litzlberg in summer 1906, fruit trees, which also appear in a series of Klimt's landscapes, can be seen (see pp. 168, 70). A photograph from 1907 (see p. 47), showing Klimt, Emilie Flöge, and two other figures in the Litzlberg orchard, includes not only these fruit trees but also the gravel path that runs through *Garden Landscape* (plate 28). The ridges of the foothills of the Alps near the Attersee, which repeatedly show up in his paintings, are also visible.

Even paintings as abstractly constructed as *Island in the Attersee* (plate 13) have their sources in nature, as a photograph of Klimt and Emilie Flöge in a boathouse in Litzl-

berg shows. In the background, we can see the small island where Schloss Litzlberg is located—its tower is just identifiable as a small tip (see p. 65).[53]

Klimt began and worked in front of the motif—whether in the garden in front of the house, after a short walk in the woods, or from the window of his room on the first floor.[54] Even inclement weather could not prevent him from concentrating on his work.[55] Klimt needed the landscape as a model and made very few alterations to it—he developed his paintings directly from the view and the existing coloration.

It was Klimt's habit, after determining the details of the scene using a viewfinder (see p. 40), to make a brush sketch on the canvas—without a preliminary drawing—and then to determine the major portions and the coloration to such a degree that he could finish the painting in his studio in Vienna. This enabled him to begin as many as six paintings during his four to six week sojourn and to develop them to a degree ready for later completion.[56]

Klimt painted slowly and extremely meticulously—he repeatedly worked on his paintings over a long span of time and developed them further, as can be seen on the existing photographs of various versions (see p. 68).[57] Each of his landscape paintings basically appears to be capable of further development, incomplete in the sense of needing an additional application of paint. In many cases, we can assume that Klimt would have continued to work on the paintings if he had not already found a purchaser.

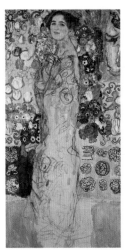

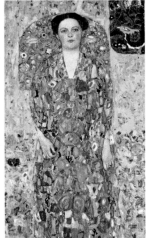

Gustav Klimt, *Portrait of Ria Munk*, 1917/18, Neue Galerie der Stadt Linz

Gustav Klimt, *Eugenia (Mäda) Primavesi*, c. 1913/14, Municipal Museum of Art, Toyota

44

Places of Internal Harmony

It cannot be a coincidence that the sky and the cosmos are almost completely missing, or reduced to diminutiveness, in Klimt's landscapes. The view is partially directed downward—in any case, into the very heart of earthly phenomena. The history of the earth takes place independent of mankind and his activities.[58] Klimt's landscapes deal with vegetal growth and recreation, a blossoming of nature within a solemnity removed from time. Only rarely is there an inkling of the shadow of a tree or an atmosphere of light or weather—the paintings remain free of the current, the passing. Nowhere is there the slightest hint of infirmity or transience. They are meditative paintings without, however, a religious dimension. They describe an inner harmony, a universal equilibrium.[59] The painterly texture of Klimt's work, especially in his later paintings, gains in material density. It fuses into one precious whole, evenly covering the surface of the canvas in a refined riot of color, coming close to decorative abstraction.

Klimt's landscapes are extremely sensual but appear, at the same time, remote and unapproachable. However, in order to capture the essence of nature among all this reverie, a certain distance was necessary between artist and motif. Klimt achieved this on the one hand through keeping the section of the countryside to be painted strictly within the rigid form of the frame, and on the other hand by rendering the subject two-dimensionally. Klimt's paintings thus receive their sense of alienation, as already discussed above, and their dignity. This makes it easy to comprehend why Klimt—and in this respect he is at one with Schopenhauer and Nietzsche — was so convinced in his recognition of art as the purest form of perception.

It appears that such timeless portrayals of the eternal power of nature were inspired by the idea of the eternal recurrence of the same. Schopenhauer's conviction of the senselessness of human existence—elaborated in "Die Welt als Wille und Vorstellung" (The World as Will and Idea)—possibly played a major role, not only in Klimt's Symbolist paintings, but also in his landscapes. In these, also, the blindly insistent forward thrust of the fertility of nature, the irresistible cycle of procreation, becomes the subject of his painting. We can see comparable features in Klimt's "figure paintings"—for example, in the towers of humans in the faculty paintings (see pp. 151, 197). Schopenhauer pondered that: "it is an awkward situation for a thinking being to stand in a borderless space, without

knowing whence and whither, being only one of countless other similar creatures, who push, drive, and torment, restlessly and rapidly develop, and pass away, in a time without beginning and end: with nothing persistent except matter and the recurrence of the same, differing organic forms, over certain paths and channels which just happen to exist."[60]

This could also be associated with Nietzsche's attempt at defining artistic creativity, harmonizing the tension between the sexual omnipotence of nature, personified by Dionysus, and the divine (Apollinian), transported from transience by the conquest of suffering through beauty.[61] Landscape paintings become the result of this "salvation through illusion"[62] and offer the viewer the feeling of "being absolutely engulfed in the beauty of illusion."[63]

1 Cf. the catalogue entry on this painting by John Collins in *Gustav Klimt: Modernism in the Making* (Ottawa, 2001), 79.

2 Friedrich Nietzsche, *Die Geburt der Tragödie* (The Birth of Tragedy), 1872 (Frankfurt am Main and Leipzig, 2000), preface of 1886 ("Versuch einer Selbstkritik"), chap. 5, p. 16, and chap. 5 of the principal text, 54.

3 Klimt's ceiling paintings for the Burgtheater can already be seen in connection with Nietzsche's *Geburt der Tragödie*—at that time, he had already been confronted with this text by Nietzsche.

4 Hermann Bahr, *Die Überwindung des Naturalismus* (The Conquest of Naturalism), Kritik der Moderne, no. 2 (Dresden and Leipzig, 1891), 152.

5 Ibid., 153

6 In this sense, the interest in international artistic elements was extremely selective, as can be seen in the catalogues of the Secession exhibitions. In the first years, painters such as Albert Besnard, Pierre Puvis de Chavannes, Fernand Khnopff, Max Klinger, and James Abbott McNeill Whistler received attention, followed, after 1900, by Jan Toorop, George Minne, and Ferdinand Hodler. It was not until the major Impressionist Exhibition, held in the Secession in 1903, that the Impressionist and Post-Impressionist paintings of a van Gogh or Gauguin were shown in representative exhibition in Vienna—and this remained a unique occurrence.

7 Georges Lafenestre writing about the Salon of 1870. Georges Lafenestre, *Le Salon de 1870*, in *L'art vivant: la peinture et la sculpture aux Salons de 1868 à 1877* (Paris, 1881), 146f. Nature has therefore once again become a yardstick and, through her, landscape painting the genre of the avantgarde.

8 Gottfried Fliedl, *Gustav Klimt 1862–1918: Die Welt in weiblicher Gestalt* (Cologne, 1989), 173.

9 Cf. the essay in this volume by Christian Huemer.

10 Cf. Carl E. Schorske, *Fin-de-siècle Vienna: Politics and Culture* (New York, 1980), 209.

11 Hugo von Hofmannsthal, *Die Malerei in Wien*, in Prosa I (Frankfurt am Main, 1950), 194.

12 For Alois Riegl, farsightedness is one of the prerequisites for "atmosphere." He writes: "but that which appears to be a merciless battle when seen close-up appears to him (the modern person) as a scene of peaceful coexistence, unity, and harmony when viewed from afar.... We call this notion of law and order over chaos, harmony over dissonance, tranquility over fluctuation, atmosphere. Its elements are peace and farsightedness." Alois Riegl, "Die Stimmung als Inhalt der modernen Kunst," in *Gesammelte Aufsätze* (Augsburg and Vienna, 1929), 28–39. (Cf. the essays by Peter Peer and Anselm Wagner in this catalogue.)

13 Alma Mahler-Werfel, *Diaries 1899–1902* (Ithaca, NY, 1999), 124.

14 Albijn van den Abeele, *Fir Forest in February* (1897), reproduced in *1900: Art*

at the Crossroads, exh. cat. (London, 2000), 259; Piet Mondrian *Woods* (1898–1900) and Fernand Khnopff *Under the Fir Trees* (1894) reproduced in Kirk Varnedoe, *Northern Light: Nordic Art at the Turn of the Century* (New Haven and London, 1988), 70.

15 There can be no doubt that Klimt was interested in photography, and the Secession repeatedly displayed artistic photographs in their exhibitions. In addition, the artist had a long friendship with Hugo Henneberg, during which Klimt portrayed Henneberg's wife Marie. Klimt repeatedly used photographs as the basis for his paintings. This is particularly apparent in his early miniature portraits, and the posthumous *Portrait Ria Munk III* of 1917/18 (ND 209). Klimt's use of a viewfinder when determining motifs is also indicative of his "photographic viewpoint." It is said that Klimt himself photographed. Cf. Wolfgang Georg Fischer, *Gustav Klimt und Emilie Flöge: Genie und Talent, Freundschaft und Besessenheit* (Vienna, 1987), 95; Renate Vergeiner and Alfred Weidinger, "Gustav und Emilie: Bekanntschaft und Aufenthalte am Attersee," in *Inselräume: Teschner, Klimt & Flöge am Attersee*, exh. cat. (Seewalchen am Attersee, 1988), 15.

16 Hugo von Hofmannsthal, *Die Malerei in Wien*, in Prosa I (Frankfurt am Main, 1950), 193f.

17 Johannes Dobai, "Die Landschaft in der Sicht von Gustav Klimt," in *Klimt-Studien, Mitteilungen der Österreichischen Galerie* 22/23, nos. 66/67 (1978/79): 250.

18 Cf. Fliedl, *Gustav Klimt*, 176.

19 The square format was used regularly in figural paintings after *Pallas Athena* of 1898. This, however, can not be compared with the exclusivity of its use in Klimt's landscapes.

20 In Klimt's case, however, we are not dealing with pure colors, as with the Impressionists (and particularly with the Post-Impressionists), but with hues, sophisticatedly attuned to each other.

21 Even though Edouard Manet and Gustav Klimt were stylistically and ideologically completely distant from each other, the public impact caused by their paintings absolutely can be compared. As was the case with the scandal concerning Klimt's faculty paintings, the public rejection and indignation that met Manet's *Déjeuner sur l'herbe* in 1863 and *Olympia*, painted two years later, was superficially based on moral grounds; but, in reality, the reason lay in the discomfort caused by the extreme, downright cutting criticism of the time and the analysis of societal conditions produced by these artists.

22 Cf. Schorske, *Fin-de-siècle Vienna*, 246.

23 Ibid., 252.

24 Ibid., 254.

25 Karl Kraus, *Die Fackel*, no. 36, March 1900, 16–19.

26 Ibid., no. 73, April 1901, 18–26.

27 Excerpts from the petition are in Alice Strobl, *Albertina-Studien* 2, no. 4 (1964): 153.

28 He turned down a major commission on the grounds "that there is no other means open to me of, even halfway, finding the peace I need." Undated letter to Fritz Waerndorfer, published in, "Unbekannte Briefe Gustav Klimts: Wie der grosse Meister schuf," reported by Karl Moser in *Neues Wiener Journal*, March 1, 1932, 10; cited from Christian M. Nebehay, *Gustav Klimt Dokumentation* (Vienna, 1969), 390.

29 Anon. in a Viennese daily newspaper, after 1918, cited from Nebehay, *Dokumentation*, 466.

30 Hermann Bahr to Josef Redlich in a letter dated February 14, 1918; see Fritz Fellner, ed., "Dichter und Gelehrter–Hermann Bahr und Josef Redlich in ihren Briefen 1896–1934," in *Quellen zur Geschichte des 19. und 20. Jahrhunderts*, vol. 2 (Salzburg, 1980), 309.

31 Schorske, *Fin-de-siècle Vienna*, 271.

32 Thomas Zaunschirm additionally interpreted the difference between organic and abstract in the female portraits based on Otto Weininger's book *Geschlecht und Charakter* (Vienna, 1903); cf. Thomas Zaunschirm, *Margarethe Stonborough-Wittgenstein: Ein österreichisches Schicksal* (Frankfurt am Main, 1987), 72. Markus Brüderlin draws attention to Wilhelm Worringer's "Abstraktion und Einfühlung"; cf. Markus Brüderlin, "Wien: Geburt der Abstraktion," in *Ornament und Abstraktion*, exh. cat. (Cologne, 2001), 122.

33 Most radically shown in the *Stoclet Frieze*, where the erotic message

(already displayed in *The Beethoven Frieze*) is transfigured into the sublimated form of the ornamental.

34 Ibid., Brüderlin, "Wien," 122.

35 Cf. Marian Bisanz-Prakken, "Programmatik und subjektive Aussage im Werk von Gustav Klimt," in *Wien 1870–1930: Traum und Wirklichkeit* (Salzburg and Vienna, 1984), 111.

36 Ludwig Hevesi, "Klimt Ausstellung," November 21, 1903, in Ludwig Hevesi, *Acht Jahre Secession: Kritik, Polemik, Chronik 1897–1905* (Vienna, 1906), 451.

37 Maurice Denis, in an article on the definition of "neo-traditionisme" in *Art et Critique*, August 23, 1890; cited from Jean Paul Bouillon, "Denis: Vom rechten Umgang mit Theorien," in *Die Nabis: Propheten der Moderne*, ed. Claire Frèches-Thory and Ursula Perucchi-Petri, exh. cat. (Zurich, 1993), 61.

38 For information on Bonnard's compositional methods, cf. Erhard Stöbe, "Die Farbe als das Kernproblem der Malerei: Pierre Bonnards Malmethode aus dem Blickwinkel eines Malers," in *Belvedere: Zeitschrift für bildende Kunst*, vol. 3, no. 2/97, 30–41. The Secessionists' conviction of the importance of decorative aspects also originated here (along with influences from the English Arts-and-Crafts movement), as did their enthusiasm for craftsmanship and the interpenetration of art and life. Through the Nabis, they had discovered numerous forms of realization: book illustrations, stage design and theater costumes, tapestries and carpet design, and even wall decorations.

39 Hermann Bahr, *Rede über Klimt* (Vienna, 1901), 15.

40 Anselm Wagner, "Aspekte der Landschaft bei Gustav Klimt," in *Inselräume: Teschner, Klimt und Flöge am Attersee*, exh. cat. (Seewalchen am Attersee, 1988), 39.

41 For information on the importance of the square in the art of the Secessionists, cf. Marian Bisanz-Prakken, "Das Quadrat in der Flächenkunst der Wiener Secession," in *Alte und moderne Kunst* 180/181, vol. 27 (1982): 40–46.

42 Cf. Fritz Novotny, "Die Landschaft," in Fritz Novotny and Johannes Dobai, *Gustav Klimt* (Salzburg 1967), 83; Wagner, "Aspekte der Landschaft," 40.

43 Ludwig Hevesi, *Altkunst–Neukunst: Wien 1894–1908* (Vienna, 1909), 211.

44 Österreichische Nationalbibliothek, Handschriftensammlung (Austrian National Library, Manuscript Collection) 201/17 (1–3); cited from Nebehay, *Dokumentation*, 503.

45 He describes the procedure in a letter to his lover, Marie (Mizzi) Zimmermann, at the beginning of August 1903: "with my viewfinder, that is a hole cut into a piece of cardboard, I looked for motifs for the landscapes I wanted to paint and found many or—if you want—nothing." Letter to Marie Zimmermann dated August 1903, cited from Christian M. Nebehay, "Klimt schreibt an eine Liebe," in *Klimt-Studien, Mitteilungen der Österreichischen Galerie*, vol. 22/23, no. 66/67 (1978/79): 108f.

46 It could easily be the case that Klimt needed a landscape that complied with his sense of form, such as the rolling foothills of the Alps. Marie-José Liechtenstein attempted to explain the reason for Klimt not painting any pictures during his stay in Mayrhofen in Tyrol in the summer of 1917 with the harsh alpine light. Cf. Marie-José Liechtenstein, "Gustav Klimt und seine oberösterreichischen Salzkammergutlandschaften," in *Kunst in Österreich 1851–1951. Beiträge zur österreichischen Kunstgeschichte des 19. und 20. Jahrhunderts*, ed. Wilhelm Jenny and Franz Pfeffer, (Linz 1951), 117. It is more possible that this was due to the forms of the mountains, which did not conform with Klimt's visual ideas.

47 *Das Werk Gustav Klimts*, Verlag H. O. Miethke (Vienna, 1914), Ausführung durch die K. K. Hof- und Staatsdruckerei (Produced by the Imperial Court Printers).

48 Cf. Novotny, "Die Landschaft," 63; Werner Hofmann, *Gustav Klimt und die Wiener Jahrhundertwende* (Salzburg, 1970), 34. For more detailed information on the signets see, Alice Strobl, *Gustav Klimt: Die Zeichnungen*, vol. 2 (Salzburg, 1982), 286–90.

49 Eugène Chevreul and Friedrich Jännicke, *Die Farbenharmonie—mit besonderer Rücksicht auf den gleichzeitigen Kontrast in ihrer Anwendung in der Malerei, in der decorativen Kunst, bei der Ausschmückung der Wohnräume, sowie in Kostüm & Toilette. Zugleich als zweite, gänzlich umgearbeitete Auflage der Farbenharmonie von E. Chevreul, hrsg. von F. Jännicke* (Stuttgart, 1878).

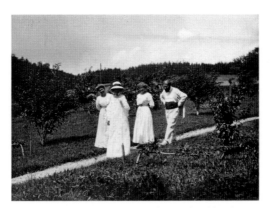

Gustav Klimt with Emilie Flöge (with hat) and friends
on a stroll in the brewery garden in Litzlberg, 1907

50 As Klimt was jointly responsible for the exhibition program of the Secession, his study of the paintings selected and exhibited must have been particularly keen. The value that the French place on color could be perceived in each painting. He could also express his wishes in connection with the hanging of the exhibits as can be seen in a letter from Paul Signac in connection with his paintings. In this, Signac recommended hanging his pictures according to the coloration of their basic tones. Events such as this must have impressed Klimt.

51 Cf. Dobai, "Die Landschaft," 265.

52 Cf. John Collins's text on this painting in *Gustav Klimt: Modernism in the Making*, exh. cat. (Ottawa, 2001), 129.

53 It is an interesting point that the same Hermann Bahr, who so vehemently advocated that an artist should display his inner being, recognized the connection between the work of art and the model of nature so clearly: "Of course its (art's) goal was always, and will always be, to depict an artistic nature, and to do this so compellingly that the others will be subjugated by its effect and forced to follow; but precisely to be able to achieve this effectiveness, for the conjunction with the others, it needs real subject matter." (Bahr, *Die Überwindung des Naturalismus*, 152–59; cited from *Die Wiener Moderne: Literatur, Kunst und Musik zwischen 1890 und 1910*, ed. Gotthard Wunberg (Stuttgart, 1981), 199, 201.

54 Letter to Mizzi Zimmermann (August 1902): "I get up early in the morning, usually around 6 a.m., sometimes earlier, sometimes later—if I get up and the weather is fine I go into the nearby forest—I am painting a small beech grove, mixed with a few conifers, this takes until about 8 a.m. Then there's breakfast and after that a swim in the lake, I'm careful about it though. Then I paint for a while, if there's sunshine a picture of the lake, if it's overcast I work on a landscape through the window of my room…. After the snack, back to painting—this time a large poplar with a storm welling up." Cited from Nebehay, "Klimt schreibt an eine Liebe," 109f. As Klimt also mentions their son Otto, who died in September 1902, in this letter to Mizzi, it can be assumed that this was written in August 1902.

55 "It was around the turn of the century. We were at our favorite *Sommerfrische* on Attersee, a small, quiet village between Attersee and Litzl-berg…. Once there was a period of bad weather, with cold, inclement weather and rain. In spite of that, we went walking, usually along almost deserted roads. In Litzlberg—the village lies across the lake from Kammer—we saw a man in a large meadow in front of an easel, in spite of the drizzle and cold, painting an apple tree, with photographic accuracy. We went closer, the grownups said a few friendly words but the genius remained cantankerously silent. It was surprising that somebody chose such simple motifs, at a time when others looked for particularly impressive scenes of the area…. it was only later that we discovered that the unknown painter was Gustav Klimt." Reminiscence by Irene Hölzer-Weineck, published in a newspaper, cited from Vergeiner and Weininger, "Gustav und Emilie." 13.

56 "I really made a strong effort in the country, I am going to bring five almost-finished paintings back with me, but I am not really satisfied with that. I hope things are better next year—if God will!" Letter to Mizzi Zimmermann (September 1902?), cited from Nebehay, "Klimt schreibt an eine Liebe," 107.

57 For example, *Pear Tree* (plate 25) was reworked. There are photographs of two earlier phases of *The Sunflower* (plate 31), one of which was determined for the collotype portfolio "Das Werk Gustav Klimts," published in 1914 (see pp. 68, 203).

58 Cf. Dobai, "Die Landschaft," 252.

59 The term *pantheism* has been inappropriately used by some writers, as this—as even Schopenhauer once smugly noted—presupposes atheism, starting from which a sense of divinity can be assigned to all natural phenomena, a conviction completely nonexistent for Klimt.

60 Cited from Bisanz-Prakken, "Programmatik und subjektive Aussage im Werk von Gustav Klimt," 112f.

61 Cf. Schorske, *Fin-de-siècle Vienna*, 221f.; Wagner, "Aspekte der Landschaft," 52 and Wagner's essay in this catalogue, in which some thoughts are reiterated.

62 Nietzsche, *Geburt der Tragödie*, chap. 12, 97.

63 Ibid., chap. 3, 41.

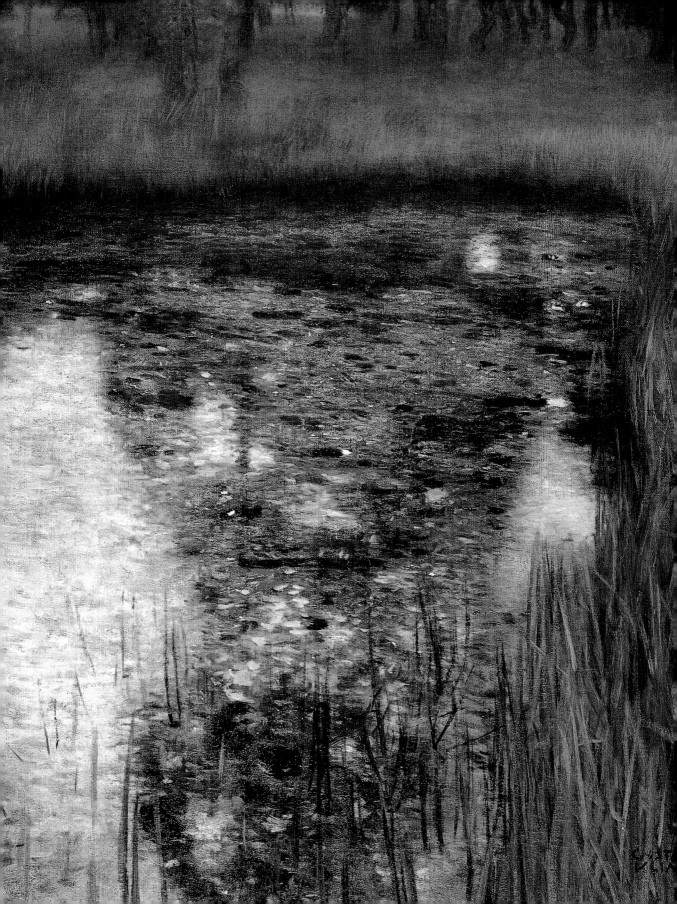

PLATES

Three small studies are the earliest known landscapes by Klimt. They appear to be apprentice pieces used for increasing his forms of artistic expression. At that time, Klimt had started to receive recognition as a decorator and painter of sophisticated ceiling scenes for contemporary building projects in the provinces and in Vienna. He, and the other two painters in the "Künstlercompagnie" — his brother Ernst and Franz Matsch — had, in addition to decorating various Viennese town palaces with their paintings, also created a painting for the ceiling of the Kursalon (spa hall) in Carlsbad. A short time later, they received the commission to design the ceiling paintings and stage curtain for the City Theater in Reichenberg (Liberec). Their activity as decorators of theaters planned by the famous architects Fellner and Helmer, was so successful that commissions for theaters in Bucharest, Fiume (Rijeka), and Carlsbad (Karlovy Vary) followed. The pinnacle was reached in 1886/88 with a commission for the ceiling above two staircases in the Imperial Hofburgtheater in Vienna — one of the most prestigious decoration assignments of the time, in one of the most prominent buildings on Vienna's Ringstrasse. This undoubtedly marked Gustav Klimt's breakthrough.

Emil Jakob Schindler,
Hacking Water Meadow, 1880,
Österreichische Galerie
Belvedere, Vienna

Programmatic art — illustrating ideas and abstract perceptions, often in allegorical form — was required for the decoration of the monumental buildings on Ringstrasse. This was the great moment of eclecticism, helping oneself from the lavish offerings of historic styles and ideas and combining them at will. It sought consecration in the glory of the past, whether in heroic historical events or within the framework of religious or mythological tales. In this respect, Klimt also created eleven illustrations for *Allegorien und Embleme* (Allegories and Emblems).

The interests and emphasis of Klimt's work at that time were completely different from when he started to broaden his horizon through landscape studies, using the results in allegorical portrayals. These included *Fable* (1883) and *Idyll* (1884) — both for the aforementioned *Allegorien und Embleme* — as well as studies for a painting for the ceiling of Empress Elisabeth's bedroom in the Hermes Villa in Lainz near Vienna, and the stage curtain *Homage to the Art of the Stage* (1886) for the City Theater in Carlsbad. At that time, Klimt had no intention of painting individual landscapes.

Klimt's entry into the world of landscapes took place by way of traditional Austrian *plein-air* painting, notably atmospheric realism. Similar to Emil Jakob Schindler and Marie Egner, Klimt selected motifs such as forest interiors and peaceful stretches of water: intimate landscapes that permitted an atmospheric portrayal in concentrated form. Klimt also favored warm, earthy colors, which he applied thoughtfully without any bright tones. His early works, painted in the open air in front of the motif, show — in addition to a precise observation of nature — great subtlety in the fine brushstrokes and delicate gradation of colors used to produced a melodious harmony. In these small-scale studies he already displayed amazing security in his handling of the effects of the light, illumination, and translucence.

The method and accuracy in which Klimt positions the staffage figure of a fisherman, standing in his boat within a section of the landscape (plate 1), is indicative of his closeness to the atmospheric realists (consider Schindler's *Hacking Water Meadow*, painted in 1880).

Even in these early pictures, Klimt seeks the moment of tranquility, of pausing and contemplating nature, that later became so characteristic for his entire landscape output. The distinct view from an elevated observation point, which he uses in one of the works, is a creative approach which recurs, years later, in a similar manner in his garden landscapes (plates 11, 27, 30).

Marie Egner,
*Forest Stream
with Bridge*, 1885,
Österreichische
Galerie Belvedere,
Vienna

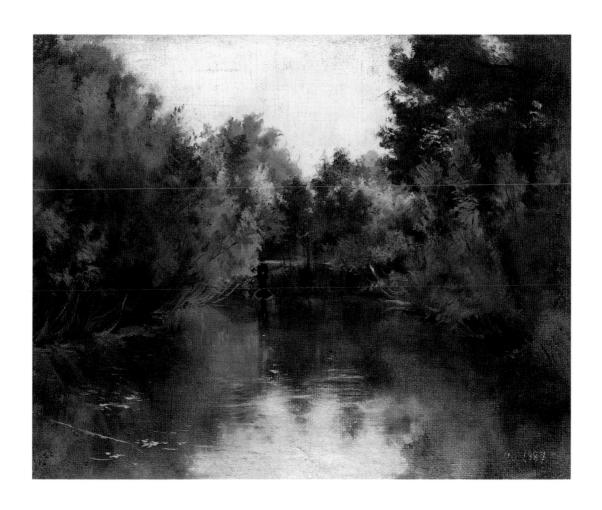

1　Secluded Pond, 1881
Private collection

2 Forest Floor, 1881/87
 Private collection

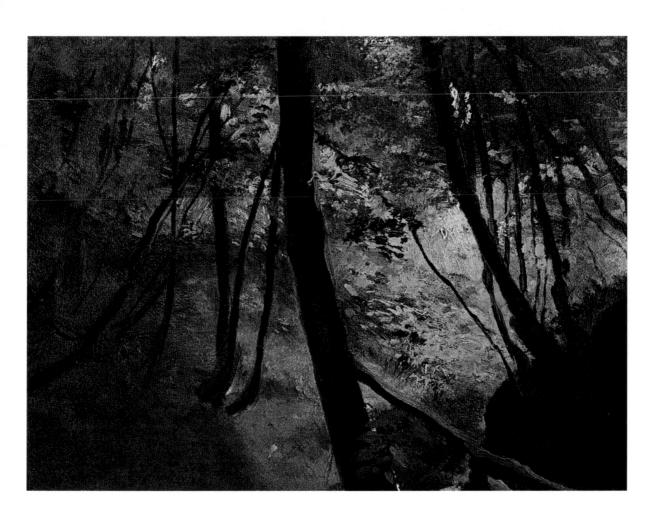

3　In the Middle of the Forest, 1881/87
　Private collection

In the years before the turn of the century, landscape paintings with a gossamer application of color and soft transitions could often be seen; the trees in *Orchard*, with their cotton-wool foliage amidst a warmly glowing green, appear to be almost hovering. Klimt contracts phenomena of nature into homogeneous areas of color, subordinates these to a decorative overall impression, and demonstrates the direction of his artistic development— sublimation through stylization. There is already evidence of the non-spatial procedure that will later characterize his entire landscape output. The only depth in *Orchard* is provided by three tree trunks, without which the depiction would be flat.

Klimt had a close affinity to Symbolism, which was seen as a counter-movement to the well-established Historicist style. Art was meant to be renewed by showing modern man his true face. In central Europe, Idealist salon art, often seeking to impress the public with paintings of pathos, was still *en vogue*. The trendsetters were painters such as Franz von Lenbach, Karl von Piloty, Wilhelm Kaulbach, Mihály Munkácsy, and in Vienna, Anselm Feuerbach and Hans Makart (in whose footsteps Klimt originally followed). One of the movements against this monumentality was a form of "nature lyricism," landscape painting with an emphasis on atmosphere, which began in the late nineteenth century and, after the turn of the century, took hold of Klimt and the Secessionists. In the Secession's Seventh Exhibition, held in spring 1900, a large number of "atmospheric" landscapes were shown, along with works by Klimt.

Klimt's landscapes from before the turn of the century already make apparent, as Hermann Bahr outlined, that: "Aesthetics are being turned around. The artist's nature no longer wants to be a tool of reality, to consummate its exact image; but precisely the opposite, reality now becomes the artist's subject matter to proclaim his own nature, in clear and effective symbols."[1]

Something spiritual is communicated by the *atmosphere* of a work. This perception played a central role in the theoretical discussions of the time and became a declared objective especially in Austrian landscape painting of the second half of the

nineteenth century with respect to the group of artists around Emil Jakob Schindler. Alois Riegl considered *farsightedness* one of the prerequisites for *atmosphere*. He wrote: "... what appears to be a merciless battle when seen closeup appears to him [the modern person] to be a scene of peaceful coexistence, unity, and harmony when viewed from afar This notion of law and order over chaos is harmony over dissonance, tranquility over fluctuation, atmosphere. Its elements are peace and farsightedness."[2] This perception also initially played a central role for Wassily

Emil Jakob Schindler, *Spring in Hacking*, 1883, Österreichische Galerie Belvedere, Vienna

Kandinsky: "Today, the observer is rarely capable of such vibrations. In art, he either looks for the pure reproduction of nature, which can serve practical purposes (the portrait in its usual sense, etc.) or a reproduction of nature with a certain interpretive content—'Impressionist' painting—or finally, states of the mind, disguised in the forms of nature (atmosphere) ... where the observer finds a resonance with his soul. Obviously, such a resonance (or dissonance) cannot remain empty or superficial, the 'atmosphere' of the work can deepen the atmosphere of the viewer—and transfigure this."[3]

Klimt, whose work before and around the turn of the century was characterized by this way of thinking, can be seen as part of an Austrian painting tradition. This is to be found in his choice of the same motifs, often with the same detail, as the atmospheric realists (lakes and ponds, forest interiors, views of orchards, or meadows and gardens bursting with flowers). In the composition of his works he comes amazingly close to the theoretical notion—precisely because his works are, more and more, sustained by this feeling of peace and farsightedness.

1 Hermann Bahr, *Die Überwindung des Naturalismus*, published as number two in the series "Kritik der Moderne" (Dresden and Leipzig, 1891), 153.
2 Alois Riegl, "Die Stimmung als Inhalt der modernen Kunst," in *Gesammelte Aufsätze* (Augsburg and Vienna, 1929), 28–39.
3 Wassily Kandinsky, *Über das Geistige in der Kunst* (On the Spiritual in Art) (Munich, 1912), 5f.

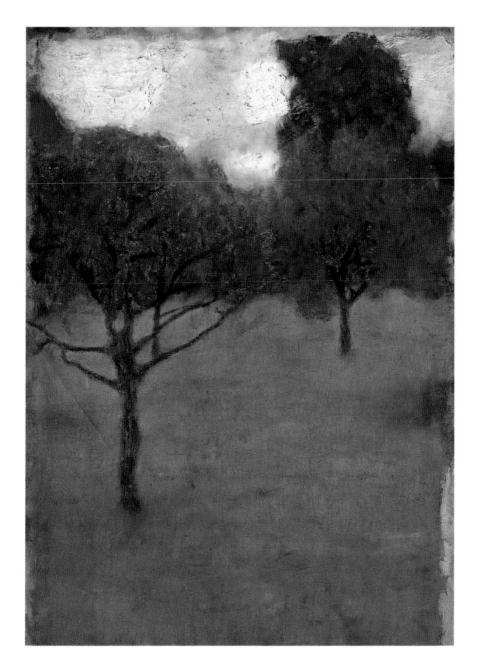

4 Orchard, c. 1896/97
Private collection

5 Farmhouse with Rose Bushes, *c.* 1897/98
Private collection

In 1898, when Klim and the Flöge family arrived in St. Agatha near Bad Goisern to spend the *Sommerfrische*, the Goiserer Valley was already famous, not only due to its sulfurous thermal springs, recommended by the "Artistic Board of the Medical Faculty,"[1] but also as a source of inspiration for landscape painters. Emil Jakob Schindler had discovered the area in 1881 and spent the summers, until 1887, in Bad Goisern, with his wife Anna and their daughters Alma (later Alma Mahler-Werfel) and Margarethe. After 1882, his students Marie Egner, Carl Moll, and Olga Wisinger-Florian followed him, and in the summers of 1884 and 1885, he was joined by the Hungarian painter Robert Nadler.[2] This landscape, with its luxuriant vegetation and a number of mills and weirs, and its picturesque situation surrounded by mountains, provided a wealth of motifs for painters who liked to capture atmospheric changes and subtle feelings.

Rudolf von Alt, former president of the Secession founded in 1897 and one of the greatest watercolor painters of the age, spent several summers in Bad Goisern (1899–1904)[3] and devoted himself to similar themes to Klimt. "There, where the path almost reaches the mountain and the forest, it divides, and on the gentle slope of a meadow with fruit trees lies the villa, with a panorama of a rock face and distant Lake Hallstatt, where Rudolf Alt used to spend his summers. I come across the master at work. ... The master was painting what he could see from the veranda: two old apple trees, their mossy trunks contorted by the wind, stand at the edge of a sunny, upward rising path, meadows to the right, meadows to the left"[4]

A railroad (which connected the west line at Attnang-Puchheim with the Enns Valley line at Steinach-Irdning) also crossed the valley. This was particularly beneficial for the region, making it especially easy to reach from Vienna. Not far from here, and on the same line, was Bad Ischl, where the Emperor traveled to annually by train to spend the *Sommerfrische*. St. Agatha, directly on Lake Hallstatt at the foot of the Pötschen Pass, is characterized by the mighty late Renaissance building of the "Agathawirt" (Agatha Inn) and

the Gothic church with its Baroque tower. It lies on the pass to Styria, and a little further on, is surrounded at the end of the valley by expansive meadows.

Klimt's painting *After the Rain* (plate 6) appears to have been painted in the orchard at "Agathawirt" (Klimt and the Flöges stayed in the neighboring house, Agatha nr. 9), next to the church consecrated to St. Agatha. From here, there is a view over the Reitern meadows to the Kalm Mountains, whose alpine pastures and wooded slopes in Gschwand and Ramsau (all districts of Bad Goisern) can be clearly seen from afar between the gnarled trunks of the fruit trees. Klimt not only captured the topography of this region in a masterly manner, but also the typical weather. The district is notorious for its drizzle. Mountains, covered with clouds, are repeatedly found in paintings by Alt, Schindler, and Moll.

After the Rain is one of the few paintings by Klimt to depict actual weather conditions. Klimt's art was aimed at timelessness, averse to the anecdotal or transient.

In its organization into peaceful, rectangular areas Klimt's painting corresponds with his technique in the drawings *Nuda Veritas* or *Envy* for *Ver Sacrum* or the poster for the First Secession Exhibition of the same year (see p. 146). A slender upright format, with emphasis not only the linear aspects of the form but also the detail, is indicative of the Secessionists' study of Japanese art. The French Nabis had also been inspired by the Far East and had favored the slender upright format in their works in the 1890s. Klimt proceeded in a similar manner in his illustrations for *Ver Sacrum*. The painting *Girl with Flowers in Her Right Hand in a Meadow* (1898) also makes use of the tension resulting from the narrow format and heightened overlapping.

Photographers such as Theodor and Oscar Hofmeister could not avoid this popular upright format either. Their photographs create an atmosphere in complete accord with the "nature-lyricism" of the time. The tree trunks in Klimt's painting also appear as individual trunks, marked by age, wind, and snow.

Gustav Klimt,
*Girl with Flowers in Her Right
Hand in a Meadow,*
illustration for *Ver Sacrum*
3 (1898): 13

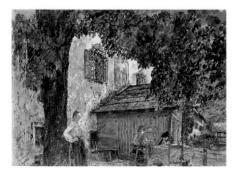

Rudolf von Alt, *Garden at the Inn in St. Agatha near Goisern*, 1903, watercolor, private collection

with the slightly darker green beneath them, produces a feeling of space, a breath of light—a gentle reminder of the mimetic of that portrayed. The foliage of the trees, however, is united by Klimt into a colorful, flat, fabric.

In these early works, it would seem that Klimt already used a telescope when working on the background to his paintings. While the bright green mountain pastures in the background are accurately taken from nature, in reality they actually appear considerably smaller and more distant. A strong structure transforms the landscape, subjugates it into a rigid construction and a decorative arrangement. This is an indication of Klimt's notion of nature independent of mankind: the natural processes of growing and maturing occur independently, without any help from man, and without taking the existence of the viewer into consideration.

The film of coloration and the soft transitions correspond with Klimt's technique of the period which, in paintings such as *Lady by the Fireplace* (below) and *Portrait of Sonja Knips* (1900, see p. 37) sought to achieve an atmosphere similar to that found in Whistler's paintings. A fresh, delicate green dominates this painting, in which chickens are decoratively positioned like white specks of color. Only the overlapping of the fruit trees,

1 Josef Rabl, *Führer durch das Salzkammergut und Berchtesgadnerland* (Vienna, Pest and Leipzig, 1883), 31.
2 Otto Wutzel, "Goisern in der österreichischen Kunst des 19. und 20. Jahrhunderts," in *Heimat Goisern—Bad Goisern in Vergangenheit und Gegenwart* (Bad Goisern, 1990), 103 ff.
3 Ibid., 105.
4 Report in the *Neue Freie Presse*, August 24, 1902.

Gustav Klimt, *Lady by the Fireplace*, c. 1897/98, Österreichische Galerie Belvedere, Vienna

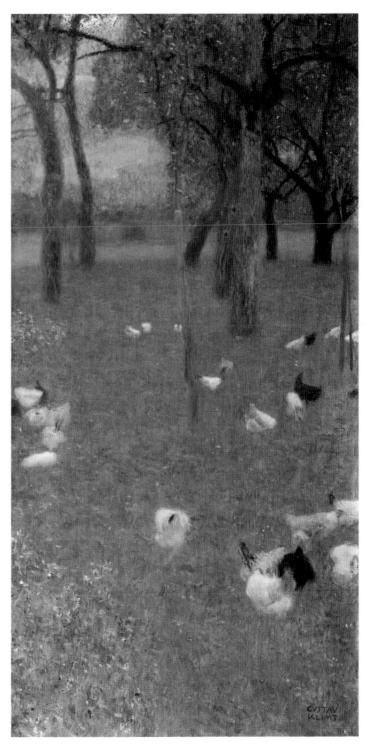

6 After the Rain
(Garden with Chickens
in St. Agatha), 1898
Österreichische Galerie
Belvedere, Vienna

Golling, with its impressive waterfall, became a popular destination for both painters and tourists at the beginning of the nineteenth century. After its connection to the railroad network in the 1880s, Golling developed into one of the ten most popular *Sommerfrische* destinations in the province of Salzburg, advertising its beautiful gardens and observation terraces, as well as a "pond for rowing." People suffering from gout could find relief in the bathing establishment, with its brine and pine-needle baths, run by the "Hackerbauer." At the end of the nineteenth century, not only the upper middle class, but also illustrious public figures—including the Duke and Duchess of Devonshire, the ambassador of the United States, Charles Francis, Prince Franz Liechtenstein, and the Hofburgtheater actress Auguste Wilbrandt-Baudius—were counted among the summer guests.[1] This made the location, with its numerous possibilities for recreation, an attractive summer destination for the Flöge family and Klimt. They traveled to Golling in mid-August and stayed until the beginning of September.

It appears that Klimt created three paintings during these weeks.[2] An orchard, in the meadows of the broad Salzach Valley, continues in the line of earlier works—an approach to the peaceful existence and growth of nature guided by his inner feelings (plate 7).

His masterful interior view of a cowshed, completely in the spirit of Claude Monet, makes the softly infiltrating back light, visualized though a mesh of multicolored short brushstrokes, the actual theme of the painting. The final painting created here was *A Morning by the Pond* (plate 8), with its soft, gossamer transitions celebrating the mirroring of the surrounding forest in a pond. The trees stand—like a dark wall—on the opposite bank of the pond as the first rays of the sun warm the background.

This construct renders apparent Klimt's study of Monet, who, at the turn of the century, repeatedly painted tranquil water surfaces such as the water lily pond in Giverny, or sidearms of the Seine at dawn. In just the same manner as Monet, Klimt models the surface of the water using short, arched brushstrokes, and produces the coloration of the pond by placing blue, pink, and violet tones next to each other, retaining, however, a restrained coloration united in earthy colors.

Claude Monet, *Branch of the Seine near Giverny*, 1897, Museum of Fine Arts, Boston

In this work, Klimt begins with his contemplation on the theme of the water surface, which takes up the major part of this painting and is cut off on several sides, as a potentially infinite continuum—something which occupied Monet so much on his way to an autonomous form of painting. This aspect is later handled even more resolutely in the *The Swamp* and his Attersee paintings (plates 9, 12, 13).

As with Monet at the turn of the century, the model of nature becomes the point of departure for attaining a feeling of harmony. In Monet's series *Morning on the Seine* the composition of the surface takes control; basking in delicate hues and in the finely graduated modulations of the countless strokes of color, and the contours have become softer, the objects increasingly dissolved. Contrary to this, Klimt did not attempt to capture the momentary aspects of the effects of light, the ephemeral side of the impression of nature, the change of weather and lighting phenomena. It was his intent to translate the viewer's feelings, resulting from the observation of a landscape, into a timeless form of absolute equilibrium. Everything in this painting appears frozen in time; even the ripples in some places on the surface of the water appear merely to have a different artistic texture. The contours of the reflections are soft.

Still or peaceful watercourses were very popular in Europe at the end of the nineteenth century, particularly in Austria. Not only the art world was fascinated by the symbolism of water, which united the creative and bearing strength of nature with moisture. Symbolist literature of the period also fêted the theme, and in music it became a source of inspiration for compositions such as Claude Debussy's *Reflêts dans l'eau.*

Symbolist art laid claim to overriding the differences between the sensual and spiritual worlds. It wanted to provide a spiritual response to natural phenomena. Retaining traditional methods of expression, it attempted to distill the picturesque character of a landscape and impressions gained in nature into an artistic atmosphere. The artist was granted the gift of profound insight, even assuming the aura of a seer. Hermann Bahr applied this pathos of the "seer" directly to the landscape: "Klimt has the power, by producing such works, to depict them in such a way that they affect us like parables or images of a spiritual condition.

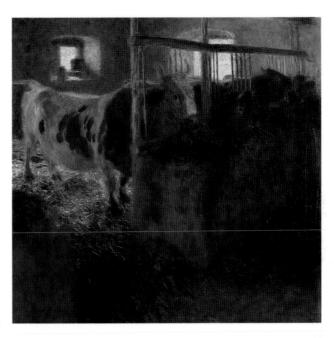

Gustav Klimt, *Cows in a Stall*, 1899,
Neue Galerie der Stadt Linz

He does not merely paint a random feeling into a randomly seen landscape, so that these two aspects would be only connected through his person, but he appears to divest them entirely of their subjectivity, making them completely 'objective,' and thus reveals that point in the inner world of his subject which corresponds with its external appearance."[3] "He is unable to touch anything without, probably unknowingly, giving it a spirit and soul, he is that person who is called an idealist."[4]

As in so many atmospheric paintings of the period, *A Morning by the Pond* does not grant a single glimpse at the sky, greatly increasing its contemplative intensity. This cropped representation has the character of being a fragment of a far greater complex of eternal natural processes. In nature's lofty tranquility and solemnity, there is a foreboding of a greater, uncontrollable power. "Deep in the subconscious of all art, of all great art, lies the longing to once again become a myth, to once again depict the totality of the universe."[5]

In his critique of the Seventh Secessionist Exhibition in March 1900, Ludwig Hevesi also used the term "atmospheric landscape," and through his description, gives us an impression of what *Orchard in the Evening*—which we only know from a black-and-white photograph—must have looked like: "We can also see three exquisite atmospheric landscapes by Klimt. One with smooth water and a great deal of sky, absolutely scurrying and flickering (*A Morning by the Pond*). The other is a sunset with mossy fruit trees with a metallic red in the sky of the background; there

is a murmuring in it along with silent matter looming up, with ever-increasing density, against the bright sky. The third (*After the Rain*, plate 6), a delicate idyll in green and gray; speckled with chickens, very individually carried out."[6]

During this *Sommerfrische*, Klimt came across the square format which so suited his search for peace and balance and which he, thereafter, exclusively used for his landscapes. Although there can be no question that the square played a central role in Viennese Jugendstil, Klimt must have felt himself affirmed in his choice of format for his landscapes by Monet. Monet had used it to increase the feeling of tranquility, and to direct attention entirely on the orchestration of the colors and harmonies within the painting.

1 Robert Hoffmann and Guido Müller, "Fremdenverkehr in Golling, Was-serfalltourismus und bürgerliche Sommerfrische (1800–1918), in Robert Hoffmann and Erich Urbanek eds., *Golling: Geschichte einer Salzburger Markt-gemeinde*, (Golling, 1991), 580ff.

2 Alfred Weidinger is to be thanked for the topographical identification of Egl Lake in Golling as the location of *A Morning at the Pond*, for his dating of *Cows in a Stall* and *Orchard in the Evening* to 1899, and their attribution to Klimt's summer sojourn in Golling. Cf., Alfred Weidinger, "Neues zu den Land-schaftsbildern Gustav Klimts" (diploma thesis, Salzburg, 1992), 40, 45–47, and note 65.

3 Hermann Bahr, *Rede über Klimt* (Vienna, 1901), 15.

4 Ibid., 16.

5 Hermann Broch, *Hofmannsthal und seine Zeit* (Frankfurt am Main, 1974) 24.

6 Ludwig Hevesi, *Acht Jahre Secession: Kritik, Polemik, Chronik 1897–1905* (Vienna, 1906), 234.

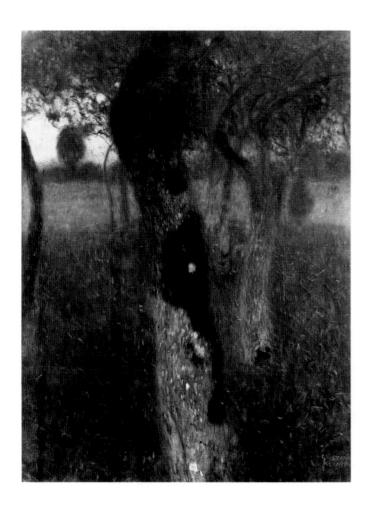

7 Orchard in the Evening, 1899
 Private collection

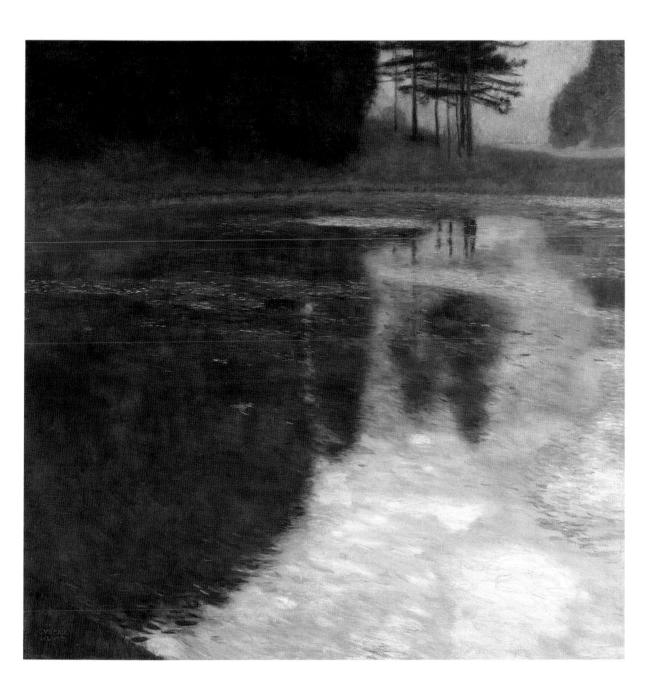

8 A Morning by the Pond, 1899
 Leopold Museum – Privatstiftung, Vienna

Klimt visited Attersee—where he was to spend his *Sommerfrische* almost every year until 1916, and where he painted the majority of his landscapes—for the first time in 1900. The Flöge family and Klimt usually went to Attersee during August and September—sometimes for only a few days, sometimes for several weeks.

Until 1907, they stayed in the guest house at the Litzlberg Brewery. The brewery was erected at the beginning of the nineteenth century and sections were reconstructed after a fire in 1899. The Litzlberg Cellar, a popular place for the summer guests to take refreshments, and, at the same time, the storeroom for Litzlberg beer, was part of the same premises, located between Litzlberg and Seewalchen. The brewing activities ceased in 1930 and the building was partially demolished after World War II. After 1895, the ruined Litzlberg Castle, situated on the lake, was rebuilt on the foundations. The castle was acquired by the steel industrialist Erwin Böhler, whose family was friendly with Klimt and supported him generously.

In Litzlberg, Klimt found the tranquility and models of nature he needed for his work. The surroundings of the brewery provided a permanent source of inspiration. No matter how abstract and alienated, they resound through all the works he painted there. Before leaving Vienna, Klimt always looked forward to his time on Attersee; he took an interest in the weather and in the vegetation of the area: "It seems that the flowers have been destroyed by the hail We'll find some walks I think that the current loneliness is impairing a true impression. Imagine discovering Litzlberg and enjoying it alone. Best greetings. Gus."[1]

In the first summer, Klimt occupied himself with themes that he had previously worked on: orchards and tranquil stretches of water. Marshes and lakes were popular themes at the time and became "a parable for the passing, but also the seductive magic transmitted by the fathomless. These scenes of melancholy and escapism provide a solemn form of seclusion."[2] Many such paintings, including Fernand Khnopff's *Silent Water* (see p. 36), Franz Stuck's engraving *Trout Pool* (1891), or Wilhelm Bernatzik's *Floodplain Landscape* (1897) were shown in the Secession exhibitions. Klimt brought

Gustav Klimt, *The Black Bull*, 1900/01, private collection. The bull was kept in a stall at Litzlberg Brewery

this uncontrollable cycle of nature into an intellectual connection with the towers of humanity he repeatedly used in his faculty paintings and later humanity paintings. There is an almost unstoppable form of continuous growth, bursting with life—a river of life, in which individual destinies are only of marginal importance. Monet's paintings of his water lily pond obviously played an important role in the composition of paintings such as *The Swamp* (plate 9). In his Attersee paintings (plates 9, 12, 13), Klimt depicts the surface water as a segment, in a similar way to Monet's depictions of the Seine or the sea; the absence of any foreground deprives the viewer of all means of orientation and, thus, achieves tension in peace. The viewer is placed immediately over the water surface that Klimt has created using regular, short, energetic strokes of radiant colors. Faced with the drastic cropping of the motif on three sides, and the high horizon, Ludwig Hevesi aptly wrote: "A frame full of lake water from Attersee, nothing but short, gray and green waves, entangled with each other."[3] Klimt had, however, painted an actual landscape—the view from Litzlberg to the lake, with the island, whose trees can be seen in the painting—cropped on the right edge of the picture, and using his artistic liberty, he omitted the dam leading to the island and the historicist villa on the island itself (see p. 15). A contemporary photograph of the boathouse, from where Klimt painted the island, shows the group of trees mentioned (see p. 65).[4]

Nothing disturbs the regularity of the water surface, while everything amplifies the impression of a continuum. The tectonic appears to be almost suspended; only the brushstrokes, becoming smaller in the depths of the painting, prevent it from being completely flat.

Hermann Bahr wrote: "Consider the painting *Farmhouse with Birch Trees* or, another, *Attersee I* (plates 11, 12). Both depict a view of nature. . . . The amateur, or the naturalist—who will always remain an amateur—will show a segment of nature which he has come across by accident or, at best, one which has made a particular impression on him, which he likes greatly. The work only develops into art when it becomes, to use the phrase, 'an artistic entirety,' that means: When one color relates to

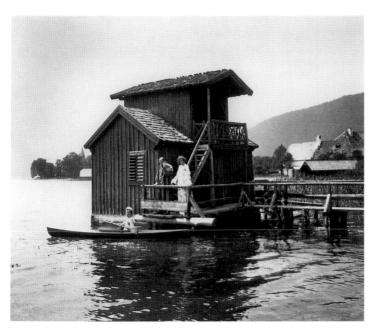

Gustav Klimt and Emilie Flöge outside a boathouse on a dock in Litzlberg, with Friedrich Paulick in a kayak. Litzlberg Island is in the background to the left, 1904

another color, one line to another line, and the colors to the lines, and all measurements stand in such fixed relationships to each other that it is impossible to imagine the painting without any single element, without immediately destroying it, whereby we have the impression of the essential and not of the coincidental, the genuine stabilization of beauty."[5]

The Attersee paintings, with their division into almost abstract rectangles, are precisely deliberated (later, with abstract methods, Piet Mondrian would use the same principle to bring areas, horizontals, and perpendiculars into a relationship to each other). *Farmhouse with Birch Trees* (plate 11) also uses a strictly orthogonal composition, formed by the slender trunks of the birch trees, and the high horizon of the meadow. The internal "drama" of composition and execution is produced in an unostentatious, but exceedingly sophisticated, manner: ultimately, there are only four vertical lines and one horizontal, placed at well-considered distances from the frame, and from each other, which give the square picture its stability and detached tranquility. Similar to the works of the "atmospheric realists," the view is drawn toward the foreground, with its grasses and flowers producing, through the absence of the sky, a meditative "inner space" in which time appears to be frozen. That in this case we are not dealing with an abstract landscape but with the meadow behind the brewery, with the white wall of the Mayr's

farm seen in the distance, is captured impressively in a contemporary photograph. In several of the photographs of Emilie Flöge in the garden at Litzlberg Brewery, fruit trees that can be recognized in some of Klimt's paintings can be seen in the background, as well as expanses of grass that are repeatedly found in works such as *Poppy Field*, *Garden Landscape*, or *Garden Landscape (Blooming Meadow)* (plates 29, 28, 27, and p. 68).

It is consistently surprising to observe just how accurately Klimt depicted what he had seen—from the chapel with poplars (which still exists today), over the views of Schloss Kammer, or the village of Unterach, to the forester's house in Weissenbach. What was actually seen is in fact the point of departure. This reminds one of Ferdinand Georg Waldmüller, whose "lower-Austrian, Flemish thoroughness"[6] also needed nature as a model and who, in his compositions with several figures, invited these people into his studio individually, where they were then painted, one after the other, into the work until it was complete. Klimt was able to enliven the stringency of his composition repeatedly by using tense asymmetries. In a letter to his lover Mizzi Zimmermann, Klimt describes how he arrived at this perfect organization through his careful selection of the area to be painted, which would satisfy the demands of Viennese Jugendstil for decorative surfaces: " . . . in the early morning, during the day, and in the evening, I looked for motifs for the landscapes I want to paint, with my viewfinder, that it is a window cut in piece of cardboard, and found many—or if you like—nothing"[7] (see p. 40).

The paintings from the first years in Litzlberg were conceived as atmospheric landscapes. This applies particularly to his masterly depictions of forest interiors, especially in the two early works *Pine Forest I* and *II* (plates 16, 17). All over Europe, painters and photographers alike were fascinated by this theme. Uncountable portrayals helped to discover new aspects. At the Thirteenth Secession Exhibition in 1902, there was an entire group of "conifer motifs," permitting a direct comparison with Klimt's paintings. "A great deal of commendable, local painting has been brought together in the Secession. At the pinnacle, however, are several absolutely magnificent paintings. In first position, without any question, are those by Klimt. It is easy to compare the gap between the works using the four or five

similar conifer motifs shown alongside each other in this ex-hibition. A series of vertical trunks, seemingly all alike, like columns in a church, seemingly a static crowd of long, vertical objects."[8] It is likely that Klimt intended to match himself against his contemporaries with his forest paintings. In view of the massive incidence of this theme in the painting and photo-graphy of the period, it hardly appears likely that the little woods behind the Litzlberg Brewery could have been the sole trigger for this series of paintings.

Klimt's mastership becomes obvious in his unparalleled sensitivity to nuances. The coolness and dampness of this shaded forest interior makes itself felt through the multitude of delicate brown, green, russet, and violet tones; the muted light is shown in only a few places with tiny flashes in the tree crowns and the glowing of a lush green between the trunks giving a feeling for the intensity of the daylight outside. Comparisons of paintings such as *Beech Forest I* (plate 20) with Antonín Slaviček's *Birch Wood Atmosphere*, or *Beech Forest II* (plate 18) with Hugo Henneberg's *Beech Wood in the Autumn* (1897), (see p. 35), make it obvious just how in-touch Klimt was with the aesthetic developments of his time.

Klimt spent relaxing days on Attersee and did not work particularly much. "I have five paintings in progress here, a sixth canvas is still blank, maybe I will take this one home in the same condition. I think I will be able to finish the other five. One lake painting, a bull in a stall, a marsh, a large poplar, and in addition some young birches; those are the motifs.

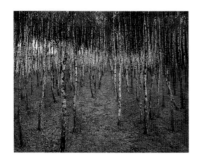

Antonín Slaviček, *Birch Wood Atmosphere*, 1897, Narodní Galerie v Praze, Prague

My appetite for work has, unfortunately, critically diminished with the progress on the pictures."[9]

Social activities played a major role, and time was found for sports and joint excursions. In a letter to Mizzi, written in the summer of 1902, Klimt describes the daily schedule of these sojourns. "I get up early in the morning, usually around 6 a.m., sometimes earlier sometimes later—if I get up and the weather is fine I go off into the nearby wood—I am painting a group of

Egon Schiele, *Sunflowers I*, 1911, Österreichische Galerie Belvedere, Vienna

beech trees together with a few conifers. This takes until about 8 a.m. Then I have breakfast and after that a swim in the lake, I'm careful though. Then I paint for a while: if the sun is shin-ing, a picture of the lake, if it's overcast I work on a landscape from the window of my room. Sometimes I neglect this morn-ing painting and, instead, study my Japanese books—outdoors. Then it's noon. After lunch I take a short nap or read—until the afternoon snack. Before or after the snack I go for a second swim in the lake; not always but usually. After the snack, back to painting—this time a large poplar tree with a storm welling up—sometimes, instead of this evening painting session, I go bowling in a neighboring village—not very often though. Then dusk falls—supper—early to bed, early to rise the next morning."[10]

Klimt altered his style when he came under the spell of pointillism. *Farmhouse* and *Fruit Trees*, both from 1901 (plates 14, 15), are witness to this development. Even before the major Impres-sionist Exhibition in 1903, a large number of works by Paul Signac were shown at the Seventh Secession Exhibition in 1900. Works by Théo van Rysselberghe were displayed at the Third and Fifth Exhibitions in 1899, and again at the Eighth Exhibition in 1900 and the 16th in 1903. Georges Seurat's major work *Sunday Afternoon on the Island of La Grande Jatte* was shown at the Impressionist Exhi-bition in 1903. These were years in which Klimt was particularly susceptible to new impulses and incorporated them into his

own personal style. His paintings up until 1902 still showed a strong affinity to the landscape, characterized by the gentle, the organic, the flowing, and the atmospheric. Klimt then started to hold objects at a distance and to abstract them. There no longer appeared to be any kind of participation. Instead, he developed a contemplative way of observation aimed at creating a discriminating artistic entity.

Klimt concentrated on formal problems and the harmony of color, whereby he transformed pointillism into his own individual style, with the dots and short brushstrokes of paint always indicating specific objects. In *Beech Forest I*, *Pear Tree*, and *Tall Poplars II* (*Approaching Thunderstorm*), we see this style at its highest stage of development (plates 20, 25, 24). In an exhibition critique, Ludwig Hevesi wrote: "One of Klimt's new landscapes is called *Approaching Thunderstorm*. It seems to be a somber, dark painting. When one looks closer, one sees that it is full of trout speckles—if one can say such a thing. It is speckled with yellow, blue, green, and violet, although it appears black. And the storm, rising to its zenith from the low-lying horizon, is not merely a black storm cloud, but a formal mosaic of angular, cloud fragments in various, uncanny dark hues, reminiscent of asphalt, sulfur, lava, ashes, etc., more drizzling than fuming, which appear to have been applied almost haphazardly The colored spots of color stem from a better-known source. This time, Klimt uses them in two landscapes, *Golden Apple Tree* and *Pear Tree*, purposefully and with special significance. He covers entire areas with this colorful abundance, probably because the eye delights in seeing such richness."[11]

However, Klimt did not give up the stringent organizational composition or the decorative structure of the surfaces of his paintings. Pointillism was only used to enliven these surfaces, to amplify the luminous and dazzling areas of color, and not to reproduce an atmosphere, the shimmering of light. He turned the achievements of the Pointillists toward the decorative, and wove his "painting mosaic" like a densely knotted carpet over the objects. Over the years, this led to a dissolution of definite structures—to a blurring of individual zones.

Klimt repeatedly showed himself to be a refined colorist. In *Birch Forest* (plate 21)[11B] each tree trunk is depicted individually, in spite of their large number. (In comparison, the tree trunks in Hodler's and Moll's paintings are all identical.) But, in the background, Klimt is successful in suggesting the dampness in the depths of the forest through his careful use of a grayish

Gustav Klimt, the Sonja Knips
Sketchbook, 1897–1905, pencil
(146 pages, bound in red leather),
Österreichische Galerie
Belvedere, Vienna

green. The initial phase of the painting can still be seen: The background is finely brushed, making clear how slowly and carefully Klimt worked and also that he corrected, when necessary. Paintings such as this permit us to follow almost every individual stage in the painting procedure.

At this time, Klimt painted the extraordinary *Golden Apple Tree* (plate 23), in which he seemed to be experimenting with the sublimation of the depicted object through the stylization of a natural theme. "The formation now came from the organic side, from the sphere of crystalline forms. This made it, at the same time, more architectonic, more mural like, naturally developing toward two-dimensionality,"[12] as Hevesi formulated in his exhibition critique. In works such as *Pear Tree* or *Roses Under Trees* (plates 25, 26), a painted mosaic increasingly spread across his pictures with a carpet-like structure. The pattern of innumerable little strokes now became the actual object depicted. The mass of leaves in the crown of a tree, for example, only becomes clear through minute corners in a painting where a piece of sky or a distant landscape can be recognized. A landscape drawing (see p. 70) in the Sonja Knips Sketchbook, showing the composition for *Roses Under Trees*, demonstrates that this was part of the concept of the picture from the outset.

One continually discovers anthropomorphic forms in the landscapes: the rose bushes in *Roses Under Trees* (plate 26), the towering, central bush in the *Farm Garden* (plate 30), *The Sunflower* (plate 31), which Hevesi compared to an "enamored fairy, whose greenish-gray garment flows downward in passionate trembling,"[13] the haystacks and bushes in the late paintings including *Villa on the Attersee* and *Forest Slope in Unterach on the Attersee* (plates 49, 58). A similar form can be found in the *Stoclet Frieze* with its stylized trees (see p. 68), as well as in the signets for the heliographs; it is a primary form of the stable, the formal support, which permeates Klimt's entire work. The gently rolling hills in some paintings such as *Garden Landscape*, *Villa on the Attersee*, and *Litzlberg on the Attersee* (plates 28, 49, 51) also remind one of the contours of the female body. It appears that Klimt used subconscious, primeval forms from our hoard of perception. Hermann Bahr attempted to approach this subject from a philosophical point of view: "Now the rosebush becomes something special in the world at large; philosophically speaking, he presents the viewer with a notion. This notion is equally found in the inner world: there is something in the soul that is Rosebush."[14] But even if one does not want to go so far, one can follow Bahr's train of

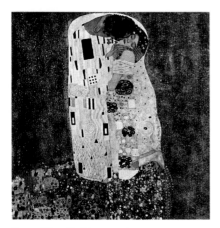

Gustav Klimt, *The Kiss*, 1st version, *c.* 1907
historical photograph

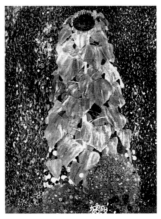

GustavKlimt, *The Sunflower*, 1st version,
c. 1907, historical photograph

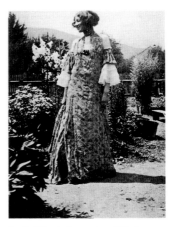

Emilie Flöge in the garden at Litzlberg
Brewery, 1906, photographed presum-
ably by Gustav Klimt, reproduced
in *Deutsche Kunst und Dekoration*
(October 1906 – March 1907)

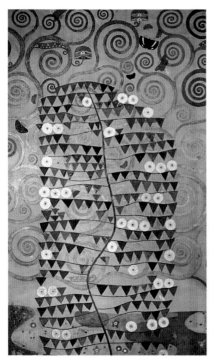

Gustav Klimt, *Tree of Life* (right-hand section with
flowering bush), 1905–09, cartoon for the
Stoclet Frieze, mixed media on paper, Österreichisches
Museum für Angewandte Kunst, Vienna

thought (being one of Klimt's closest confidants), when he describes Klimt's
spiritual and mental world with great sensitivity—he could "not even think
without feeling." He continues: "We normally think in words; if we are partic-
ularly attentive, we believe we can hear voices from within. It is, however,
obviously his nature that he thinks visions in faces."[15]

Richard Muther was one of the first to recognize a connection between
Klimt's feelings for form in the landscape and the sensuality of his female
images: "In addition to the feeling for form, there is an amazing sense for the
voluptuous atmospheric power of colors. . . . A miserable nature, a nature,
working in the service of man, a sedate nature, peaty bogs and steaming fields
were never painted by Klimt. In his work, even the lake is not threatening
or gloomy. It resembles a beautiful woman's silk gown, shimmering and
flirtatiously sparkling with blue, grass green, and violet tones. Klimt always
remained an eroticist. . . . The motifs themselves are scarcely different from
those painted by hundreds of others, but one recognizes Klimt on account of
the tenderness, the lascivious softness of the feeling for nature."[16]

Time and again, we find thoughts reflected, simultaneously, in works of
various genres. In *The Sunflower*, and *The Kiss*, the compositional similarity of the
form rising out of a flower-bed is astounding. That this was even more
pronounced when the pictures were being painted can be seen in a number of
black-and-white photographs and a color heliograph taken during the early
stages of both works (*above*), which were then reworked later. In these garden
paintings (see plates 30–32), which partially appear to be like gouaches begun
in the open air, perspectives are provided by the differing sizes of the flowers;
these, however, become indistinct through the absence of any transition
between the forms and the sonorous coloring. Klimt chose the flowers with
the precise intention of orchestrating them and the richness of their colors, so
as to amplify complementary contrasts. "In *The Sunflower*, which rises up out of
a cluster of dahlias, chrysanthemums, marguerites, morning glories, phlox,

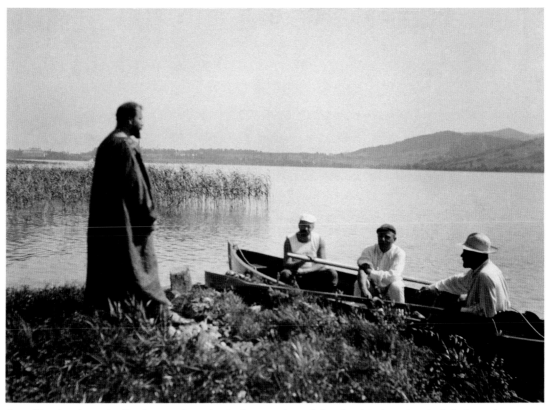

Gustav Klimt (standing on bank) in his painter's smock in Litzlberg, together with three friends in the rowboat; in the background on the left is Schloss Kammer, 1903

and asters into the painted area, completely filled with broad, green foliage, the golden mean is achieved: the color explodes rejoicing, without forfeiting its noble origin, the form loses tension, nature and ornament find harmony."[17]

In 1906, a major van Gogh retrospective was held in the Miethke Gallery in Vienna. This greatly influenced Klimt, Kokoschka, and Schiele, who recognized undreamed-of possibilities for artistic expression. In Klimt's paintings of country gardens, nature takes on an overflowing richness and fervent sensuality. Van Gogh's influence is recognizable in the large, colorful flowers in the foreground, in the simultaneous view from above and afar, and, of course, in the sunflower motif. It appears that, in these years and particularly in his works at Kammer, Klimt had reached his conclusions on the art of the French Symbolists—the Nabis.

"The appeal of his landscapes lies in the tasteful, discrete, refined, flimsy, cunning cheerfulness, which in no way burdens the walls. His motifs are country gardens and meadows, that are both beautiful and useful—like a Persian carpet."[18] In pictures such as the *Poppy Field* (plate 29) everything seems to dissolve into pure color, in a colorist ecstasy, a festival of complementary tones. Klimt's registration of nuances in their emotional, formal, and colorist aspects, nurtured by the knowledge of the color theory followed by the French painters, is here shown at its peak.

Despite his detachment, Klimt was able to touch the soul in his landscapes. As in poetry, where in addition to the sense of a word, sound, syntax, and rhythm provide meaning, Klimt used colour tones to convey an equivalent of the impression of nature. Klimt never made a self-assessment or provided information on his person.[19] However, his landscapes, with their precious autonomy, their removal from their counterpart in nature, and their perfected stylization, suggest a deeper insight. What Klimt particularly admired in Schopenhauer was the philosopher's conviction that the "chosen"—poets, artists, and great thinkers—possess the gift of "questioning visualization."[20]

Gustav Klimt, *Sketch of a Landscape*, The Sonja Knips Sketchbook, 1897–1905, p. 55, Österreichische Galerie Belvedere, Vienna

1 Postcard from Vienna to Emilie Flöge on the Attersee, dated July 8, 1908, cited from Wolfgang Georg Fischer, *Gustav Klimt und Emilie Flöge. Genie und Talent, Freundschaft und Besessenheit* (Vienna, 1987), 173.

2 Werner Hofmann, *Gustav Klimt und die Wiener Jahrhundertwende* (Salzburg, 1970), 16.

3 Ludwig Hevesi, *Acht Jahre Secession* (Vienna, 1906), 318.

4 Cf. Alfred Weidinger, "Neues zu den Landschaftsbildern Gustav Klimts," (diploma thesis, Salzburg, 1992), 60f.

5 Hermann Bahr, *Rede über Klimt* (Vienna, 1901), 15.

6 Albert Paris Gütersloh, "Klimt – ein Bild in Worten," in: *Gustav Klimt – Egon Schiele. Zum Gedächtnis ihres Todes vor 50 Jahren*, exh. cat. (Vienna, 1968). Cited from Otto Breicha (ed.), *Gustav Klimt: Die Goldene Pforte. Werk— Wesen—Wirkung* (Salzburg, 1978), 110.

7 Letter, August 1903, to Marie Zimmermann dated August 1903, cited from Christian M. Nebehay, "Klimt schreibt an eine Liebe," in *Klimt-Studien, Mitteilungen der Österreichischen Galerie 22/23*, no. 66/67, (1978/79,): 108f.

8 Hevesi, *Acht Jahre Secession*, 370.

9 Letter to Marie Zimmermann dated July 3, 1900, cited from Nebehay, *Klimt-Studien*, 105f.

10 Letter to Marie Zimmermann dated August 1903, cited from Nebehay, ibid., 109f. Date corrected to 1902 in Weidinger, "Landschaftsbildern," 82f.

11 Hevesi, *Acht Jahre Secession*, 451.

11B This painting actually represents beech trees, as can be seen in that particular forest.

12 Ludwig Hevesi, "Gustav Klimt und das Malmosaik," in *Altkunst – Neukunst* (Vienna, 1909), 211.

13 Hevesi, "Weiteres über Klimt," in ibid., 319.

14 Bahr, *Rede über Klimt*, 16.

15 Ibid., 18.

16 Richard Muther, "Seine Sinnlichkeit kennt keine Grenzen," in Hans Rosenhagen, *Studien* (Berlin, 1925). Cited from Breicha, op. cit. 52.

17 Max Eisler, "So wurde seiner Kunst die Zeit zum Schicksal," in *Gustav Klimt* (Vienna, 1920). Cited from Breicha, *Klimt-Studien*, 46.

18 Anton Faistauer, "Im Vergleich," in *Neue Malerei aus Österreich. Betrachtungen eines Malers* (Zurich, Leipzig, Vienna, 1923). Cited from Breicha, *Klimt-Studien*, 186f.

19 "I am not fluent in the spoken or written language, particularly if I have to express myself on my work. Even if I have to write a simple letter, I'm scared stiff as I would be faced with seasickness. For this reason, one will have to do without a literary or artistic self-portrait. That is really not a pity. Anyone who wants to know about me—as an artist, for that is the only thing of importance—should look closely at my pictures and try to discover what I am, and what I want." Gustav Klimt manuscript in the Library of the City of Vienna, cited from Breicha, op. cit. 33.

20 Cf. Marian Bisanz-Prakken, "Programmatik und subjektive Aussage im Werk von Gustav Klimt," in *Wien 1870–1930: Traum und Wirklichkeit*, ed. Robert Waissenberger, (Salzburg and Vienna, 1984), 113.

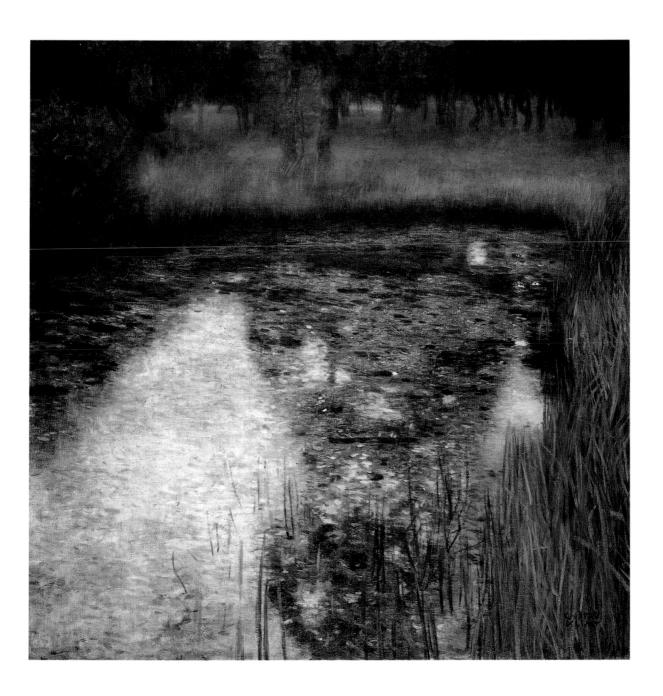

9 The Swamp, 1900
 Private collection

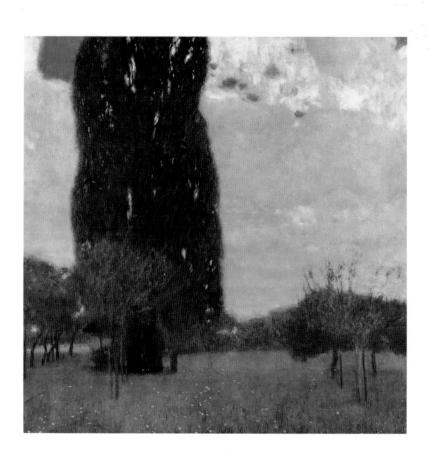

10 Tall Poplars I, 1900
 Neue Galerie New York

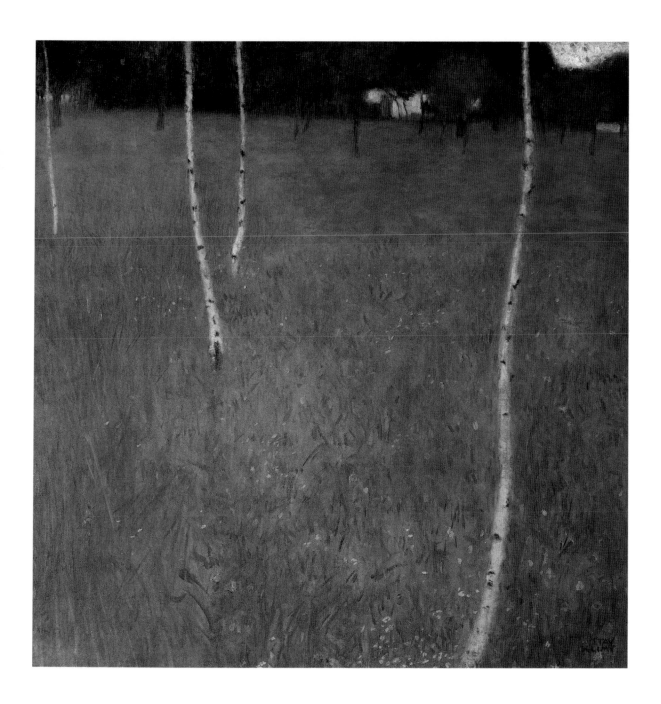

11 Farmhouse with Birch Trees
(Young Birches), 1900
Private collection

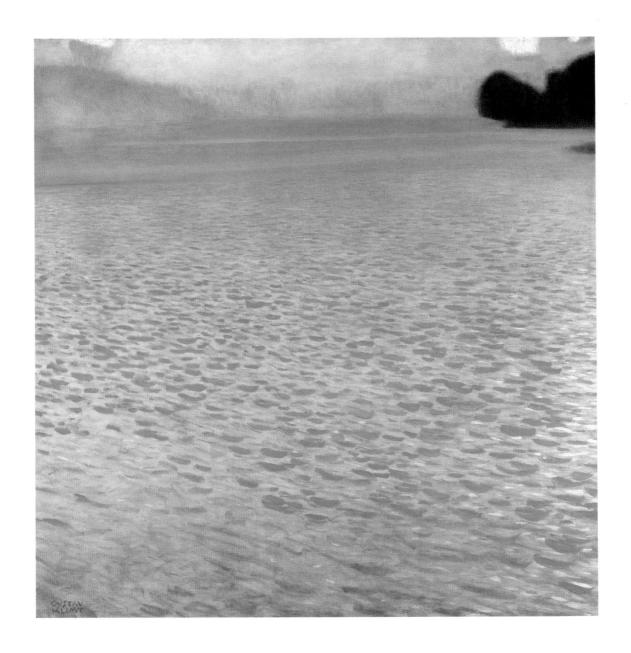

12 Attersee I, 1900
Leopold Museum – Privatstiftung, Vienna

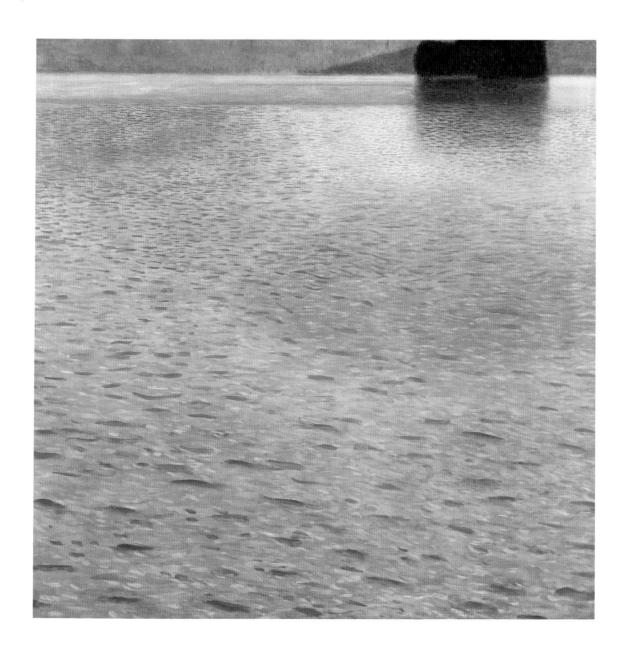

13 Island in the Attersee, 1902
Private collection

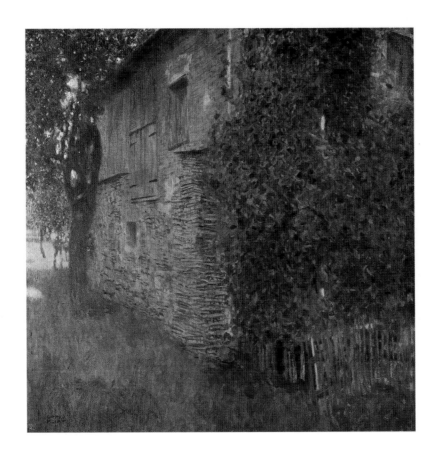

14 Farmhouse, 1901
Private collection

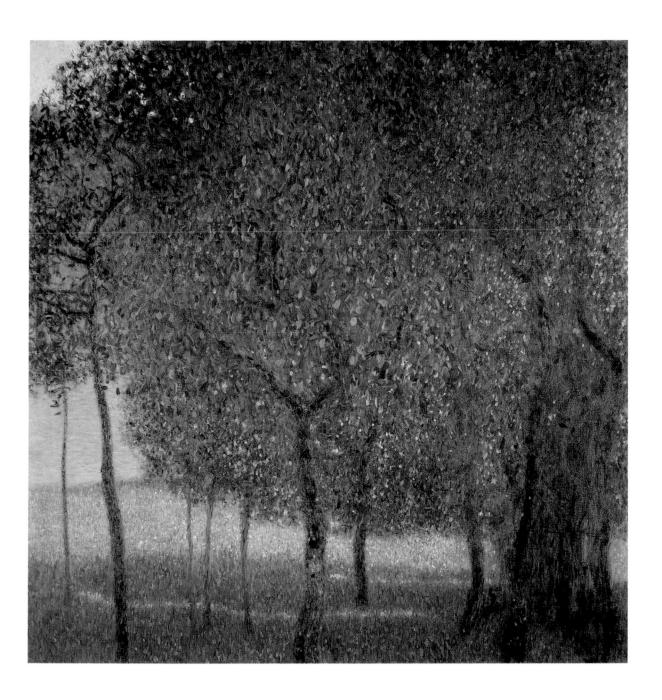

15 Fruit Trees, 1901
Private collection

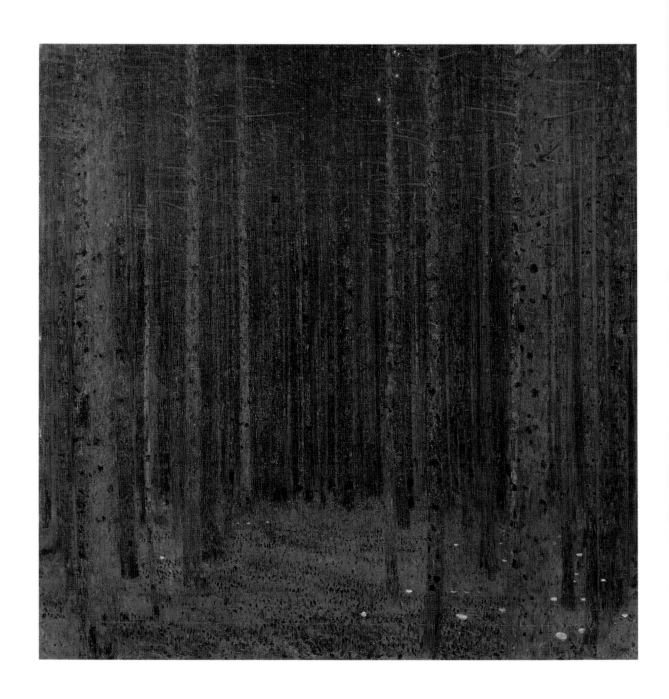

16 Pine Forest I, 1901
Kunsthaus Zug, deposit of Foundation Collection Kamm

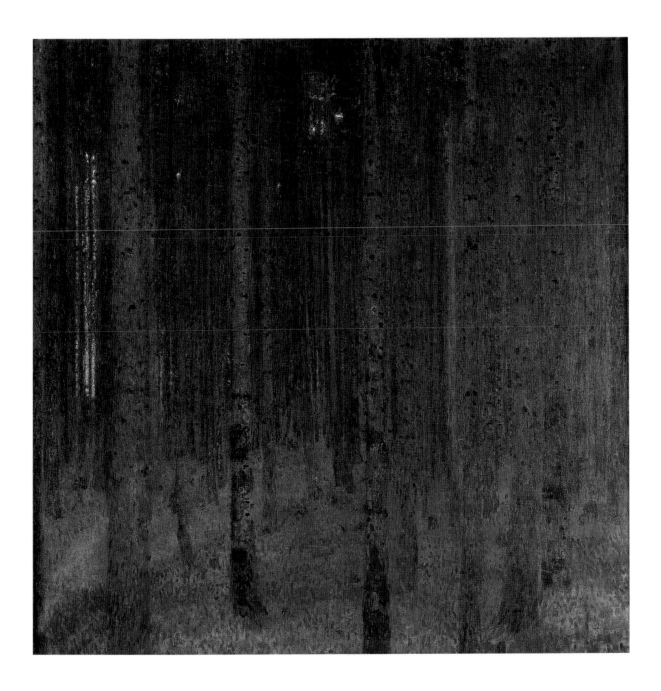

17 Pine Forest II, 1901
 Private collection

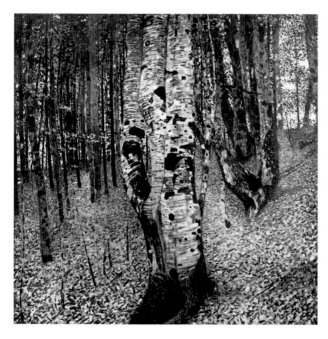

18 Beech Forest II, *c.* 1903
Present location unknown

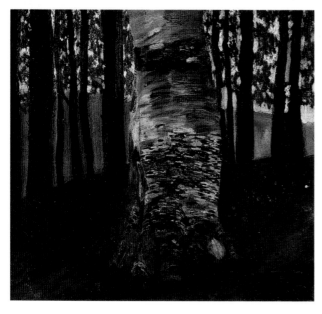

19 Beech Tree in the Forest (study)
c. 1903
Private collection

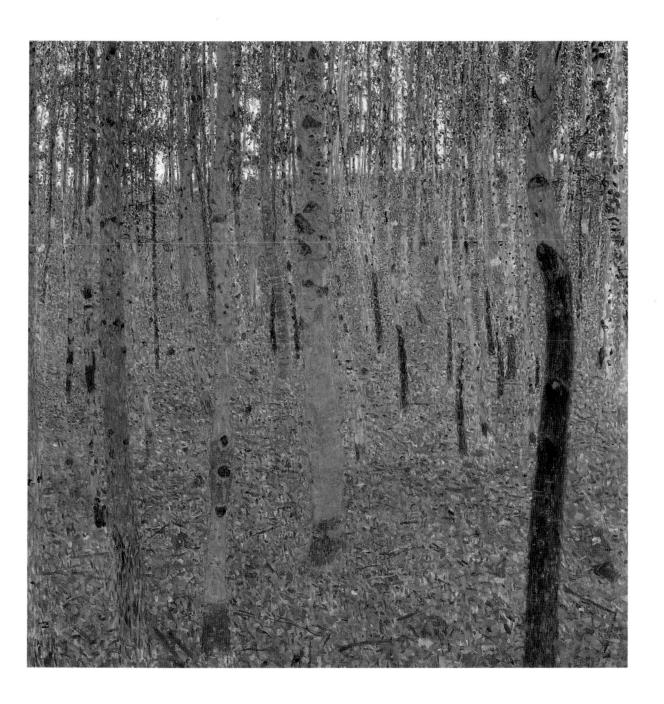

20 Beech Forest I, *c. 1902*
 Gemäldegalerie Neue Meister,
 Staatliche Kunstsammlungen Dresden

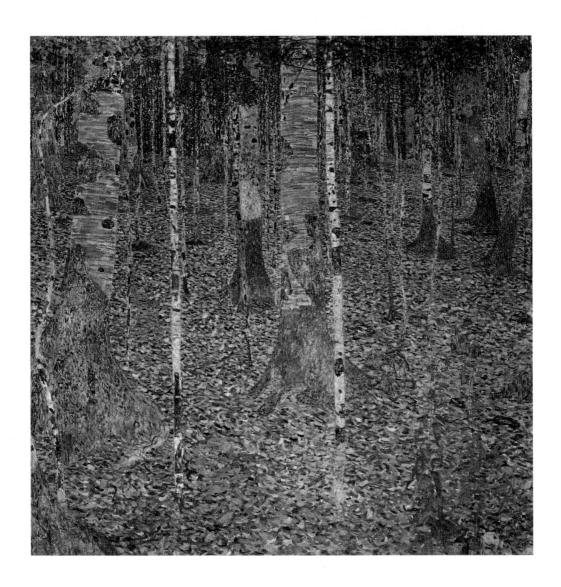

21 Birch Forest, 1903
 Private collection

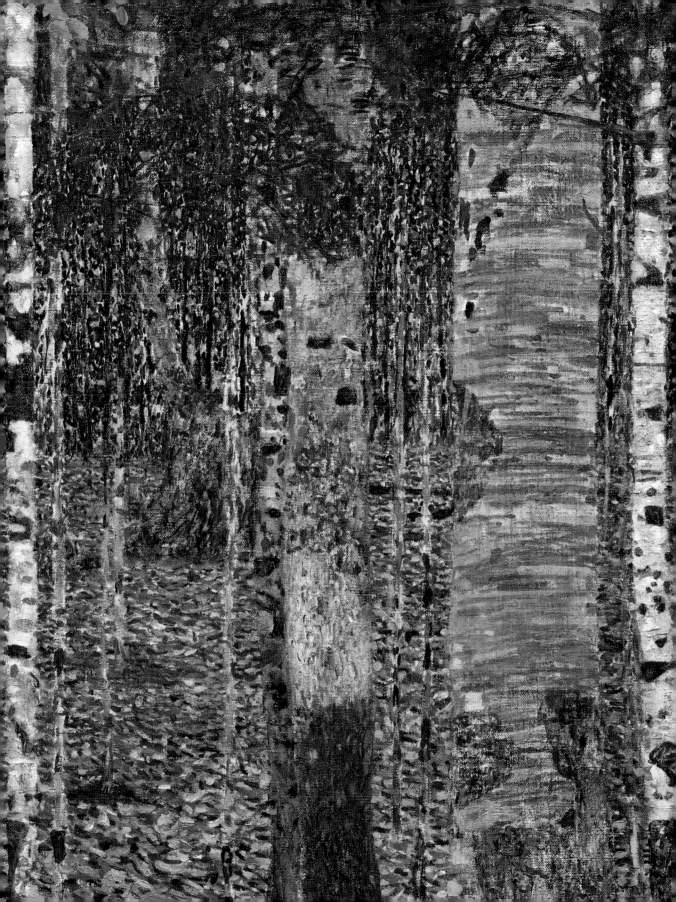

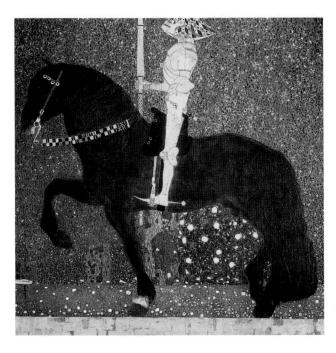

22 Life, A Struggle
 (Knight; The Golden Knight), 1903
 Aichi Prefectural Museum of Art, Nagoya

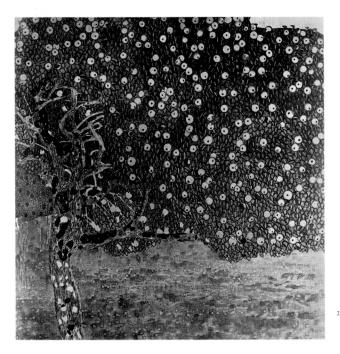

23 Golden Apple Tree, 1903
 Lost in a fire at Schloss Immendorf,
 Lower Austria, in 1945

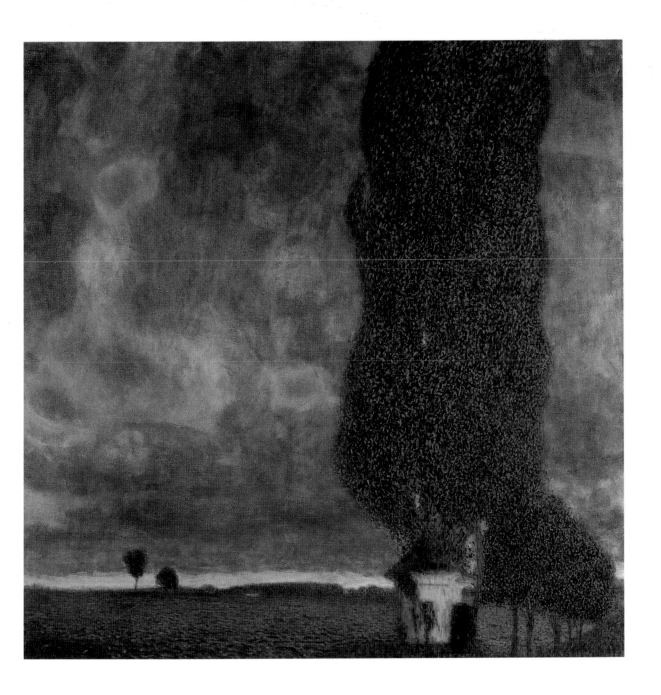

24 Tall Poplars II
 (Approaching Thunderstorm), 1902
 Leopold Museum – Privatstiftung, Vienna

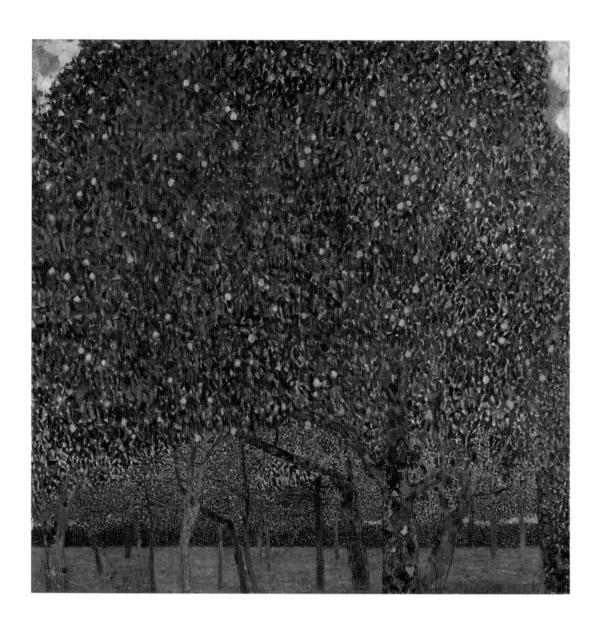

25 Pear Tree, 1903 (later reworked)
Busch-Reisinger Museum, Harvard University Art Museums,
Cambridge, Massachusetts, gift of Otto Kallir

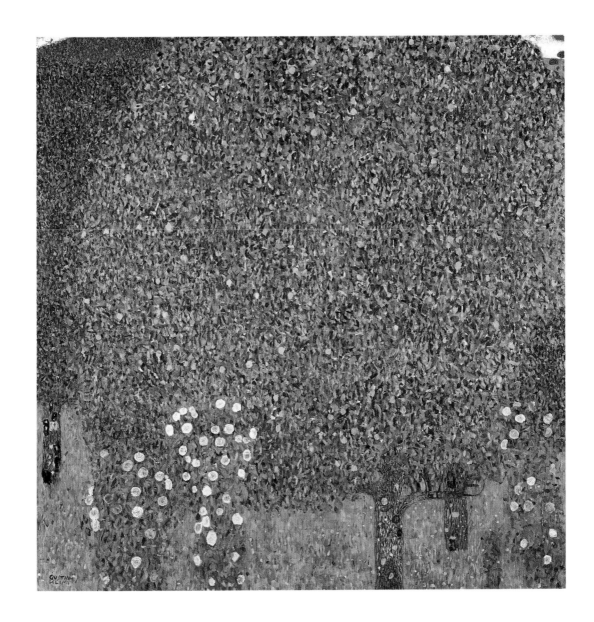

26 Roses Under Trees, *c.* 1905
Musée d'Orsay, Paris

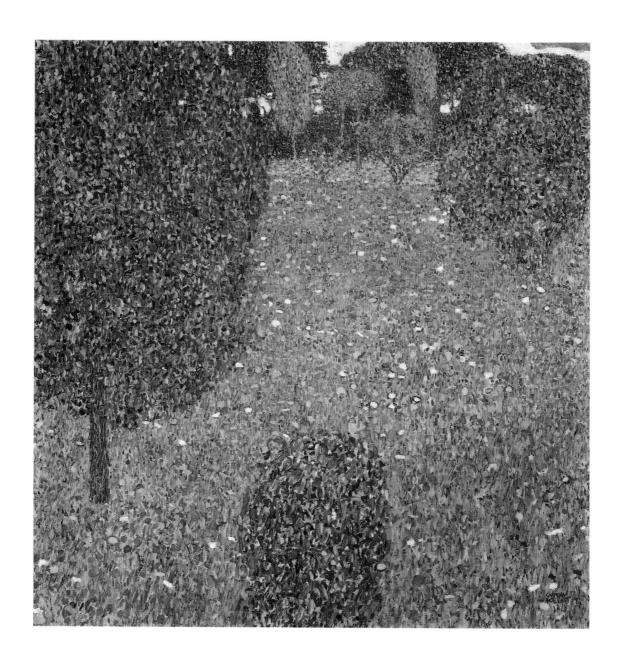

27 Garden Landscape
(Blooming Meadow), *c.* 1905/06
Private collection

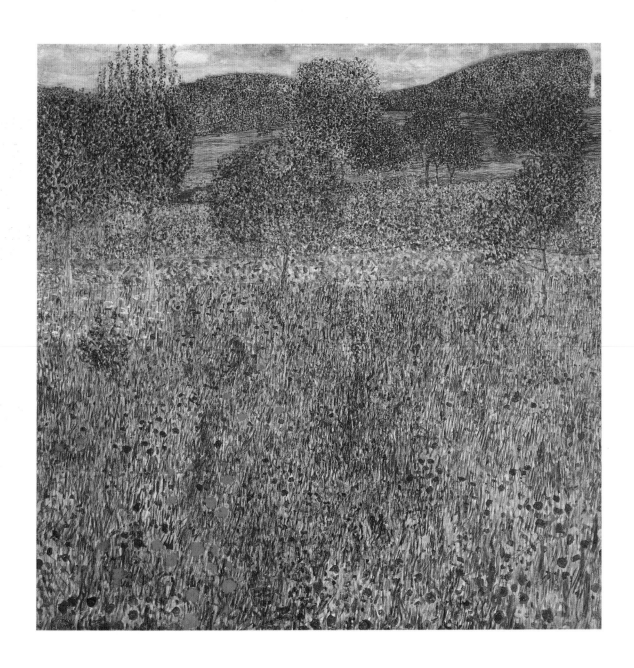

28 Garden Landscape, 1907
Carnegie Museum of Art, Pittsburgh

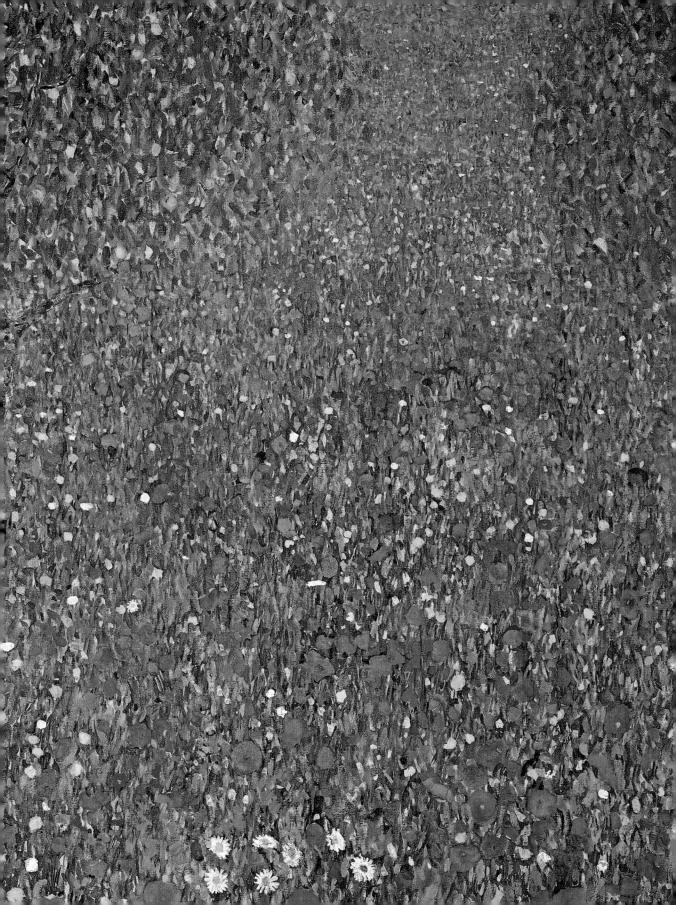

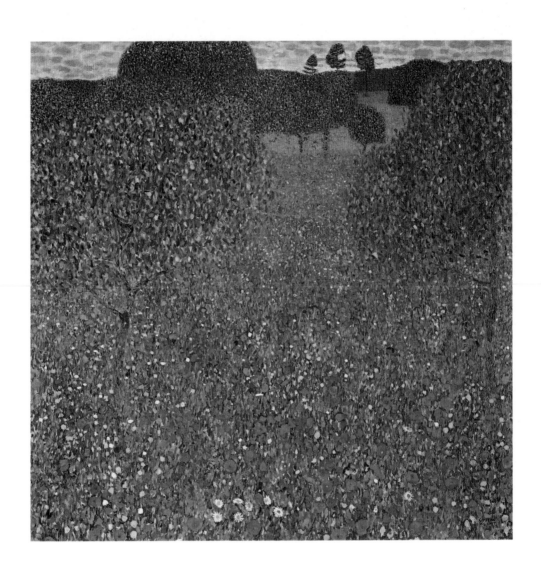

29 Poppy Field, 1907
 Österreichische Galerie Belvedere, Vienna

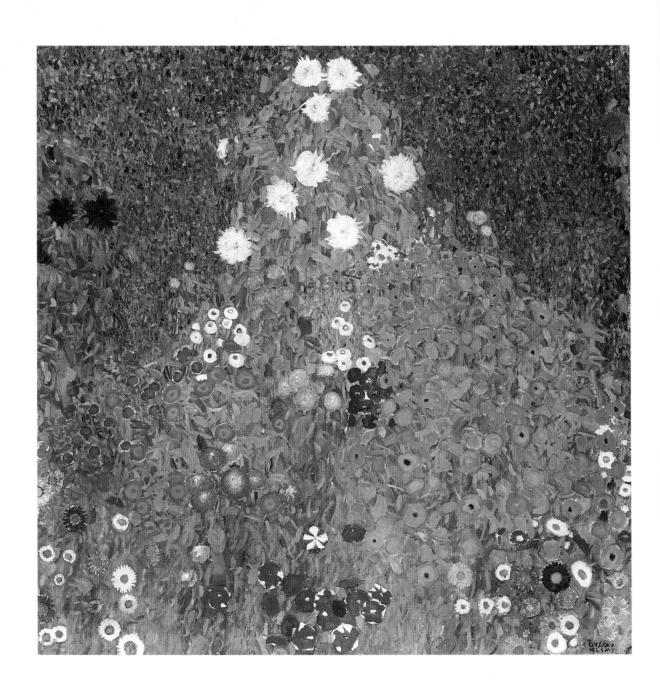

30 Farm Garden, *c.* 1905/06
Private collection

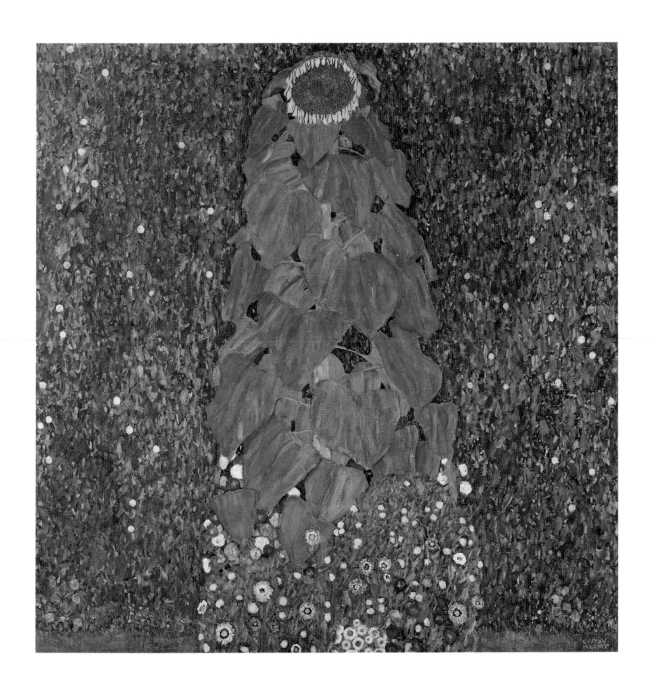

31 The Sunflower, 1907
 Private collection

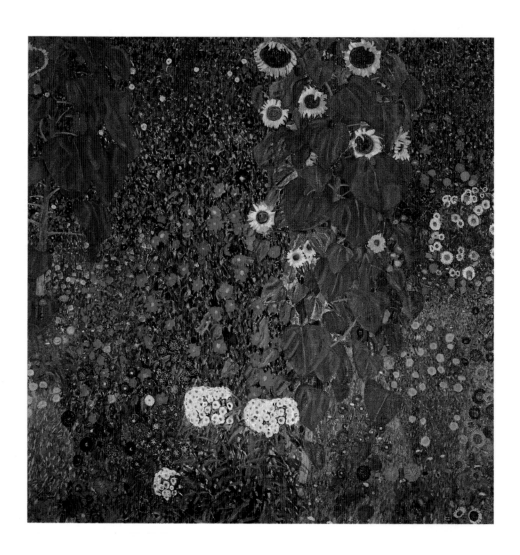

32　Farm Garden with Sunflowers, *c. 1907*
　　Österreichische Galerie Belvedere, Vienna

In 1908, the Flöges and Klimt transferred their summer quarters to the nobler west bank of the Attersee. Up until 1912, they spent their summers in Villa Oleander in Kammerl near Kammer am Attersee—usually from the middle of July until the middle of September. It seems that the artist's improved financial situation, and his increasing need for solitude, led to this change.

Villa Oleander was built in 1879 by Countess Khevenhüller, the owner of Schloss Kammer, to serve as an "economical summer residence," and furnished with items from the castle. It was originally intended to turn Schloss Kammer, which was used as a hotel every summer after 1872, together with the surrounding villas (Villa Oleander, Seevilla, Waldhütte, and Nussvilla), which belonged to the estate, and Hotel Kammer, which functioned as a Grand Hotel, into a superior place in which to spend the *Sommerfrische*.[1] The countess' financial ruin, however, thwarted this project, and the Villa Oleander was sold to the Scherer family from Vöcklabruck. They let the house in the summer months until it was sold to the Meiss-Kurz-Hardtentorff family in 1916.[2]

"There is a large number of people seeking recreation, who look for—and find—remedy and refreshment in this small paradise called Kammer. Really excellent relaxation possible through the simplest and most natural means . . . avenues, magnificent parks and gardens surrounding the castle, an establishment for swimming and taking baths, a circle of beautifully built villas which belong to the castle . . . footpaths, winding their way over the neighboring hills, are all things which uplift a person's heart and improve his health."[3]

Villa Oleander still exists today, and lies on the shore of the Attersee with a view of Schloss Kammer,

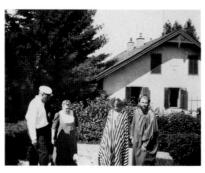

In the garden at Villa Oleander in Kammerl.
Left to right: Hermann and Barbara Flöge,
Emilie Flöge, and Gustav Klimt, 1908

The crucifix on the side of the road through
Kammerl, near the Nöhmer Inn, *c.* 1968

located in a small cove on the other side. This scene must have fascinated Klimt because he chose the castle, situated on a small peninsula as the motif for five paintings. Three works show the Schloss from various angles from the shore of the lake; the other two depict it from the land. Klimt found two other motifs in the castle park and on the shore of the peninsula with its park (plates 33–39).

Schloss Kammer on the Attersee I (plate 33) shows the view across the water to the castle, with Seewalchen church tower to the left. The massive block to the left of the former Chamer Fortress, and a section of the tract, built in 1607–09, can be clearly identified.

United by the lush green of the vegetation, all the elements in this painting combine to form a carpet-like whole. The facades, the roofs, the foliage formed by regular, short brush-strokes, become colored areas of equal value. The castle on the peninsula and the shore with the village Seewalchen behind it, merge into a single mesh of color. Spatiality is suspended.

Klimt was obviously fascinated by the problems of reflections. Softly melting into each other, the colors of the castle and vegetation reverberate on the surface of the water, partially in muted and partially in heightened tones.

If one looks for the position from which Klimt painted this picture, one discovers that the only possibility for achieving such a view is from Villa Oleander—this means that there was a distance of eight hundred meters between the artist and his motif. As already noted by Johannes Dobai and corroborated in field studies by Wagner and Weidinger, the majority of the pictures of Schloss Kammer (as well as the later paintings of Lake Garda and Weissenbach)

Schloss Kammer on the Attersee, picture card sent by Klimt to Anna Klimt in Vienna, presumably in 1908, private collection

were painted looking through an opera glass or telescope from the opposite shore, and not, as had previously been assumed, from a boat.[4] *Schloss Kammer on the Attersee II* (plate 34) was also created with the assistance of a telescope; it was painted from the Empire Monument located above the village. It is more rigidly constructed out of various layers; the landscape is organized in strips, similar to van Gogh's *The Plain near Auvers-sur-Oise* (see p. 200). The model in nature is compressed onto the surface, without light or shadow, or atmospheric indications.

In *Schloss Kammer on the Attersee III* (plate 36), Klimt appears to have changed the color of the castle roof, which towers behind the other buildings, from a dark tone to a red one, in order to make the tonal orchestration of the painting richer. The emphatic cropping of the composition, as in *Schloss Kammer on the Attersee IV* (plate 38), results from its being painted from the garden of the former Seehotel Kammer; it is, however, utterly peaceful and balanced, with the painting being arranged into horizontal and parallel strips.

The Schloss Kammer paintings make particularly clear how Klimt's personal style of pointillism developed into a mosaic-like form, filling its assigned areas with a suspense-free equilibrium, with areas of contrast to surface of the facades and water.

Klimt and Emilie Flöge in a rowboat; the wall along the bank runs below Villa Paulick, 1909

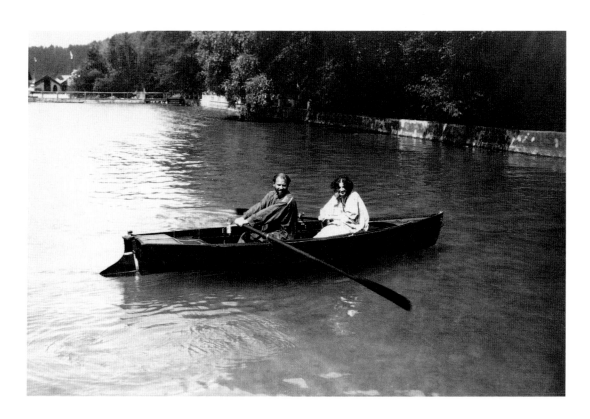

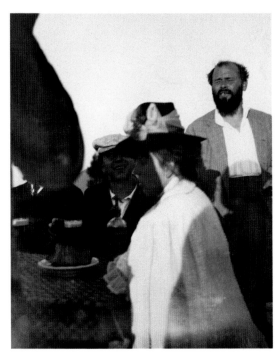

Gustav Klimt with friends on an excursion to the Gahberg mountain (note the binoculars in his hand). Helene Klimt is in the foreground and Heinrich Böhler to the left, 1908

Park (plate 35) was painted in the park on the land-facing side of Schloss Kammer and is organized orthogonally, resolutely constructed from rectangles of varying colors and density. This is further amplified by the regularity of the short brushstrokes. The actual theme of these paintings was an "all over"—the interaction of green, yellow, blue, and violet tones in their assigned areas. The thick tangle of the crowns of the trees—and as such, the rigid organization of the painting—is only penetrated once, in the upper left third of the painting, by a slender, slightly curving tree trunk.

"Painting appears most picturesque, most artistic, if we keep it free of all poetic associations, all historical aspects, aspects which are otherwise important," wrote Franz Wickhoff.[5] Klimt's motifs were usually not particularly spectacular, the pictorial construction was clear and austere. The irresistible attraction of these paintings, however, lies in the sophisticated color modulation of their surfaces. The same principle of frontality and parallelism, and also of positive and negative forms, complemented, as necessary, by the regular texture of the paintings, can be seen in *Farmhouse in Upper Austria* (plate 40). The view is focused by two trees framing the motif; no consideration is

given to the foreshortening of the perspective of the side wall of the house; once again, there is an impression of various layers stacked behind each other. In this painting, there is no sky—a characteristic of Klimt's landscapes. The many gray-violet tones come as a surprise. In addition to yellow, they serve as a contrast to the *chromoxyd feurig* (blue-green color), which Klimt had a particular penchant for using in green areas. Starting from this neutral basis, he was able to develop the further chromaticism of the painting, and intensified the coloration of his paintings more and more. Two bright, lightly painted sections in the foliage in the center of the picture have not been completed. Klimt, like Cézanne, was never finished—he always saw his paintings as works in progress.

Apple Tree I (plate 41); a single tree radiates such solemnity, even monumentality. It appears almost personified in its dignity and magnificence, with its dazzling fruit. On account of its architectural stringency, this painting makes clear just how great a role the architecture of the painted space played for Klimt. The corners of the paintings were assigned the function of contributing those colors necessary for the coloration. In the upper left corner of this painting Klimt uses a calculated quantum of blue, essential for the work.

Apple Tree I reveals a change in Klimt's work; it is more graphically constructed. The trunk and angular branches are presented in all their power and self-assurance. The dazzlingly red apples seem to be independently elaborated, the brushstrokes of the foliage of the tree appear particularly energetic.

The contour of the tree's crown is composed of zones executed in small brushstrokes with a darker coloration on both sides. Particular attention was paid to the flowers in the foreground. As so often in Klimt's work, they form a pedestal, and at the same time, a drama of chromatic orchestration. Flowers

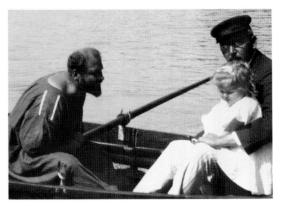

Gustav Klimt with Hermann Flöge and Flöge's daughter Trude in a rowboat near Kammerl on the Attersee, *c.* 1910

were one of Klimt's passions, revealed in his correspondence: "On my journey here to Bavaria, I have seen so many meadow flowers which gave me such a wonderful feeling."[6] In the following year, 1909, he enthused to Emilie: "On the way through my garden the breath of spring—birdsong—the buds are opening—one day can make a difference!"[7] In "Orchard with Roses" (plate 43), Klimt turned the garden of the villa into an image motive, proven by the photo of Emilie Flöge in one of her "reform dresses". From the villa, he focused his passionate gaze with a telescope back towards Litzlberg, of which he had especially fond memories. Klimt is said to have found the landscape in which Villa Oleander was set less attractive than the countryside around Litzlberg.

In 1912, in *Avenue in Schloss Kammer Park* (plate 39), Klimt returned to the theme of the castle—this time from the land, although the lake intrudes into the picture from the left. The view shows the avenue leading to the castle with the entrance in the background. Klimt maintains his typical frontality, placing the building, however, at a greater distance from the viewer. Details of the building are portrayed with great accuracy. The composition is strikingly asymmetrical, yet achieves its tension precisely through this aspect. The bold dots of color and

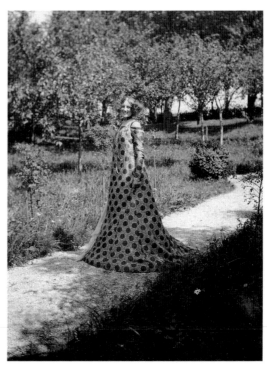

Emilie Flöge in the garden of Villa Oleander at Kammer wearing a "reform dress" from a collection designed by both Klimt and Flöge, 1910

especially the trunks and branches of the trees, with their exaggerated contours, underline Klimt's treatment of van Gogh's painterly style, something that had occupied Klimt since 1903.

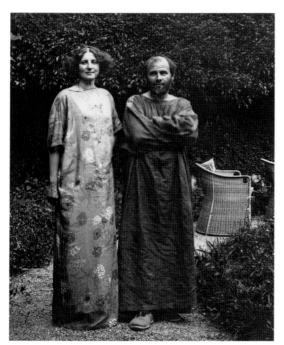

Emilie Flöge in a "reform dress" and Gustav Klimt in his painter's smock in the garden at Villa Oleander in Kammerl, 1910

1 Cf. Leo Kegele, *Das Salzkammergut nebst angrenzenden Gebieten in Wort und Bild* (Vienna, 1898), 170.
2 Cf. Renate Vergeiner and Alfred Weidinger, "Gustav und Emilie: Bekanntschaft und Aufenthalte am Attersee," in *Inselräume: Teschner, Klimt und Flöge am Attersee*, exh. cat. second edition (Seewalchen am Attersee, 1989), 27, n. 2.
3 Kegele, "Salzkammergut," 170.
4 Johannes Dobai, "Oeuvrekatalog der Gemälde," in Fritz Novotny and Johannes Dobai, *Gustav Klimt*, 2nd ed. (Salzburg, 1975), 308, 372. Anselm Wagner, "Aspekte der Landschaft bei Gustav Klimt" in *Inselräume*, 45–50.
5 Werner Hofmann, *Gustav Klimt und die Wiener Jahrhundertwende*, (Salzburg, 1970).
6 Postcard dated July 9, 1908, sent to Emilie Flöge from Munich. Cited from Wolfgang Georg Fischer, *Gustav Klimt und Emilie Flöge* (Vienna, 1987), 173.
7 Postcard dated September 9, 1909, sent to Emilie Flöge, ibid., 175.

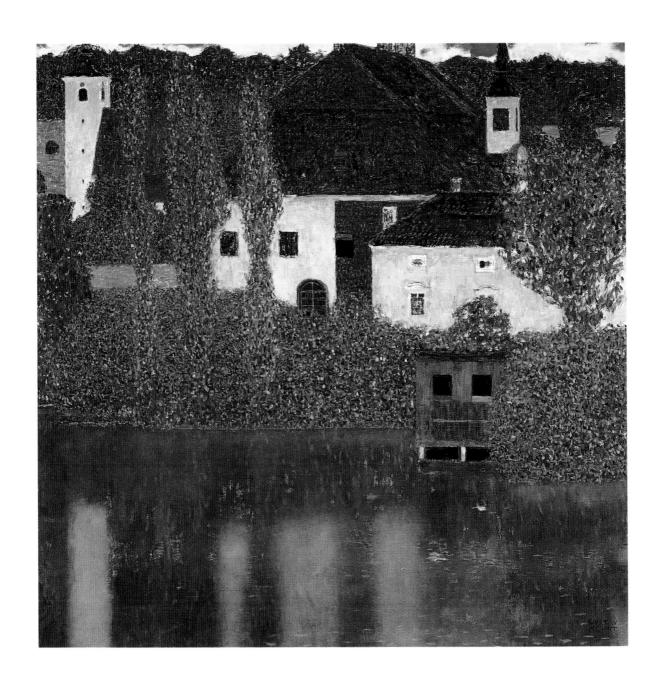

33 Schloss Kammer on the Attersee I, 1908
Národní Galerie v Praze, Prague

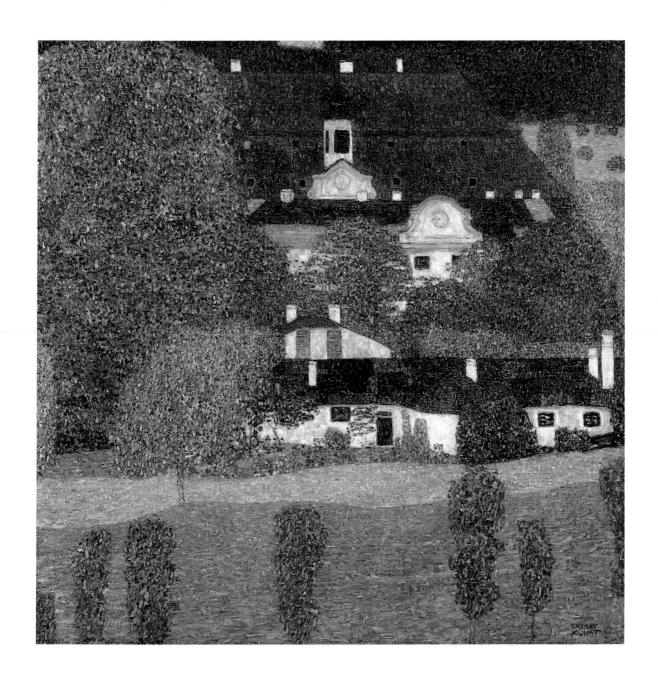

34　Schloss Kammer on the Attersee II, 1909
Private collection

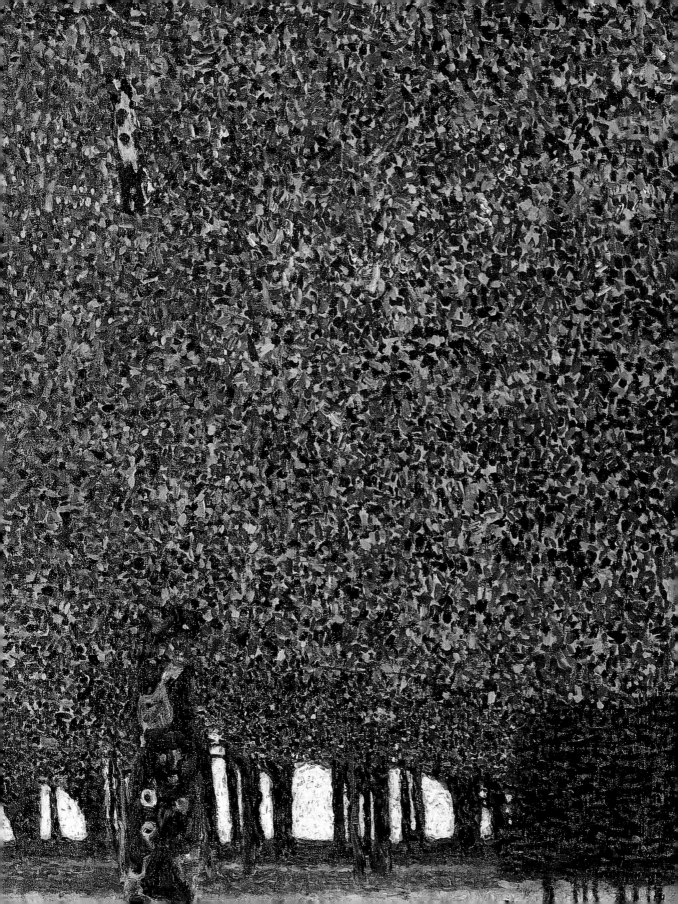

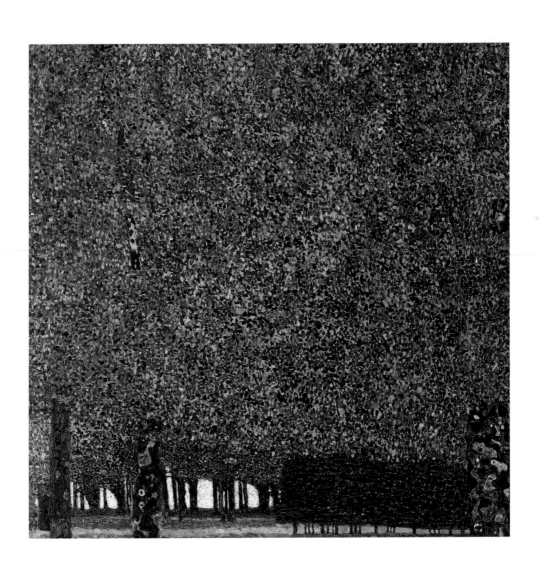

35 Park, 1909
 The Museum of Modern Art, New York, Gertrud A. Mellon Fund

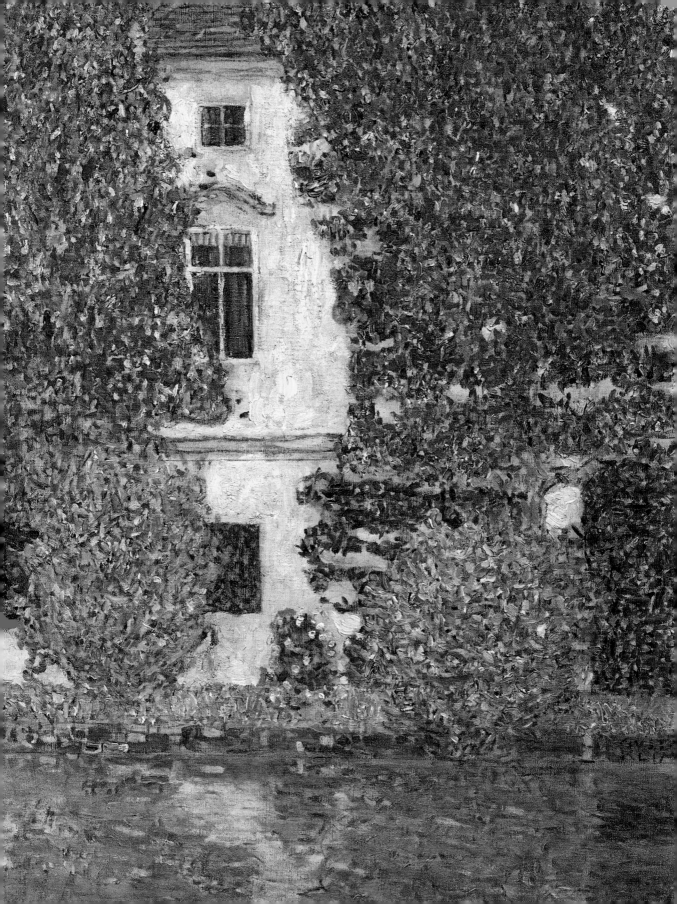

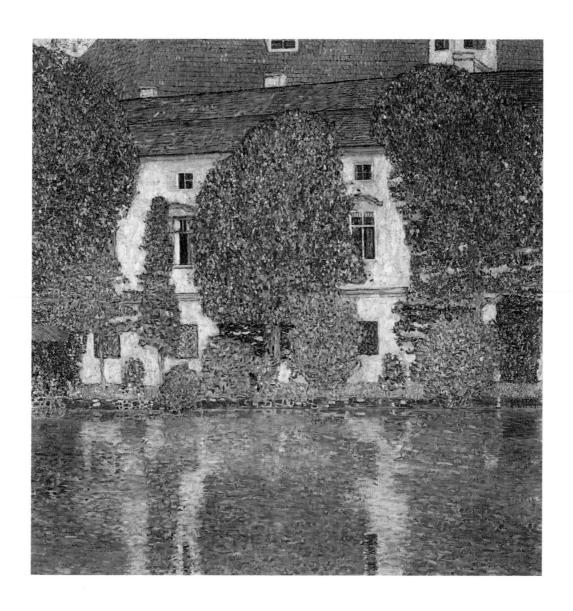

36 Schloss Kammer on the Attersee III, 1910
Österreichische Galerie Belvedere, Vienna

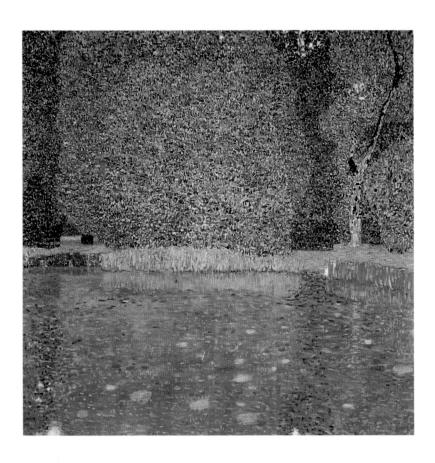

37 Pond at Schloss Kammer on the Attersee, 1909
Private collection

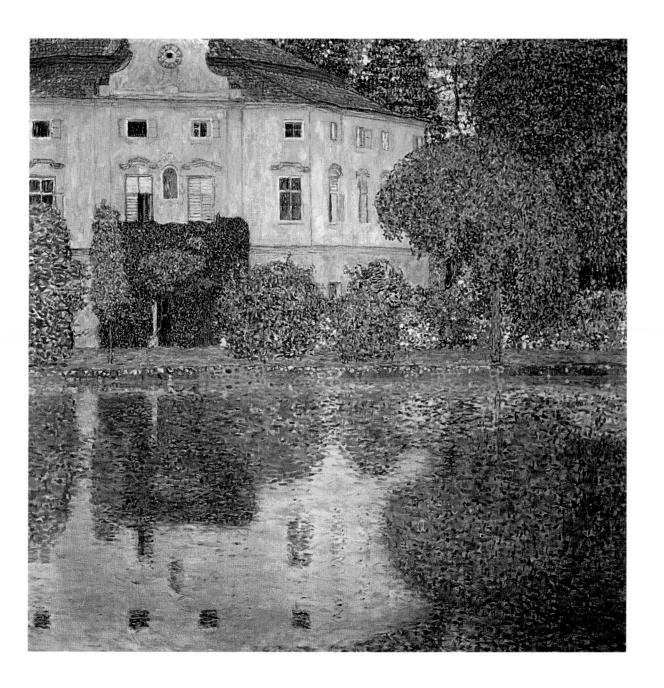

38 Schloss Kammer on the Attersee IV, 1910
Private collection

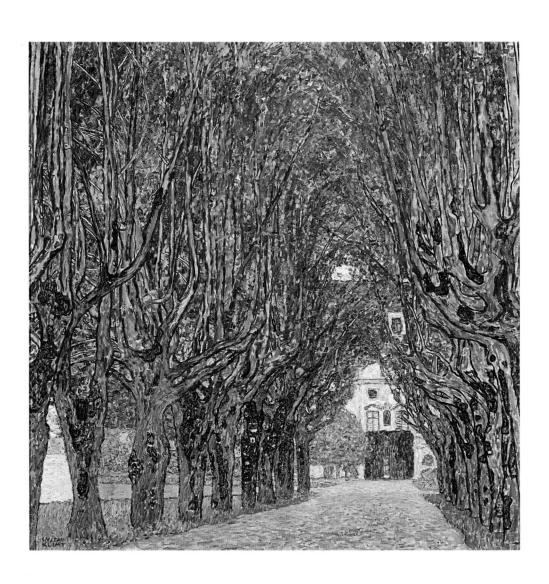

39 Avenue in Schloss Kammer Park, 1912
Österreichische Galerie Belvedere, Vienna

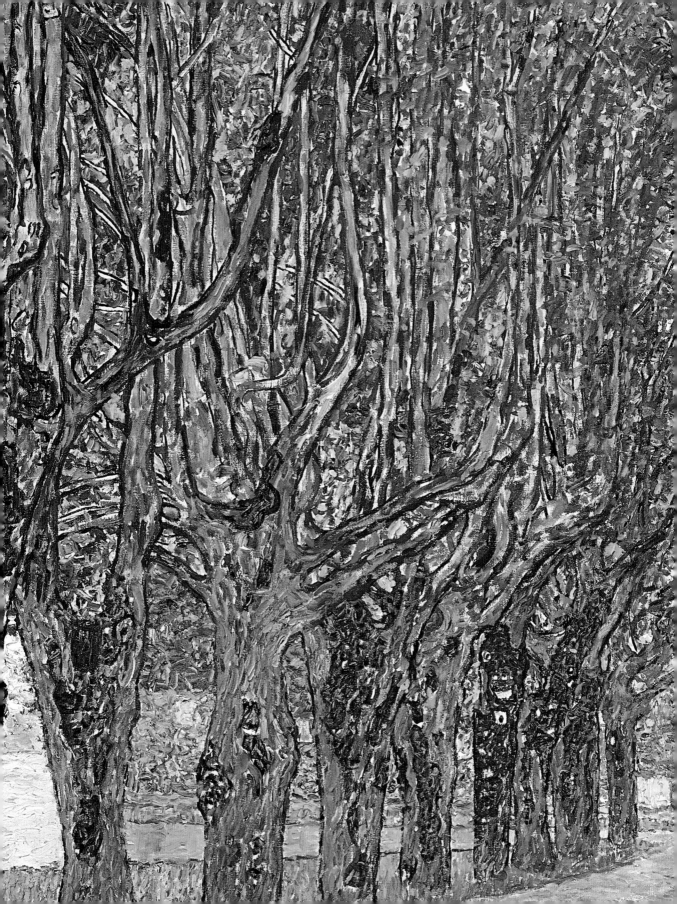

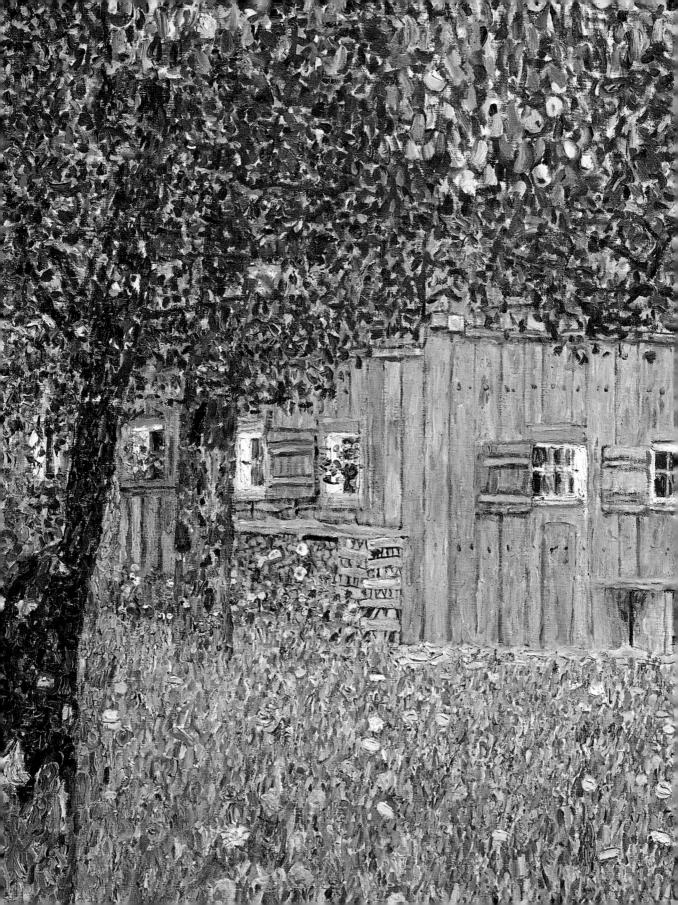

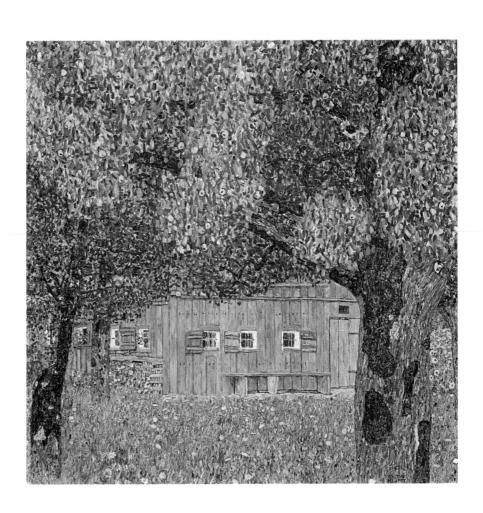

40 Farmhouse in Upper Austria, 1911
Österreichische Galerie Belvedere, Vienna

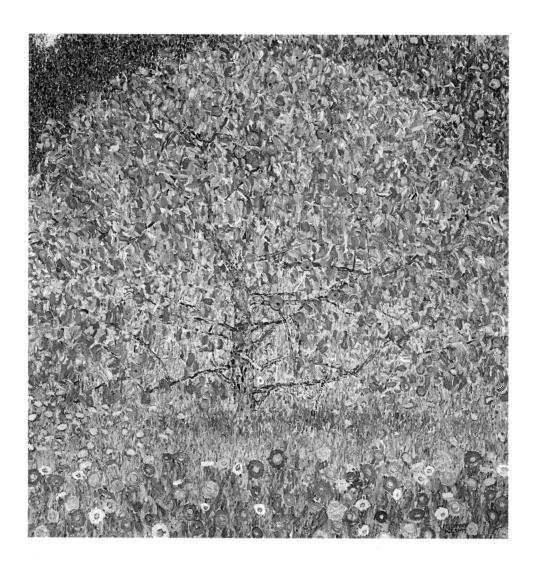

41 Apple Tree I, *c.* 1912
Private collection

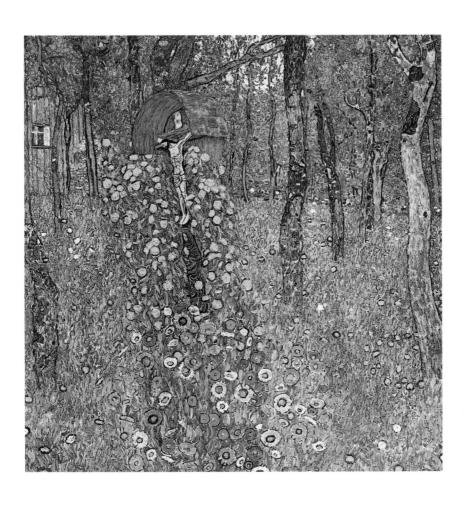

42　Farm Garden with Crucifix, 1912
　　Lost in a fire at Schloss Immendorf, Lower Austria, in 1945

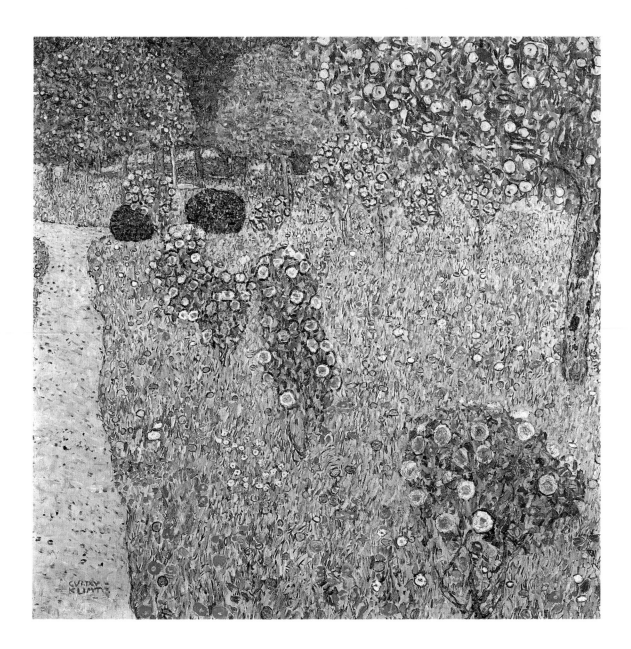

43 Orchard with Roses, 1912
Private collection

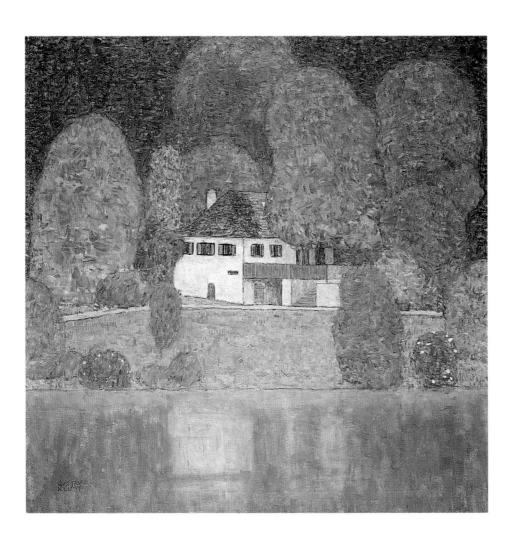

50 The Litzlbergkeller on the Attersee, 1912–16
Private collection

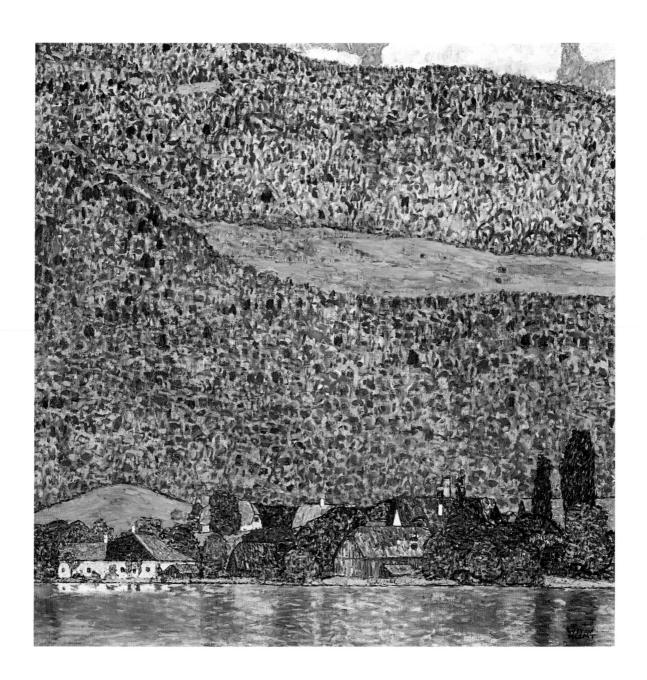

51 Litzlberg on the Attersee, 1910–12
 Rupertinum, Museum für moderne und zeitgenössische Kunst, Salzburg

Klimt and the Flöge family spent the period from July 31 to September 10, 1913, on Lake Garda, where they, among other places, stayed in the Albergo Morandi in Pieve (Tremosine). From there they had a magnificent view of Malcesine and Scaliger castle, on the opposite shore, and Cassone, four kilometers further to the south. Three landscape paintings, including two of villages on the lake, were the harvest of this trip.

Josef Hoffmann, Palais Stoclet, Brussels, 1905—09, the garden front

The paintings *Church in Cassone* and *Malcesine on Lake Garda* (plates 44, 46) undoubtedly show Klimt's reaction to Cubism which he had experienced during his trip to Paris in 1909,[1] and, in particular, to the works of Egon Schiele. The painters had frequent contact during this period. The two artists definitely discussed the new phenomenon of Cubism, particularly as Schiele had had the opportunity of seeing Cubist paintings in the Goltz Gallery in Munich in 1912 and, in addition, had called one of his city paintings "Cubist City" on a postcard he wrote at that time.[2] Both artists translated this new style into a form of flatness. No longer was three-dimensionality of interest, but subdivision into regular geometric shapes. Klimt constructed his Lake Garda paintings out of individual layers rather than from blocks. Even though the houses are depicted more spatially than usual in these paintings, they are still always subordinate to an overall flat concept.

It is clear that Klimt was stimulated by Schiele's emphatic linearity, approaching his subjects with a noticeable preference for contours. At the same time, the composition and linearity retain great tranquility. These are not emotionally supportive lines with a specific intrinsic value, as in Schiele's works, but the composed limitations of colored areas. Johannes Dobai drew attention to the fact that, in Klimt's

Egon Schiele, *The Little Town III*, 1912/13, Leopold Museum — Privatstiftung, Vienna

Malcesine on Lake Garda, *c.* 1960

architectural depictions, "the building elements are interlocked ... in a complex, balanced, ornamental manner, similar to the forms in the architecture of Josef Hoffmann"[3] who also had a strong preference for clear, austerely framed surfaces. Just how close these two artists were in their sense of form can be seen in Hoffmann's *Contribution towards an Artistic Architectural Perception* from 1897 in which — confronted with Capri's anonymous architecture — he states that an "artistically motivated thought, with its flat simplicity" is the formative influence and that the buildings "always result in a complete, integral, homogeneous picture, which, with its bright colors and simple silhouettes, stands out clearly against the blue sky or the dark background of the mountains."[4]

Considering from where Klimt painted *Malcesine* and *Church in Cassone*, it becomes apparent how independent a picture can be from the natural model. At first it seems as if the viewer is merely looking at the opposite shore. Klimt depicts the towns from a raised position on the Val di Sogno peninsula on the same lake shore with a view diagonally across the water (see photograph). He places the focus, the precise segment seen through a telescope, on the houses below the castle hill as well as the church. The gray-blue area in the upper-left corner turns out to be, surprisingly, the slope of an additional mountain range, fading in the distance.

In contrast to the solemnity of the other two paintings, *Italian Garden Landscape* (plate 45) is characterized by cheerfulness. Klimt makes radical use of the diagonal to connect the foreground and background. The glance is drawn to the upper right, then to the left and again downward toward the foreground. The two posts, which can be seen in the midst of the floral carpet, and the house in the background develop a strong pull

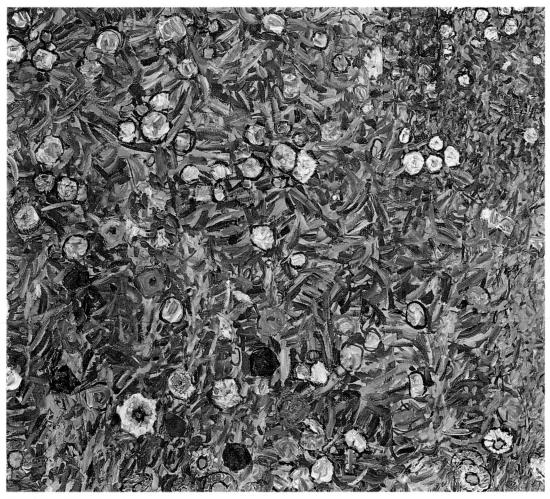

Gustav Klimt, *Italian Garden Landscape*, 1913 (plate 45, detail)

toward the depths of the painting, without it actually being per-
spectively constructed.

Similar to van Gogh, whose art was repeatedly studied by
Klimt, the foreground is given prominence and seen as parti-
cularly meaningful, its materiality emphasized and depicted
precisely in luminous colors. The flowers are integrated in a
well-considered manner, in the ingenious relationship of their
refined coloration. In order to draw attention to—or amplify
—their impact, a green meadow is counterpoised.

Klimt did not like travelling; it is a well known fact that he
only ever left Austria with great reluctance—he would always
be overcome by homesickness at the border and would im-
mediately turned around, if he had had his way. His friends, and

those who accompanied him on his travels, reported that,
when on his way home, he became increasingly happy the closer
he came to the border, and that he sang to himself "The wind
is blowing briskly toward my homeland."[5]

1 Max Eisler, *Gustav Klimt* (Vienna, 1920), text to plate 21; Johannes Dobai,
 "Die Landschaft in der Sicht von Gustav Klimt," in *Klimt-Studien*, Mit-
 teilungen der Österreichischen Galerie, 22/23, no. 66/67 (1978/1979): 264.
2 Dobai, "Landschaft," 264.
3 Ibid., 261.
4 Josef Hoffmann, "Architektonisches von der Insel Capri. Ein Beitrag für
 malerische Architekturempfindungen," in *Der Architekt III*, 1897. Cited from
 Anselm Wagner, "Aspekte der Landschaft bei Gustav Klimt," in *Inselräume:
 Teschner, Klimt und Flöge am Attersee*, exh. cat. (Seewalchen, 1988), 43.
5 Cf. Unpublished reminiscence by the painter Lenz (1860–1948). Cited from
 Christian M. Nebehay, *Gustav Klimt Dokumentation* (Vienna, 1969), 496.

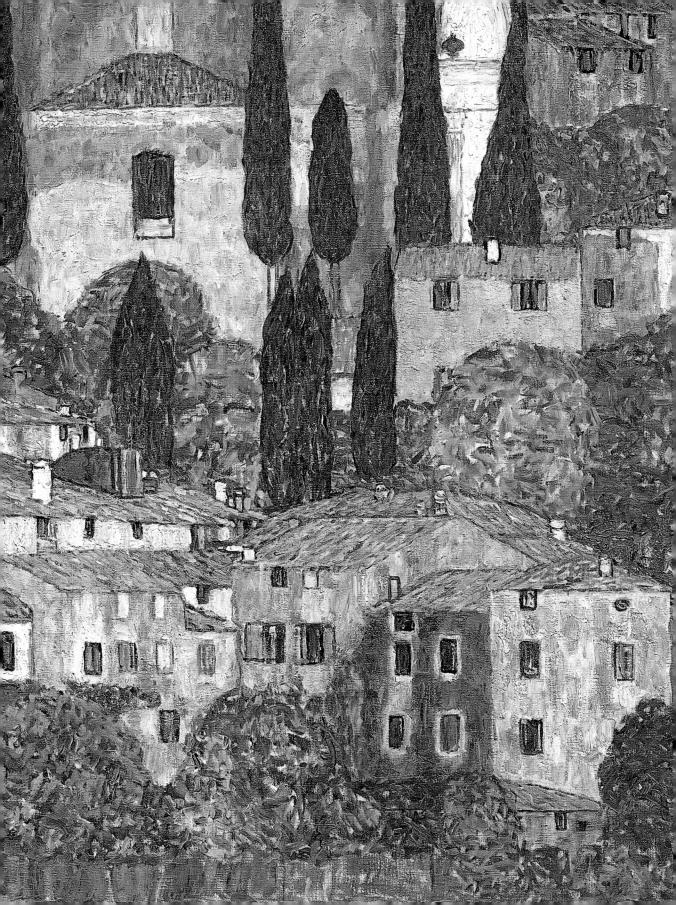

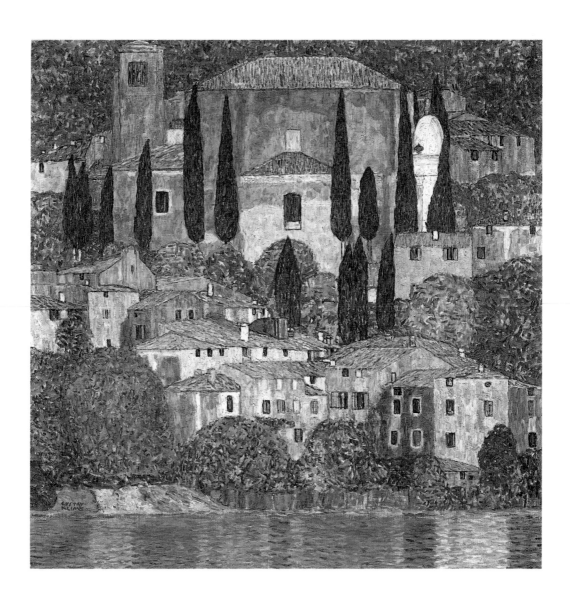

44 Church in Cassone, 1913
Private collection

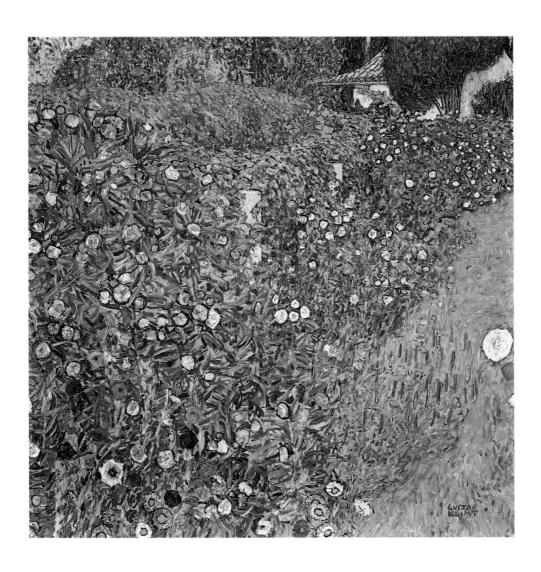

45 Italian Garden Landscape, 1913
 Kunsthaus Zug, deposit of Foundation Collection Kamm

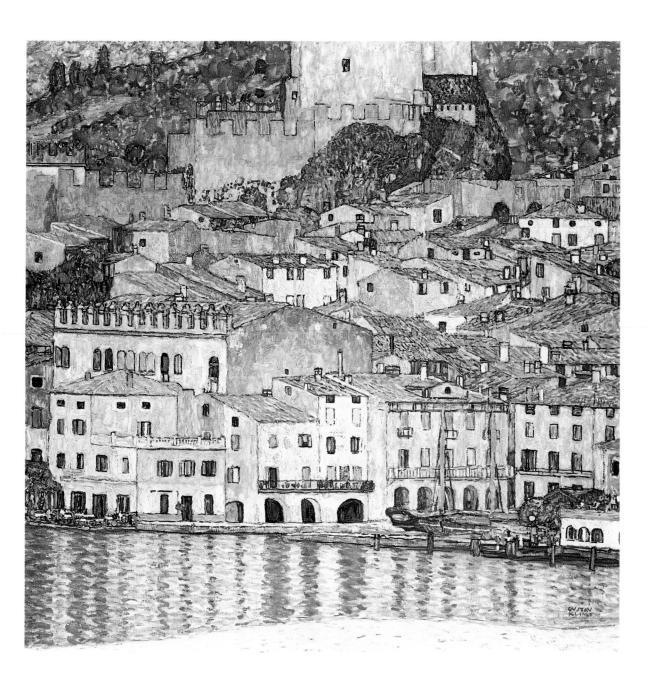

46 Malcesine on Lake Garda, 1913
 Lost in a fire at Schloss Immendorf, Lower Austria, in 1945

From 1914, Klimt worked in his studio in the Feldmühlgasse 11 in the thirteenth district of Vienna, and walked there, every morning, from his apartment in the Westbahnstrasse 36 in the city's seventh district. The painter Carl Moll described the artist's typical morning: "Klimt was an early riser and, eager for movement, strolled early in the morning from the Westbahnstrasse where he lived with his mother and sister—whom he had to provide for—all the way to Tivoli dairy in distant Meidling. Its oldfashioned atmosphere, near Schönbrunn, appealed greatly to him, the most modern of artists. As a famous regular guest he was really pampered; an opulent breakfast—where a huge portion of whipped cream played a major role—had to get him through the day. It was also customary for

Vienna: Schönbrunn, postcard by the Wiener Werkstätte, no. 137, designed by Urban Janke, sent by Gustav Klimt on February 27, 1909, private collection

his friends to meet him there. Nähr, the young Schiele and others. During the day he shuts himself in his studio. The way there always led him through Schönbrunn Park: first of all to Josef-städterstrasse and later to Unter-St.-Veit."[1] Wilhelm Dessauer made a similar report: "Every morning began with barbell exercises. Then he strolled to the 'Tivoli' and had a hearty breakfast with *gugelhupf* and a bowl of whipped cream."[2] "Discussions about art were strictly forbidden at these meetings."[3]

Klimt was a nature lover, and needed contact with nature and the elements and, in particular, plants. He chose his studios on the grounds that they had a garden large enough to give him the opportunity to plant flowers. He also waxed lyrical about his garden on his postcards. His keen interest in flowers is shown repeatedly in his writings—indeed, it is apparent in his entire work, particularly in his late paintings where he covered the backgrounds of his female portraits with opulent, dazzlingly colorful floral ornaments. In particular, his last sketchbook, from 1917, is full of studies of the most varied blossoms, along with notes on the distinctiveness of their colors. In a postcard, dated March 11, 1916, which he sent to Emilie Flöge from Vienna, he writes: "The resplendent sun has arrived making this almost a day of rejoicing! 'Crocus' or 'Krokus' are blooming in the garden, and the ground appears to be a starry sky. The spirit becomes brighter, and the valor and strength No mention in your letter about the flowers in the region."[4]

His morning stroll of four kilometres to Tivoli for breakfast permitted Klimt to have close contact with nature and to get sufficient exercise to perform his daily, slow-going, concentrated work. The impression caused by weather and the landscape is reflected in his correspondence: "TIVOLI, stormy winds, cheerful. Yesterday evening, gentle rainfall, a wonderful earthy smell —the glorious smell of spring— spring in the nostrils—today winter and cold again. Contact a bit disturbed by company, have to write the card before …"[5] Another indication that he had grown so fond of Schönbrunn and his daily breakfast there can be seen in his preference for a postcard from the Wiener Werkstätte with a view of Schönbrunn by Urban Janke.

It hardly comes as a surprise that Klimt was soon tempted to paint the ceremonial silence of this regal park, and to provide it with something of the aura so typical of all of his landscapes. As so often, Klimt chose a very specific viewpoint with an eccentric distribution of the subject matter. Only a few large, formal blocks dominate the painting in which Klimt's predisposition for horizontals and verticals comes to fruition. The scene receives its tension principally through the incline of the steep hill on the left of the picture, and through the contrast in the mirror-like water surface with the stringency of the rest of the painting.

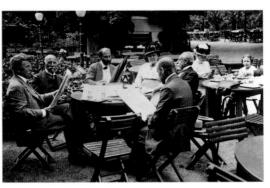

Gustav Klimt outside Café Tivoli near Schönbrunn, *c.* 1914

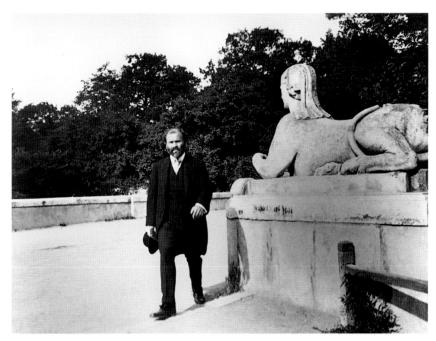

Gustav Klimt on his way to Tivoli dairy near Schönbrunn, *c.* 1914

Klimt relies on his mastery at enlivening these areas of color through the refined use of numerous tones, guiding our eye toward the play of the coloration. The leafy areas of the trees and the tranquil surface of the water of Neptune Pond, are divided into many parts and consist of numerous, interwoven green tones with the violet hues of the shadows forming a contrast. That iota of shining red and blue, necessary for the coloration of the picture, is introduced in a few places.

Klimt placed great importance on technical details. The various modi of brushstrokes are virtually celebrated — precise in the hedges, more energetic in the trees above, more sweeping and blurred in the central weeping willow with its sparse foliage, downright expressive and almost without direction in the water, gentle and gossamer in the clouds with their genuinely "cloudy" undulating forms. It is precisely the varying strength of the strokes which makes the difference between material reality and the mirrored image so explicit. By devoting the major portion of the painting to the water surface, Klimt's intention becomes apparent: transforming nature into an *image* and into a surface structured by colors, following only an internal harmony.

In a letter, dated May 22, 1917 to Dr. Othmar Fritsch, who transacted the purchase of a painting for a client, one learns something of Klimt's business sense. "Unfortunately, I cannot let the painting *Schönbrunn Landscape* go for 6,000 crowns — I have to insist on 8,000. I could, however imagine a ten percent cash discount, with two, or possibly three, drawings thrown in."[6] Egon Schiele wrote about Klimt's relation to money, saying: "He earns a lot, really a lot, but he spends it all. He says that 'money must flow, otherwise it doesn't interest me.'"[7]

1 Carl Moll, "Meine Erinnerungen an Gustav Klimt," *Neues Wiener Tagblatt*, January 24, 1943, cited from Christian M. Nebehay, *Gustav Klimt Dokumentation* (Vienna, 1969), 54.
2 Wilhelm Dessauer, "Zwanzig Jahre nach Klimts Tod," *Neue Freie Presse* (Vienna, 1938), cited from Nebehay, *Dokumentation*, 53.
3 Prof. Remigius Geyling, who was one of the "breakfast group," cited from ibid., 54.
4 Postcard mailed from Vienna to Emilie Flöge, dated March 11, 1916, cited from Wolfgang Georg Fischer, *Gustav Klimt und Emilie Flöge: Genie und Talent, Freundschaft und Besessenheit* (Vienna, 1987), 183.
5 Postcard dated March 1, 1913 to Emilie Flöge, cited from Fischer; ibid., 183.
6 Letter, private collection.
7 Egon Schiele, "Klimts Herzensgüte war echt," in Arthur Roessler, *Erinnerungen an Egon Schiele* (Vienna, 1948), cited from *Gustav Klimt. Die Goldene Pforte. Werke — Wesen — Wirkung*, ed. Otto Breicha (Salzburg, 1978), 157.

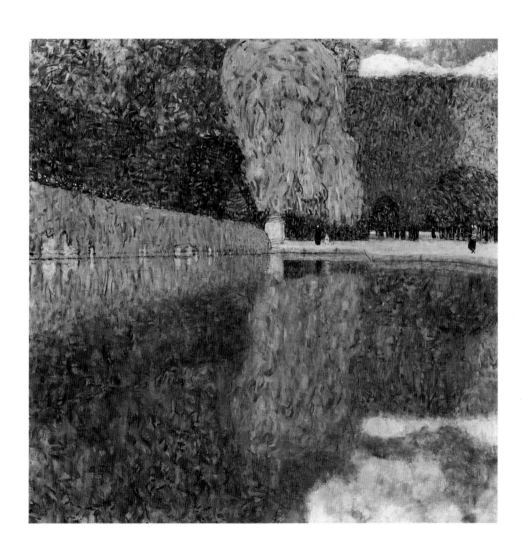

47 Schönbrunn Park, 1916
Private collection

In 1913, the Flöges and Klimt spent their *Sommerfrische* on Lake Garda. Villa Oleander was therefore let to other guests and was not available to Klimt the following year. Klimt decided to spend the next summer in Weissenbach on the south shore of Attersee, where a relative of the Flöge sisters, Friedrich Paulick, lived in Villa Brauner and could help them find suitable accommodations.[1] The Flöge sisters, their mother Barbara, and the young Helene Klimt moved into the house next door, situated directly on the lakeside, whereas Gustav Klimt found lodgings in the forester's house on the outskirts at the entrance to the Weissenbach Valley. The sojourns in Weissenbach in the years 1914–16, usually lasted from the middle or end of July until mid-September. In spite of their separate lodgings, Klimt and the Flöges met every day and spent the majority of their time with each other. People often saw Klimt in his "caftan-like cloak, wandering around with his easel and laden down with painting utensils. He was fairly cantankerous, if not unfriendly, and hardly had contact with the local inhabitants."[2]

The forester's house in Weissenbach, where Klimt stayed was chosen twice as a motif for a painting: once, only as a fragment, as an inviting facade with a number of open windows, and, the other time, from the characteristic distance which made the depiction even more remote (plates 48, 49).

Bromide postcard sent by Gustav Klimt while in Weissenbach to Julius Zimpel in Vienna, dated August 30, 1914, private collection

In *Forester's House in Weissenbach on the Attersee* (plate 48), which shows the side view of the building toward the low wing, the relationship to Egon Schiele's *Facade of a House (Windows)* (see. p. 128) from the same year is immediately apparent, even if it is difficult to say who was influenced by whom. On the one hand, in the past, Schiele had often adapted themes and pictorial solutions from Klimt's paintings and, on the other hand, Klimt acknowledged Schiele's drawing talent, with its expressive lines. It can be assumed that, in this case, Schiele was the model for Klimt—the depiction diverges too greatly from Klimt's usual compositional procedure. The segment depicted is pushed very close to the house wall so that, fundamentally, only the five windows become the subject of the painting. In 1910, Schiele had already used a similarly radical view of a facade in his gouache *The Town Hall at Krumau*. The drawing-like perception of the whole picture with its stark contours is not typical of Klimt and never appeared again in this severity.

In his painting *Villa on the Attersee* (plate 49), Klimt again resorts to this drawing technique by outlining the objects in black, and in the precise way he depicts the structure of the objects, such as the shingles on the roof or the flowers on the shrubs. This carpet-like structure, which uniformly covers the surface of the painting with colored speckles, makes the objects appear incorporeal. However, the various green, yellow, and red tones provide coloristic unanimity, and the evenness of the colored texture gives an impression of complete harmony. At the edges of the picture, two dark bushes, truncated by the borders, provide an effective support for the composition. The tranquil separation, in horizontal zones, is related to the backgrounds of the portraits such as *Adele Bloch-Bauer II* or *Mäda Primavesi* (see pp. 41, 205) and shows how Klimt was able to use one creative approach in various genres.

The colorful splendor of large blossoms in the foreground testifies once again to Klimt's passion for flowers, as seen in the paintings *Garden Path with Chickens* and *Garden Landscape with Hilltop* (plates 55, 56), for which drafts for the coloration of the bloom have been preserved in a sketchbook (*opposite*). It is known that Klimt selected his studios on the basis of their peaceful locations and suitable gardens. Here, he cultivated flowers—which also

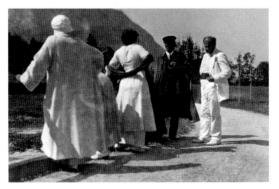

Klimt with friends on an excursion around Weissenbach, with the Ackerschneid mountain range in the background, 1916

impressed the young Schiele: "Every year, Klimt adorned the garden surrounding the house in Feldmühlgasse with flower beds — it was a joy to go there surrounded by blossoms and old trees."[3] The now-famous photographs by Moriz Nähr, which show Klimt amid the exuberantly flowering garden in front of his studio, give us an impression of this (see photographs at beginning and end of this book).

Particularly in his later years, Klimt became increasingly receptive to the overflowing luxuriance and sensual power of vegetal nature. In *Garden Landscape with Hilltop* the entire spectrum, ranging from meadow flowers and rose bushes to fruit trees, is presented. Klimt's deserted landscapes, in which time appears to be frozen, are pictures of an earthly paradise in a never-ending summer. The painting *Garden Landscape with Mountain-Top* (plate 56) attempts to capture the broadest possible view of the landscape on canvas. What has previously been seen as perhaps a meadow on an incline with a mountain-ridge behind it proves with a more detailed knowledge of the topography, to be a view from above of the delta of the Weissenbach with the foothills of the Sechser Kogel behind it. Klimt must have been placed near

Gustav Klimt, *Group of Flowers*, left: green, *right, from top to bottom*: light pink, burning orange on green, narcissus white, p. 95 in a sketchbook dated 1917, private collection

the middle of the central area of forest, the ground seems to have been laid down for what was perhaps to be an expanse of rock (this part of the site has now been destroyed by a quarry) and in the upper left-hand corner of the picture another wooded mountain-ridge rising in the background would have been painted, so that the mountain would also have completely filled this part of the picture. As so often in Klimt's landscapes, the only space left open would thus have been the small, cloudy piece of sky at the top of the right-hand side – a little flash of sky-blue.

Two other pictures painted in Weissenbach sought, however, to achieve not a telescopic effect, but so to speak the opposite perspective – a kind of wide-angle effect: *Farmhouse in Weissenbach with the Schoberstein* (plate 57) and *Garden Landscape with Mountain-Top* (plate 56).

To paint *Farmhouse in Weissenbach* Klimt did not go far from his house. He merely crossed the Weissenbach and turned to look back, so that the mountain behind his house and its wooded slopes became the subject of the picture. In the upper left-hand corner, the striking peak of the Schoberstein peeps above the treeline; on the right, one can see rocky expanses, practically unwooded, which have remained almost unchanged to the present day. Here it is not the Attersee which appears in the foreground but the Weissenbach (the course of which has changed as a result of several inundations since the Second World War) and one of the farmhouses beside the road at the entrance to the Weissenbach valley.

Houses at Unterach on the Attersee (plate 52) belongs to a group of architectural paintings which Klimt began, along with two views of villages on Lake Garda, during his stay in the summer of 1913. Klimt's trip to Paris in 1909, during which he became acquainted with the art of Paul Cézanne, the Cubists, and the Fauves group of artists, had not failed to make an impression. In his architectural paintings, Klimt does not strive for shortening or perspective; the houses and the massive, bright school-building are depicted with clear contours; they appear non-plastic and stand in no relationship to the broad overhanging roofs and shaded areas beneath; the various front and side facades all appear to be seen head on. In this case, a powerful telescope on a tripod was put to use. Klimt painted the motif across the lake from a distance of approximately three kilometers from the southwest-end of Weissenbach at the lake shore.

The painting medium and texture assumed a new importance. Klimt, who previously had painted in a fine, flowing man-

Card from Klimt with photograph of Litzlbergkeller, sent to Anna Klimt in Lower Austria, 1902, private collection

the house and in a higher position. As in *Villa on the Attersee* (plate 49), he dissolved the foreground into a profusion of flowers, shrubs and fruit-bearing orchard trees – but in the background he showed, with characteristic accuracy, the wooded slopes of the Secher Kogel and on the right-hand side the rock-face falling away steeply towards the lake. One should not be confused by the lighter areas of the picture, which is obviously unfinished. In

ner, began to work more viscously and freer, to enliven the colored areas of his paintings with variations in texture. Klimt drafted his paintings in front of the motif, directly on the canvas with the brush, without any preliminary sketching. He then defined the coloration of the individual objects with a few brushstrokes. This sufficed to enable him to complete the paintings in Vienna, as was the case with *Garden Landscape with Hilltop* and *Houses at Unterach on the Attersee*. Klimt had used this method since his Litzlberg paintings, created after the turn of the century, as mentioned in a letter to Mizzi Zimmermann: "I have really made a concerted effort while in the country. I am going to bring five almost-finished paintings back with me, but I am really not satisfied with that. I hope things will be better next year, if God will!"

Despite their festiveness, a new, melancholic, sometimes expressive element creeps into his late works, as can be seen in his pictures of figures such as the portrait *Johanna Staude* (1917/18). In paintings such as *Garden Path with Chickens* or *Garden Landscape with Hilltop* the objects are surrounded by scrawling, dark contours. The construction in *Garden Landscape* is peculiarly unbalanced — Klimt selected dreamlike, glowing colors, and, using light tones, applied these thinly. The dark contours followed, giving the forms a completely new, almost crystalline intrinsic value where ornaments no longer provide distraction but create structure.

In *Apple Tree II* (plate 54) the brushstroke becomes more free and fleeting, even bold, especially in the row of trees in the background. Given its general character, the subject of *Apple Tree II* must remain a subject of conjecture. But this, at least, may be suggested: it perhaps represents the view from the Weissenbach

Egon Schiele, *Facade of a House (Windows)*, 1914, Österreichische Galerie Belvedere, Vienna

valley. As it opens out, to the north towards the lakeshore promenade in Weißenbach with its young trees, as it appears in a photograph of Gustav Klimt and Friederike Beer-Monti dating from 1916. Here the mountains divide, leaving an open view of the whole length of the Attersee. This, and the morning mist which appears in places, could explain the large area of sky which shine through in the upper half of the picture. In this, one of his very last landscape paintings, the artist made an exception and resorted to a smaller format, returning to a theme that had occupied him ever since he was young; the isolated tree as the symbol of life (plates 25, 41). An apple tree is set against a low horizon, beneath an overcast, late summer day. The dominating crown of the tree, the sky, and the row of trees on the horizon are painted in a broad, sweeping — and for Klimt — very free Impressionist manner, whereby the brushstrokes of the background are placed *alla prima*. The layout of the painting, with the apple trees moved from the central axis and the cropping on three sides, is particularly audacious. With all the vitality of this depiction, the distribution of the fruit still shows Klimt's leaning toward the ornamental. The apples, outlined in black, are placed in the uniformly dark mesh of the foliage so that, with their slightly stylized form, they are displayed like jewels to the viewer. The coloration displays a melancholy characteristic of the late work — a hushed earnestness.

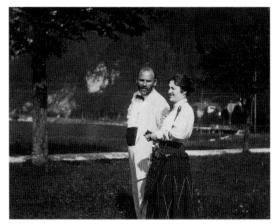

Gustav Klimt and Friederike Beer-Monti in Weissenbach, summer 1916

1 Friedrich Paulick was the son of Friedrich Paulick, Sr., whose daughter married Hermann Flöge (Emilie, Hermine, and Pauline Flöge's brother).
2 Report by Herta Schrey, the former owner of the villa Sans Souci in Weissenbach, in a letter to Alfred Weidinger, cited from Alfred Weidinger, *Neues zu den Landschaftsbildern Gustav Klimts* (diploma thesis, Salzburg, 1992), 134.
3 Reminiscence by Egon Schiele, quoted from Fritz Karpfen, *Das Egon Schiele-Buch* (Vienna, 1921), 89.

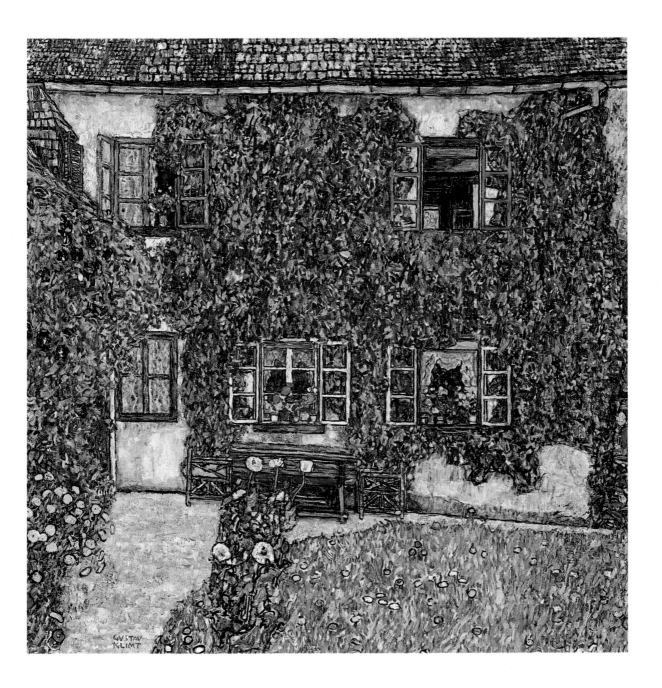

48 Forester's House in Weissenbach
on the Attersee, 1914
Neue Galerie New York

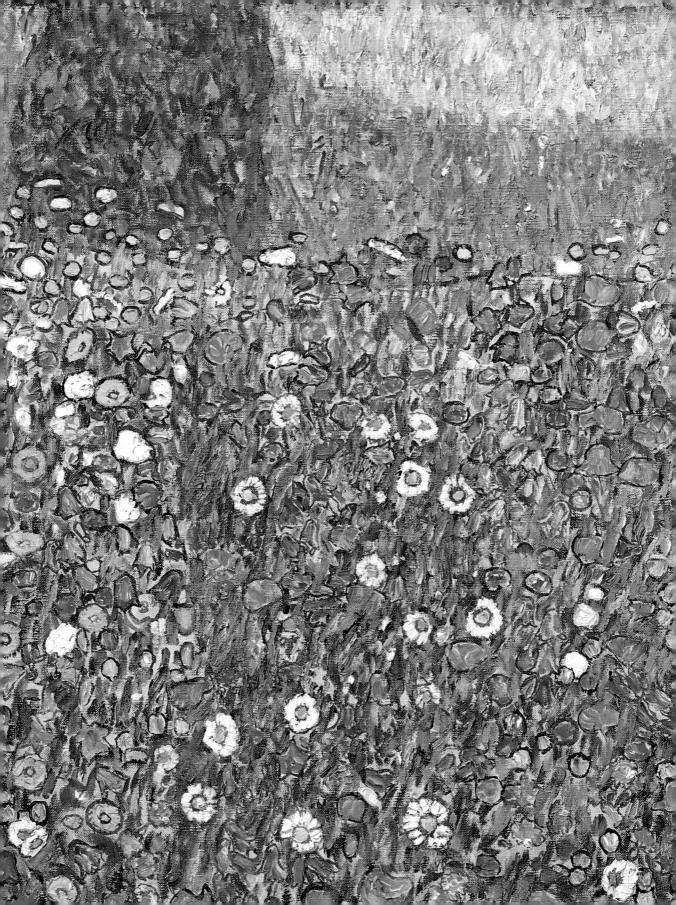

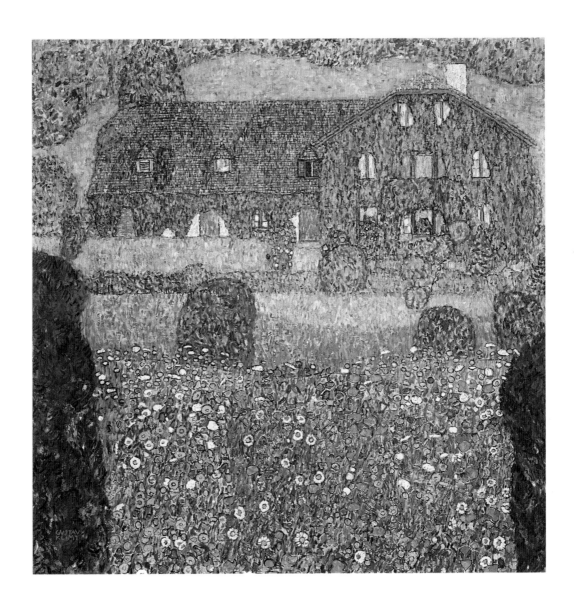

49 Villa on the Attersee, 1914
Private collection

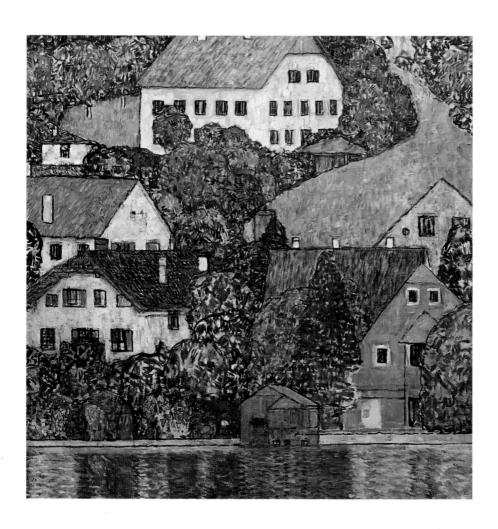

52 Houses at Unterach on the Attersee, c. 1916
 Private collection

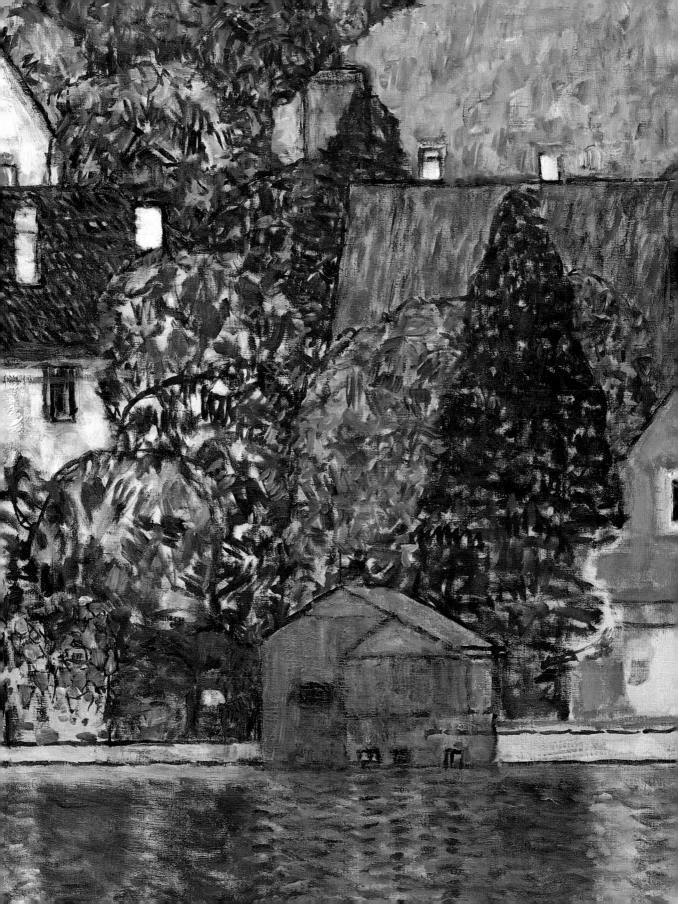

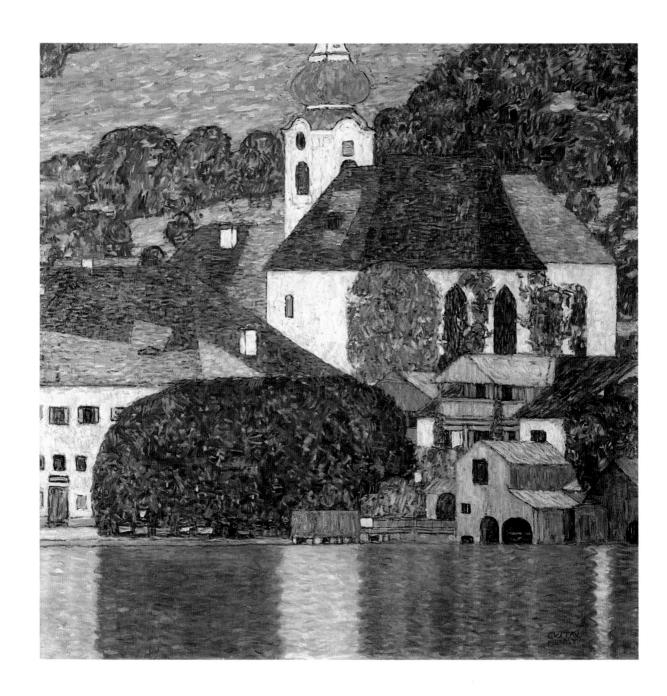

53 Church at Unterach on the Attersee, 1916
 Private collection

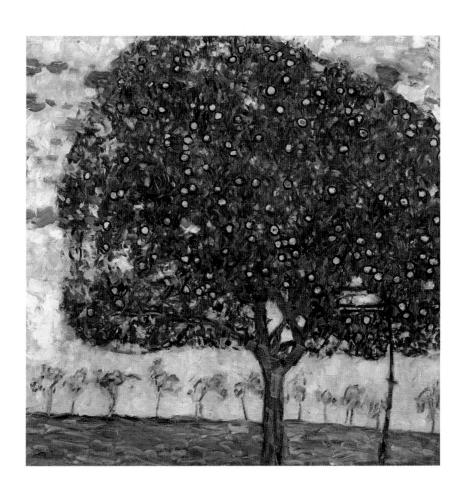

54 Apple Tree II, 1916
Private collection

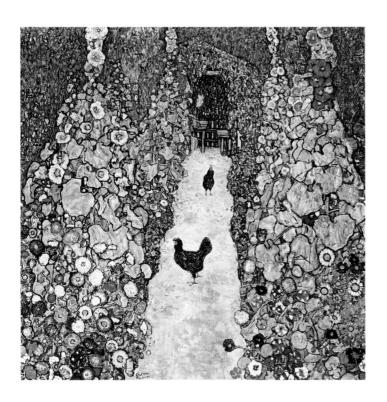

55 Garden Path with Chickens, 1916
 Lost in a fire at Schloss Immendorf, Lower Austria, in 1945

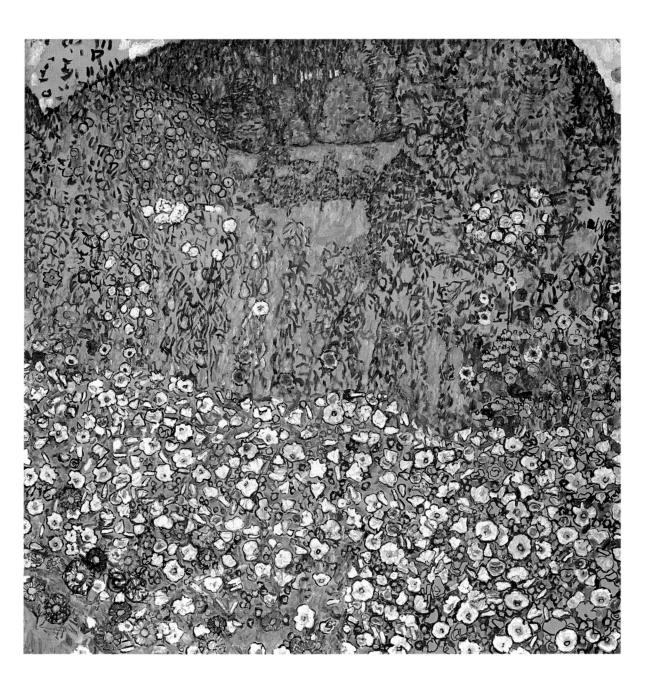

56 Garden Landscape with Hilltop, 1916
Kunsthaus Zug, deposit of Foundation Collection Kamm

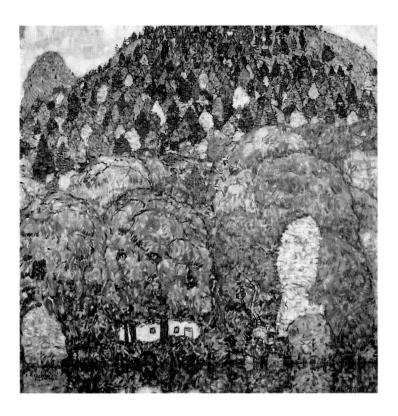

57 Farmhouse in Weissenbach with the Schoberstein, 1916
 Private collection

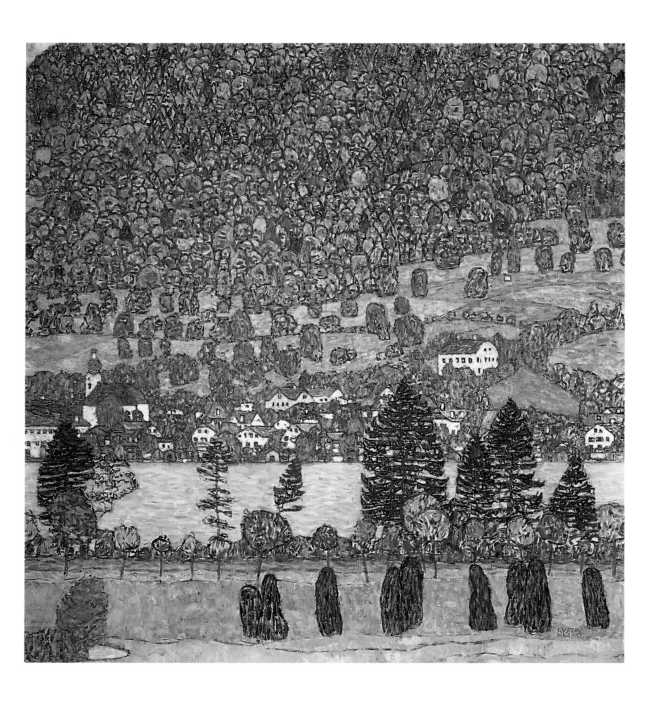

58 Forest Slope in Unterach on the Attersee, 1916
 Private collection

From 1912 to 1917, Klimt and Emilie Flöge spent part of every summer — usually in July — taking the waters in Bad Gastein — the spa famous for its radon springs and with hot thermal water. There is evidence that they had accommodations in the Villa Imperial in 1914. Klimt seemed to have been longing for recreation as we can see from a postcard, dated May 17, 1914, sent to Emilie Flöge: "In the morning, it is sunny and clear, warm and windy — incredible air full of wonderful fragrances; here and there, a few light traces of rain in the sky. And I am full of longing and lust for 'Gasteingastein' or anywhere! I am sitting on a bench in a hilly park, more landscape than park — airing myself, both internally and externally. Affectionate greetings, Gustav."[1]

Klimt's letters from this period are full of complaints about his lack of interest in working, tiredness, about his own health: "little pleasure for work — It looks like my already weak interest in working is sinking even more — It's boring, I get up without much joy."[2] On another occasion he wrote: "I didn't want to write on the first day — I was too 'down'. Worn down, washed out, crushed — afflicted with all the complaints of discontent!"

In a drawing in one of the few sketchbooks preserved, Klimt outlined the composition of his painting *Gastein*. This, and some additional illustrations of conifers in the same sketchbook, indicate that Klimt drafted the comparatively small painting in Gastein and completed it in his Viennese studio. The composition and coloration are outlined to such an extent that he only had to elaborate the painting at a later date. This working method seems understandable in view of the fact that Klimt's sojourns in Gastein were usually fairly short — Klimt was a prolific writer but only one single postcard has been preserved. As his motif, Klimt chose the hotels on the northwest slope of Gastein — referred to by the locals as the "Italian Quarter." In the foreground is the Hotel Waismayr; to the right is the Hotel de l'Europe,

Sketch for the painting *Gastein*, from Klimt's sketchbook of 1917, p. 81, private collection

Badgastein. Postcard from Gustav Klimt from Kammer am Attersee to Julius Zimpel in Vienna, July 1912, private collection

behind this — to the left — Elisabethhof; in the second-to-last row the Wildbad and Reineke Hotels, and in the upper-right Söntgen and Bellevue.[3]

Painted with the aid of binoculars, the layers of houses are compressed and drawn closer to the viewer, as in a theater backdrop, and appear unreachable. The edge of the painting makes a radical incision, severing the houses in the middle of their facades. Tension is achieved through their bright surfaces and the powerful, free brushstrokes used for the conifers with their dark coloration. Paintings such as *Apple Tree II* and *Houses at Unterach on the Attersee*, give us an indication of this artistic method (plates 54, 52).

In his late work — also influenced by Schiele — Klimt's landscape art is highly graphically orientated. In *Gastein* he perfects an arrangement of rectangular elements which appear even more two-dimensional, as a whole, than his Lake Garda paintings *Church in Cassone* and *Malcesin on Lake Garda* (plates 44, 46). In the aforementioned sketch, the basic pictorial concept becomes apparent. The houses have nothing crystalline about them, no plastic density; it appears that only the surface relationships between light and dark have been fleetingly defined.[4]

In comparison to earlier paintings, a conspicuous change has taken place: the painting no longer exudes the festive atmosphere — sometimes cheerful, sometimes solemn — of earlier landscapes. Instead it appears visibly bulky, ready to burst, strangely inorganic and unbalanced. While *Church in Cassone* is captured in serene tranquility, in *Gastein* everything appears steeper, more dramatic, even endangered. Has Klimt's art acquired a new, expressive trait, a new unrest? Or could it be the inner tension of a man approaching the end of his life?

1 Cited in Wolfgang Georg Fischer, *Gustav Klimt & Emilie Flöge.* (Vienna, 1987), 184.
2 Ibid.
3 Cf. Alice Strobl, *Gustav Klimt. Die Zeichnungen 1912–18*, vol. III (Salzburg, 1984), 246.
4 Cf. Fritz Novotny and Johannes Dobai, *Gustav Klimt* (Salzburg, 1967), 69.

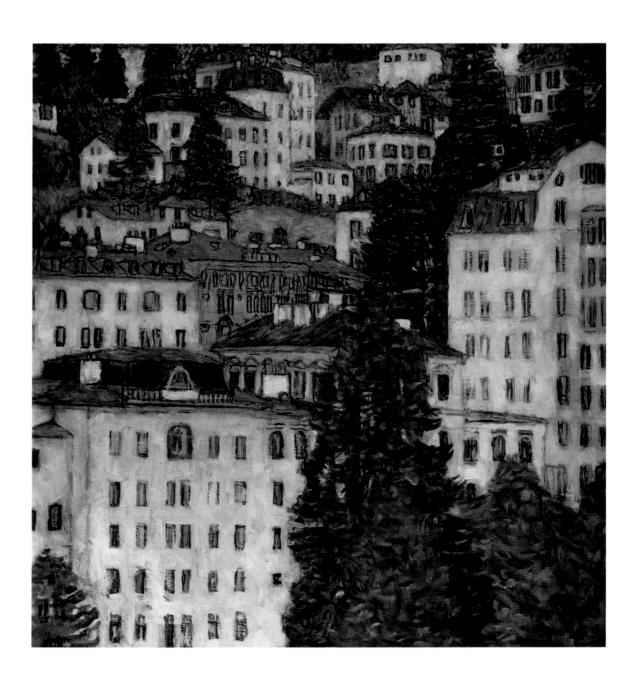

59 Gastein, 1917
Lost in a fire at Schloss Immendorf, Lower Austria, in 1945

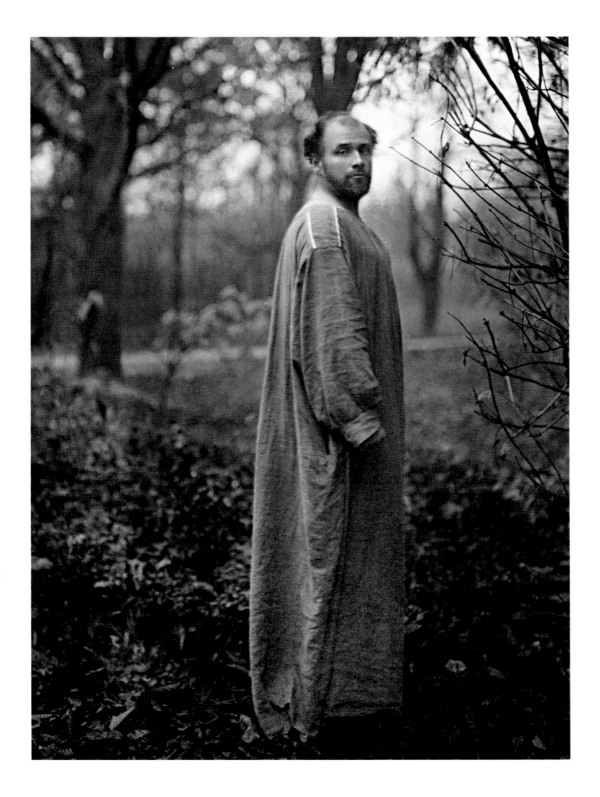

Gustav Klimt — The Prophet of Viennese Modernism
Marketing and Cult at the Secession

Christian Huemer

"Even in his external habits, the way of life of the artist should be different to that of other people. They are Brahmins, a higher caste, made noble not by birth but through their free spiritual development."

<div align="right">FRIEDRICH SCHLEGEL (1772–1829)[1]</div>

The "Homeless" Works

On April 3, 1905, after a year of attacks and criticisms, Gustav Klimt sent a letter to the Imperial Ministry for Culture and Education in which he asked to be released from his contract for the "faculty paintings" for the University of Vienna. He repaid the advance he had received from the State so that he could, once again, have control over the controversial paintings. In an interview with the art critic Berta Zuckerkandl, Klimt made the following statement in connection with the official artistic policies: "I would never—particularly under this Ministry—take part in an official exhibition, unless absolutely forced to do so by my friends. Forget the censorship. I am going to take matters into my own hands. I want to liberate myself. I want to break away from all these unpleasant, ridiculous aspects that restrict my work, and return to freedom. I refuse all official support, I will do without everything."[2] Klimt's polemic was directed principally against the so-called generosity of governmental sponsorship, which he felt took "the dictatorship of exhibitions and discussions with the artists" upon itself whereas it should have had a position only as "mediator and as a commercial factor."[3] To him, it was apparent that official organizations would support only the "weak" and "false." This demonstrative farewell from the public—once more in the name of freedom and genuine art—marked Klimt's definitive transfer to private clients and the market

system. His development shows, in a paradigmatic way, the various stages of the transformation that took place in the artistic field in Vienna. In his early years, he was celebrated as the heir of the aristocratic painter Hans Makart and received the highest recognition from official circles; he then progressed through the *juste-milieu* institution of the Secession to finally come into contact with the modern, art dealer-critic system.[4] The Secessions of Central Europe functioned principally as transitional institutions between the periods of governmental and private patronage and produced a delayed and cautious independence of the artistic environment, compared with Paris. There can be no question that these changes in the Viennese artistic world—in which Klimt himself played such a crucial role—were of major importance for both his creativity and the development of his individual artistic personality. His latent wish to remove himself to the seclusion of his realms of creativity (the studio or nature) could not be reconciled with a system in which the professional artist was somehow forced to give his image a concrete form in his confrontation with public opinion. The destiny of his faculty paintings—which represent, both formally and in terms of content, a key position in Klimt's oeuvre—reflects his transformation from a potential aristocratic painter to an exhibition artist.[5] The state originally commissioned these works as ceiling paintings for a specific location. However, through their numerous presentations, they mutated into exhibition paintings before finding their way into private collections, after being rejected for permanent installation in the newly founded Moderne Galerie.[6] One could even go so far as to claim that Klimt had taken the changes that had occurred in aesthetic reception so much into consideration that the final painting, *Jurisprudence* (see p. 159), makes a much greater impression on a gallery wall than on a ceiling.[7]

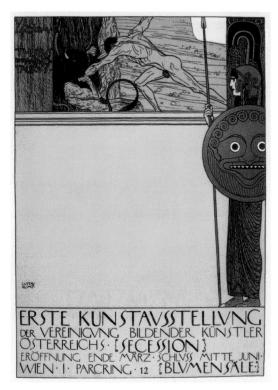

Gustav Klimt, *Poster for "I. Kunstausstellung der Vereinigung bildender Künstler Österreichs — Secession"* (First Exhibition of the Society of Pictorial Artists in Austria — Secession), first version, 1898, lithograph. Historisches Museum der Stadt Wien, Vienna

If one agrees with Wolfgang Kemp's statement that one can only "understand what happens in a painting when one understands what happened to the painting,"[8] one can comprehend the term "homelessness" as a description of the essence of a modern work of art. In bourgeois society, art was deprived of its traditional role (cult or representation) and was continuously faced with the challenge of redefining itself. The confrontation with the results of the social and industrial revolution for the production, distribution, and reception of art led to an alternation between a sense of crisis and renewal pathos; in any case it led to an increase in self-reflection. Gottfried Semper (later, one of the two architects of the Kunsthistorisches Museum in Vienna) gave a particularly lucid analysis of the problematic situation when he noted in 1851: "The path that our industry, and with it the entire artistic world, is following unrelentingly is obvious: everything is calculated and adjusted to the market. A market object

must permit universal applications and cannot express any other condition than that given by the purpose and material of the object. It has no predestined location, just as little as the character of the person who will be its possessor is known."[9] This means that a work of art is necessarily, not voluntarily, "an end in itself" and its sole aim is to be purchased. Autonomy and the mercantile character of these symbolic goods are, therefore, two aspects of the one phenomenon. This is the reason for most modern artistic judgments originating structurally from the contrast between art and money.[10] The arena for this confrontation in connection with the monopoly on artistic legitimization was created by the institutionalization of exhibiting, which gradually developed from an occasional, special event into the sole form for the presentation of art. The traditional commissioner has been replaced, as the target person and power player, by an anonymous audience with its governor—the art critic. The exhibition hall has become the central exchange medium for the defunctionalized work of art; it is a kind of purgatory in which the verdict of the most holy "instances of consecration" decides whether the work will be given over to the jaws of hell—the market—or receive a place on Parnassus—in the museum. This precarious basic situation makes it clear why, since the beginning of the nineteenth century, artists have placed such great importance on their control over exhibition space and, therefore, over the conditions for the reception of their work. The Viennese Secession, which was founded in 1897, recognized the problem facing art under intensified market conditions and addressed the problem head on. The strategies employed by this artists' society, as well as the programmatic activities of its president, Gustav Klimt, clearly demonstrate several aspects of the special paths taken by the Viennese "Moderne."

The Expulsion of the Money Changers from the Temple of Art

The rhetorical arsenal of modern artists' societies usually claims that they were forged out of idealism. However, sometimes the martial myths concerning their foundation fail to provide an accurate idea of the heroism of their activities. Klimt's poster for the First Exhibition of the Viennese Secession (*above*) depicts the god-fearing king's son Theseus, who is about to liberate the youth of Athens from the tyranny of the Minotaur, with one fell swing of his sword. Pallas Athena, with the apotropaic shield of Medusa, the virginal protector of the polis and art,

surveys, in strict profile, "as though it were Act I in the Secessionist drama."[11] With this unmistakable allegory of victory over the enemies of the Secession and the "indifference"[12] of the prevailing taste, Klimt utilized the avant-garde attitude of a fight for liberation for the Secession's benefit. The fact that the censors intervened—on moral grounds—against the nakedness of Theseus was absolutely beneficial to the propagation of this heroic image.

If one permits oneself a somewhat more prosaic interpretation of these events by trying to ignore the pathos that results from voluntarism, one can hardly be convinced by the vociferously proclaimed, youthful explosive force at the time of the foundation of the society, particularly since no new style or truly revolutionary work of art had emerged. The exodus of a group of nineteen artists around Klimt from the Künstlerhaus, the only official artists' society in Vienna, was much more the result of internal disputes that reached their peak in disagreements concerning the election of the board and hanging committee. A monopolistic institution like the Viennese Künstlerhaus—similar to the Paris Salon—was structurally no longer in the position of being able to adequately represent the increasing number, and diverse interests, of its members. The hegemonious power of the representatives was increasingly perceived as influence from outside. A deregulation and liberalization of exhibition activities, connected with a loss of power for the Künstlerhaus Society, could only be justified with aesthetic arguments and mythical self-stylization. The programmatic idea of the Secession aimed at the moralistic polarization of the young and old, modernity and tradition, internationalism and provincialism, and particularly those two aspects that were at the heart of the matter—art and commerce.

The writer Hermann Bahr (see p. 199), who claimed that he "had driven the young painters out of the society,"[13] stated in the Secession's main publication, *Ver Sacrum*: "The purpose of the Secessions in Munich and Paris was to place a 'new' art alongside the 'old.' The whole affair was an argument about a better form in art … artist against artist; it was an argument between schools, doctrines, temperaments."[14] In Vienna, however, it was still necessary to fight for the right for artistic activity. The Künstlerhaus had become a market hall, a bazaar, where dealers flaunted all kinds of wares. Bahr made what was at stake absolutely clear: "Business or art, that is the question of our Secession. Shall the Viennese painters be damned to remain petty businessmen, or should they attempt to become artists? Those who are of the opinion that paint-ings are goods, like trousers or stockings, to be manufactured according to the client's wishes, should remain in the 'co-operative.' Those who want to reveal—in painting or drawing—the secrets of their soul are already in the 'society'."[15] The most efficient instrument for undermining the credibility of the exhibition monopoly sanctioned by the state, and, as a countermove, to legitimize and finance elite, private projects was represented by the dichotomy of art and money. At least, this could be learned from the collapse of the Paris Salon which, for decades, had been discredited by making similar accusations.[16] The international art presentations, which had become more and more gigantesque, and whose dissonant, spectacular character had increasingly taken on the character of a World's Fair,[17] principally satisfied the nation's desire to represent itself, rather than the interests of the individual artists since the interrelation "between a broad, diffused audience and a broad and diffused offer"[18] had become unsettled. If marketing aimed at the optimization of bilateral satisfaction, it was exactly here that a start would have to be made. In Paris, the paradoxical situation developed that commercial galleries and private artists' societies were much more capable of creating an aura of being distanced from the market than the governmental mega-event of the Salon. The secret of success lay in the creation of exclusivity, which meant a reduction in the number of works exhibited and a reform in the circumstances of reception. The Viennese Secession had close connections to the international art market and took advantage of these new marketing strategies.

Attempts were repeatedly made to link any commercial reproaches (which Klimt also made) concerning the activities of the Künstlerhaus with the lack of quality of a historicism frozen in routine. Actually, the scope of the exhibitions was so wide-ranging that one could find progressive and antiquated works directly alongside one another.[19] Its Achilles' heel—ignoring "schools, doctrines, and temperaments"—lay in the barely administrable flood of submitted works, which the commissioners hung, after selection by the jury, like mosaics on the exhibition walls. Thousands of paintings were displayed, hung in several rows, frame to frame, to make the greatest possible use of the space available for display. According to the critic Richard Muther, there was a gap on the wall only when a purchaser chose to take his picture home immediately, which appears to have been the rule.[20] At an early stage, Anselm Feuerbach criticized the loud polyphony of the standard forms of presentation and arrangement, which the Secession was determined to rectify:

"All human seeing, hearing, thinking, feeling has its limits. Anybody will close his ears when he hears ten hurdy-gurdies playing at the same time.... Our exhibitions are pathological institutions of anxiety, in which quantity is supposed to make up for the lack of quality. On the occasion of these large art markets, I am overcome by the feeling of despondency."[21] In such polyglot assemblages a work of art was regarded as an isolated entity, a packaged area,[22] whose greatest happiness and major goal would be the one-painting exhibition. The Künstlerhaus repeatedly organized such exhibitions with great success. In 1878, twenty-three thousand visitors[23] saw Hans Makart's painting of *The Entry of Carl V into Antwerp*, and in 1882 fifty thousand made the pilgrimage to admire Mihály Munkácsy's *Christ before Pilate*. These colossal, sensationalist paintings were usually commissioned by art dealers and then displayed—against payment —on year-long tours through the most important European and American cities.[24] These celebrated "masters of the traveling painting,"[25] whose activities became possible only through the new transportation networks of the railways, reinforced the idea of the work of art without a predetermined location, the mercantile character of which became increasingly apparent. These illusionary spectacles were presented in darkened rooms, where they could count on the curiosity of a mass audience. This followed in the tradition of panoramas and dioramas and offered a foretaste of the cinema. Walter Benjamin pointed out that "the simultaneous contemplation of paintings by a large group of persons, as was the case in the nineteenth century, is an early symptom of a crisis in painting that was not triggered off by photography alone but, relatively independently of this, through the demands the work placed on the masses."[26] In Klimt's painting *Nuda Veritas* (1899, *above*)—the painted manifesto of the Secession—the artist replaced the "work's demands on the masses" with the demands of the work on truth, for a small circle of the chosen. An epigram by Schiller, in the upper section of the painting, proclaims: "If you cannot please all through your activities and work—please a few. It is bad to please many." Below this, the naked figure of a maiden—completely frontal—with voluptuous red-

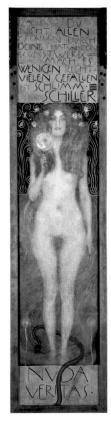

Gustav Klimt,
Nuda Veritas, 1899.
Theatermuseum, Vienna

blond hair and a piercing glance, holds a dazzling mirror demonstratively in front of the viewer. A snake winds itself around the feet of this personification of Truth, brought so close to the observer, as an allusion to the mortal sin of envy. In *Ver Sacrum* (March 1898) Klimt had originally confronted the emblematic portrayal of Envy with the *Nuda Veritas*, and only in the final painting were these two aspects merged. In the first, drawn version the work was inscribed "Truth is fire and to tell the truth means to glow and burn. / L. Schefer." Klimt wanted art to be seen as an instrument of knowledge, which permitted insights outside the scope of the normal sensation of reality and which, therefore, was disconcerting for many. Marian Bisanz-Prakken has brought the mirror of the *Nuda Veritas*— reflecting light in concentric circles—into connection with Arthur Schopenhauer's simile of a concave mirror.[27] In this text from the volume *Parerga und Paralipomena*, which was very popular at the time, Schopenhauer compares the genuine work of art with a concave mirror, "in so far as that which it conveys is not its own, tangible self, its empirical content, but something which lies outside, which cannot be grasped with the hand, the true, difficult-to-grasp spirit of the matter."[28]

In addition to the orientation of the work of art toward its essential spirit, hidden behind its sensuous appearance, the communicative-theoretical aspect of the simile is also relevant. According to Schopenhauer, genius itself can also be compared with a concave mirror because it concentrates light and warmth to an astonishing degree, but "this only is effective in one direction and requires the observer to have a particular point of view." Opposed to this, a convex mirror reflects light in all directions. This metaphorical description indicates that the previously diffused effect of a work of art on the general, entertainment-seeking public is focused and intensified by genius and directed at a circle of insiders. This persistent courting of the observer with a "particular point of view" can be seen as a specific aspect of the Viennese Secession. The concept of an "ideal partnership between the creators and enjoyers,"[29] established by the society and propagated by Klimt, which rewarded the artist's client with participation in the

creative interpretation of his work, elevated both parties above the passive, consuming mass and granted them increased distinction. One of the peculiarities of the Viennese Secession is that the avant-garde rebellion of its protagonists remained within certain boundaries and that their work found acceptance not only among patrons in the upper classes. The Viennese city council provided land for the construction of their building, and the state also

few years later, for a single portrait.[34] Credibility was obtained using very subtle marketing strategies, which concealed the *conditio sine qua non*—the commercial character of the exhibition object.[35] This impression of indifference—overlooking the pedagogical facade of the Secession—was mainly achieved through a "free self-consecration" in the previously cited Schlegelian sense. "Because it not only saw its personal interests, but the

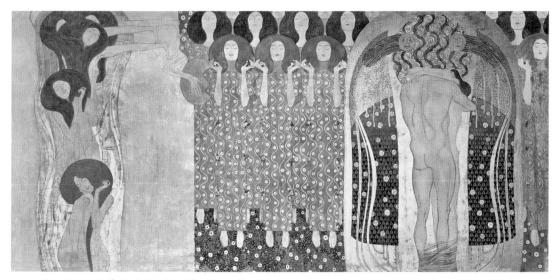

Gustav Klimt, *Here's a Kiss for All the World* (detail from *The Beethoven Frieze*) 1902, mixed media on plaster, Österreichische Galerie Belvedere, Vienna

repeatedly provided subsidies. Even Emperor Franz Joseph I was welcomed to the first exhibition, which raised the Secession to the status of a society on a par with the Künstlerhaus. Franco Borsi and Ezio Godoli had in mind this subliminal contradiction between this aggressive rhetoric and official recognition when they spoke about the "phenomenon of an instantly institutionalized avant-garde."[30] That only passionate critics, such as Karl Kraus, recognized the Secession as a new player on the art market may come as a surprise considering the society's commercial success.[31] At the very first exhibition more than half of the works exhibited were sold for a total of 85,000 gulden, yielding a profit of 3,858 gulden.[32] One year later, Bahr purchased the *Nuda Veritas* from his friend Klimt for the special price of 4,000 crowns (2,000 gulden), at a time when the costs for the construction of his house by Joseph Maria Olbrich amounted to nearly 12,000 crowns.[33] This sum represents the price that Klimt could demand, only a

holy matter of art itself in acute danger, and in solemn enthusiasm for this, was prepared to take this burden upon itself and wanted nothing more than to achieve this, its own goal, using its own means; this was the reason for establishing itself under the motto VER SACRUM."[36]

Concerning the Metaphysical Priority of Art

"Consecrate! A word which our artistic world, due to its well-known meager possibilities of employment, has long given up. One has no time at all for consecration if one must chase after daily bread that one does not find every day. The competition—everyone against everyone—has become increasingly intensified since the end of the monumental building period."[37] The Secessionists saw this return to atmosphere and consecration as a plausible way to safeguard the special status of art given the mercantile

usability or, to put it differently, to reestablish the distance between the market and art worlds. Its exhibition rooms were intended to suppress all indications that could detract from the dignity of the artwork; it had to be shielded from the proximity of the nearby Naschmarkt (one of Vienna's permanent food markets) in order to be able to exude something like the silent holiness of a church; the hieratic, closed-to-the-external-world character gave the Secession building on Karlsplatz the aura of a symbolic site. Even Bahr compared the building with a temple area, leading in three stages from the external world to the Holy of Holies: the visitor first "comes under the laurel wreath to the courtyard to purify his spirits," then he strides through "the area for the works," before finally reaching "the architecture for contemplation and worship, the chapel."[38]

The Beethoven Exhibition of 1902, for which Klimt created the famous *Beethoven Frieze* (see pp. 149, 198, 199) can be regarded as the most important and solemn production of the Secession. This was an attempt, in the ephemeral conditions of an exhibition, to realize the restoration of the connection between architecture, painting, and sculpture in a monumental modern work of art. In contrast to those eras in which the unity of art, religion, and society continued uninterrupted, this exhibition was forced to re-create these aspects in an environment for which no definite context of the production and reception of art existed. It must be noted, however, that the interdisciplinary model of contextualization was not the only one proposed by the Secession. The ambitious exhibition *The Development of Impressionism in Painting and Sculpture*, held in 1903, shows that, even in those days, modern formalistic argumentations were much more applicable to the French situation than to the Austrian. One-man exhibitions, such as Klimt's in the same year, would have hardly been possible in the old "institutions of anxiety." This was one of the "main ideas" meant to counteract the isolation of the artwork and the disintegration of the various art forms. "The longing for a major assignment, going far beyond the usual painting of studies or other pictures, stemmed from the desire to risk, in one's own house, that which our age has denied the artistic spirit: the purposeful decoration of an interior. We ourselves wanted to experience the sanctification of a work, with a purpose and a reason."[39] The heightened importance of the Beethoven Exhibition was reached through the apotheosis of an artistic genius who was seen as being able to deliver tortured mankind from agony and decadence. The cultic and spatio-artistic center of the exhibition was provided by Max Klinger's polychrome *Beethoven sculpture*. Seated on his heavenly throne, his chest bared, and gazing solemnly into eternity, the musical hero rules over the earthly valley of woes. This iconographic conglomerate of Jupiter, Prometheus, and the Messiah, superelevated through his own individual features, characterized Beethoven as an artistic visionary. Josef Hoffmann, who was responsible for the overall direction of the project, referred to a basic form of Christian sacral architecture by producing a three-naved space with apses to create "a feeling of a temple for one who has become God."[40] In the room on the left-hand side, Klimt unfolded his allegory of the salvation of mankind through the arts in which, according to Egon Schiele, the "entire Klimt religion"[41] was expressed. The long, left-hand wall was devoted to the longing of mankind for happiness. *Well-armed strength*, begged by suffering and weak mankind, takes, out of compassion and ambition, the battle upon himself. Strong-willed and well-armed, the noble knight —who can be seen as a figure of identification for the artist—rides forth to do battle against the depravity of the world and the power of blind instincts. He has to resist the threats posed by the giant Typhoeus and the three Gorgons—sickness, insanity, and death. Voluptuousness, unchastity, immoderateness, and gnawing sorrow form the supporting group of the *Hostile Powers* and darken the narrow side of the room. On the final open wall—permitting a glance at the Beethoven monument—the analogy reaches its climax in a symphonic final idea, "The Ode to Joy." Finally everything is conciliatory: "The longing for happiness finds its satisfaction in poetry." The catalogue of the Fourteenth Exhibition proclaims that the arts lead mankind "over into the ideal realm, where we find only pure happiness, pure joy, and pure love." The choir of the heavenly angels praises this *Kiss for All the World*, symbolized by a tenderly embracing couple protected by a golden cape (see p. 149).

The ideology celebrated by this *Gesamtkunstwerk* transformed art into a kind of replacement for religion and participation in an exhibition likened a kind of service of beauty within the framework of a secular ritual. The Secession's extremely missionary vision of art, which was devoted to the romantic belief that creative subjectivity revealed real values, was vehemently opposed to the profane, pluralistic proffering of everyday art exhibitions and ordained its artists with higher orders. In the baroque city of Vienna, it seemed appropriate to continue with the idea of a *Gesamtkunstwerk* in order to give each object its "particular, individual place within the code of grace"[42]—even in the modern age. A self-imposed commission, such as the

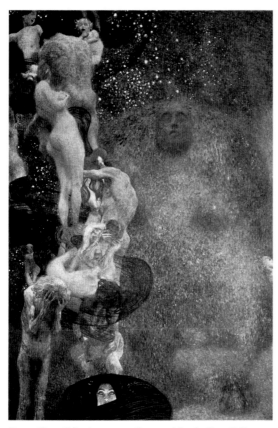

Gustav Klimt, *Philosophy*, c. 1900, ceiling panel for the Great Hall at
Vienna University, lost in a fire at Schloss Immendorf, Lower Austria,
in 1945

shrink away from putting science, as the saving grace of
mankind, back in its place, and this in its place of origin.
After the rejection of an initial draft program, the duo of
Klimt and Franz Matsch received the commission in 1894.
This team also included (until his death in 1892) Klimt's
brother Ernst. Known as the "artist company," it had
earned its laurels principally through the ceiling paintings
for the magnificent main staircases of the Burgtheater and
Kunsthistorisches Museum. Its trademark—the indistin-
guishability of their individual hands—made it possible
for this collective, which was founded during their studies
at the Viennese School of Applied Arts, to carry out mon-
umental projects at a rapid speed. The increasing stylistic
divergences of the two artists became apparent in the case
of the "faculty paintings." According to Matsch, the distri-
bution of the work was decided, as was usual, by draw. He
himself painted the central picture depicting *The Victory of
Light over Darkness*, as well as the faculty of *Theology*; Klimt
was responsible for the remaining three faculties—*Philoso-
phy*, *Medicine*, and *Jurisprudence* (*left*, see also pp. 159, 197). I will
not go into the aforementioned destiny of the paintings in
great detail here; however, the reasons for the vehement
rejection Klimt's works received is of interest. In 1900,
when the painting *Philosophy* was shown at the Seventh
Exhibition of the Secession, it triggered a storm of protest.
The interest of most critics was concentrated on the hov-
ering group of figures that form a column on the left side
of the painting, described in the catalogue as "genesis, fer-
tile existence, and passing." The Vienna correspondent of
the influential Munich magazine *Die Kunst für Alle* (Art for
All) provided an apt description: "The painting shows how
mankind, seen as a part of the universe, is nothing more
than a dull, spineless mass, driven forward—in happiness
and unhappiness—in the service of eternal propagation;
dreaming from the first flickering of his existence to his
powerless descent into the grave. In between, there lies
only a brief ecstatic period of union and a painful drifting
apart. Love has been a disappointment, both in terms of
pleasure and knowledge. Destiny never changes. Isolated
from cold clear knowledge, isolated from the eternally
veiled questions of the universe, mankind struggles in his
battle for happiness and knowledge and remains a mere
pawn in the hands of nature, which uses him for its
eternal, never-changing purpose of propagation."[44] In the
pessimistic worldview of Klimt's *Philosophy*—based on
Schopenhauer's ideas—mankind was absolutely subju-
gated to the physical demands of his existence; the cate-
gories of space, time, and causality.[45] The impersonal will,
the source of all inclinations and desires, determined, as an

Beethoven Exhibition, primarily dedicated to the cult of
the artist, risked being accused of being a self-referential
event if its altruistic salvation potential were called into
question. Carl E. Schorske remarked about this theme: "If
ever there was an example of collective narcissism, this
was it: artists (Secessionists) celebrating an artist (Klinger)
celebrating a hero of art (Beethoven)."[43] The suspicion
that Klimt and his colleagues thought primarily of liberat-
ing themselves from the "enemy powers" of the anony-
mous market world is not so far-fetched.

The artist's exclusive claim to truth and the tension
between the subjective symbolic world and universal
validity shows the real conflict potential inherent in the
controversial faculty paintings. Klimt's sense of mission—
or should it be called artistic pride—in respect to this last,
large-scale commission in the Ringstrasse epoch, did not

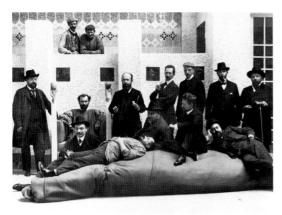

Moriz Nähr, *Gustav Klimt, with his colleagues from the Secession in the Beethoven Exhibition*, April 1902; back row, *left to right*: Anton Stark, Gustav Klimt (*seated*), Adolf Böhm, Wilhelm List, Maximilian Kurzweil, Leopold Stolba, Rudolf Bacher; front row, *left to right*: Koloman Moser, Maximilian Lenz, Ernst Stöhr, Emil Orlik, Carl Moll

inescapable power, human fate and guaranteed the preservation of the species. This "cold clear knowledge" was, according to Schopenhauer, incapable, due to its striving after causal explanations, of influencing the way of the world or of solving the enigmas of its manifestation. Above all, the symbolic declaration of bankruptcy of the materialistic sciences, with their optimism concerning progress, led to protests from academia. The hanging of such heretical paintings in the lecture hall of the university was to be prevented because the dignity and triumph of science were not treated with due respect. The rector Wilhelm Neumann stated that *Philosophy* did not deserve "to be portrayed in a puzzling painting, as a puzzling sphinx at a time when it sought to find its source in the exact sciences."[46] One generation previously, celebrated artists such as Lawrence Alma-Tadema or Mihály Munkácsy—to mention only two to whom Klimt was close in his early years—had accepted positive knowledge as the regal way to truth and the basis for their painting. The "artist metaphysic" of Nietzsche and Schopenhauer permitted art to free itself from the old stigma of appearance or deception and to assert its metaphysical pre-eminence as the preferential form of knowledge. That his contemporaries saw things in a similar manner is shown in a scarcely noticed article "Philosophy and the Cultural Re-evaluation of our Time."[47] In this article, the critic describes the spirit of *Philosophy* as being "modern theosophic" in as much as the "struggling to break through the imprisoning

boundaries of sensual experience unites the human spirit in a tangible, perceptible way with the infinite, the eternal, that which lies beyond all which is visible." He takes this as proof for the transition "from the allegoric to the symbolic" in modern painting.

Whereas the allegory relies on the pure convention of understanding and appears cold and dogmatic vis-à-vis a meaning not of its own making, the symbol lays claim to the immediate connection between individual experience and universal truth. The power of a symbol lies in its reference to the infinite of a totality, whereas the potential of an allegory is exhausted with the deciphering of a meaning. "The symbol appears as the inexhaustible, indefinitely decipherable as opposed to the allegory with its precise, absolutely exhaustible meaning—it is like a comparison between art and non-art."[48] The "indistinct," "enigmatic" content of *Philosophy*, which makes demands on one's own creative imagination, renouncing all traditional allegories, was repeatedly criticized. Kraus, for example, questioned the universal relevance of Klimt's ideas when he wrote, "But who is really interested in how Herr Klimt imagines philosophy? A non-philosophical artist could paint philosophy; he would have to allegorize it in the way it appears in the philosophical heads of his time."[49]

It is really more than just a subtle difference in accentuation if Peter Altenberg's book, published in 1896, is entitled *How "I" See Things* or *How I "See" Things*. The author clarified this discussion, which appears at first glance to be hair-splitting, saying that, of course, the second version was correct as "the single 'being' is worthless, destiny's miserable fooling around with the individual. Being the 'first' is everything. He has the mission, he is the leader, he knows that entire humanity follows him. He has been sent ahead by God!"[50] Deprived of the credibility of his mission, the modern artist is just as much in danger of disintegration and isolation within the masses as his defunctionalized work.

Viennese Prophet versus Parisian Flaneur

Even though he stood in the limelight—particularly during the first "heroic" years of the Viennese Secession Klimt flirted with the idea of "being not particularly interesting as a person." Therefore, one has to do without a literary or artistic self-portrait: "Anyone who wants to know anything about me—as an artist, the only noteworthy aspect —should study my paintings closely and, from them, try

Oskar Kokoschka, *Poster for "The Storm,"* 1910, Szépmüvészeti Múzeum, Budapest

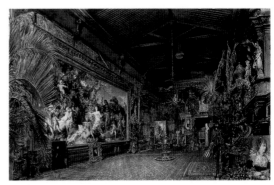

Rudolf von Alt, *Hans Makart's Studio*, 1885, Historisches Museum der Stadt Wien, Vienna

to deduce what I am and what I want."[51] Klimt's self-portrait was never painted; his artistic *imago* was, in spite of this alleged discretion, apparent in its self-stylization. The strength of his concrete judgment and his inward-looking viewpoint predestined him as a visionary and artistic prophet, stigmatized by the lack of understanding of the masses. A photo by Moriz Nähr (*opposite*), taken shortly before the opening of the Beethoven Exhibition, shows Klimt, self-assured, surrounded by his followers, on a throne that must be understood as a reference to his geniality, transfigured in the exhibition hall. His high forehead with locks like St. Peter's, and his caftan-like painting smock, which he wore not only when he was painting, also played a part in giving the painter the image of a prophet. This characterization has to be preferred to that of a priest because Klimt placed great importance on his aversion to the scriptures.[52] In other photographs, the artist wanders, transported and lost in meditative reverie, through an overgrown garden in front of his studio. The princely painter Makart regarded his studio (*above right*) as a

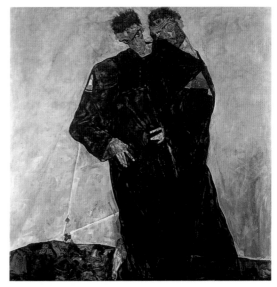

Egon Schiele, *The Hermits*, 1912, Leopold Museum – Privatstiftung

The garden outside Klimt's
studio at Feldmühlgasse 11,
Vienna XIII, 1911

Edouard Manet, *Bar at the Folies-Bergère*, 1882, Courtauld Institute Galleries, London

place for representation, where he celebrated the societal integration and high standing of the artist. For Klimt, the studio was an idyllic retreat from his confrontation with the hostile public. Makart identified with the aristocratic Peter Paul Rubens who, in the seventeenth century, elevated himself far beyond the status of mere artisan, associating with the rich and powerful as an equal. Klimt used another strategy to distance himself from the masses, initiating a series of sacral self-portraits at the turn of the century, which demonstrated the artist's painful search for a higher vocation. In Egon Schiele's double portrait *The Hermits* (see p. 153), both artists wend their way through a barren landscape; Klimt's closed eyes indicate rapt absorption, the crown of thorns around Schiele's brow stamps him as a martyr. This type of christomorphous self-portrait, in which the artist viewed himself as an outsider and victim of society, appeared increasingly in the early twentieth century in Vienna in works by Oskar Kokoschka (see p. 153), Richard Gerstl, and Kolo Moser.[53]

Distance and inapproachability appear to be effective tricks in preventing the destruction of the aura that Benjamin defined as the "singular appearance of a distance, no matter how close it is."[54] The passionate desire of the masses to make things spatially and humanly more understandable leads to the perception whose "sense for homogeneity in the world" has tendencies of eliminating the hierarchies of the humanistic world. Edouard Manet and the Impressionists were reproached, on more than one occasion, for not giving the human face more importance than a still life or landscape. The egalitarian point of view of the Parisian *flaneur* is the complete opposite to

that of the Viennese prophet within the cast of modern painters. The comparison is possibly of heuristic value because both artists, although not at the same time, appear at the same level of autonomatization of the artistic landscape. In response to the capitalistic penetration of all areas of life, the view in Vienna turned inward whereas, in Paris, a radically outgoing view become the sign of the "Moderne." Where the mirror of the *Nuda Veritas* (see p. 148) solemnly challenges the fathoming of the "difficult-to-grasp spirit of the thing," the mirror in the *Bar at the Folies-Bergère* (*left*) reveals, in an ironic fashion, the venality of all matter. The naked truth, which Manet tried to probe artistically, is tied to the experience of the free market, which is based on public presentation, seduction, and mass consumption. The still life of the bottles in the foreground of the painting cannot be seen in any traditional iconography; it is nothing more than a presentation of goods. The barmaid behind the bar becomes, through the covetous look of the man, just as much a purchasable object as the other things offered for sale in the crowded establishment. That Manet saw the situation of art in this context can be observed in a small marginal detail: he placed his signature on the label of a wine bottle as if this were a small picture within the picture, thereby positioning his artistic identity within the codex of the business world.[55] The overemphasizing of the eye, the dispassionate, distanced view, are part of the habitus of the *flaneur*; he is "one, at the mercy of the crowd,"[56] according to Benjamin, and shares "the situation of other goods" and, one might add, the situation of art. The contrary reactions to the purchasability of beauty makes it clear why Manet's courtesans become modern heroines whereas Klimt, as a designated "painter of women," bans this aspect from his oeuvre.

An early Klimt biographer wanted, erroneously, to credit him with a similar confrontation with the modernity of the city, by reporting on the source of inspiration for his *Philosophy*: "In Vienna, it was his custom to always stand on the open platforms of the streetcars, which were operated by steam in those days, and the billowing clouds of smoke that enveloped him gave him the idea to introduce such mist into his paintings to depict separation and, at the same time, meeting, through the gray, oppressive, black, heavy clouds that engulfed him."[57] In the early 1870s, Manet intentionally moved his studio to the proximity of the Gare Saint-Lazare, to be able to physically experience the atmosphere surrounding the "modern Pegasus"—the locomotive. Klimt, however, tended toward the *secessio*, the retreat to the *hortus conclusus* of his

studio or the bosom of his followers. Of course, around 1900 the antimaterialistic, escapist attitude as a reaction to bourgeois mercantilism and the fleeting quality of urban existence had found its international expression in Symbolism.[58] The Symbolist aesthete, with his distinguished sensitivity, saw himself only too gladly as the "pauvre imbécile d'un autre âge."[59]

Correspondingly, the pre-classical periods—or "primitive" as they were then called—were transfigured into eras in which a picture was more than a portable window with the illusion of reality, having also a fixed connection to the wall. This was the only way for the term "decorative" to obtain a quasi-spiritual dimension, which went much further than simple ornamentation: "Decorative painting is, strictly speaking, the true art of painting. Painting can be created only to decorate with thoughts, dreams, and ideas the banal walls of human edifices. The easel-picture is nothing but illogical refinement invented to satisfy the fantasy or the commercial spirit in decadent civilizations. In primitive societies, the first pictorial efforts could only be decorative."[60]

For similar reasons, Klimt expressed his dissatisfaction with the modern art system in his opening speech at the 1908 Kunstschau: "It is well known that we do not perceive the exhibition as the ideal form for creating contacts between the artist and his audience, the realization of major public activities would be much more valuable to us for this purpose."[61] Scholarship has thoroughly investigated Klimt's stylistically close relationship to the Belgian Symbolists, such as Jan Toorop and Fernand Khnopff. However, it has thus far been overlooked that his Byzantine artistic habitus had its roots in the prophetic self-stylization of a Joséphin Péladan. The Symbolist critic, novelist, and mystic was the founder and Sâr (a title given to the Assyrian kings) of the "Ordre de la Rose + Croix Catholique du Temple et du Gral," which organized international salons in Paris between 1892 and 1897 with artists such as Gauguin, van Gogh, and Bernard. His external appearance, as shown in a portrait by Alexandre Séon (*right*), could be the exact image of Klimt, and the blue satin caftan should be proof enough that Klimt's archaic clothing did not originate principally in the practical Viennese reform fashion created by his friend Emilie Flöge.

The cultural historian Nicholas Green showed, in an excellent essay on the economic context of modern painting in Paris, how, in the late nineteenth century, the main criterion for works of art moved away from "the rarity of the object to the singularity of the artist."[62] There, it was the critical category of the temperament that could

Alexandre Séon, *Portrait of Le Sâr Mérodack Joséphin Péladan*, 1891, Musée des Beaux-Arts, Lyon

reconcile the landscape painter with the demands of the market. With Klimt, spiritual and material values converge primarily in the decorative works of his "golden period."

1 Friedrich Schlegel, "Ideen," in *Werke in einem Band*, Die Bibliothek der deutschen Klassiker (Vienna and Munich, 1971), 23:107.
2 Berta Zuckerkandl, "Die Klimt-Affäre," in *Zeitkunst: Wien 1901–1907* (Vienna and Leipzig, 1908), 165.
3 Berta Zuckerkandl-Szeps, "Eine reinliche Scheidung soll sein," in *Gustav Klimt: Die Goldene Pforte. Wesen – Werk – Wirkung*, ed. Otto Breicha (Salzburg, 1990), 92
4 After the "Klimt Group" left the Secession in 1905, Klimt exhibited his works principally in the Miethke Gallery. Cf. Werner J. Schweiger, "Damit Wien einen ernsten Kunstsalon besitze: Die Galerie Miethke unter besonderer Berücksichtigung von Carl Moll als Organisator," *Belvedere: Zeitschrift für bildende Kunst* 2 (1998), 64–83.
5 The exhibition artist has to accept the lofty but unsecured legacy of the court artist. Cf. Oskar Bätschmann, *The Artist in the Modern World: The Conflict Between Market and Self-Expression* (New Haven, 1997); and

Martin Warnke, *Hofkünstler: Zur Vorgeschichte des modernen Künstlers* (Cologne, 1985).

6　The major industrialist August Lederer, a friend and patron of Klimt's, provided him with the necessary funds (30,000 crowns) to repurchase the painting and, for this, received *Philosophy*. The paintings *Medicine* and *Jurisprudence* were purchased by Klimt's painter colleague Kolo Moser between 1910 and 1912. After changes in ownership, all three came into the possession of the Österreichische Galerie Belvedere. In 1945 they were destroyed by fire at Schloss Immendorf (Lower Austria), where they had been taken for safekeeping. For information on the history of the faculty paintings, see Alice Strobl, "Zu den Fakultätsbildern von Gustav Klimt," *Albertina Studien* 4 (1964), 138–69.

7　In her reflections on "discursive space," Krauss proposed the theory that modernist works internalize their display medium and, therefore, tend to be flat. Rosalind E. Krauss, *The Originality of the Avant-Garde and Other Modernist Myths* (Cambridge and London, 1985), 133.

8　Wolfgang Kemp, *Der Anteil des Betrachters: Rezeptionsästhetische Studien zur Malerei des 19. Jahrhunderts* (Munich, 1983), 116.

9　Gottfried Semper, *Wissenschaft, Industrie und Kunst* (Mainz and Berlin, 1966), 40.

10　Pierre Bourdieu, *Die Regeln der Kunst: Genese und Struktur des literarischen Feldes* Frankfurt am Main, 1999), 261f. Broch, however, had already claimed that: "'L'art pour l'art' and 'business is business' are two branches of the same tree." Hermann Broch, *Hofmannsthal und seine Zeit: Eine Studie*, ed. Paul Michael Lützeler (Frankfurt am Main, 2001), 22.

11　Carl E. Schorske, *Fin-de-siècle Vienna: Politics and Culture* (New York, 1980), 215.

12　Moll interpreted the poster in the following way: "Theseus, the symbol of youth, has conquered Indifference!" Carl Moll, "Osterstimmung im Wiener Kunstleben," in *Osterbeilage der Wiener Allgemeinen Zeitung*, 1898, cited from Marian Bisanz-Prakken, *Heiliger Frühling, Gustav Klimt und die Anfänge der Wiener Secession 1895–1905*, (Vienna and Munich, 1999), 211.

13　Cited from Hansjörg Krug, "Gustav Klimt: 'Nuda Veritas' / 1899," in Oskar Pausch, ed., *Nuda Veritas Rediviva: Ein Bild Gustav Klimts und seine Geschichte*. Mimundus 8, Wissenschaftliche Reihe des Österreichischen Theater Museums, Vienna (Cologne and Weimar, 1997), 10. Bahr, as an influential member of the literary movement "Jung-Wien" had already anticipated, in 1896, a possible solution for the divergences that had become public: "There is no other alternative, some patrons of the arts will have to rent a couple of bright halls, somewhere in the city, and show the Viennese, in small intimate exhibitions, every six weeks or so, what is happening artistically in Europe." See "December 1896" in Hermann Bahr, *Secession* (Vienna, 1900), 2.

14　Hermann Bahr, "Vereinigung bildender Künstler Österreichs: Secession," in *Ver Sacrum* 1 (1898). Cited from ibid., 12f.

15　Ibid., 13. In the statutes, signed by Gustav Klimt, it was demanded "that the exhibitions be placed on a purely artistic basis, free from market character," which appeared to be incompatible with the practices of the Künstlerhaus. Christian Nebehay, ed., *Gustav Klimt: Dokumentation* (Vienna, 1969), 135.

16　In the terminology of French art criticism, used in connection with the Salons of the nineteenth century, one often encounters terms like "grande boutique d'image," "grand marché de l'art," "charactère mercantile," "bazaar," "entrepot," or "hangar." This reproach can only have come into use after the opening of the Salon for non-academicians in 1791, due to the ever-growing number of exhibits (including an increase in the "lower" kinds, such as genre and landscape painting) that were offered for sale, whereas in the pre-revolutionary system, most works were commissions.

17　It is not very well known that Karl Marx recognized the fetish character of goods during his visit to the First World's Fair in London in 1851, where industrial products were displayed, isolated from their utility value, like works of art. The goal of the artist must be to maintain the special status of art, by developing strategies which counteract its capitalist metamorphosis into a fetish or good. See Yves-Alain Bois, "Exposition: Esthétique de la distraction, espace de démonstration," in *Les Cahiers du Musée National d'Art Moderne* 29 (fall 1989), 57–79.

18　Kemp, *Anteil des Betrachters*, 113.

19　In the Jubilee Exhibition in the Künstlerhaus in 1898, the exhibits included works by Monet, Rodin, Besnard, Puvis de Chavannes, Klinger, and Liebermann, who were regarded by the Secession as "officers of modern art" "…these names, and the whole thing is just a huge bazaar! It's just like being at an auction, screaming wenches put their goods on offer and nowhere can one come to a pure feeling." Hermann Bahr, "April, 1898," in *Secession*, 47.

20　Richard Muther, "Wiener Kunstleben," in *Die Zeit*, December 30, 1899, 202.

21　Henriette Feuerbach, ed., *Ein Vermächtnis von Anselm Feuerbach* (Munich, 1920), 249f.

22　Brian O'Doherty, "In der weissen Zelle = Inside the White Cube," in *Artforum* (1976), 13.

23　The number of visitors is quoted from Eva Pöschl, "Der Ausstellungsraum der Genossenschaft bildender Künstler Wiens 1873–1913" (diss., University of Graz, 1974), 59.

24　For information on how art dealers functioned as producers from the conception, over presentation and marketing, to sales, see Christian Huemer, "Charles Sedelmeyer (1837–1925): Kunst und Spekulation am Kunstmarkt in Paris," *Belvedere: Zeitschrift für bildende Kunst* 2 (1999): 4–19. That the Secessionists really did position themselves against Sedelmeyer's style of art management in the Künstlerhaus is shown by insinuations from Hermann Bahr such as: "…and our Klingers and Whistlers are apparently called Munkácsy and Brožik!" Both were represented by Sedelmeyer in Paris and shown, in flamboyant fashion, in the Künstlerhaus.

25　Ludwig Hevesi, "Michael von Munkácsy," in *Altkunst Neukunst: Wien 1894–1908*, ed. Otto Breicha (Klagenfurt, 1986), 573.

26　Walter Benjamin, "Das Kunstwerk im Zeitalter seiner technischen Reproduzierbarkeit," in *Gesammelte Schriften*, ed. R. Tiedemann and H. Schweppenhäuser (Frankfurt am Main, 1974), I:497.

27　Marian Bisanz-Prakken, "Programmatik und subjektive Aussage im Werk von Gustav Klimt," in *Wien 1870–1930: Traum und Wirklichkeit*, ed. Robert Waissenberger, (Vienna and Salzburg, 1984), 114f.

28　Arthur Schopenhauer, *Sämtliche Werke* (Munich, 1913), vol. 5, *Parerga und Paralipomena*, chap. 31, § 379, 711.

29　Gustav Klimt, Eröffnungsrede der "Kunstschau 1908," cited from Breicha, *Goldene Pforte*, 138.

30　Franco Borsi and Ezio Godoli, *Wiener Bauten der Jahrhundertwende: Die Architektur der habsburgischen Metropole zwischen Historismus und Moderne* (Stuttgart, 1985), 73.

31　Karl Kraus's criticism of the Secession is coupled with anti-Semitism: "Just as every aristocrat used to have his domestic Jew, every stockbroker has his domestic-Secessionist. Herr Moll, as is well known, the art dealer for jobber-broker Zierer and the coal profiteer Berl, and Herr Klimt is permitted to instruct Frau Lederer in secessionist painting…. Who can be surprised that, with the increasing intimate relationship between the Secession and the stock-exchange, the mercantile spirit of this flock of artists is becoming increasingly active?" *Die Fackel* 59 (Nov. 1900), 19f.

32　See also: Ludwig Hevesi, *Ver Sacrum* 1, no. 5, May, 1898.

33　Krug, "Nuda Veritas," op. cit., 12.

34　In 1908, Klimt sold the portrait of Emilie Flöge to the Niederösterreichische Landesmuseum for the sum of 12,000 crowns with the remark: "The price is that which I receive today for a portrait commission." See Wolfgang Krug, "Die Kunstsammlung des Niederösterreichischen Landesmuseums," in *Waldmüller-Schiele-Rainer, Meisterwerke des Niederösterreichischen Landesmuseums vom Biedermeier bis zur Gegenwart*, exh. cat. (Vienna and Munich, 2000), 7; and Tobias G. Natter, "Fürstinnen ohne Geschichte? Gustav Klimt und die Gemeinschaft aller Schaffenden und Geniessenden," in *Klimt und die Frauen*, ed. Tobias G. Natter and Gerbert Frodl, exh. cat. (Vienna and Cologne, 2000), 63.

35　For information on the negation of economy in the artistic field, see Pierre Bourdieu, "La production de la croyance," in *Actes de la recherche en sciences sociales* 13 (February 1977), 4–43.

36　Max Burckhard, "Ver Sacrum," in *Ver Sacrum* 1 (1898), cited from Bisanz-Prakken, *Heiliger Frühling*, 210.

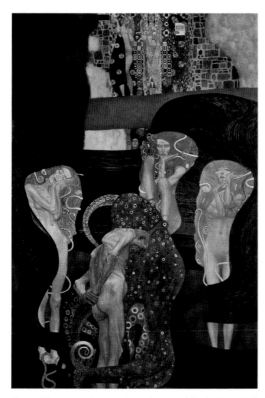

Gustav Klimt, *Jurisprudence*, 1902/07, ceiling panel for the Great Hall
at the University of Vienna, lost in a fire at Schloss Immendorf,
Lower Austria, in 1945

37 Ludwig Hevesi, "Ver Sacrum" (February 15, 1898) in *Acht Jahre Sezession: Kritik —
 Polemik — Chronik,* ed. Otto Breicha (Klagenfurt, 1984), 8.
38 Hermann Bahr, "Meister Olbrich" (October 1898) in *Secession,* 63.
39 Ernst Stöhr, "Katalog der XIV. Ausstellung der Secession" (Vienna, 1902),
 cited from Bisanz-Prakken, *Heiliger Frühling,* 214.
40 Hevesi, "Ver Sacrum," 390.
41 Breicha, op. cit., 157.
42 Werner Hofmann, "Gesamtkunstwerk Wien," in *Der Hang zum Gesamtkunstwerk:
 Europäische Utopien seit 1800,* ed. Harald Szeemann, exh. cat., (Aarau and Frank-
 furt am Main, 1983), 92.
43 Schorske, *Wien,* 254.
44 *Die Kunst für Alle* 15 (1900): 500.
45 That Klimt was acquainted with Schopenhauer's philosophy indirectly
 through his study of Wagner's essay on Beethoven or through conversations
 with Hermann Bahr and other ardent Schopenhauer admirers in his circle is,
 in my opinion, obvious even though there is no unequivocal evidence for
 this. See, in particular, Peter Vergo, "Gustav Klimts Philosophie und das
 Programm der Universitätsgemälde," *Mitteilungen der Österreichischen Galerie*
 22/23, no. 66/67 (1978/79): 69—100, or, more recently, "Between Modernism and
 Tradition: The Importance of Klimt's Murals and Figure Paintings," in *Gustav*

 Klimt: Modernism in the Making, exh. cat. (New York, 2001), 19—40; and
 Bisanz-Prakken, "Programmatik," 110—20.
46 *Wiener Tagblatt,* March 27, 1900, quoted from Strobl, "Zu den Fakultäts-
 bildern," 153.
47 Ferdinand Feldegg, "Gustav Klimts Philosophie und die Cultur-
 umwertung unserer Tage," in *Der Architekt: Wiener Monatshefte für Bauwe-
 sen und Decorative Kunst* 6 (1900), 23—26.
48 Hans-Georg Gadamer, *Wahrheit und Methode* (Tübingen, 1975), 70. For the
 antinomy of the notions allegory-symbol, see, in particular, Paul de
 Man, *Die Ideologie des Ästhetischen* (Frankfurt am Main, 1993) 83—105.
 Benedetto Croce describes the symbol as "a synonym for intuition";
 the allegory on the other hand, "is science or art, which creates
 knowledge." Benedetto Croce, *Gesammelte philosophische Schriften in deutscher
 Übertragung,* ed. Hans Feist, I. Reihe 1: Aesthetik als Wissenschaft vom
 Ausdruck und allgemeine Sprachwissenschaft. Theorie und Ge-
 schichte (Tübingen, 1930), 37.
49 Karl Kraus, *Die Fackel* 36 (March 1900), 19.
50 Peter Altenberg, "Individualität," in *Die Wiener Moderne: Literatur, Kunst
 und Musik zwischen 1890 und 1910,* ed. Gotthart Wunberg (Stuttgart,
 1981), 425.
51 Manuscript in the Library of the City of Vienna, cited from Breicha,
 Goldene Pforte, 33.
52 According to Bourdieu the antagonism prophet—priest is the equi-
 valent of the medieval difference between "auctor" and "lector." See
 Pierre Bourdieu, "Une interprétation de la sociologie religieuse de Max
 Weber," *Archives européennes de sociologie* 12, no. 1 (1971), 3—21; and "Genèse et
 structure du champ religieux," *Revue française de sociologie* 12 (1971),
 295—334.
53 Cf. Klaus Albrecht Schröder, "Zur Typologie des Selbstportraits in
 Wien zwischen 1900 und 1918," in *Sehnsucht nach Glück: Wiens Aufbruch in die
 Moderne: Klimt, Kokoschka, Schiele,* ed. Sabine Schulze, exh. cat. (Frankfurt
 am Main and Osterfildern-Ruit, 1995), 235—51.
54 Benjamin, "Kunstwerk im Zeitalter," 479.
55 Ruth E. Iskin, "Selling, Seduction, and Soliciting the Eye: Manet's Bar
 at the Folies-Bergère," *Art Bulletin* 77, no. 1 (March 1995), 25—44; and Paul
 Wood, "Commodity," in *Critical Terms for Art History,* ed. Robert S. Nel-
 son and Richard Shiff (Chicago and London, 1996), 257—80.
56 Walter Benjamin, "Das Paris des Second Empire bei Baudelaire," in *Ge-
 sammelte Schriften,* ed. R. Tiedemann and H. Schweppenhäuser (Frank-
 furt am Main, 1974), 1:557.
57 Emil Pirchan, *Gustav Klimt* (Vienna, 1956), 29.
58 The artistic self-identification as a prophet is, therefore, not merely a
 phenomenon restricted to the Viennese fin-de-siècle but found in the
 idealistic avant-garde; consider Paul Gauguin and the group of the
 "Nabis" (Hebrew: prophets). The artistic identity of the Viennese
 Secession was described with the utmost terseness in the poem writ-
 ten for the solemn inauguration of the artists' colony organized in
 Darmstadt by Joseph Maria Olbrich: "Are you greatness, master in
 spirit/Leader and seer, the master: then stay/Are you the knowing,
 the solving, the freest:/Then up, perform your duty, divide/with a
 mighty movement, the cloth, unveil/the secret for us, here is
 your cathedral!" Cited from Bätschmann, *Ausstellungskünstler,* 163 f. For
 information on the ideology of Symbolism, see Patricia Mathews,
 Passionate Discontent: Creativity, Gender and French Symbolist Art (Chicago and
 London, 1999).
59 G.-Albert Aurier, "À propos de l'Exposition universelle de 1889," in
 Oeuvres posthumes, ed. Remis de Gourmont (Paris, 1893), 342, cited from
 Mathews, *Passionate Discontent,* 32.
60 G.-Albert Aurier, "Symbolism in Painting: Paul Gauguin" (1891), quot-
 ed from H. Chipp, *Theories of Modern Art* (Berkeley, 1968), 92.
61 Gustav Klimt, Eröffnungsrede der "Kunstschau 1908," quoted from
 Breicha, *Goldene Pforte,* 137.
62 Nicholas Green, "Dealing in Temperaments: Economic Transfor-
 mation of the Artistic Field in France during the Second Half of the
 Nineteenth Century," *Art History* 10, no.1 (March 1987): 59—78.

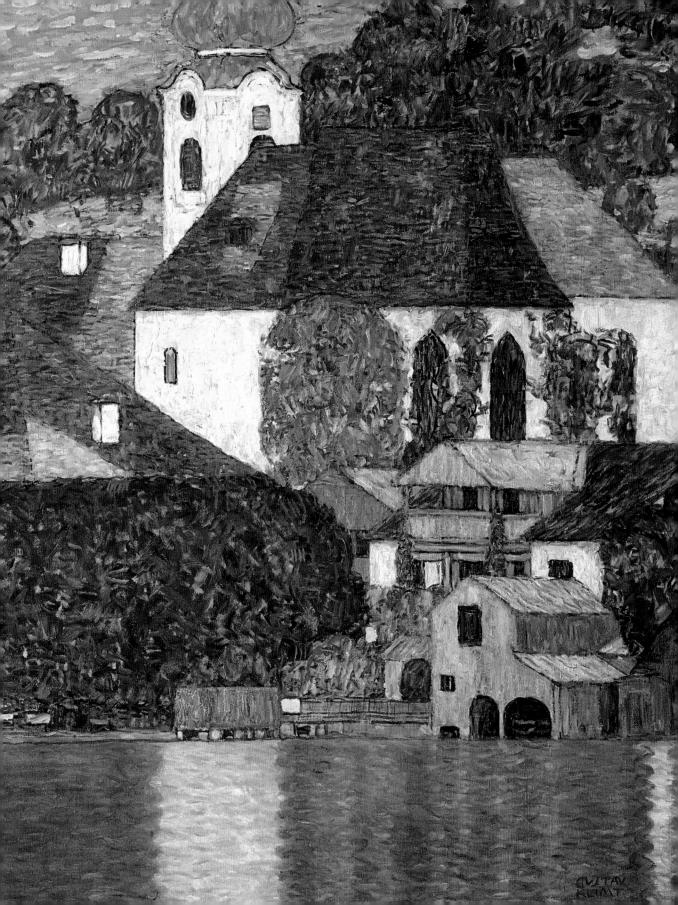

Klimt's Landscapes and the Telescope

Anselm Wagner

In the concluding chapter of the picture story *Plisch und Plum* (Ker and Plunk) by Wilhelm Busch (1832–1908), published in 1882, an eccentric guest appears. Clad in fine tweed and wearing a pith helmet he strides through the German heath with his telescope poised:

> Traveling in this neighborhood,
> A chap whose wealth is more than good,
> In his hand, a telescope,
> Comes this Mister, known as "Hope."
> "Why not," — and here it's Hope who's talking—
> "Watch distant things, the while I'm walking?
> It's lovely *there*, as like as not,
> And I am *here*, no matter what!"[1]

Wilhelm Busch, *Mr. Hope*, illustration in *Ker and Plunk* (Heidelberg, 1882)

Of course exploring nature in this way cannot be without mishap for long. Mr. Hope tumbles into a pond, the dogs Ker and Plunk retrieve his pith helmet and telescope, and this makes such an impression on the wealthy Englishman that he immediately buys both animals from their owner for a vast sum—thus sealing the social advancement of the two pooches and leading to the story's happy ending.

If we take Mr. Hope to mean more than his function in Busch's story then he is an apt symbol of an aesthetic concept characterizing the early modernists from the nineteenth through the early twentieth century. In the character of Mr. Hope, Busch goes far beyond the cliché of the rich Englishman who is both distinguished and eccentric.[2] Mr. Hope is the colonial and Victorian variation of *homo aestheticus*. He prefers the technically produced view into the distance to the walker's immediate experience of nature. His gaze into the distance arises not from the drive of a scientist or huntsman but the need for aesthetic enjoyment, for beauty: "It's lovely *there*, as like as not,/ And I am *here*, no matter what!" "Here" may also be lovely but the lack of distance to "here" makes purely aesthetic viewing impossible. "Here" is space but it is not a picture. Becoming a picture presupposes distance. Now "there" or "elsewhere," the distance on the edge of the horizon, can also be seen with the naked eye. Essentially, this was the concept behind all European landscape painting from the Renaissance: creating from a distance a panorama of a wide, traversable landscape, ranging from the tree at the edge of the path to the faraway horizon and stratified into fore-, middle, and background. Mr. Hope is more radical in this respect. He fades out the fore- and middle ground and concentrates only on the background, which becomes for him his sole focus. "Elsewhere" only becomes truly beautiful when one surrenders totally to distance, draws it up close, and utterly immerses oneself in it—even at the cost of becoming calamitously blind to all that is close at hand as a result of this tunnel vision. This surrendering, however, is purely optical, and any form of tactile or whole body experience is excluded (indeed, as the fall into the pond reveals, this only hampers optical perception). In this respect, Mr. Hope is a brilliant caricature of the

modernist idea of the art viewer *avant la lettre* as envisaged by Clement Greenberg: a pure, bodiless eye and a monocular one at that. "Where the Old Masters created an illusion of space into which one could imagine oneself walking, the illusion created by a modernist is one into which one can only look, can travel through only with the eye."[3] The image that Mr. Hope sees through his telescope in fact has an essential characteristic of modern painting (according to Greenberg, the quintessential characteristic):[4] it is flat, at least considerably flatter than an open landscape seen through the naked eye. The magnifying lens condenses tiers of space, optically compressing objects into a single, shallow layer that in reality are far apart, and making objects appear diminished in volume. Busch already exposes this abstract "traveling eye" of the Greenberg mold as that which postmodern, feminist, and post-colonialist critique later discovered it to be: in truth it is white, Western, male, and middle-class.

Now the Busch-Greenberg connection may, on account of the great distance in period and subject-matter between the two, appear all too associative, and admittedly Greenberg makes no mention of a distant image. This term, however, plays a central role in the art theory of the German sculptor Adolf von Hildebrand (1847–1921), whose rigorous observation of art as a purely optical and formal phenomenon ultimately reached Greenberg by way of the Viennese art historian Alois Riegl (1858–1905).[5] Astonishingly for a sculptor, Hildebrand demanded in his *Problem der Form in der bildenden Kunst* (The Problem of Form in Fine Art), composed between 1888 and 1893,[6] that painters and sculptors translate their impression of nature into pure planar images. This literally pictorial planar image he terms a "distant image," because from close up nature is experienced in a less optical and more haptic way and cannot be grasped at one glance, whereas in the distance it flattens out to a purely optical and thus pictorial phenomenon.[7] In order to attain this purely planar distant image, Hildebrand even advised closing one eye because there are always elements of the near view in stereoscopic vision.[8] The task of every artist was therefore "to remove what is tormenting from the cubic form,"[9] which means transforming it into a flat distant image. Mr. Hope would be in agreement with Hildebrand to the extent that he

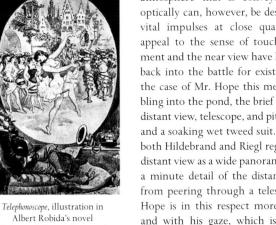

Telephonoscope, illustration in
Albert Robida's novel
The Twentieth Century (Paris 1883)

gazes into the distance with one eye to procure the pleasure of untormented beauty.

Riegl not only adopted from Hildebrand the contrasting couplet of the haptic near view and optical distant view but also the aesthetic preference for the latter. For him the distant view was a prerequisite for atmosphere, the central content of modern art: "This notion of law and order over chaos, harmony over dissonance, tranquility over movement we call atmosphere. Its elements are tranquility and the distant view."[10] This atmosphere that is conveyed purely optically can, however, be destroyed by vital impulses at close quarters that appeal to the sense of touch: "Movement and the near view have hurled me back into the battle for existence."[11] In the case of Mr. Hope this meant: tumbling into the pond, the brief loss of the distant view, telescope, and pith helmet, and a soaking wet tweed suit. Of course both Hildebrand and Riegl regarded the distant view as a wide panorama and not a minute detail of the distance gained from peering through a telescope. Mr. Hope is in this respect more modern, and with his gaze, which is detached from his walking body by an optical instrument, he is closer to Greenberg's abstract eye than to Hildebrand's and Riegl's distant image.

The separation of body and gaze by means of a telescope has the advantage for the viewer that he remains invisible to what he sees. Whether hunter, military scout, or voyeur, the observer has the privilege of invading something hidden, something that is not aware of this penetration and lingers in the naïveté of seclusion. This voyeuristic concept also has a long tradition in aesthetic discourse. As Michael Fried demonstrated, Denis Diderot (1713–84), the French philosopher and art critic, had already demanded that painters render their figures as if they were oblivious of being observed by the beholder of the picture.[12] Fried conveyed in this way, as Helmut Draxler established, "the original scene of the phantasm of 'pure vision'," which plays a central role in Fried's modernism that rejects all theatricality.[13] However, in this mode of "seeing in order not to be seen," Draxler identifies "the epitome of middle-class imagination."[14]

Seeing into the distance without being seen is one of the essential traits of television. At Mr. Hope's time this was still a vision of the future, although it already existed in

the minds of researchers and inventors and had been discussed both at a popular and literary level since the 1880s. A year after *Ker and Plunk*, Albert Robida's science fiction novel *The Twentieth Century* was published.[15] The novel describes "telephonoscopes" (*opposite*), which project the erotic and exotic from far-off countries live into the middle-class living room and are a staggeringly exact prediction of the television society. In this way, a lady enjoys the opera from her bed or a bachelor relishes the charms of scantily clad dancers. The picture telephone was based on the idea of interconnection and in the visions of Robida and, later, Jules Verne this would especially be a way for separated lovers to communicate with each other, not only acoustically but also optically. It is interesting that in most of these utopias and utopian caricatures the distant image holds an erotic fascination, the longing of the (usually male) subject for something distant that always turns out to be a yearning for the far-off female object, which appears to him as a live image.[16] The faraway lady of courtly love now becomes graspably close without forfeiting the allure of distance. Our Mr. Hope, however, is a far cry away from this—he has completely sublimated his sexuality with his (phallic) telescope, which he uses to satisfy his craving: the craving for "elsewhere" and for beauty. This behavior has obvious imperialist connotations. The colonialization of large parts of the world from the mid-nineteenth century onward was driven ahead by researchers, explorers, and capitalists whose characteristics are united in the topee-clad Mr. Hope as the representative of the preeminent colonial power. His desire for the distant view corresponds with the need arising from the increasing globalization of economies and politics to combat distances with new technologies like the telegraph[17] or telephone.[18] The technical attempts to follow these with tele-images in the same way date back to 1843.[19] The talk was of "electrical telescopy" and as early as 1884 an "electrical telescope" was patented in Berlin. The German term for television, *Fernsehen*, emerged for the first time in 1891. It was to be another thirty-five years until the BBC's first experimental television broadcasts, but the feverish efforts of researchers and the accompanying discussions in literature and printed media meant that from the 1880s onward, television was an important technical hope for the future. Of course the

Walter Pichler, *TV-Helmet* (*Portable Living Room*), 1967, object made of polyester with a TV set, painted, Generali Foundation, Vienna

television picture differs from the telescope image because there are no optical changes in the former. The shortening of distance is not visible in the television picture so that the fading out of the immediate vicinity—and thus the loss of reality—is more complete.

A combination of telescope and television was constructed by the Austrian artist Walter Pichler (*left*). A television screen was mounted at the end of a tube which, when placed over the head, guaranteed tunnel vision with no distractions. This portable construction also allowed the wearer to watch television while walking around, presumably with consequences that would be just as calamitous as those experienced by Mr. Hope. In fact the excursions into cyberspace that we embark on today by donning the "data pith helmet" are the perfect solution to Mr. Hope's longing for a virtual "elsewhere" that can be entered only optically.

The topicality of the aesthetic attitude personified by Mr. Hope is therefore unbroken. If it is correct that this is a symptomatic value for the early modernists, this must be reflected in the art of that time. Standing for many indirect references are the cited theory and sculptures by Hildebrand. A direct realization of Hope's "telescope aesthetics" seems conversely to have occurred only once.

In the summer of 1915, Gustav Klimt sent a postcard to his sister Hermine in Vienna from his holiday abode on the Attersee in the Upper Austrian Salzkammergut: "Arrived safe and well. Forgot opera glasses—need urgently. Helene will bring them with her. Regards Gustav."[20] The photo shows Villa Paulick in Seewalchen on the Attersee which Klimt often frequented[21]—not a glimmer of an opera or theater anywhere. Why then did the painter need this educational bourgeois gadget so "urgently" in the country? His niece Helene Donner was quoted in 1969 by Christian Nebehay as having said that Klimt used opera glasses when he was painting his Attersee landscapes.[22] Strangely enough, Nebehay did not analyze this reference further. When Johannes Dobai studied Klimt's landscapes nine years later he tried to explain the specific aesthetics of the painting *Orchard with Roses* (plate 43)—albeit in a more metaphorical form: "Just as a fragment of nature that we have selected ourselves with a telescope appears to be a compact whole, this painting seems to convey a fragment of the universe with a harmony akin to music. It is

more than a coincidence that Klimt appears to have painted some of his landscapes with a telescope or used a viewing frame." The "viewing frame" (see p. 40), a small square frame made of card or ivory, was used by Klimt on his expeditions to seek out landscape motifs, like many *plein-air* painters of his day.[23] In the cited monograph on Klimt's landscape paintings published in 1978 and 1981, Dobai places the telescope on a par with the viewing frame and reduces it to its function of presenting a detail as a totality. He mentions the main function of the telescope—making distant objects appear close and concentrating them optically into one plane—only briefly in the catalogue raisonné of 1967.[24] Yet this is a phenomenon that strikes the viewer of Klimt's landscapes immediately and is mentioned by all commentators: their pronounced planarity. Fritz Novotny refers to the "large forms, flat as a stage set, having only the effect of silhouettes,"[25] of "par-

we used photographs taken with a focal length of thirty to forty millimeters, which roughly corresponds to the natural field of vision and a focal length of 250 millimeters (telelens) to simulate the "opera glasses effect."

The slice of landscape chosen for *Church at Unterach on the Attersee*, without sky or wide panorama as is almost always the case with Klimt, suggests that the painter/viewer was relatively close to the buildings. In 1968 Nebehay sought out this spot in a boat, supposedly fifty meters away from the bank, and took a photograph of it that he reproduced in his documentation next to Klimt's painting. At a glance it can be seen that it is impossible for Klimt to have painted his picture from this vantage point. The church steeple rises into the sky, so the chosen position was much too low. We doubled the distance until the steeple was backed completely by the range of hills (*below left*). However, from here also the viewpoint seems too low: the houses in front

 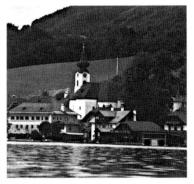

Unterach am Attersee, photograph (standard lens), from a distance of 100 m, 1988

Unterach am Attersee, photograph (standard lens), from a distance of 300 m, 1988

Unterach am Attersee, photograph (telephoto lens), from a distance of 300 m, 1988

allel tiers like theater scenery";[26] Nebehay notes the "flat houses placed in rows as if chopped from a child's cut-out sheet."[27] Of course planarity is a feature of almost all (landscape) painting around 1900, and nobody would ever mainain that this was all the result of using telescopes and opera glasses. The assertion that Klimt indeed used opera glasses can only be proven if he painted something that would have been invisible to the naked eye.

While preparing for the exhibition *Inselräume: Teschner, Klimt und Flöge am Attersee* in 1988 at the Villa Paulick in Seewalchen, Alfred Weidinger and I put this to the test.[28] We selected the painting *Church at Unterach on the Attersee* of 1916 (plate 53) because the architecture and vegetation in this motif have hardly changed since Klimt's day. To verify this

almost totally conceal the church walls, and the meadow on the left in the background of Klimt's painting can hardly be seen. In addition, the cubic effect of the building and the diagonal vanishing lines contradict the strict orthogonal structure in Klimt's painting. From this position he would not only have had to stylize the architecture and landscape but also redesign and supplement it to result in this arrangement. The photograph in the center shows the same view from the same direction, but this time from a distance of about three hundred meters. The overlappings now correspond more with the painting, the roof ridge of the inn and the eaves of the church roof now follow one line, and the overall image has become much flatter due to the increased distance. How-

ever, the field of vision has expanded to such an extent that smaller details like the landing stage, precisely rendered in the painting, can no longer be detected with the naked eye. At this point, according to the hypothesis, Klimt would have had to reach for his opera glasses. We simulated this with a telephotograph from the same position (*opposite page, far right*). Here the section of the scene has again been compared with the painting, and the details are now clearly distinguishable. Above all, the three spatial zones of water, village, and hill have been compressed into a flat layer.

We could well have contented ourselves with this result. On closer analysis, however, we discovered several details that could not really be explained. The row of trees on the top left of the painting is concealed by the roof of the inn in the telephotograph. Similarly, the roof that protrudes between the inn and the church is not as high as in Klimt's landscape. Is it really conceivable that the artist, who here, as in other works, was meticulously faithful to the motif, conjured up additions to the scene or changes that would have entered his field of vision from further away? In addition, it seemed highly dubious that Klimt really painted from a boat, something which Marie-José Liechtenstein and later Nebehay and Dobai had assumed.[29] His more than one-square-meter canvas would have reacted like a small sail to every gust of wind, not to mention the constant rocking and motion of the waves. As Klimt almost never did preliminary drawings and studies for his landscapes but started painting directly onto the canvas in situ, he would have been exposed to such disturbances. It is hard to believe that he tolerated this, bearing in mind his notorious sensitivity and the total peace and quiet which he needed to paint.[30] As we found out in our experiment, it is virtually impossible to use opera glasses in a rocking boat. If we assume that Klimt used an optical instrument then it was from steady ground. The only possible location for this is from the opposite bank near Weissenbach, a distance of over two kilometers. With the naked eye the houses at Unterach have shrunk to tiny dots, which would render even the best opera glasses useless in providing the necessary enlargement. Klimt would have needed to ask for a telescope of the same caliber as Mr. Hope's from Vienna, of which there had hitherto been no mention in the sources.

Fortunately, Alfred Weidinger then made an important discovery. During his investigations at Villa Paulick he stumbled upon a photograph of 1904 showing Klimt on the villa's landing stage with a telescope and tripod in front of him (*above*). The wooden stand was even found in

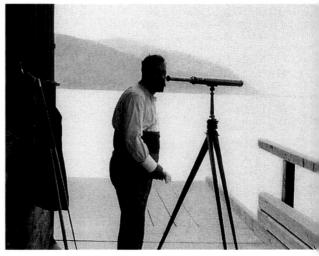

Gustav Klimt with a telescope on the landing stage at Villa Paulick in Seewalchen, 1904

the villa's attic, and we exhibited it in the aforementioned exhibition of 1988. From the photograph, Weidinger roughly identified Klimt's telescope, and with a similar model of 1905 with tenfold magnification he managed to find the spot where Klimt probably painted *Church at Unterach on the Attersee*. The picture illustrated on page 166 shows a photograph taken through this telescope that was set up on the lake's bank one kilometer south of Weissenbach and directed along exactly the same line toward Unterach as the previous positions of our boat. Now, the trees on the left, thicker in Klimt's day but in exactly the same position, emerge at the same height as the church steeple. The section of roof overlapped by the inn and church has a height which corresponds with the painting.

This proof that Klimt had painted the *Church at Unterach on the Attersee* from the opposite bank using a telescope[31] encouraged us at that time to hypothesize that the other views of Unterach had been created in the same way (plates 52, 58). Greater changes to architecture and trees meant that it was more difficult to find evidence for these paintings, but the planar, stacked *Houses at Unterach on the Attersee* (plate 52) betray the same telescope optics as the buildings of the *Church at Unterach on the Attersee*. For Klimt, this method was by far the most practical because in the summers of 1915 and 1916 he lived in the forester's house in Weissenbach[32] and worked daily on a number of paintings for a few hours at a time.[33] Long boat rides are hardly suitable for the rapid change in location that this would have

entailed. Later, Weidinger proved that a telescope was used also for earlier paintings: for *Schloss Kammer on the Attersee I* (1908, plate 33) and *Schloss Kammer on the Attersee II* (1909, plate 34) as well as for the two paintings from Lake Garda of 1913, *Church in Cassone* (plate 44) and *Malcesine on Lake Garda* (plate 46). All of these are buildings by a lake that were painted from the opposite bank.[34] Particularly impressive is the comparison of *Schloss Kammer on the Attersee I* with the actual motif: "Gustav Klimt certainly painted this picture from the sun deck of the boathouse at the Villa Oleander. It was only possible from this vantage point to find the pictorial motifs in this constellation. Klimt looks over the broad expanse of Attersee to Schloss Kammer…. The facade … is reflected in the smooth surface of the lake's water. The same applies to the striking steeple of Seewalchen church. Nobody seems to have an inkling that

Unterach am Attersee, photograph taken through a telescope from the opposite bank, 1988

between the mansion and the church there is an expanse of lake measuring eight hundred meters …. Klimt shortens the distance between mansion and church to a minimum."[35] As Verena Lobisser demonstrated in a photograph taken using a telephoto lens in August 2001 (*right*), the chosen prospect from the boathouse is slightly too low. Lobisser therefore presumes that Klimt painted the landscape from a window on the first floor. It can be assumed that all of the artist's Schloss Kammer depictions were translated onto canvas with the help of a telescope.[36] This also applies to *The Litzlbergkeller on the Attersee* of 1915/16 (plate 50). Previously, Weidinger and I had presumed that it was the sole Attersee landscape painted from an angle that could have been achieved only in a boat, and that in this instance Klimt used postcards and photographs.[37] But here also Lobisser managed to find the right spot on the opposite bank.

At this point the question springs to mind of whether Klimt could have simulated the telescope effect with his own photographs taken with a telelens. Klimt was an enthusiastic amateur photographer,[38] and in his early period around 1890 he frequently painted from photographs; later on there are isolated incidences of this.[39] The painting *Forest Slope in Unterach on the Attersee* (plate 58) presents an especially plausible example because the artist, contrary to his usual practice, included the near bank and thus compressed a space of about three kilometers into a single pictorial plane, which is barely possible even with a telescope. Klimt would have had telelenses of adequate quality at his disposal, and to a certain extent Vienna even led the way in their technical development. The first modern telelens was constructed as early as 1890 by Adolph Steinheil and in 1892 was presented in the Viennese journal *Photographische Korrespondenz*.[40] After patents were registered in England and Germany, Karl Fritsch manufactured a telelens in his optical workshops in Vienna in 1892 with a visual angle of seven to ten degrees, providing fourfold magnification. In 1895 the Carl Zeiss Works produced a lens that already had a focal length of 152 millimeters. In 1912 a product of the C. P. Goerz company even managed to attain a focal length of 400 millimeters so that in a photograph of a church clock, four kilometers away, the minute hand could still be identified. R. Demachy linked telelenses to painting for the first time in 1898. He compiled a substantial report about its use in photographic art in which he referred to the "totally new representation of the background perspective," which "even excited the attention of painters."[41] In 1905 the telelens was even termed the "objectif d'artiste."[42]

True, until then no telephotographs had emerged that could be traced to Klimt, so much remains speculative. Conversely it is also conceivable that after seeing telephotographs by professional photographers, Klimt became

Schloss Kammer on the Attersee, photograph taken using a telephoto lens from the opposite bank, 2001

aware of the potential offered by optical instruments to shorten distances and flatten images. He would then have simulated the effects of the telelens with his opera glasses or telescope. Of the photographers with whom Klimt was evidentially in contact, Heinrich Kühn (1866–1944) deserves a special mention. With Hans Watzek and Hugo Henneberg, Kühn belonged to the photographer trio that was the driving force behind the Vienna Camera Club. In 1902 this club exhibited in the Vienna Secession,[43] of which Klimt was the first president, and their photographs were even published in *Ver Sacrum*, the Secession's official journal. Klimt was briefly on the editorial team and regularly delivered illustrations for *Ver Sacrum*.[44] In addition, Klimt portrayed Henneberg's wife Marie in 1901–02.[45] Kühn probably already used telelenses at the beginning of the century, and this can be seen to greatest effect in a series dated about 1915, which shows hikers viewed from a steep top angle and projected onto a single plane by the zoom effect (*right*). The typical views in alpine photography of mountain panorama and sky have here been deliberately faded out.

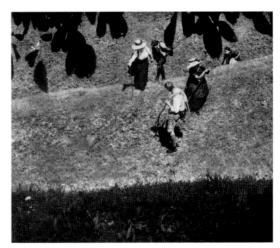

Heinrich Kühn, *Hikers II*, c. 1915, bromide oil print

Although it may now seem clear that Klimt used optical instruments, there is still uncertainty about the artist's motives. If we adopt the most obvious assumption—that he wanted to create a planar image—then there is still the aforementioned objection that thousands of early and classic modernist artists painted landscapes with some degree of planarity without reaching for technical aids like opera glasses, telescopes, or telelenses. The two-dimensional effect was evoked by artistic means alone, such as the planar application of paint, emphasizing the intrinsic value of color, and not using central perspective, to cite a few examples. Why then did Klimt put himself through the laborious procedure of looking with one eye through a telescope countless times to translate, stroke by stroke, this distant image onto the canvas?

In the search for comparable examples that come close to Klimt's intentions one meets with difficulties. Apart from a few exceptions, landscape painting around 1900 followed the well-established, century-long concept of the widest possible panorama—in other words, creating atmosphere through a distant view as described by Riegl. This concept was followed by the most diverse positions—artists with little in common with Klimt, like Paul Cézanne or painters belonging to the *Brücke* group in Dresden, as well as more closely related artists such as Ferdinand Hodler, who transformed Lake Geneva into a boundless world landscape. If a section of nature were

depicted close up, which was more rarely the case, then the tendency was to concentrate on the foreground scene without placing this in the distant background. Such pictorial effects, created especially from a raised vantage point or with the gaze focused toward the ground, were employed a number of times in early Klimt landscapes, such as *Farmhouse with Birch Trees* of 1900 (plate 11) or *Garden Landscape (Blooming Meadow)* of 1905–06 (plate 27).

By contrast, in early Cubism near and distant pictorial elements were tightly interwoven into an interlocking plane. It is interesting to compare Klimt's landscapes with the incunabula of this movement, Georges Braque's *Houses at L'Estaque* of 1908 (see p. 168), which appeared the same year as Klimt's first telescope paintings. A comparison with Daniel Henri Kahnweiler's 1909 photograph of this motif reveals how Braque arbitrarily plunged the background houses forwards and stacked them over rather than behind the buildings in the center, achieving a completely different effect from Klimt with his equally radical shortenings of distance. The Cubist picture lives from its diagonals, angles, and edges, continually suggesting volumes, which is something that Klimt avoided. In this respect the *Houses at Unterach* (plate 52) are considerably flatter than those at L'Estaque. That in spite of this they appear just as spatial as their Cubist counterparts is thanks to their higher degree of illusionism and faithful rendering of details. Even if Klimt did not paint an edge on the yellow house at the top center—in other words, did the exact opposite to the edge-obsessed Braque—Klimt's house does not appear to be ironed out into a flat plane

because the roof form automatically makes us add this edge in our mind's eye. If Braque's painting were devoid of edges then it really would appear totally flat. The much higher degree of illusionism that Klimt employs means that he is more reliant on nature's motif and can take fewer liberties in the composition than Braque. Accordingly he is dependent on optical aids like the telescope. On the other hand, the function of this planarity is completely different. In the case of Braque one does not so much look *into* a picture as *onto* a painted surface—it is well known that later Cubism increasingly

Georges Braque, *Houses at L'Estaque*, 1908, Kunstmuseum Bern

emphasized the objecthood of the picture's support and made the final break with Alberti's definition of a panel painting as a "window to nature," ultimately achieving the degree of flatness that for Greenberg was the fulfillment of modernism. Conversely, in the case of Klimt, despite the reduced plasticity of the buildings and the flatter overall appearance in contrast with Braque, one has the sensation of looking *into* a relatively deep space. What Klimt could only achieve with the assistance of telescopic instruments is an illusion of depth, which paradoxically is compressed onto the picture's surface. Thus we feel a sense of great closeness and immediacy to these depictions, but at the same time are kept at a distance: the far-off image that has been drawn close retains this distance because of its two-dimensional appearance. This distance dialectic is not a trait of Braque's pictures or other exponents of flatness because these artists use less illusionism, and a planar painting can only be identified as a distant image through a relatively high degree of illusionism. In Braque's work illusionistic categories like closeness and distance have already become irrelevant.

This example again demonstrates that Greenberg's formalistic thesis—that abstract art did not emerge as an end in itself but as a result of artists' aspirations for ever increasing flatness—is not valid.[46] For Klimt, like for most of his important contemporaries, planarity does not hold any intrinsic value. The paradigm of the planar surface applies most to his Secessionist phase around 1900, shaped by fashion (and thus formalistic considerations), but certainly not to the works from the last decade of his life. The planarity of Klimt's landscapes is a side effect of the distance dialectic he aspired to but which was not his goal.

If this had been the case, it could have been achieved much more easily.

A comparison with the most closely related landscapes by Egon Schiele (1890–1918) clearly demonstrates this. Schiele's *Stein on the Danube with Vineyard Terraces* of 1913 (*opposite*) shows a planar tier of buildings parallel to the picture on the opposite bank of a stretch of water—a typically Klimtesque motif. In this painting Schiele, like Klimt, was even relatively faithful to the motif and did not paint from memory or modify his subject as is so often the case in his landscapes.[47] The surface of the water in the foreground, the houses' facades in the middle ground, and the vineyards in the background are in a single plane; aligning the spatial zones one behind the other has been transformed into stacking one on top of the other. This planarity may well build up a certain distance to the beholder but does not generate the dialectical relations of bringing the distant into the foreground, as found in Klimt's landscapes. Schiele dispenses with an atmospheric and hence illusionistic effect through the planar application of paint that moves beyond the Post-Impressionist system of dots. Without a shadow of a doubt, Schiele has arbitrarily leveled out his optical impression, whereas Klimt's landscapes always convincingly convey that his planar images correspond precisely with what he saw. Klimt's landscapes are to be deemed as equally exact "portraits" as his portrayals of Viennese society ladies.

One could now raise the objection that this diagnosis of Klimt's motifs has merely shifted the question to another level without really offering a satisfactory answer. After all, what intention can be linked with the illusion of the distant being brought closer? It could be argued that this reflects an aesthetic need that was impressively caricatured by Mr. Hope. Yet this only touches on the frame of references and not the specific qualities of Klimt's art.

A look at Klimt's pictures with figures promises a solution to our problem. Generally the tendency is to regard the landscapes as strictly separate because in contrast to the figure compositions they are not set in a symbolist or mythological framework. This is true, but in their fundamental artistic and ideological purpose Klimt is following the same goal in both genres. One encounters a phenomenon similar to the landscapes, particularly in his numer-

ous erotic paintings and drawings.[48] Here, Klimt is well aware of how to capture sex appeal for the viewer: hitched up skirts, open blouses, ruffled blankets, stockings, and shoes revealing more than they conceal make the naked body appear undressed and provide exquisite surroundings that heighten the sensuality of exposed flesh. With their legs wide apart, Klimt's models sprawl across the canvas and are often rendered from a foreshortened view from above so that they seem to rise up as if weightless, directing gazes toward their open lap. Yet the male eyes are denied the final intrusion—which of course only

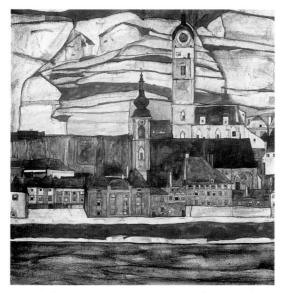

Egon Schiele, *Stein on the Danube with Vineyard Terraces* (large version), 1913, private collection

heightens the erotic tension. Seemingly unintentionally and unobserved, as if they were only being looked upon by an unnoticed voyeur from the distance, these women are self-absorbed. Distance is also created by the occasional ornamental contour that merges clothing and body into a large, planar form. A dialectic of artistic devices reduces tactile obscenity. As Nike Wagner noted, "Danae's large thighs... voluptuously fill the foreground of the picture, however, the flesh has hues of such transparent bluish, greeny yellows that they seem abstract like a hazy horizon."[49] Presentation and withdrawal, near and far merge together as in the landscapes. It is striking that Klimt frequently describes autoerotic acts, scantily concealed

with mythological subjects in his paintings (*Danae*, see p. 170), but openly revealed in his private drawings.[50] Woman reduced to pure sexuality becomes a personification of erotic fulfillment per se, which does not seem diminished by any longing extending beyond herself. This sexuality defined as exclusively feminine—one needs only to think of Karl Kraus' assertion that "the sexual instinct of woman, certainly in the moment of use, becomes her sole preoccupation"[51]—Klimt always renders as a state of passive surrendering[52] and dreamy reverie,[53] as a preconscious, even prenatal condition. Significant here is the embryonic pose of *Danae* and her series of uteral shroudings comprising sheet, veil, planes of color, and finally the square format. Even the most daring of depictions lacks the revolutionary explosives to destroy sexual taboos as Gert Mattenklott established: "his girlfriends or entranced masturbators do not really want to cause a scandal. They are pictures of a solipsistic self-immersed world where man can only participate as an onlooker and voyeur, lascivious and enthralled, but always left outside in fascinated suspense."[54]

Much the same can be said of his landscapes. These are also pictures of a solipsistic self-immersed world where man—gazing into it with a telescope—is onlooker and voyeur. He may not be lascivious, yet he is enthralled and, above all, is always on the outside, divided from the observed object by the wide expanse of water that can only be traversed optically. The self-immersion of the landscape is complete. The strict orthogonal composition of Klimt's square formats[55] conveys tranquility and stability; man and beast have been excluded as potential disturbers of this peace; no breeze, no change in the weather, not even the movement of light and shadow is permitted; all brushstrokes convey only balance and rich repleteness, never expressiveness or dynamism. Klimt's landscapes seem to be detached from time, existing in a kind of dreamy passiveness. Their hermetic solipsism is due essentially to the telescope: the closely cropped image, the tight spatial layering, and the lack of foreground despite the impression of a closely viewed scene are all engendered by looking through a telescope. The same applies to the absence of a wide panorama, indeed the overall lack of spatial orientation. Hence the landscape appears neither distant nor near; it is purely and simply "elsewhere," only in artistic vision is it visible but never traversable and eludes all access. Through its technically produced illusionism, however, it keeps its promise that it really exists somewhere and as a result retains its powers of attraction and seduction in a transferred sense. With the

"tunnel vision" of the telescope—and with this alone—Klimt could realize his world image based on immanence and concentrate entirely on closely cropped details of reality without degenerating into prosaic realism. The telescope effect serves here to convey a (paradoxical) feeling of transcendence that does not abandon immanence but evokes the sense of an earthly paradise. Even the most banal of objects from these rural surroundings acquire in Klimt's vision the aura of an enchanted, detached world.[56] This dreamy transfiguration of reality is reminiscent of Friedrich Nietzsche's "Apollonian dream state,"[57] described in *The Birth of Tragedy*, in which "the world of the day veils itself and a new world, clearer, more intelligible, more gripping than the other and yet more shadowy... is born before our eyes."[58] The distance brought closer by the telescope is "clearer, more intelligible" while at the same time "more shadowy" in its detached incorporeality. Klimt's use of a telescope is just as dialectical as its result. On the one hand, Klimt's technically transformed vision and his modernist "yearning for distance" seem very progressive. Indeed, in this respect he was akin to no other artist of his day, and this is a crucial factor determining the epochal significance of his landscapes. On the other hand, like with Mr. Hope, Klimt's art expresses a regressive attitude, a classic middle-class escape mechanism with romantic roots that extends to the television society and cyberworlds of the present day. The sensitive epicurean Klimt would like to get away: away from the hectic city of Vienna, away from the crumbling Habsburg monarchy, away from the turmoil of World War I. His art seeks that "elsewhere," that utopian place where, as he once wrote, "fate will let us enjoy pleasure."[59]

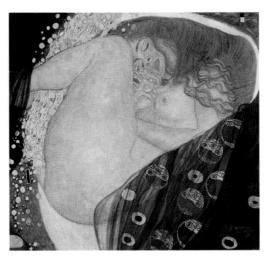

Gustav Klimt, *Danae*, c. 1907/08, private collection

5 Cf. Henning Bock, "Einführung: Die Entstehung des 'Problems der Form'," in *Adolf von Hildebrand: Gesammelte Schriften zur Kunst*, ed. Henning Bock (Cologne and Opladen, 1969), 17–40, here 37.

6 The different versions published between 1893 and 1913 are printed in ibid. In the following text the last version of 1903 is quoted (197–265). Regarding the complicated genesis of this work, for which Hildebrand had partially developed his theses as early as 1881, cf. Bock in ibid., 24–33.

7 Cf. Hildebrand in ibid., 206ff., 237.

8 Cf. ibid., 206.

9 Ibid., 242.

10 Alois Riegl, "Die Stimmung als Inhalt der modernen Kunst," in *Gesammelte Aufsätze* (1899; reprint, Augsburg and Vienna, 1929), 28–39, here 29. For more detail see the essay by Peter Peer in this volume.

11 Ibid., 30.

12 Cf. Michael Fried, *Absorption and Theatricality: Painting and Beholder in the Age of Diderot* (Chicago and London, 1980), 103.

13 Helmut Draxler, "Das reine Sehen, die Familie und der Tod: Versuch über die Sozialisierung des Blicks," *Texte zur Kunst* 1 (1990): 139–49, here 139f. Cf. Michael Fried, "Art and Objecthood," in *Minimal Art: A Critical Anthology*, ed. Gregory Battcock (New York, 1968), 116–47.

14 Ibid., 140.

15 Albert Robida, *Le vingtième siècle* (Paris, 1883).

16 Cf. the many pictorial documents in Sven Thomas, "1879–1925: Utopien vom Fernsehen," in *TV-Kultur: Das Fernsehen in der Kunst seit 1879*, ed. Wulf Herzogenrath et al. (Dresden, 1997), 134–41.

17 Invention of the telegraph message by Samuel Morse in 1837–44; laying of the first cable connection between Great Britain and the United States in 1857–58.

18 Invention of the telephone by Alexander Graham Bell in 1872; patent and construction of an experimental line in 1876.

19 For the following data, cf. Joseph Hoppe, "Eine Chronologie 1843–1996," in *TV-Kultur* (see note 16 above), 19–23, here 19; Joseph Hoppe, "Wie das Fernsehen in die Apparate kam: Die Anfänge von Technik und Programm der Television," in ibid., 24–47.

20 Manuscript collection, Österreichische Nationalbibliothek, 201/17 (1–3), quoted from Christian M. Nebehay, *Gustav Klimt Dokumentation* (Vienna, 1969), 503.

21 Cf. Renate Vergeiner and Alfred Weidinger, "Gustav und Emilie: Bekanntschaft und Aufenthalte am Attersee," in *Inselräume: Teschner,*

1 Zugereist in diese Gegend, / Noch viel mehr als sehr vermögend, / In der Hand das Perspektiv, / Kam ein Mister namens Pief. / "Warum soll ich nicht beim Gehen" — / Sprach er — "in die Ferne sehen? / Schön ist es auch anderswo, / Und hier bin ich sowieso."
Wilhelm Busch, *Max and Moritz: With Many More Mischief-makers More or Less Human or Approximately Animal*, trans. and ed. H. Arthur Klein (New York, 1962), 110.

2 Whereas Busch uses anti-Semitic clichés in chapter 5 in a very superficial way.

3 Clement Greenberg, "Modernist Painting," *Art and Literature* no. 4 (Spring 1965): 193–201, quoted from Charles Harrison and Paul Wood, eds., *Art in Theory 1900–1990: An Anthology of Changing Ideas*, 3rd ed. (Oxford and Cambridge Mass., 1992), 754–60, here 758.

4 Cf. ibid., 755ff.

Klimt und Flöge am Attersee, exh. cat., 2nd ed. (1st ed. 1988), (Seewalchen am Attersee, 1989), 5–27.

22 Cf. Nebehay, *Gustav Klimt Dokumentation*, 456, n. 4.

23 Johannes Dobai, "Die Landschaft in der Sicht von Gustav Klimt: Ein Essay," *Klimt-Studien: Mitteilungen der Österreichischen Galerie* 22/23, nos. 66/67 (1978): 241–72; reprinted in Johannes Dobai, *Gustav Klimt: Die Landschaften* (Salzburg, 1981), 32f.
Klimt wrote in a letter from Attersee to Marie Zimmermann at the beginning of August 1903: "On my first day here I didn't start working straight away, … early in the morning, during the day and in the evening I looked for motifs to paint in my landscapes with a 'viewing frame,' which is a hole cut into a cardboard lid, and I found much— or you could also say nothing." Quoted from Christian M. Nebehay, "Gustav Klimt schreibt an eine Liebe," *Klimt-Studien*, ibid., 101–18, here 108f. With regard to the ivory viewing frame cf. Nebehay, *Gustav Klimt Dokumentation*, 452f.

24 Johannes Dobai, "Katalog der Gemälde," in Fritz Novotny and Johannes Dobai, *Gustav Klimt* (Salzburg, 1967), 308, 372.

25 Fritz Novotny, "Die Landschaft," in *Gustav Klimt*, (Salzburg, 1967), 53–70, here 60.

26 Ibid., 64.

27 Nebehay, *Gustav Klimt Dokumentation*, 452.

28 The following section is a revised version of the chapter "Distanz-Dialektik" from my essay, "Aspekte der Landschaft bei Gustav Klimt," in *Inselräume*, 40–65, here 54–58.

29 Marie-José Liechtenstein, "Gustav Klimt und seine oberösterreichischen Salzkammergutlandschaften," *Oberösterreichische Heimatblätter* 5, no. 3/4 (1951): 297–317, here 300; Nebehay, *Gustav Klimt Dokumentation*, 452; Dobai, *Landschaften*, 31.

30 After 1900 Klimt declined a major commission, stating: "I have no other means of sustaining to some degree the peace and quiet I need" (Gustav Klimt to Fritz Waerndorfer, undated letter, "Unbekannte Briefe Gustav Klimts. Wie der grosse Maler schuf, mitgeteilt von Karl Moser," *Neues Wiener Journal*, Jan. 3, 1932, 16; quoted from Nebehay, *Gustav Klimt Dokumentation*, 390). At the same time he stopped organizing exhibitions and in Vienna led an increasingly reclusive existence. He was usually surly to passers-by who met him when he was painting outdoors; see for example Irene Hölzer-Weineck's account (quoted in Vergeiner and Weidinger, "Gustav und Emilie," 13). Finally Klimt's accommodation at Attersee between 1900 and 1916 reveals a growing need for peace and seclusion.

31 Our discovery was ignored by scholars for a long time. We were, after all, only students and not acknowledged Klimt specialists. In addition the exhibition catalogue (see note 21) did not find its way into many public libraries, although two editions were published.

32 Cf. Alfred Weidinger, "Neues zu den Landschaftsbildern Gustav Klimts" (thesis, Salzburg University, 1992), 131ff., 166.

33 Cf. Klimt's daily routine described in a letter to Marie Zimmermann dated August 1902, quoted in Nebehay, "Gustav Klimt schreibt an eine Liebe," 109f.

34 Cf. Weidinger, "Neues zu den Landschaftsbildern," 111ff., 137ff.; Alfred Weidinger, "Der Landschaftsmaler," in *Gustav Klimt*, ed. Toni Stooss and Christoph Doswald, exh. cat. (Stuttgart: Kunsthaus Zürich, 1992), 53–71, here 56.

35 Weidinger, "Neues zu den Landschaftsbildern," 111f.

36 Verena Lobisser kindly informed me that *Schloss Kammer on Attersee II*, for example, was painted from the emperor's monument above the village. It was only from here that he could see the roof formation as it appears in the painting and for this he would, however, have required a telescope.

37 Cf. Wagner, "Aspekte der Landschaft," 58; Weidinger, "Der Landschaftsmaler," 54.

38 Cf. Wolfgang G. Fischer, *Gustav Klimt und Emilie Flöge: Genie und Talent,*

Freundschaft und Besessenheit (Vienna, 1987), 95; Vergeiner and Weidinger, "Gustav und Emilie," 15.

39 For example, in the posthumous portraits of Ria Munk painted between 1911 and 1918; cf. Tobias G. Natter, "Female Portraits," in *Klimt's Women*, ed. Tobias G. Natter and Gerbert Frodl, exh. cat., English ed. (Vienna: Österreichische Galerie Belvedere; Cologne, 2000), 76–147, here 140.

40 Cf. for this and the following facts Wolfgang Baier, *Quellendarstellungen zur Geschichte der Photographie*, 4th ed. (Munich, 1980), 313f. (with sources).

41 *Bulletin du Photo Club de Paris* (1898): 353–63, quoted from Baier, ibid., 314.

42 C. Puyo, *Photographische Mitteilungen* 42 (1905): 339, quoted from Baier, ibid.

43 Cf. Ulrich Knapp, *Heinrich Kühn: Photographien* (Salzburg and Vienna, 1988), 12–17.

44 Cf. Christian M. Nebehay, *Ver Sacrum 1898–1903* (London, 1977), 255, 268, 291; *Ver Sacrum* (1902), 1; 4:25ff.; 7:30ff.; 10:31.

45 Cf. Natter, "Female Portraits," 95ff.

46 Cf. Greenberg, "Modernist Painting," 756.

47 Cf. Erwin Mitsch, *Egon Schiele*, 4th ed. (Munich, 1981), 42.

48 Cf. for more detail Anselm Wagner, "Ich schliesse mich selbst ein: Zur hermetischen Erotik Gustav Klimts," in *Inselräume*, 79–83.

49 Nike Wagner, *Geist und Geschlecht: Karl Kraus und die Erotik der Wiener Moderne* (Frankfurt am Main, 1983), 48.

50 Cf. Wagner, "Ich schliesse mich selbst ein," 81f. Independently of myself, Laura Arici reached the same conclusion that Klimt's *Danae* is a metaphor for female masturbation; cf. Laura Arici, "Danae," in *Gustav Klimt*, ed. Toni Stooss and Christoph Doswald, exh. cat. (Stuttgart: Kunsthaus Zürich, 1992), 146. On the depiction of female masturbation in general cf. Laura Arici, "Schwanengesang in Gold: Der Kuss—eine Deutung," in ibid., 43–51, here 47f.

51 Karl Kraus, "Der Fall Riehl" (1906), quoted from Werner Hofmann, *Gustav Klimt und die Wiener Jahrhundertwende* (Salzburg, 1971), 35.

52 In accordance with this sexual dualism that looks back on a long Western tradition, the Viennese sexual psychologist Otto Weininger asserted that for women in general, "waiting for a man… is simply waiting for the moment when she can be completely passive" (Otto Weininger, *Geschlecht und Charakter*, 2nd ed. (Vienna and Leipzig, 1904), 356, quoted from Hofmann, ibid., 32).

53 Thus Klimt's protagonists who surrender themselves to the "stream of life" mostly have their eyes closed. Apart from *Danae* and *Leda*, other prominent examples are: the faculty paintings (1900–03), *The Kiss* (1907–08), *The Virgin* (1913), *Death and Life* (before 1911/16) and *The Bride* (1917–18).

54 Gert Mattenklott, "Figurenwerfen. Versuch über Klimts Zeichnungen," in *Gustav Klimt*, exh. cat. (Hanover, 1984), 27–35, here 28.

55 On the aesthetics and symbolism of the square in Klimt's landscapes, cf. Wagner, "Aspekte der Landschaft," 50ff.

56 Cf. Hofmann, *Wiener Jahrhundertwende*, 16.

57 On the significance of Nietzsche's Apollonian theory for Klimt's landscapes, cf. Wagner, "Aspekte der Landschaft," 60ff. Hitherto Nietzsche's Dionysian theory has been predominantly employed to explain Klimt's faculty paintings. See, for example, Hans Bisanz, "Ornament und Askese: Wiener Stilkunst, Schiele, Kokoschka," in *Ornament und Askese im Zeitgeist des Wien der Jahrhundertwende* (Vienna, 1985), 130–41, here 136; William MacGrath, "Les reveurs dionysiaques," in *Vienne 1880–1938: L'apocalypse joyeuse*, exh. cat. (Paris, 1986), 172–79, here 178; Carl E. Schorske, *Fin-de-siècle Vienna: Politics and Culture* (New York, 1981), 228ff. Schorske relates Klimt's *Philosophy* to Nietzsche's *Thus Spoke Zarathustra*.

58 Friedrich Nietzsche, *The Birth of Tragedy*, trans. Douglas Smith (Oxford, 2000), 52.

59 Gustav Klimt to Emilie Flöge, postcard, March 1916, quoted from Fischer, *Gustav Klimt und Emilie Flöge*, 166.

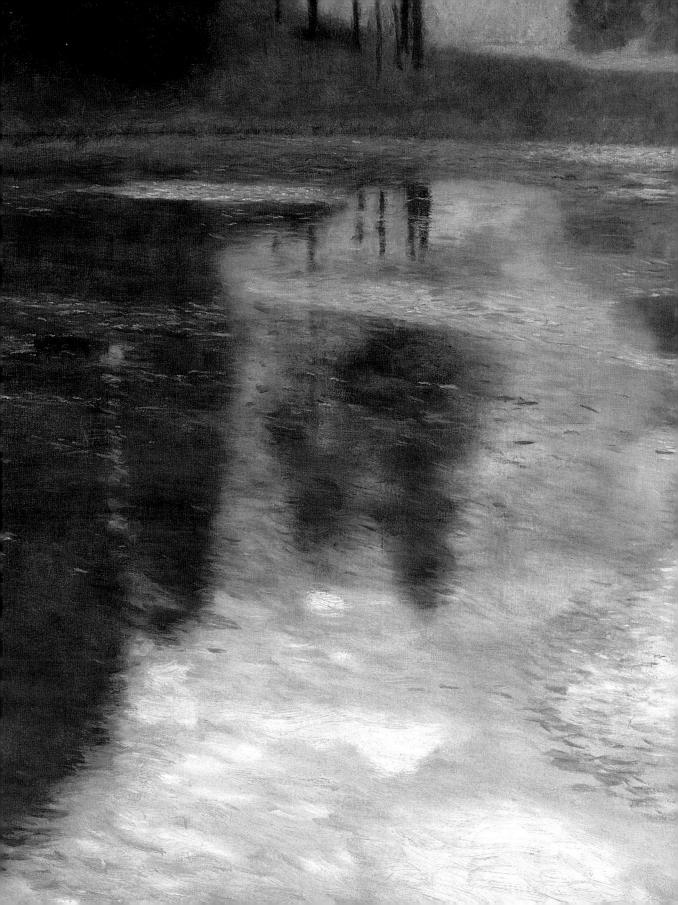

Klimt's Landscapes and their Place
in Austrian Landscape Painting of the Nineteenth Century

Peter Peer

By the time he turned to landscape painting, Gustav Klimt had long since reached the zenith of his career,[1] which raises the question as to the aesthetic position of these landscapes which so abruptly appeared in his oeuvre about 1898,[2] their relationship to Austrian landscape painting, and the influences or traditions with which they were linked.

Klimt's beginnings stood under the sign of the Historical Revival. During the first decade of his career he occupied himself with prestigious commissions, principally large-scale designs for interiors. These entailed adapting figurative compositions to the architectural context and gave him the reputation of being the successor to Hans Makart. Portrait painting had been a further focus of his work, whereas landscapes had played no role up to this point.

Naturally Klimt was acquainted with contemporaneous Austrian landscape painting and its approaches.[3] The academy still devoted itself, if in revised form, to the effectively picturesque Alpine landscape genre. On the other hand, the majority of Austrian artists had received more or less strong influences from international Realism or Impressionism.[4] Naturally the spectrum included both conservative artists who followed the academic rules of subject matter and style and artists who sympathized with modern tendencies. At that time Klimt was viewed as belonging to the progressive camp, in the Secession and on the Viennese art scene as a whole. So it is remarkable that, despite certain modern features, the motifs and compositions of his landscapes were rooted in nineteenth-century Austrian landscape painting.

Klimt's landscapes focus on the same motifs over and over again. They depict rural gardens with luxuriant meadows and orchards or teeming with various flowers and fruits. Other paintings are close-cropped views of farmhouses or country estates set in the midst of blossom-ing, proliferating greenery. There are also depictions of ponds and marshes, a few "portraits" of individual trees, park landscapes, and several forest scenes. In later years, these were supplemented by views of the town of Unter-ach and of Kammer Castle, and by motifs from Attersee and Lake Garda.

Although his style changed markedly from his earlier to his later works, Klimt's choice of motifs hardly altered at all. The focus was invariably on a quiet, unsullied slice of nature in which man's presence was marginal, indicated at most by evidence of cultivation, gardening or land-scaping, and occasionally architecture. Only the late series of Unterach and Kammer Castle motifs, and the images of Malcesine and Cassone on Lake Garda, lifted the viewer out of a contemplative immersion in the an-onymous environment to consider some definite topogra-phy, if never rendered with the precision of a Renaissance view.

These paintings are marked by two idiosyncracies. First, they are devoted to unremarkable, somewhat mundane, motifs. Second, these simple landscape excerpts are suf-fused by a profound tranquility; the pictorial framework is harmoniously ordered and conveys moods that reflect an understanding of nature guided by a subjective sensi-bility.

The value placed on mundane slices of nature has a tradition in Austrian landscape painting that reaches back to the first half of the nineteenth century. Among the ear-liest were Ferdinand Georg Waldmüller's studies of trees of the 1830s, which the artist hung beside his "finished" paintings at academy exhibitions as works of more or less equal rank.

Thanks to an emergent appreciation for realism in early-nineteenth-century landscape art, the composition-al patterns of the Baroque and Neoclassical tradition were overcome in favor of an objective view of the subject at

Ferdinand Georg Waldmüller, *Maple Trees near Ischl*, 1831,
Österreichische Galerie Belvedere, Vienna

Emil Jakob Schindler, *The Moon Rising above the Prater Water Meadows*,
c. 1877/78, Österreichische Galerie Belvedere, Vienna

began to emerge in the early 1870s. As a reaction to the dominant doctrine of the heroic Alpine landscape, this approach set standards, in terms of supplementing an objective observation of the natural scene by purely emotionally experienced qualities or by a lyrical interpretation of the subject. The Austrians found confirmation for

hand. The environment was put, as it were, in a static, neutral state in which the qualities and idiosyncrasies of the world of things could be illuminated. Then, toward the middle of the century, artists' interest began to shift to the overall impression of landscapes. In addition to precise or naturalistic renderings of topographical conditions, they began to focus on the transitory and ephemeral qualities of the natural cycle, especially by observing the effects of shifting light and how it altered the form and color of things. Great attention was paid to the phenomena of the times of day and the seasons, as well as to changing weather conditions. Together with topographical and environmental features, such phenomena helped evoke "atmosphere" that played such a prominent role in late-nineteenth-century landscape painting. The range of approaches was diverse, from the late works of Franz Steinfeld and Waldmüller to the oeuvre of the extraordinary August von Pettenkofen, who as early as 1850 adopted formal features from French landscape painting, especially of the Barbizon School. Still, all three artists represented exceptions at this period.

The preference for plain, unspectacular motifs and their depiction in the context of nature in continual change formed the basis for the atmospheric realism that

this in the *paysage intime* of the Barbizon School. The major representatives of atmospheric realism were Emil Jakob Schindler, Eugen Jettel, and Rudolf Ribarz. Robert Russ adopted this tendency only hesitantly and in part. In contrast, Tina Blau and Theodor von Hörmann developed at a quite early date a comparatively naturalistic approach in which the evocation of mood played a subordinate role. Initially harshly rejected and criticized, atmospheric realism gradually burgeoned into the artistic ideal of several generations of Austrian landscape painters, down to the twentieth century.

What becomes evident in atmospheric realism, as in realistic landscape painting in the nineteenth century as a whole, is a thematic shift in which the painterly qualities of a motif began to take precedence to its content or meaning.[5] The raging mountain streams of the Alpine painters gave way to quiet river backwaters; storm-whipped pines at the timberline were rivaled by unspectacular views of gardens, parks, or meadows; grandiose images of the dramatic world of peaks and glaciers were supplanted by depictions of a tranquil environment whose naturalness and lack of drama encouraged contemplation. Accordingly, artists were accused of "purposely seeking out uninteresting motifs."[6] Most academic artists were

highly skeptical of contemporaneous landscape art and its message. August Schaeffer considered it an "empty painting of things... which labors under the misconception that everything in nature, just as it is, could be a subject of art." Schaeffer still preferred the "signifying" Alpine pictures of Albert Zimmermann.[7]

law of causality."[10] This is why Riegl demanded absolute truth to nature in art, because for him, a strict adherence to the law of causality formed the basis of the modern aesthetic. Landscape, which involved capturing the incessantly changing face of nature while taking account of its intrinsic laws, was thus the leading genre of contemporary

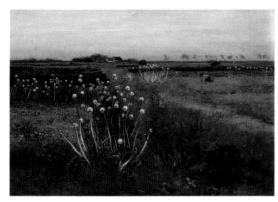

Eugen Jettel, *Flowering Onion Field*, 1897, Österreichische Galerie Belvedere, Vienna

Rudolf Ribarz, *Dutch Landscape with Farmsteads*, 1877, Österreichische Galerie Belvedere, Vienna

"Atmosphere" as the Content of Modern Art

The "recognition of the beautiful in the true"[8] and its realization in mundane slices of the natural scene was the real driving force behind Austrian landscape painting in the final decades of the nineteenth century—*Stimmung*, an elusive word connoting atmosphere, mood, or state of mind, was the order of the day. Franz Wickhoff and Alois Riegl viewed the striving for aesthetic effect, the conveying of such an atmosphere, as the unique and fundamental task of contemporary painting. They saw it as a reaction against a growing cultural pessimism that had resulted from profound social and economic transformation and concomitant change in value systems.[9]

Riegl in particular attempted to define the phenomenon of atmosphere in the context of the history of ideas. Scientific insights had shaken the traditional, religion-based view of the world, and opened the door for an objective and rational conception of the workings of nature. Modern art, the art of evoking an atmosphere or mood, Riegl believed, essentially rested on this knowledge of harmony based on the laws of nature. So atmosphere, the goal of all modern painting, reflected nothing else but the comforting belief in the "inexorable workings of the

art in Riegl's eyes.[11] Atmosphere could be artistically conveyed, he believed, through "calm" or "peace" and "the distant view," whereas "motion" or "the nearby view" precluded or prevented an evocation of atmosphere. In accordance with the distinction between visual and tangible qualities in a work of art, he believed the realization of these factors in painting (in contrast to sculpture) could be guaranteed only by the "distance intrinsic" to this medium.[12]

In Austria, the concept of the atmospheric landscape was associated especially with the art of Emil Jakob Schindler. Schindler had long before expressly emphasized the importance of atmosphere in contemporary painting.[13] Ludwig Hevesi saw "progress in the Viennese landscape" assured especially by Schindler, whom he called the "master of Viennese atmospheric landscape..., the purest lyrical personality in recent Austrian art."[14] And Harald Fischel summed up: "As diverse as were the directions Schindler took..., it was always an atmospheric world of poetic charm into which he introduced us."[15] The requirement of "truth to nature" raised by Riegl was anticipated by Schindler to the extent that he viewed every work of art as an independent creation, yet each work was nonetheless dependent on nature in so far as it was impossible for the

artist to go beyond the forms and appearances of nature.[16] It was necessary "to arrive at the work of art from and through nature," and to crystallize "the artistic act out of natural elements."[17]

Schindler was accordingly critical of the new medium of photography, because it left "hand, eye and mind completely idle." Although he did accept photography as an aid to the painter, he believed its results, "without making contact with our mind, address themselves merely to the eye, which dismisses them forever with a rapid glance. In terms of absolute correctness of forms and shadows, these pictures apparently far surpass what art has previously achieved; in terms of intellectual edification, the ability to produce an impression, artistic language, giving and taking, [photographs] stand at a level abysmally below that of the worst of previous periods of art."[18]

Similarly, Wickhoff viewed the spread of photography as liberating painting from the compulsion to slavishly imitate appearances, permitting it to return to purely artistic concerns.[19] Whereas photography stimulated French Impressionism in many ways (perspective, the momentary snapshot), its artistic message and inspirational effect were largely overlooked in Austrian landscape painting until the early 1890s.[20] This circumstance once again underscores the differences between French Impressionism and the atmospheric realism of Austrian painting.[21] "The French continually look for technical problems," explained Wick-

Eugen Jettel, *River Landscape with Boat*, c. 1880,
Österreichische Galerie Belvedere, Vienna

hoff; Impressionism and *plein-air* painting, those "highly significant transitional stages in the development of modern painting," were invented and propagated in France.[22] However, the apex of modern art was achieved not in France but in England, where from the beginning of the nineteenth century, said Wickhoff, artists strived "to develop and promote atmosphere in painting, which now finally has become the common property of all civilized nations." At the forefront of this development he saw James Abbott McNeill Whistler.[23]

In addition, Wickhoff viewed the communication of atmosphere in modern painting as a task which had previously been mastered only in music and poetry.[24] He thus linked the various artistic disciplines on the basis of their intrinsic capabilities. The same associative thinking was

conveyed by Whistler in paintings that bore such titles as *Nocturne* or *Symphony,* incidentally echoing Harald Fischel's descriptions of Schindler's works as a "symphony in green" or "symphony in gray."[25] Schindler himself projected a universal arch over the various fields of art: "The art of poetry condenses and shapes existence, music its sounds, visual art its 'appearance.'"[26]

The Relationship between Atmosphere and Motif

While Wickhoff and Riegl generally thought any type of subject matter to be suitable for conveying atmosphere or mood,[27] Austrian landscape artists tended to take a more limited view. They selected their motifs with great care, as indicated by the strong, almost programmatic presence of certain motifs and themes in many of their oeuvres. The evident link between a certain, desired atmosphere and corresponding motifs arose from these artists' emotional relationship to their environment, a relationship shaped by skepticism with regard to the achievements of industrial civilization and concern with a loss of traditional values. Here, once again, the connections between atmospheric realism and the Barbizon School become apparent.

Schindler's artistic sensibility was shaped by the idea of an original nature, unsullied by the influences of civilization. The French Impressionists' depictions of modern urban life and their interest in social aspects in the widest sense held no appeal for him. In this respect he agreed with Corot, who held a similarly escapist position and likewise rejected certain Impressionist subjects and motifs.[28]

Despite stylistic and thematic differences, representatives of Historicism were likewise skeptical with regard to social developments and technical and scientific progress. Carl Rahl believed that rationalism and scientific progress had destroyed the basis of artistic work, suppressed the world of myth and fantasy.[29] This widespread skepticism with regard to the positivism of the period and doubt in the validity of scientific insights for life, were also shared by Klimt,[30] possibly as a result of his beginnings in the Historical Revival orbit. This may also explain why Klimt adopted the motifs of the atmospheric painters and not,

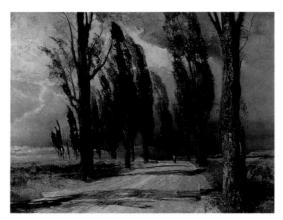

Emil Jakob Schindler, *Avenue of Poplars in a Storm, c.* 1892,
private collection

favorite motifs, mentioning "poplars at twilight during a rising storm."[33] How much this motif recalls Schindler's well-known variations on the poplar-lined avenue outside Plankenberg! One of Schindler's three large-format paintings represents an *Avenue of Poplars in a Storm.*[34]

Klimt's express interest in observing a certain mood, which already inspired Schindler in face of the same motif, is remarkable. In another place Klimt reported that, weather permitting, he intended to work in the nearby woods: "I am going to paint a little beech grove there... intermixed with a few coniferous trees."[35] Several of his views of forest interiors shortly after 1900 link up with the tradition of the subject in the hands of Hugo Darnaut, Hugo Charlemont, Adolf Kaufmann, Theodor von Hörmann, and Marie Egner. *Poppy Field* of 1907 (plate 29) reveals an affinity with depictions of flowering fields and meadows by Egner and Olga Wisinger-Florian. Klimt's *Avenue in Schloss Kammer Park* (plate 39), with its motif of a path leading into the distance, likewise fits effortlessly into the canon of atmospheric realism. It also put us in mind of works by Charlemont, Wisinger-Florian, and, again, Schindler, who once described paths or roads as guiding ideas in landscape, as "signposts through the picture."[36] Not least, the composition bears a resemblance to Rudolf von Alt's *In Teplitz Palace Park,* 1876, at whose end, framed by dense foliage and tree limbs, parts of the palace facade are visible.

like Theodor von Hörmann or Tina Blau, typically Impressionist subjects such as crowded city streets or marketplaces. The atmospheric realists sought their subjects far from the city, in the remote and serene outdoors. Tranquil pools and ponds appeared as frequently in their work as scenes of shady forest glades or views across an expanse of meadowland. Yet human beings were not entirely absent from the natural scene. Again and again, figures appear in these landscapes — farmers, fishermen, or hunters — representatives of the rural populace whose role, though marginal, nevertheless conveys their immediate link with nature and their dependence on its boons.

With a sole exception, *Schönbrunn Park* (1916, plate 47), Klimt adopted the themes of atmospheric realism while eschewing its depiction of figures. His early works, for instance, depicted a farmhouse with a rosebush, or numbers of orchards, one enlivened by chickens. At the spring exhibition of the Secession in March 1900, Ludwig Hevesi reported seeing "three delightful atmospheric landscapes... The third, a fine idyll in green and gray, dotted with chickens" (plate 6).[31] Klimt's painting *Farmhouse with Birch Trees* (plate 11) relates, in terms of motif, to the tradition of atmospheric realism to the same degree as *Tall Poplars I* (plate 10) or the variations on ponds and backwaters (plates 1, 8, 9). In retrospect, Harald Fischel too recalled these subjects, which occurred just as often in Schindler's oeuvre, saying that Schindler "particularly loved slender birches with white trunks, and white poplars; again and again he sought out the green water of the Prater marshes, the gray, glittering play of waves on the Danube."[32] In a letter Klimt referred to some of his

Formal and Compositional Aspects

Klimt apparently adopted the compositional styles of atmospheric realism, as well as certain motifs. We frequently find excerpts of scenes in which the foreground takes up the largest part of the pictorial field, and the view into the distance, because of the high-placed horizon line, plays a subordinate role. Such tendencies were common in Austrian art from the late 1870s,[37] especially in the work of Eugen Jettel and Rudolf Ribarz, and of the Schindler students Egner and Wisinger-Florian. Their favorite motifs included fields and meadow landscapes, as well as homely gardens with vegetable plots and fruit trees, which gave rise to the nickname of *Kraut und Rüben,* or common garden-variety pieces.[38] This genre can be said to have formed Klimt's entry into landscape painting.

Cases in point are his first four depictions of fruit orchards and one of a farmhouse, still in a vertical format, followed by two views of ponds and the *Farmhouse with Birch Trees.* It was not until *Tall Poplars I* (1900), that Klimt

selected an expansive landscape view; yet he would return again and again to an extremely close vantage point. What links these paintings to works of atmospheric realism, apart from the motifs and their close cropping, is the tipping up of the foreground area with respect to the more distant passages. In this regard, it is interesting to compare Klimt's *Poppy Field*, 1907, with Wisinger-Florian's *Flowering Poppies*, 1895–1900. One has the impression of looking through a wide-angle lens that projects the landscape onto a convex surface. The elements in the near foreground are depicted from a high vantage point and relatively clearly, while the landscape grows flatter toward the background, and its details merge into a conglomerate of light and color. This contrast creates a feeling of proximity and distance without eliciting an impression of spatial depth of the kind produced by the means of classical perspective.

The formal and compositional influence of Japanese art is more than obvious. Painters such as von Pettenkofen, Ribarz, and Jettel made frequent trips to France over a period of decades, where Japanese woodblock prints enjoyed great popularity from the early 1860s. In addition, the World's Fairs, such as that held in Vienna in 1873, gave a wide public the opportunity to acquaint themselves with Japanese art. Its influences appeared again and again in the works of Jettel and Ribarz in particular. Their segmenting of landscape elements, their decorative arrangement of views with grasses or flowers in the near foreground and a wide expanse of landscape behind, made the works of these two artists prime representatives of *Japonisme*.

Corresponding tendencies in the work of Klimt, in other words, reflected an international trend that had gained a footing in Austrian landscape paintings a few decades previously. Some of his forest interiors executed around and after 1900 likewise evince Japanese traits (plates 16–21). The forest theme had played a role in Austrian painting since the Biedermeier period (c. 1815–48), and was frequently treated in atmospheric realism. In contrast to the Biedermeier artists, however, the atmospheric realists constricted the point of view and typically concentrated on excerpts that shut out the wider surroundings. Hörmann's view of a beech wood is articulated by the verticals of the closely standing tree trunks, between which the forest floor, covered with red autumn leaves, is visible. The trunks in the foreground are still individually rendered and three-dimensionally modeled, whereas those in the background merge with the reddish ground and flecks of sky to form a homogeneous, flat pattern. Yet the distinction between foreground and background —

in fact, the attempt to define different pictorial levels — ultimately founders on the decorative overall effect of the composition. Proximity and distance counterbalance each other: depth is negated by the flat, interlocking planes of the trees and intermediate spaces. Even the broad diagonal of the pond does not so much evoke depth as serve as an autonomous plane with the aid of which the coloristic dominance of the luminous red forest floor is interrupted and toned down for the sake of integration in the overall composition. This coloristic balance continues in the treatment of the foliage, which is distributed evenly among the tree limbs in the upper half of the picture.

Klimt treats the motif of the forest interior in the same way. The regular placement of the tree trunks lends these compositions a rhythmical effect; trees and forest floor combine to form a decorative plane; limbs and foliage are used to structure the areas above the horizon. Even more strongly than Hörmann, Klimt emphasizes the staccato of parallel trunks. The trees nearest the viewer, naturalistically modeled, represent the forest as a whole, whose details grow increasingly vague into the background.

This approach reflects a connection with certain ideas then current in the natural sciences. "Law" and "sequence" were key concepts of modern science. Hermann von Helmholtz thought the observation of discrete facts to be meaningful only if they revealed the "law of a series of repetitive phenomena."[39] Separate observations were viewed as parts of a sequence that was known or yet to be discovered. And Ernst Mach determined, in optical experiments, that the rectified orientation of various flecks made a pleasant impression on the viewer. Riegl argued in a similar vein when he gave priority to knowledge of causal relationships in nature ("distant view") over an observation of details ("nearby view"), and declared this to be the essential foundation of atmosphere in painting.[40] Riegl detected analogies between the laws governing natural forms and those of art.[41] Instead of imitating natural things, he stated, artists should work in conformance with the formal laws of nature and make its symmetry and proportions visible.

The condensation of separate elements into a homogeneous, flat pattern at the expense of spatial depth — a decorative stylization or ornamentalization of objective forms — was central to Klimt's intentions. In his portraits of trees, park views, and fruit trees, finely articulated ornamental structures play a greater role than in the forest interiors or meadow pieces, in which remnants of spatial

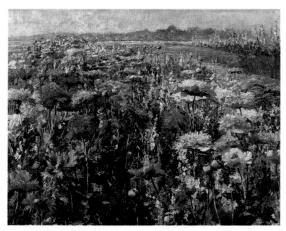

Olga Wisinger-Florian, *Flowering Poppies*, c. 1895/1900,
Österreichische Galerie Belvedere, Vienna

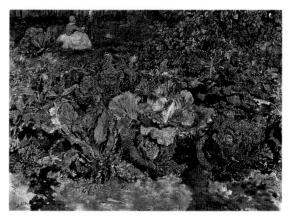

Rudolf von Alt, *Vegetable Garden at Villa Dumba in Liezen*, 1879,
Albertina, Vienna

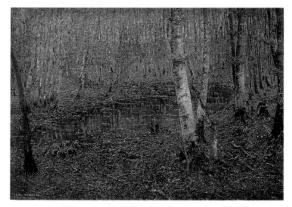

Theodor von Hörmann, *Pond in Beechwood*, 1892,
Tiroler Landesmuseum Ferdinandeum, Innsbruck

structuring are still present. The dense foliage of the crowns of the trees extends across almost the entire picture plane like a finely patterned carpet (plates 25, 26, 29, 35). Frequently the motif can be identified only on the basis of the tree trunks at the lower edge, or by treetops whose limbs show in places through the mosaic of leaves.

Although one hesitates to compare such compositions with nineteenth-century landscapes, these works anticipated many of what are considered Klimt's radical innovations in terms of form and motif. Rudolf von Alt's watercolor *In Teplitz Spa Park* (see p. 180), executed in 1877 — a quarter of a century before Klimt's works — evinces the same components as Klimt's views of parks and trees. As in Klimt's compositions, finely textured treetops fill the larger part of the surface in Alt's picture, leaving only a few sections of limbs or small flecks of sky visible. Only a narrow strip at the lower edge is devoted to the depiction of a lawn, path, and broad tree trunks. Alt evokes his "mosaic" of foliage through a plethora of lights and models the texture of the tree crowns in light-dark values, whereas Klimt abstracts the factor of light in the diverse color values of the paint flecks. Also, Alt's nearly square format, like Secessionist canvases in general, implies an equilibration of the excerpt independent of the motif that draws the viewer's attention to the formal structures of the separate elements without determining their position within the pictorial space.

A reception of the themes, motifs and characteristics of nineteenth-century Austrian landscape painting, especially atmospheric realism, was not the sole source of Klimt's approach to landscape. Yet it represented an important point of departure that constantly accompanied his work in parallel with various other influences from contemporaneous European art.

In addition, as becomes apparent on closer scrutiny, the borderline between the regional and the international in Austrian landscape painting of the latter half of the nineteenth century was by no means clear, and it developed traits that definitely reflect an involvement with international currents. Atmospheric realism proved receptive to innovative elements, one of the reasons why this style enjoyed such longevity in Austrian art far into the twentieth century. In addition, the concept of *Stimmung* and the preference for certain associated motifs played a material role both in Austrian and German painting and in the considerations of theoreticians, critics, and artists. A turn to what in retrospect proved to be the progressive style of Impressionism did not take place in Austria across the board. Rather, atmospheric realism was looked upon as an

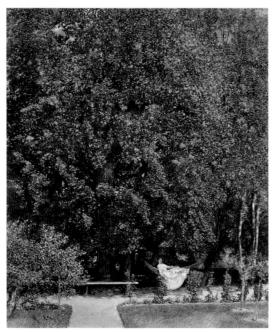

Rudolf von Alt, *In Teplitz Spa Park*, 1877, watercolor with white paint, Österreichische Galerie Belvedere, Vienna

adequate reaction to the naturalism of French painters and their sense of *réalité moderne*. Klimt's paintings reflect this circumstance extremely clearly. His interpretation of the theme involved no break with local traditions but began on the basis of a landscape art that in many respects was much more modern than might first meet the eye.

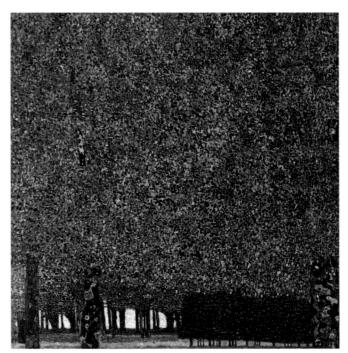

Gustav Klimt,
Park, 1909
(see plate 35)

1 With regard to Klimt's personal motives in devoting himself to landscape, see Johannes Dobai, *Gustav Klimt: Die Landschaften* (Salzburg, 1983), 13.

2 Apart from a few paintings done in the early 1880s, which can be viewed more as a result of a naturalistic orientation in the early work and hence represent exceptions. See also *Gustav Klimt*, ed. Toni Stooss and Christoph Doswald, exh. cat. (Zurich, 1992), cat. nos. G 1, G 2.

3 Regarding the situation of Austrian art and landscape painting around the turn of the century, see Gerbert Frodl, "Die Malerei: Künstlerhaus-Secession-Hagenbund," in *Das Zeitalter Kaiser Franz Josephs, Teil 2). Glanz und Elend 1889—1916*, exh. cat. (Vienna, 1987), 253—63.

4 Due to the conservative climate at the Vienna Academy, many young artists preferred to study at German art centers such as Düsseldorf, Munich, or Karlsruhe, where they became acquainted with the most recent developments in landscape painting. These influences, particularly as regards palette and brushwork, made themselves felt in Austria in the early 1890s. While maintaining the motifs of atmospheric realism, many artists clearly departed from its tone-in-tone palette. The dots and flecks of their paint application bore a superficial resemblance to French Impressionism.

5 On this topic, see Götz Pochat, *Geschichte der Ästhetik und Kunsttheorie: Von der Antike bis zum 19. Jahrhundert* (Cologne, 1986), 555.

6 *Zeitschrift für bildende Kunst* 9 (1874); supplement *Kunstchronik*, 405.

7 August Schaeffer, *Die Kaiserliche Gemäldegalerie in Wien: Moderne Meister* (Vienna, 1903), 202.

8 *Carl Schuch*, quoted in *Carl Schuch 1846—1903*, ed. Gottfried Böhm, exh. cat. (Mannheim and Munich, 1986), 103.

9 Franz Wickhoff, "Über moderne Malerei" (1897), in *Franz Wickhoff: Abhandlungen, Vorträge und Anzeigen*, ed. Max Dvorak (Berlin, 1913), 2:21—44; Alois Riegl, "Die Stimmung als Inhalt der modernen Kunst" (1899), in *Alois Riegl: Gesammelte Aufsätze*, ed. Karl M. Swoboda (Augsburg, 1928), 28—39.

10 Riegl, "Die Stimmung," 34f.

11 Ibid., 36.

12 Ibid., 34.

13 Harald Fischel, "Emil Jakob Schindler," *Die graphischen Künste* 16 (1893): 57.

14 Ludwig Hevesi, *Österreichische Kunst im 19. Jahrhundert* (Leipzig, 1903), 2:254.

15 Harald Fischel, "Emil Jakob Schindler," *Zeitschrift für Bildende Kunst*, n.s. 9 (1897/98):102.

16 Fischel, "Schindler" (see note 13), 56. Apparently Riegl's discussion of the atmospheric landscape strongly relied on quotations and statements by Schindler. One indication is an almost verbatim passage in which Riegl speaks of the reception of natural impressions beyond which art "cannot go, but which it recreates with the aid of its intrinsic means." See Riegl, "Die Stimmung," 34.

17 Quoted in Heinrich Fuchs, *Emil Jakob Schindler* (Vienna, 1970), 24.

18 Fischel, "Schindler," 108.

19 Wickhoff, "Über moderne Malerei," 33.

20 Scattered exceptions were Austrian artists active in France, such as Eugen Jettel. In terms of motif, many of Jettel's paintings of the early 1890s exhibit clear parallels with the works of French landscape photographers, their formal translation having the naturalism characteristic of photography. Of course, mention should also be made of the later, intensive involvement of the Vienna Secession with photography. On the whole, however, research on the history of photography in Austria and visual artists' involvement with it is sadly still in an extremely rudimentary state, so great caution is advised in making any evaluation in this regard.

21 See Andrea Winklbauer, "Impressionismus contra Stimmung: Über das Verhältnis der Österreicher zur französischen Landschaftsauffassung—1868 bis 1903," in exh. cat. (Kunsthaus Mürzzuschlag, 1994), 14—21; Michael Kausch, "Impressionismus und Stimmungsimpressionismus: Wechselwirkungen, Gemeinsamkeiten und Unterschiede der französischen und österreichischen Landschaftsmalerei des 19. Jahrhunderts," in *Faszination Landschaft: Österreichische Landschaftsmaler des 19. Jahrhunderts auf Reisen*, exh. cat. (Salzburg, 1995), 27—47.

22 Wickhoff, "Über moderne Malerei, 36.

23 Ibid.

24 Ibid.

25 Fischel, "Schindler," 59f.

26 Ibid.

27 Wickhoff, "Über moderne Malerei," 33f.; Riegl, "Die Stimmung," 30.

28 Eva Struhal, "Emil Jakob Schindler," in exh. cat. (see note 21), 211; Christoph Heilmann, Michael Clarke and John Sillevis, eds.), *Corot, Courbet und die Maler von Barbizon: "Les amis de la nature,"* exh. cat. (Munich, 1996), 106.

29 Werner Kitlitschka, *Die Malerei der Wiener Ringstrasse* (Vienna, 1981), 59f.

30 Dobai, *Klimt Landschaften*, 11.

31 Ludwig Hevesi, *Acht Jahre Secession, Kritik—Polemik—Chronik* (Vienna, 1906), 234.

32 Fischel, "Schindler," 103.

33 Letter by Gustav Klimt to Marie Zimmermann, 1903; quoted in Gottfried Fliedl, *Gustav Klimt 1862—1918* (Cologne, 1989), 174.

34 On this topic, see Martina Haja, "Thema mit Variationen—Schindlers Pappelallee bei Plankenberg," in Peter Weninger and Peter Müller, *Die Schule von Plankenberg: Emil Jakob Schindler und der österreichische Stimmungsimpressionismus*, exh. cat. (Vienna, 1991), 32—37.

35 Quoted in Fliedl, *Gustav Klimt 1862—1918*, 174.

36 Fuchs, *Schindler*, 26.

37 The earliest painting to which these criteria apply is probably a study of a pumpkin by August von Pettenkofen. See Martina Haja, "'Kraut und Rüben'—Beobachtungen zur österreichischen Freilicht-Malerei im späten 19. Jahrhundert," in *Mitteilungen der Österreichischen Galerie* 30, no. 74 (1986): 44.

38 Based on a statement by the painter Rudolf Ribarz, who spoke of "Kraut-und-Rüben-Malerei," Martina Haja coined the term "Kraut-und-Rüben-Stück" to emphasize both the leitmotif and its excerpted depiction. See ibid., 43 n. 1.

39 Oskar Bätschmann, *Entfernung der Natur: Landschaftsmalerei 1750—1920* (Cologne, 1989), 187 n. 133.

40 Riegl, "Die Stimmung," 34.

41 Bätschmann, *Entfernung der Natur*, 190ff.

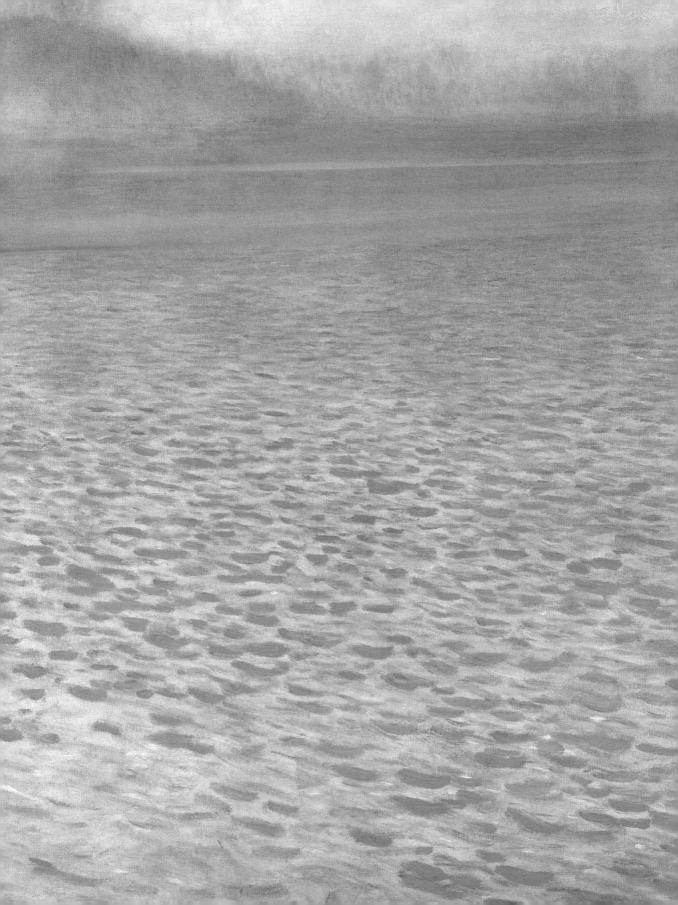

Klimt's Painting Technique and Artistic Means

Erhard Stöbe

The Work Situation

Little is known about Gustav Klimt's working habits. Evidently no photograph exists showing him in the process of painting. The photos of his studios are empty of people, and in none of them does the master appear, brush in hand, at his easel. Not even the very public work on *The Beethoven Frieze* (see pp. 149, 198, 199) seems to have been photographically documented. It would seem justified to conclude that Klimt did not wish to be captured in the pose of the artist at work.

Nor has a palette of the kind that has come down to us from other prominent artists been found in the case of Klimt. What we can say with a high degree of certainty is that he frequently worked for very long periods on his paintings, continuing to make alterations even at very late stages. The articulation of surfaces in a pointillist manner required time and concentration.

The paint surfaces of the landscapes Klimt supposedly executed on site, out of doors, bear no environmental traces—none of the insects, plant or leaf fragments, or the like, that might be expected to have adhered to them.[1] We may conclude that the final paint layer, as visible today, must have been applied in the studio. Based on reports, however, we can assume that Klimt sat in front of the motif when making oil sketches[2] and possibly when preparing initial compositional sketches on a larger canvas. Yet this work directly from the motif cannot have progressed very far, because the canvas format used for the landscapes, 110 by 110 centimeters, would have become unmanageable even in the slightest breeze – one can imagine the scene, as the artist battles with his canvas on the shore of Attersee, a popular sailing lake.

Gustav Klimt, *Attersee I*, 1900 (plate 12, detail)

The Materials

Support and Ground

I shall treat the components of painting support and ground as one, because Klimt himself, instead of selecting them separately, purchased his canvases already primed in one of the day's leading art supply shops.[3] For his landscapes he invariably employed standard sizes. From the turn of the century onward, these were square formats ranging from 80 by 80 to 110 by 110 centimeters.[4]

An oil sketch of 1903, titled *Beech Tree in the Forest* (plate 19), is described as "oil on cardboard," and thus represents an exception. The surface has a rough, grainy texture. Whether it represents that of common cardboard or the applied texture of a commercial painting board remains to be determined. In general, Klimt painted on canvas.

Apart from a few exceptions, he preferred fine-textured canvas. In one case, the *Portrait of Sonja Knips* (see p. 37), Klimt employed a two-ply type of canvas weave which at the time was known as "Roman linen" and is now called "Panama." This two-ply fabric had a clearly visible texture and was stronger than the normal weave. Subsequently Klimt apparently concluded that heavy canvas was not necessary and began to employ fine canvas for the relatively large-scale late Symbolist compositions. Since he did not paint in impasto, there was little fear of a disproportion between strength of support and thickness of paint layer. Klimt apparently preferred smooth surfaces, selecting double-primed canvas in which the barely tangible fine texture was largely filled. The grain of the canvas is no longer detectable with the fingertips, yet visually one still has the impression of primed canvas, of a surface. In other words, the surface is not so completely filled as the paint supports used by earlier Viennese artists, who preferred a mirror-smooth effect.

In the majority of cases, the ground consists of half gesso with an admixture of siccative oils. Oil ground was also used in rare cases. The artist's choice seems to have been determined by the purpose for which the canvas was to be used.

In connection with the group of Weissenbach paintings (plates 48–58) and following works, Klimt's preference for half gesso apparently changed. He augmented the increased brightness of his palette with a brilliant white ground, which is best produced by means of pure gesso in a vehicle of glue or sizing.[5] However, this ground had the disadvantage of weak adhesion to color tones that were subject to high shrinkage (such as lead white and chrome green brilliant), which could lead to a partial rising or flaking of the brushstrokes. The relatively dry gesso primer layer could not take up the tension of the shrinking paint. However, such damage probably could not have been foreseen in Klimt's day. In addition, only a single coat of gesso primer was applied, which lent the surface a livelier effect and made the brilliance of the colors appear not homogeneous but as if flickering across the plane. Experiments with various grounds, of the kind Egon Schiele made, are not found in Klimt's case.

Fixative from the Richard Bier company, c. 1910, private collection

Canvas Samples

The types of canvas employed by Klimt evince no great variety. A few samples taken from his paintings exhibit the following characteristics:

Portrait of Sonja Knips, 1898	9 warp strands, two-ply
Half gesso ground	5 weft strands, two-ply
Farmhouse with Birch Trees, 1900	15 warp strands
Half gesso ground	21 woof strands
Adele Bloch-Bauer II, 1912	15 warp strands
Oil ground	21 weft strands
Villa on the Attersee, 1914	15 warp strands
Gesso ground	17 weft strands
The Bride, 1918	15 warp strands
Half gesso ground	21 weft strands

Evidently a certain type of canvas was employed consistently over a period of twenty years. It was a relatively fine weave that was used even for larger formats (e.g. *The Bride*,

166 × 190 cm, see p. 208). The later Attersee paintings were executed on a less densely woven canvas, primed with a ground that contained less oil, or none at all. These works form an independent group, in terms of materials as well as style.

The catalogue of an art supply company, dating to around 1911, lists similar types of ready-primed canvas that would have served Klimt's purposes well. These include:

Ebeseder Co., no. 5	9 warp strands, two-ply
Roman oil ground	15 weft strands, two-ply
Ebeseder Co., no. 10	16 warp strands
Half gesso ground	19 weft strands [6]

As such correspondences indicate, Klimt apparently purchased his canvases ready-primed and in consistent quality from the trade. Both canvases and grounds have survived the decades in very fine condition —his choice was a good one.

Preliminary Drawing

Klimt employed various materials in the preliminary drawings for his paintings. Landscapes were sketched out with a pointed brush, in oil thinned with turpentine, or occasionally in pencil. In the pure studio works, such as the portraits and the Symbolist compositions, Klimt also employed charcoal for preliminary sketching.

Price list for oil paints from the Pelikan sales catalogue, 1909, private collection

Paints and Pigments

It is not known whether or not Klimt obtained all of his oil paints from a certain company. There was a great range available on the Vienna market at that period.[7] Companies still in existence today offered artists' supplies over one hundred years ago. Klimt, like many other painters, probably selected the colors he needed from various ranges and brands. His earliest idol in landscape painting, Emil Jakob Schindler, employed resin oil paints.[8] Others perhaps followed his example.

In Viennese artists' and restorers' circles, Klimt, Schiele, Oskar Kokoschka and others were said to have employed a "mixed technique," that is, a combination of tempera and oil. Actually, Kokoschka seems not to have begun experimenting in this vein until his Dresden period, and Oskar Laske, in Vienna, not until the 1920s. There is an example in Klimt's oeuvre, *Poppy Field* (plate 29), where some of the lighter colors, such as the yellow, were apparently ground with a watery vehicle. Still, the evidently poor paint adhesion might have been due to other reasons, such as a thinning of the yellow to achieve higher brilliance. In fact, I have detected water-soluble pigments only in a single painting of Klimt's, *Portrait of a Lady in White* (right), where they occur in the underpainting of the incarnadine and the hair. Judging by its solubility in water, the product used was apparently a type of gouache or poster paint. Since Klimt left very few works on paper, one must assume that although he mastered this technique, he did not hold it in the highest regard.[9]

Klimt was an oil painter first and foremost. He received his training at the School of Decorative Arts from Julius Berger,[10] a solid if not brilliant technician who occasionally executed the auxiliary figures in Schindler's compositions. So his knowledge of means and materials was adequate, if perhaps not extending to special experiments with paint media. Klimt employed what he had learned without much change throughout his career, his development relating more to texture and the handling of the paint media. As far as media are concerned, he apparently used turpentine only, but obviously no fat medium mixed of turpentine, resin, and linseed oil. This is indicated by the rather matte surface character of his unvarnished paintings, in which the oils have a slight gloss only where they have been applied unthinned. Klimt's essays into gold might be viewed as an experimental series within the development of his techniques and chromatics.

The Palette

Since little is known about Klimt's working habits, we shall have to rely on comparative examples in discussing the question of his palette.

Antique dealers occasionally receive old palettes that artists had once presented to friends or buyers of their work. In the middle, where the paints were mixed, one occasionally finds a small motif (in the example available to me, a putto holding a paint tube under one arm and brandishing brushes and palette with the other). This presentation image is surrounded by small quantities of dry paint, just as it was squeezed from the tube, which record how the artist arranged tones on his palette. The palette sketch (see p. 186), judging by its motif and style, can be dated to the final decades of the nineteenth century. The colors, arranged in a semicircle, read from left to right: dark green (brilliant chrome oxide), light green (Veronese earth?), four brown gradations (glazing, opaque, cool, and warm), black, ocher, dark yellow, light yellow (Naples yellow?), lead white, Venetian red, burnt ocher,

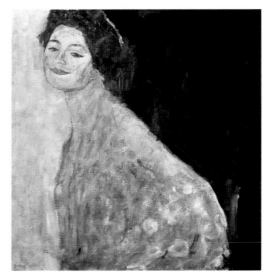

Gustav Klimt, *Portrait of a Lady in White*, c. 1917/18. Österreichische Galerie Belvedere, Vienna

light red (vermilion?), two red lakes, presumably madder lake (brownish) and carmine lake (pinkish), brown glaze (undefinable), and four blue gradations (cerulian, ultramarine, indigo, Prussian blue).[11] The interesting thing

about this arrangement is that the light tones in the middle separate the blues from the greens. Not all of the pigments can be definitely determined, despite the fact that they were squeezed unmixed onto the wooden palette; the dark gradations in particular have lost much of their color value. It naturally would be overhasty to draw conclusions about Klimt's palette from the present one, as it merely represents a random example from his period of activity, which, moreover, is likely more typical of the Schindler school. One imagines that Klimt would not have required such a range of browns, but more variants of green.

Klimt always placed the highest demands on himself as an artist. His earliest known landscapes reflect an orienta-

Palette with small painting of a putto as a dedication, 1880s, private collection

tion to Schindler (see plates 1–3). These were doubtless done directly from the motif, as their small formats would suggest. At this period Klimt's palette was still far from its later brilliancy. He used the academically recommended landscape palette, with a limited selection of brown, gray, and green gradations from the medium range — blue was seldom included, despite its being standard for the rendering of sky. In many cases, green was produced indirectly, that is, by mixing gray and brown tones. Even today green is still considered a difficult color, a bias that presumably had its source in a period when permanent green pigments were available only in a very limited range, which was the case down into the eighteenth century.

In view of the intensity with which Klimt addressed the problem of green, we may assume that he had several brilliant green pigments at his disposal. Mixing greens from Prussian blue and yellow or ocher, as recommended in the art manuals of the day, would have been more suitable to tone-in-tone painting than to chromatic adventures. Also,

a green mixed of Prussian blue and yellow would have been difficult to reconcile with the violet Klimt employed for shadows.

Still, the limited palette of the 1870s and 1880s had the advantage of permitting great flexibility in the production of tonal sequences and fine gradations. In his small sketches, Klimt concerned himself with the problem of light, employing his means with such great skill that the moods and atmospheres evoked give one a sense of *déjà vu*. The paint application is not heavy or impasto, yet dense in its description of forms; the stroke models the forms carefully without departing from them. An interesting feature in one of these small paintings is the use of an accessory figure. This feature would reappear, and serve the same space-defining function as the equally small accessory figures in the much later *Schönbrunn Park*, 1916 (plate 47).

The Use of Color as a Painterly Means

The texture of Klimt's paintings reveals a continual development in his knowledge of the medium. Persistent application to the means of expression and design characterizes his oeuvre throughout the decades and confirms the artist's ability to adopt the results of others without slavishly copying them.

By the time Klimt returned to landscape at the end of the 1890s, his palette and method of paint application had made great progress. Now he no longer avoided clear, bright greens; the expansive flat color planes of his meadows would have scandalized the previous generation of artists, both in terms of paint handling and visual impact.

The paint surfaces are still quite dense, yet the largely tranquil planes are enlivened by rapid brushstrokes and their potentially decorative effect counteracted by asymmetrically placed accents of other colors. A similar approach can be seen in the work of Ferdinand Hodler (see, for example, *Ergriffenheit* (Profound Emotion), of 1900, Österreichische Galerie Belvedere); Hodler, however, favored a less indeterminate paint application. The soft impression engendered by Klimt's forms and illumination was probably inspired more by Symbolist painters such as Henri-Eugène Le Sidaner, whom he surely knew from the journal *The Studio*, than by the Impressionists, whose work was hardly published at that period.

Klimt used drawing to establish a solid compositional framework in the landscapes but rarely to define interior form. That left room for color to assume new tasks, a liberation, however, of which Klimt took only tentative

advantage. In the years up to 1903, his chromatics and brushwork made great strides forward. The works of the period clearly reveal different lines of development which, partly simultaneously, partly consecutively, led to a new overall approach to painting.

Klimt's stringency of composition emerged from a focus on a certain landscape excerpt. That a scene rendered immutable with such apparent ease could ultimately reveal a visual order was the result of an intensive involvement with the possibilities contained in visual design. Klimt's finished pictures were, at bottom, perfect compositions in the guise of proliferating plant life.

In this connection, the sketch *Beech Tree in the Forest* (plate 19) provides an interesting supplement to our knowledge of Klimt's working procedure. It reflects the way in which he could paint from a motif without resorting to consciously structuring brushwork. In the finished paintings of this period, the plane is articulated by means of brushstrokes set in sequential or alternating rhythms. The compositions usually rest on a simple conception based on the relationship of tension between large, rectangular planes. This disposition, by nature, brings the idea of landscape into play and establishes the basic definition of the image.

As Klimt's concern with landscape began to increase, he was already beginning to borrow a compositional motif from Symbolism—parallelism. The vehicle for this was tree trunks. After initially ranging across the available space only tentatively (as in *Farmhouse with Birch Trees*, plate 11), the trees later began to form much closer ranks. As Klimt launched into this group of paintings he adopted the subject of the forest interior, as found, say, in Arnold Böcklin or the Munich Circle (plates 16, 17).

Klimt counterpointed the dark bands of the trunks with a second layer of space, containing light values reduced almost to the form of points—a free composition of almost white dabs that relates to the entire square of the surface. In the upper portion of the canvas these points are defined as self-luminous (functioning as sky), and in the lower, as illuminated (functioning as blossoms). There is not a tree trunk in Klimt's landscapes that is simply dashed off. Each is accorded equal attention and care.

Gustav Klimt, *Golden Apple Tree*, 1903.
Lost in a fire at Schloss Immendorf,
Lower Austria, in 1945

Among the tree trunks a sort of communication is set up which virtually constitutes the pictorial space. These long, slender, variously textured patches of paint substance reveal how strongly the composition is determined by color. Klimt disposed with modeling, as he would again and again, by means of shading, thus abandoning one of the three components that defined previous painting: drawing, color, and relief.[12] Relief, an element that helps determine illumination, was deprived of its function, which was accorded instead to color. This step was one that Klimt shared with many other European artists. The expansive planar passages are color arrangements in their own right. They do not repeat the plane of the paint support in a merely decorative way. A sense of depth is engendered by means of strokes and dabs that grow smaller and more closely spaced toward the top of the canvas. Each intermediate space is rendered individually; the negative shapes stand on an equal footing with the positive shapes that contain them — equal attention is devoted to every area of the picture plane.

In the landscapes of 1902—03 Klimt worked out an abundance of possibilities on which, after the adventure of the "Gold Period," he would later be able to build. In addition to lending rhythm to compositions by parallel rankings of form, Klimt explored the tonality of a reduced range of color. His water surfaces, in particular, gave the impression of a tonal sequence based on the look of photography. No painter of the previous period would have been capable of rendering the surface of water in this way. Yet an eye trained by viewing photographs had an alternative manner at its disposal to develop gradations from light to dark.

Klimt soon put this exploration of photographic gradations aside. The brushstrokes in this group of works are calm and hovering and fluidly interact with the defined planes, as if to draw attention to the gradual sequencing of the tones. Yet in addition to parallelism and tonality, Klimt was involved almost concurrently with another issue that would challenge him again and again: the rendering of expansive areas by means of finely articulated patterns or grids of dots and strokes. The brushstrokes are not used to model things; an effect of relief is clearly neglected in favor of color and reduced drawing. The rhythm

established by the brushstrokes seems motivated by a desire akin to that of gestural abstraction — to let the image emerge without conscious intervention. The painting process seems to have been carried out in a trance.

Golden Apple Tree (plate 23), destroyed in World War II, would always have represented an exception among Klimt's landscapes, because in it his intention focussed more on the employment of gold as a visual device in its own right than on the factor of landscape content. Although he derived confirmation for his employment of gold from his confrontation with Byzantine gold mosaics

Japanese Landscape using the gold lacquer technique, Edo period, lid of a box, private collection

in Ravenna in May and December, 1903, Klimt's model was actually Japanese lacquer paintings, in which the artists transcended an exclusive focus on the metallic character of this material to create entire images, not just certain passages, with metallic pigments alone.

The Investigation of Fluorescence

The only pigments we were able to detect with the aid of fluorescence in Klimt's palette were zinc white (which he used along with lead white) and Lac de Garance (geranium lake). Zinc white fluoresces greenish and acts differently from lead white in tonal blends, but does not form as solid a lineolic oxide layer. Lac de Garance was adopted from Western European painting; mixed with white, the pigment produces a brilliant pink, without the brownish cast of madder mixtures.

Composition

Color is the determining element in Klimt's imagery, or is at least placed on a par with form. Consequently, spatial, material, and atmospheric meanings in the compositions are conveyed through the paint substance and the diverse types of brushwork with which it is applied. Drawing plays only a modest role. For the Schindler school, one-point perspective was still a key device. Klimt is a different matter. In a strongly perspectival situation, such as that of *Avenue in Schloss Kammer Park* (plate 39), depth is counteracted by the building facade and bands of color gradations (from gray to light green) running parallel to the horizon. Although these bands represent a section of path and pond, compositionally they form a unit. Klimt does not even allow the notion of perspective depth to arise.

The axial systems in Klimt's landscapes are not as orthogonal as might appear at first sight. Many of the axes leading diagonally into the distance are not sufficiently supported by the framework of the drawing, but rather are underscored by the interrelationships of color planes. Again, *Avenue in Schloss Kammer Park* may serve as an example.

Among the many shades of green, there is a dark, square, delimited fleck that relates to a red zone that is only vaguely recognizable as a roof. These two color areas refer to the castle, indicating the vertical extent of the facade, as if the yellow of the wall were stretched between them. A light green passage adjacent to the dark green at the left, indicating a tree, is not intended to complement the red, and thus can detach itself from the building elements to clearly convey the meaning of a tree.

Numerous structures and networks of color relationships engender a sense of condensed, shallow space. In paintings based on the classical proscenium stage, the image—in terms of color as well as form—always seems to begin to appear behind the painting surface and extend from there into illusionary depths. In Klimt's pictures, in contrast, the colored image appears to begin right at the surface and to project outward toward the eye.[13] In accordance with the fundamental pattern underlying the concept of "landscape," horizontality predominates; converging lines of perspective are just as absent as attempts by any other means to draw the eye into the distance. All of these paintings seem informed by an urge akin to organic growth, a development from bottom to top that needs no recourse to precise description of plant anatomy to underscore it. In a few paintings, the central motif is rounded off, so as not entirely to coincide with the square of the format. Yet the corners are not sloughed over but treated

with care. Even the tiniest section bears a suggestion of sky, perhaps the only bit of blue in the picture, or a component of some other spatial layer.

In the final phase of his career, the variety of Klimt's landscape types was enriched by views in which accumulations of buildings were depicted (the Lake Garda canvases and *Gastein*; plates 44–46, 59). Curvilinear compositional elements were set off by a rigorous grid of verticals, horizontals, and diagonals set at various angles. Colored building facades now began to mitigate the gradations of green that play such a dominant role in Klimt's landscapes. The superimposition of several textures of slightly different scale and density engenders a coexistence of expansion and contraction, a network of motions, color pulsations that, instead of pressing outward beyond the given contour, appear to advance forward, toward the viewer's retina.

In a few groups of works, especially in the portraits, Klimt did in fact employ ornamentation and design the backgrounds in a decorative manner. Ornament, as a design principle, is generally cited as characteristic of his entire oeuvre. In the landscapes, however, the act of painting unfolds in an uninterrupted, if not entirely spontaneous, way, suggesting comparisons with the late Monet, with Bonnard or Vuillard. The large, stippled planes of Klimt's tree crowns and meadows are not modeled, but neither do they possess an ornamental character.

By the same token, the graphic framework of his compositions cannot be called decorative or ornamental. Even in the initial division of the surface, Klimt avoids every decorative tendency. Although there are correspondences among the divisions, there are no symmetries that would convey a sense of repetition. Even elements whose contours are by nature uniform, such as the windows in a house wall (see p. 48), are developed quite individually once the contour has been established. Accumulations of the same variety of plant, too, are always rendered with a great degree of variation.

Gustav Klimt belonged to the generation of artists who set out to reform the conception of the painted image in the final decades of the nineteenth century and early decades of the twentieth. What made his landscapes appear decorative was an inability to understand his attempts to redefine the legibility of space, as rendered in two dimensions. Despite his strong ties with the tradition of painterly values, Klimt was an innovator, one who wrested new impulses from the architecture of the painted plane. By analogy to the classical typology of cultural myths, he was an Empedoclean figure — keeping, preserving, and finally, rushing forward.[14]

1 By contrast, the portrait of *Mathilde Schönberg in the Garden*, of 1907, by Richard Gerstl (1883–1908), was doubtless painted out of doors, judging by the bits of grass adhered to the paint at the lower edge of the canvas when I inspected it in 1994. These have since been removed. For contributions to a documentation of Gerstl's life and work, see *Mitteilungen der Österreichischen Galerie* 18 (1974): 157, no. 39.

2 Cf. plate 19.

3 The leading art supply shops of the day were: Anton Chramosta's "Zur Stadt Düsseldorf" on Kärntnerstrasse; Alois Ebeseder on Opernring: and Richard Bier on Tegetthoffstrasse. All of these shops were a ten minute's walk from the Secession and the Academy of Visual Arts.

4 French painting had introduced standard sizes for prefabricated painting supports whose proportions related to subject matter; i.e., landscape formats and portrait formats had different height-to-width ratios. The advantage of this standardization for artists and the trade consisted in the fact that canvases could be rolled for shipment to exhibitions after marking them with the dimensions printed on the standard stretchers, which eliminated the necessity of measuring them before restretching. Then, in the Secession period around 1900, the square format came into currency, and the standard dimensions were usually rounded off to the nearest centimeter (the earlier norms had been based on the inch measure).

5 Klimt probably learned this method of priming during his stay in Italy, on Lake Garda. It would seem unlikely that he went to the trouble of carrying primed canvases with him from Vienna. Italy is extremely accommodating to artists, and all the required materials are easily obtained there. The painting ground of preference in Italy consists of Bolognese gesso and rabbit glue (*gesso e colla di coniglio*), by which Italian artists swear. The defects in the ground of the Weissenbach paintings are probably attributable to the difficulty of imitating this Italian ground in Austria, where the tradition was a different one.

6 See Ludwig Hans Fischer, *Die Technik der Ölmalerei* (Vienna, 1911), a practical little book which also contains samples of materials.

7 Ibid.

8 Information kindly provided by Dr. Sabine Grabner; see "Aus den Erinnerungen eines Malers," *Fremdenblatt*, January 4, 1921.

9 The reconstruction of Klimt's technique on the basis of the oral tradition and that of his contemporaries up to half a century after his death are very interesting in this regard. The implication that errors could have slipped into the oral transmission and the assumptions derived from this are discussed by Erich Plaim in *Traum und Wirklichkeit*, exh. cat. (Vienna, 1985), 499.

10 Information provided by Dr. Erika Patka, archive of the Universität für Angewandte Kunst, Vienna (formerly Kunstgewerbeschule, the school of arts and crafts that Klimt attended).

11 The prices of oils in tubes (medium size) varied from 0.60 crowns for inexpensive earth pigments (ocher, iron oxide) to 3.60 crowns for expensive pigments (cerulian blue, cobalt violet). By way of comparison, the sales catalogue cost 3 crowns. Cf. Günther Wagner, (Vienna and Hanover, 1909).

12 In the fifteenth century, the Medicean Academy, a circle around the philosopher Marsilio Ficino, developed what they termed "paragons," an analysis of the means of art and philosophical guidelines for their employment. The constituitive elements of painting were defined as drawing, relief, and color (*disegno, rilievo, colore*). These rules, considered binding, held undisputably valid until the latter decades of the nineteenth century.

13 This very fragile state can be easily worsened by restoration or other measures, such as improper varnishing.

14 Empedocles, Greek philosopher (Agrigento, *c.* 450 B.C.). The verbal root from which his name derives can be associated with two verbs, one connoting "to preserve" and the other "to rush forward," opposite tendencies that are indeed found in the philosopher's biography.

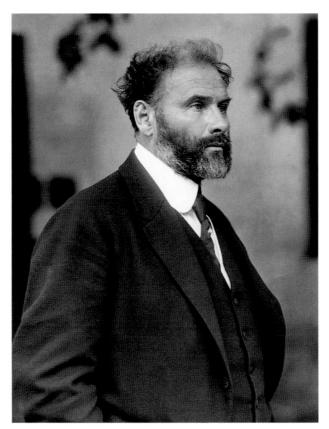

Gustav Klimt, *c. 1910*. Photo: Moriz Nähr

Gustav Klimt: A Biography and List of Landscape Paintings

1862

Gustav Klimt was born on July 14 as the second of seven children to Ernst and Anna Klimt (née Finster) in Linzerstrasse 247, in the 14th district of Vienna. The family of his father, an engraver, originated from Drabschitz (Trávčice) near Leitmeritz (Litoměřice) in northern Bohemia; his mother's family came from Vienna. His father was unsuccessful in his profession and, from 1873 onward, having lost his source of income, was forced to live with his family in impoverished circumstances.

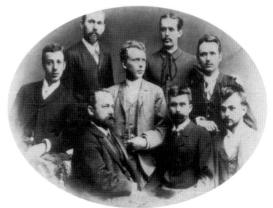

Ferdinand Laufberger's class at the Arts & Crafts School, *c.* 1880 (front row, *left to right*: Ferdinand Laufberger, Gustav and Ernst Klimt; back row, *left*: Franz Matsch

The house in Linzerstrasse 247, 14th district, Vienna, where Gustav Klimt was born. Klimt's parents lived in the room to the right of the entrance; the house was demolished in 1967. Photo: *c.* 1900

1876 – 83

Gustav completes his eight-year schooling and afterwards enrolls as a regular student in the School of Applied Arts of the Austrian Museum for Art and Industry (today the University for Applied Arts in Vienna). His brother Ernst (born in 1864) is a student at the same school, later followed by their brother Georg (1867–1931), a sculptor and engraver who created numerous frames for Gustav's paintings. In the two-year preparatory course for the School of Applied Arts, Klimt studies under

Michael Rieser, Ludwig Minnigerode, and Karl Hrachowina. The school for painting was run by Ferdinand Laufberger (1829–81) and, after his death, by Julius Victor Berger (1850–1902). The Klimt brothers receive a scholarship amounting to twenty gulden per month. From an early age, the brothers are forced to help support their family by painting miniature watercolor portraits from photographs and preparing technical drawings for the ear specialist Adam Pollitzer.

Ernst and Gustav Klimt, and their fellow student Franz Matsch (1861–1942), are involved in the organization of Hans Makart's "Grand Procession" celebrating the silver wedding anniversary of the Imperial couple Franz Joseph I and Elisabeth.

In 1880, the two brothers and Matsch receive their first decoration commission to paint *Poetry, Music, Dance,* and *Theater* for the architect Johann Sturany's *palais.*

Secluded Pond, 1881 (no ND no.)[1]

Forest Floor, 1881/87 (no ND no.)

In the Middle of the Forest, 1881/87 (no ND no.)

1 ND refers to the catalogue raisonné by Johannes Dobai in Fritz Novotny and Johannes Dobai, *Gustav Klimt* (Salzburg, 1967)

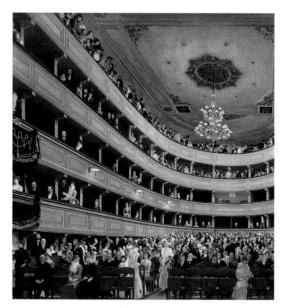

Gustav Klimt, *Auditorium of the Old Burgtheater*, 1882, gouache, Historisches Museum der Stadt Wien, Vienna. Many well-known members of Viennese society (such as actress Katharina Schratt and actor Alexander Girardi from the Hofburgtheater) had their portraits painted by Klimt, who depicted them with photographic precision.

Gustav Klimt, *Theater in Taormina*, detail, 1888, oil on plaster. Central ceiling panel on the northern staircase at the Burgtheater in Vienna

1883 – 85

The Klimt brothers, along with their fellow student Franz Matsch, move into a studio in the Sandwirthgasse 8 (6th district) and found the "Künstlercompagnie." Due to their stylistic similarities, it is difficult to accurately ascribe unsigned works to the individual artists. The Compagnie receives several commissions (for ceiling paintings and curtains) from the Viennese architectural studio of Fellner and Helmer, which, between 1872 and 1914, designed numerous theaters in Austria-Hungary, Germany, Switzerland, and the Balkans. In addition, they provide designs for tapestries and copies of old masters for the King of Romania.

All three work on *Allegorien und Embleme* (Allegories and Emblems), published by Martin Gerlach during the period 1882 – 84. Gustav Klimt provides eleven full-page illustrations, with reproductions of paintings and drawings, specifically created for the volume.

1886 – 88

The first important commission received by the "Künstlercompagnie" is for the decoration of the two staircases of the newly constructed Viennese Burgtheater, completed by Karl von Hasenauer after the resignation of Gottfried Semper. This commission is granted by the Imperial Building Committee on October 20, 1886. The theater director Adolf von Wilbrandt specifies the history of the theater as the theme. The "Künstlercompagnie" is presented to the Burgtheater patron Emperor Franz Joseph I at the opening of the new house. The Emperor, who had paid for the construction and upkeep of the house from his private coffers, expresses his extreme approval. In the magazine *Kunst für alle*, Friedrich Pecht describes Klimt as Hans Makart's "heir."

In 1887, the City of Vienna commissions two large watercolors portraying the interior of the old Burgtheater. Gustav Klimt paints the view from the stage towards the entrance, and Matsch depicts the view from the entrance to the stage. The highly detailed paintings portray two hundred members of Viennese society.

In August 1888, Gustav travels with his brother to Innsbruck, Salzburg, and the Königsee. In 1889, once again in Ernst's company, he visits the Salzkammergut for the first time, staying in St. Wolfgang and Gmunden.

1890

On April 26, Gustav receives the "Kaiserpreis," valued at 400 gulden, in recognition of the Burgtheater watercolor, which had been displayed in the Künstlerhaus in March.

On June 8, Gustav and Ernst travel to Venice and then to Carinthia.

1891

The Kunsthistorisches and Naturhistorisches Museums in Vienna are constructed following plans by Gottfried Semper and Karl von Hasenauer. The "Künstlercompagnie" receives a commission for corner paintings on the staircases. For the first time, the artists differ in their painting styles: Matsch and Ernst Klimt remain faithful to the academic style, whereas Gustav Klimt's personification of the Antique era, Glycera the lover of the ancient painter Pausias, is shown as a modern woman in contemporary clothing. The Emperor, who had the museums constructed using private funds, thanks the artists with his "most-esteemed praise."

Gustav joins the Künstler-Genossenschaft.

Ernst and Gustav Klimt, *The Buffoon at a Street Theater Performance in Rothenburg ob der Tauber*, 1891/94, oil on canvas, private collection

Gustav Klimt's blue painter's smock, Historisches Museum der Stadt Wien, Vienna

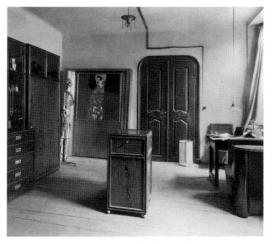

Room leading to the studio shared by the Klimt brothers and Matsch in Josefstädterstrasse 21 (furniture designed by Josef Hoffmann, manufactured by the Wiener Werkstätte). Back wall: *Hope II*, c. 1907/08

1892

The Klimt brothers and Matsch move into a studio in the Josefstädterstrasse 21 (8th district) where Klimt works until 1914. In his publication entitled the *Egon Schiele Buch* of 1921, Arthur Roessler describes his impressions: "One entered surrounded by flowers and ivy. This had been Klimt's workplace for years. Entering through a glazed door, one came into the entrance where painting frames and other materials were heaped up. Three additional working rooms led off of this. Hundreds of drawings were strewn around the floor. Klimt always wore an ankle-length, pleated smock."

Klimt's father and his brother Ernst die on July 13 and December 9, respectively. Ernst had been married to Helene, the daughter of the Viennese meerschaum pipe maker Hermann Flöge, who, along with her two sisters, ran a famous fashion salon. A daughter, also named Helene, was the offspring of their brief marriage, and Gustav became her guardian.

Ernst's death leads to the dissolution of the "Künstlercompagnie." Franz Matsch becomes the favorite of the Burgtheater star Charlotte Wolter and advances to become a sought-after portraitist of Viennese society.

1893

On January 6, Klimt visits Totis (Tata) in Hungary to paint the picture *Auditorium of the Theater at Schloss Eszterházy*, which wins the silver medal at the Künstlerhaus Exhibition in March. In October, Matsch is appointed professor of painting at the School of Applied Arts.

On December 21, Klimt is nominated for the professorship of the specialist school for historical painting at the Academy of Fine Arts; the Polish artist Kazimierz Pochwalski, however, is given the chair.

Gustav takes up contact with a rowing club, practices club swinging and other sports.

1894

On September 4, the Academic Senate of the University of Vienna grants Matsch and Klimt the commission for the ceiling paintings for the Great Hall of the university building, designed by Heinrich von Ferstel.

In December, the Munich Secession exhibits in the Künstlerhaus, on the initiative of young members of the Viennese society.

The Burgtheater paintings are published in the third volume of the series *Die Theater Wiens* (Viennese Theaters). During his inaugural speech, *On Modern Architecture*, held at the Academy of Fine Arts, Otto Wagner talks about "Nutzstil" (utility style).

Gustav Klimt, *Love*, 1895, Historisches Museum der Stadt Wien, Vienna

1895

At the unveiling of a monument commemorating Emil Jakob Schindler, Klimt becomes acquainted with Schindler's daughter Alma—the later Alma Mahler-Werfel. He begins work on the commission for the music room in Nikolaus Dumba's town palace on the Parkring in Vienna I. *Auditorium of the Theater at Schloss Eszterházy* wins first prize at the Antwerp Grand Prix.

1896

In February, Klimt is accepted as a member of the board of the Society for Reproductive Art, which had commissioned *The Actor Josef Lewinsky as Carlos in "Clavigo"* (see p. 32).

Orchard, 1896/97 (ND 98)

1897

In 1892, the Munich Secession had been established with Franz von Stuck as its founder; in 1893, the Berlin Secession—with Max Liebermann as its initiator—followed. On April 3, Klimt officially informs the board of the "Society of Viennese Graphic Artists" and the Viennese press of the establishment of the "Society of Austrian Graphic Artists." The initial list of members consists of forty names. The Society's president is Klimt; its honorary president Rudolf von Alt. The "Secession" is planned to be a group within the framework of the "Society of Viennese Graphic Artists" (Künstlerhaus-Genossenschaft) with the goal of reforming artistic life and the character of exhibitions. The intention is to elevate Austrian art to the international level. On May 22, along with eight other artists, Klimt silently leaves the hall during a tumultuous session of the general assembly of the Künstlerhaus-Genossenschaft. Following this, a vote of disapproval—with four objections—was carried out in the Künstlerhaus. On May 24, Klimt and twelve other artists reject this vote in an official letter and leave the society. Nine artists leave in the days that follow. The first general assembly of the new society is held on June 21. Klimt, Josef Hoffmann, and Carl Moll are responsible for exhibition activities until 1905.

On April 14, in the earliest correspondence with Emilie Flöge still extant, Klimt apologizes for not being able to continue on the course—this probably is in connection with the French lessons which both took until July 1900.

He spends the summer with the Flöge family in Fieberbrunn in Tyrol.

At Twilight, 1897 (no ND no.)

Silk Apple Tree, 1897 (no ND no.)

Farmhouse with Rose Bushes, c. 1897/98 (ND 99)

1898

In January the first issue of the Secession's magazine *Ver Sacrum* appears with Hermann Bahr and Max Burckhardt as literary advisers. Burckhardt writes: "And therefore, we appeal to each of you regardless of your rank or fortune. We do not recognize any difference between art … for the rich and the poor."

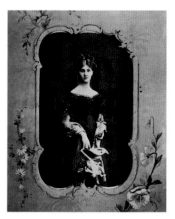

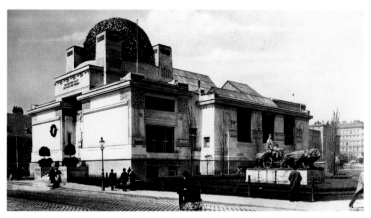

Marie Zimmermann, Klimt's muse, nude model, and mother of two of his sons, c. 1903

The Vienna Secession, Karlsplatz, Vienna (built according to plans by Joseph Maria Olbrich), photographed shortly after its opening, c. 1900

Klimt rents an additional studio in Florianigasse 54 (8th district) for his work on the faculty paintings.

Klimt has to alter the poster for the First Secession Exhibition (March 26–June 15) which displays a naked Theseus in battle with the Minotaur (see p. 146). The exhibition itself—with more than 56,000 visitors and sales amounting to 85,000 gulden—is a great success.

On May 4, Klimt is reelected president of the society, against the opposition of some members.

On May 26, the artistic commission of the Ministry for Education decides that the female figure representing "suffering humanity" in the faculty painting *Medicine* is too obscene and recommends replacing it with the figure of a youth (see p. 197).

Klimt becomes a member of the International Society of Artists, Sculptors, and Engravers, under the chairmanship of James McNeill Whistler.

Klimt spends several weeks with the Flöge family in St. Agatha in the Salzkammergut. Notes in this connection are dated August 11 and September 17.

On November 12, the 2nd Secession Exhibition is opened in the new Secession Building, designed by Joseph Maria Olbrich, on land provided by the Viennese City Council. The words "Der Zeit ihre Kunst, der Kunst ihre Freiheit" (To the age its art, to art its freedom) are inscribed above the portal.

After the Rain, 1898 (ND 107)

Dusk, 1898 (no ND no.)

1899

March 18—May 31, 4th Exhibition of the Secession at which Klimt exhibits his *Nuda Veritas* (see p. 148) and *Schubert at the Piano,*

one of the paintings above the door in the music room in the Palais Dumba. In 1900, Hermann Bahr, in *Secession*, praises the *Schubert* painting: "Recently I said that Klimt's Schubert is—in my opinion—the most beautiful picture ever painted by an Austrian Here, I once again had that feeling: it depicts what our miserable words are incapable of doing; but we cannot survive if it is not revealed to us and this is the reason that art was given to man."

Klimt travels around Italy from April 14 to May 6, visiting Florence, Genoa, Verona, and Venice with Carl Moll's family. Alma Schindler, Moll's stepdaughter, reports on Klimt's financial situation in a diary entry dated April 28: "Five women are absolutely dependent on him: his mother, his sister, his sister-in-law, her sister, and a young niece. This is all fine and dandy but he isn't selling anything."

Not later than August 11 until September 1 at the earliest, Klimt stays with the Flöge family in Golling near Salzburg. In August he and one of his models, Marie (Mizzi) Zimmerman become parents of a son named Gustav (Gusterl).

Orchard in the Evening, 1899 (ND 106)

Secluded Pond in Schloss Kammer Park, 1899 (ND 108)

1900

March 8–June 6; 6th Exhibition of the Secession. Among the works displayed is *Philosophy*, the first of Klimt's faculty paintings for the Great Hall of the University of Vienna (see p. 151). The exhibition attracts 35,000 visitors, and *Philosophy* gives rise to criticism. Polemical newspaper articles are published, 87 university professors protest against the hanging of the painting in the Great Hall, and the board of the Secession protests to the

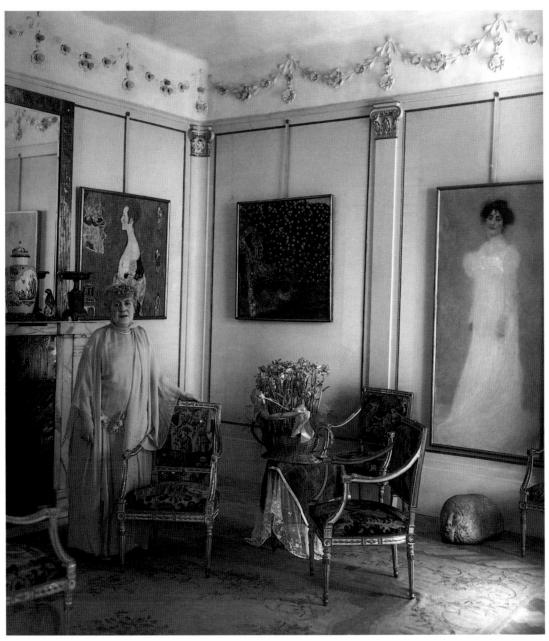

Serena Lederer in her apartment in Bartensteingasse 8, Vienna I, surrounded by paintings by Klimt (*left to right: Wally*, 1916, *Golden Apple Tree*, 1903, *Portrait of Serena Lederer*, 1899), photo: Martin Gerlach Jr., *c.* 1930. Paintings that were in the possession of the Lederer family are marked with an asterisk* in this biography. The family had the largest collection of Klimt's works. These were confiscated by the National Socialists in 1938 and lost in a fire in Schloss Immendorf in 1945. The following paintings also formed part of the Lederer collection: compositional sketches for *Jurisprudence* (ND 86) and *Philosophy* (ND 87, 1897/98); *Schubert at the Piano*, 1899 (above the door to the Music Room in the Palais Dumba, Parkring 4, ND 101); *Music II*, 1899 (same location, ND 89); *Medicine*, 1900/1907 (ceiling panel for the Great Hall at Vienna University, ND 112); *Jurisprudence*, 1902/07 (same location, ND 128); *Procession of the Dead*, 1903 (ND 131); *The Women Friends*, 1916/17 (ND 201); *Leda*, 1917 (ND 202). *Medicine* and *Jurisprudence*, ND 112, 128, passed into the possession of the Österreichische Galerie in 1945.

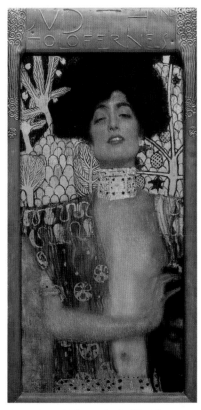

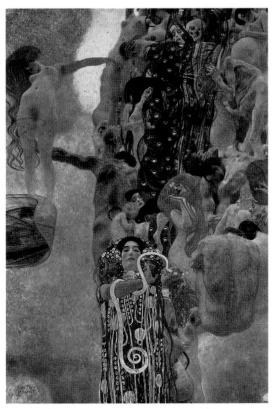

Gustav Klimt, *Judith I*, 1901, oil and gold leaf, Öster-
reichische Galerie Belvedere, Vienna. The frame
was designed by Gustav Klimt and worked in metal by
his brother Georg

Gustav Klimt, *Medicine*, 1900/07, ceiling panel for the Great Hall at the
University of Vienna, lost in a fire at Schloss Immendorf, Lower Austria,
in 1945

Minister of Education against the protest. Franz Wickhoff sends a telegram from Rome to the Rector of the University of Vienna to express his disapproval at the uproar surrounding Klimt's painting. In a counterstatement to the university circular by twelve professors—including Wickhoff—they question their protesting colleagues' competence at judging artistic matters. At a meeting of the artistic commission of the Ministry of Education on May 12, the petition of those professors opposed to Klimt is turned down. In his lecture "What is ugly?" held before the philosophical society of the University of Vienna, Franz Wickhoff once again defended *Philosophy*. In his book *Acht Jahre Secession* (Eight Years Secession) which appeared in 1906, Ludwig Hevesi takes the side of those in favor: "Klimt's *Philosophy* is a magnificent vision, in which, one could say, cosmic fantasies are at work. The whole scene still shows us the chaos from which it has freed itself, or rather, continually frees itself as an

eternally flowing life, incessantly taking on form and then fading away again … The contrast of its light to the colorful fogginess and dazzling darkness up there is Klimt's ingenious artistic idea. He had to paint an allegory of the most mysterious of sciences, and found a genuine artistic solution for this problem." On the other hand, Karl Kraus noted, in *Fackel* of March 1900: "And, in addition, I have been told that the Rector of the University stated, when the commission presented him with the draft that this was 'not philosophy, but a youth, thinking prematurely about where children come from.' Herr Klimt recognized that his allegory had failed, consulted people who he, with his naïve understanding of philosophy, trusted, and created the picture that is now on show in the little Secession temple…. Herr Klimt wanted to allegorize philosophy. Unfortunately he has an even dimmer view of it than of jurisprudence, which he is also supposed to paint."

Georg Klimt
(1867–1931),
metal sculptor
and medallion
maker, in his
workshop in
Vienna

At the Paris World Exhibition, held from April 15 until November 12, *Philosophy* wins the gold medal. Other paintings exhibited include *Pallas Athena* and *Portrait of Sonja Knips.*

Starting no later than August 12, Klimt spends the first summer holiday with the Flöge family on Attersee, staying at Litzlberg Brewery, returning to Vienna around September 3.

The Swamp, 1900 (ND 109)

Farmhouse with Birch Trees, 1900 (ND 110)

Tall Poplars I, 1900 (ND 111)

Attersee I, 1900 (ND 116)

1901

The second faculty painting, *Medicine,* is displayed at the 10th Secession Exhibition (March 15 – May 12) and also attracts attention — this time it is the portrayal of a naked, pregnant woman that is the cause of controversy. This leads to parliamentary questions being raised in connection with the purchase of paintings by Klimt. When the Viennese Academy for Arts proposes Klimt as professor, he is denied the chair. On March 19, the demand by the public prosecutor's office to confiscate the issue of *Ver Sacrum,* including the studies for *Medicine,* is turned down on the basis that these are studies for artistic purposes.

Gustav Klimt, *The Hostile Powers,*
end wall of *The Beethoven Frieze,* 1901/02,
Österreichische Galerie Belvedere, Vienna

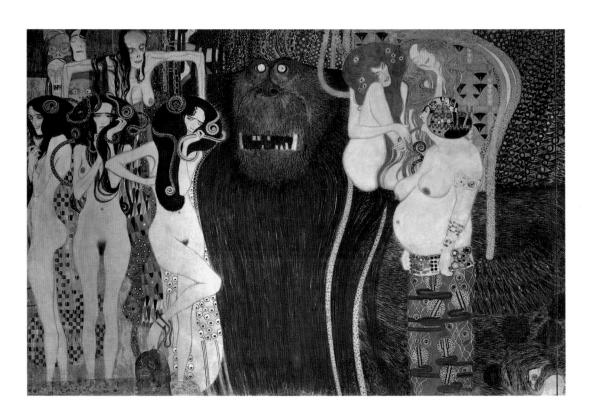

The Historical Museum of the City of Vienna acquires Klimt's contributions to *Allegorien und Embleme*, which are exhibited in the Viennese City Hall at an exhibition organised by the publishers Gerlach and Schenk. The Bavarian State Painting Collection in Munich purchases the study to *Music I.*

In August Klimt spends time on Attersee with the Flöges.

On November 22, the 12th Exhibition of the Secession, mainly presenting artists from Scandinavia, Russia, and Switzerland, opens. Edvard Munch's *Angst* (1894) is displayed, and an entire room is devoted to works by the Dutch Symbolist Jan Toroop.

Farmhouse at Kammer on the Attersee, 1901 (ND 118)

Fruit Trees, 1901 (ND 119)

Pine Forest I, 1901 (ND 120)

Pine Forest II, 1901 (ND 121)

Lake Shore (*Birches on the Attersee*), 1901 (no ND no.)

1902

The 14th Secession Exhibition (April 16 – June 27) is devoted to Max Klinger's *Beethoven Sculpture*, which, in secessionists' opinion, eclipsed Rodin's works. Each Secession artist contributes one work, at no fee, in order to be able to keep Klinger's sculpture in Vienna and, together, provide a triumphant reception for it. The exhibition has a sacral character — each object demands adoration. In 1908, in *Acht Jahre Secession*, Ludwig Hevesi wrote in connection with the *Beethoven Exhibition*: "This is a church for art, which one enters seeking edification and leaves as a believer." (Klinger's home city Leipzig was quicker than Vienna; the sculpture later found its home in the Gewandhaus in Leipzig).

Klimt creates the twenty-four-meter long *Beethoven Frieze* for this exhibition. At a meeting of the upper chamber, the Seces-

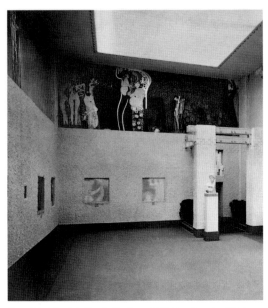

View of the left side-hall at the Beethoven Exhibition, the 14th exhibition to be held by the Vienna Secession, 1902 (on the wall, at the top: Klimt's *Beethoven Frieze*; rear wall: *The Hostile Powers*; narrow wall: two tableaux by Ernst Stöhr; by the exit: Max Klinger's *Girl's Head*

sion, Klimt, and, in particular, the *Beethoven Frieze* are criticised. At the 13th Secession Exhibition in February, Klimt had already exhibited *Goldfishes* which he supposedly had originally wanted to call "To my critics" and which he saw as a rebuke to the reactions — ranging from uncomprehending to hateful — to his faculty paintings.

During his visit to Vienna on June 7, 1902, Rodin admires the frieze ignoring Klinger's statue.

On June 22, Klimt and Marie become parents of a second son, Otto, who dies in September.

From July 30 until August 21 at the earliest, Klimt spends time with the Flöge family in Litzlberg on Attersee.

Island in the Attersee, 1902 (ND 117)

Beech Forest, c. 1902 (ND 122)

A Summer's Day, 1902 (no ND no.)

Tall Poplars II, 1902 (ND 135)

1903

The 16th Secession Exhibition (January 17 – February 28) bears the title *The Development of Impressionism in Painting and Sculpture*. The Secession buys one of the five exhibited paintings by Van Gogh, *Plain near Auvers-sur-Oise,* and donates it to the Moderne Galerie (today the Österreichische Galerie Belvedere) in Vienna.

Hermann Bahr, author, dramatist, critic, and friend of Klimt, c. 1910

Vincent van Gogh, *The Plain near Auvers-sur-Oise*, 1890, Österreichische Galerie Belvedere, Vienna. The painting was exhibited in Vienna in 1903 at the 16th Secession Exhibition

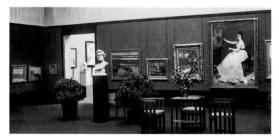

View of the 16th Secession Exhibition, *The Development of Impressionism in Painting and Sculpture*, 1903; on the wall are paintings by Edouard Manet

Emilie Flöge in her Vienna fashion salon, 1910, photographed by Madame d'Ora

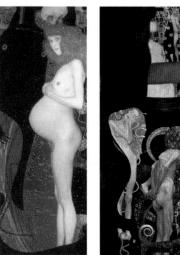

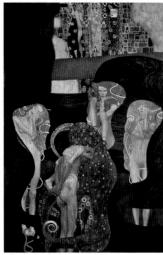

Gustav Klimt, *Hope I*, 1903, National Gallery of Canada, Ottawa

Gustav Klimt, *Jurisprudence*, 1902/07, ceiling panel for the Great Hall at Vienna University, burnt at Schloss Immendorf, in 1945

Ferdinand Hodler visits Vienna, becomes friends with Klimt, and, during the course of their friendship, purchases his *Judith I*.

Using Whistler's *The Gentle Art of Making Enemies* as a model, Hermann Bahr publishes hostile critiques and commentaries under the title *Gegen Klimt* (Contra Klimt).

In May, Klimt visits Venice and Ravenna, then Venice, Padua, Florence, and Pisa between November 28 and December 10.

In May, Josef Hoffmann, Kolo Moser, and Fritz Waerndorfer found the Wiener Werkstätte, where several paintings by Klimt are later put on permanent display.

From July 30 at the latest until September 7, Klimt visits the Flöge family in Litzlberg on Attersee.

On November 11, the artistic commission of the Ministry of Education inspects and approves the faculty paintings. Matsch, on the other hand, is criticized. Due to the differences in quality, it is suggested that Klimt's faculty paintings should not be displayed in the Great Hall of the university but in the Moderne Galerie.

From November 14 to January 6, Klimt has the entire Secession at his disposal for the exhibition *Klimt Kollektive*. Among the eighty works, the unfinished faculty paintings—*Philosophy*, *Medicine*, *Jurisprudence* (see pp. 159, 197, 200)—are displayed for the first time.

The decoration of the rooms—white walls with gray and gold moldings—lies in the hands of Kolo Moser, the entrance is the responsibility of Josef Hoffmann. The poster, a variation on *Pallas Athena*, is designed by Klimt.

On November 1, Hermann Bahr is forbidden to read Arthur Schnitzler's *Reigen* in public—the work is considered obscene and scandalous.

At the end of the year, *Ver Sacrum* ceases publication.

Life, A Struggle, 1903 (ND 132)
Golden Apple Tree, 1903 (ND 133*)
Pear Tree, 1903 (ND 134, later reworked)
Birch Forest, 1903 (ND 136)
Beech Forest II, c. 1903 (ND 137)
Beech Tree in the Forest, c. 1903 (no ND no.)

1904

The gold and silversmith Paul Bacher purchases the Galerie Miethke; Carl Moll becomes its artistic director. The gallery becomes Klimt's future representative in Vienna.

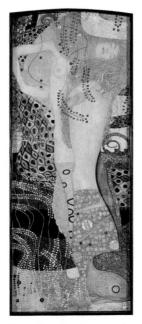

Gustav Klimt, *Water Serpents I*, 1904/07, Österreichische Galerie Belvedere, Vienna

On January 26, the Ministry of Education turns down the Secession's request to send only works by Klimt (*Philosophy, Jurisprudence*, and two landscapes) to the international exhibition in St. Louis; Austria finally cancels its participation.

Belgian industrialist Adolf Stoclet commissions Josef Hoffmann to construct a representative *palais* in Brussels. Stoclet had lived in Vienna for several years and became acquainted with Hoffmann through Carl Moll. Klimt receives the commission for the execution of a marble frieze—the *Stoclet Frieze*—for the dining-room.

At the *Grosse Kunstschau* in Dresden, Klimt exhibits *Goldfishes* and *Life, a Struggle*, and at the First Exhibition of the German Artists' Society in Munich, *The Procession of the Dead*.

On July 1, the Fashion Salon Flöge opens in Mariahilferstrasse in Vienna. Until its closure in 1938, it remains one of the leading addresses in the city.

From July 29 at the latest until August 3 at the earliest, Klimt and the Flöge family summer in Litzlberg.

1905

On April 3, Klimt renounces his commission for the faculty paintings; the Ministry points out that the paintings are already state property. After a lively exchange of correspondence and newspaper interviews with Klimt, the Ministry hands over the faculty paintings to him on April 27. On May 25, Klimt refunds

Postcard sent by Klimt from Seewalchen am Attersee to Julius Zimpel and family in Vienna; front: "Warmest greetings, Gustav, August 3, 1906;" reverse: "Many thanks for your congratulations and the drawings, which are very beautiful." Private collection

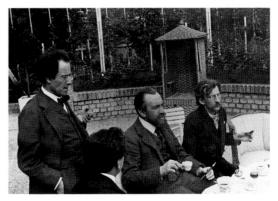

At Villa Moll (*l.* to *r.*): composer Gustav Mahler, theater director Max Reinhardt, artist Carl Moll and composer Hans Pfitzner, 1905

his fee. On April 12, he is interviewed by Berta Zuckerkandl for the *Wiener Allgemeine Zeitung* and discusses the history and criticism of the faculty paintings, also emphasizing his own artistic freedom: "I would never—particularly under this Ministry—take part in an official exhibition, unless absolutely forced to do so by my friends. Forget the censorship. I am going to take matters into my own hands. I want to liberate myself. I want to break away from all these unpleasant, ridiculous aspects which restrict my work. I refuse all official support, I will do without everything....The main thing is, I want to be in the front position, acting against the way in which the Austrian state, the Ministry of Education, deals with artistic matters. It grasps every opportunity for attacking genuine art and genuine artists. It supports only the weak, only the false The state should not pretend to be a sponsor by merely handing out pittances. The State should not dare to meddle in exhibition activities and artistic debates where it is simply its obligation to act as a go-between and commercial factor and to leave artistic initiatives completely in the hands of the artists."

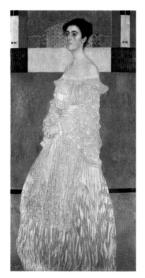

Gustav Klimt, *Portrait of Margarethe Stonborough-Wittgenstein*, 1905, Bayrische Staatsgemälde-sammlungen, Neue Pinakothek, Munich

Klimt's appointment as professor at the Academy of Fine Arts is definitively turned down—possibly on the intervention of the successor to the throne, Franz Ferdinand; Berthold Löffler is named instead of Klimt.

Klimt is in Berlin from May 19–21, where fifteen of his paintings—including the *Three Ages of Women* and *Hope I*—are shown in the Exhibition of the Deutscher Künstlerbund. Klimt, jointly with Ferdinand Hodler and Ulrich Hübner, is awarded the Villa-Romana-Preis, but cedes it to Max Kurzweil. Takes part in the International Art Exhibition in Munich. The group around Klimt—which includes Adolf Böhm, Adolf Hölzel, Josef Hoffmann, Carl Moll, Adolf Roller, and Otto Wagner—that stresses the importance of artistic crafts, leaves the Secession in June; the remaining group, led by the painter Josef Engelhart, wants to limit the works shown at the exhibitions to pictures.

Klimt spends the period from July 26, at the latest, until at least August 4 with the Flöge family in Litzlberg.

On December 9, Richard Strauss's opera *Salome* is premiered in Dresden; Gustav Mahler is not permitted to perform it at the Vienna Opera.

Roses Under Trees, c. 1905 (ND 147)
Garden Landscape (Blooming Meadow), c. 1905/06 (ND 148)
Farm Garden, 1905/06 (ND 144)

1906

On March 12, Klimt is named an honorary member of the Royal Bavarian Academy of Fine Arts in Munich.

In connection with work on the *Stoclet Frieze*, Klimt travels to Brussels and London from May 1–12. In London, the Wiener Werkstätte exhibits at the "Earl's Court Imperial Royal Austrian Exhibition." At the opening, he meets Charles Rennie Mackintosh and returns to Vienna via Berlin and Dresden.

During his summer holiday in Litzlberg, photographs are taken of Emilie Flöge modeling clothes.

Klimt visits Florence on December 7.

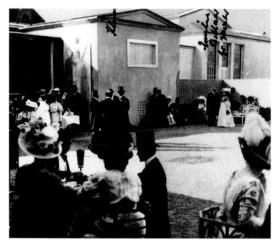

Courtyard to the "Kunstschau" at its opening, 1908; photo and writing: Emma Teschner. Klimt, with back to camera, with three other men; Emilie Flöge, composer Julius Bittner, and Kolo Moser's wife are near the wall

1907

In May, Franz Blei publishes his translation of Lucian's *Dialogues of the Hetaerae*, with illustrations in collotype by Klimt.

Klimt goes to Berlin, where the art dealers Keller and Reiner display his faculty paintings in February and March. Klimt's work does not meet with great acceptance in Germany. He

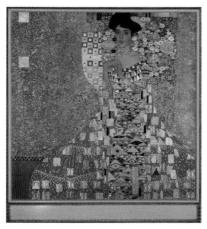

Gustav Klimt, *Adele Bloch-Bauer I*, 1907, oil, silver and gold leaf, Neue Galerie, New York

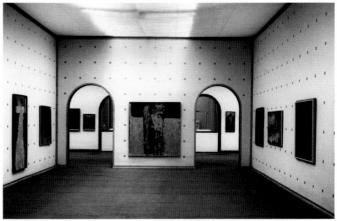

View of the Klimt Hall (room 22), designed by Koloman Moser, at the 1908 "Kunstschau" in Vienna; back wall: Gustav Klimt, *The Three Ages of Woman*, 1905

 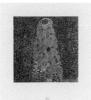

Gustav Klimt, *Golden Apple Tree*, 1903
Collotype from *Das Werk von Gustav Klimt*, 1918

Gustav Klimt, *The Sunflower* (2nd version), *c.* 1907
Collotype from *Das Werk von Gustav Klimt*, 1918

Gustav Klimt, *Tall Poplars I*, 1900
Collotype from *Das Werk von Gustav Klimt*, 1918

Das Werk von Gustav Klimt, 1918, de luxe edition with collotypes of works by Klimt and commentaries by Hermann Bahr and Peter Altenberg, Hugo Heller Kunstverlag, Vienna (first pub. in 1914 by H.O. Miethke as *Das Werk Gustav Klimts*)

takes part in the Viennese art exhibition at the Arnold Gallery, Dresden, and the International Art Exhibition in Mannheim.

In summer, Klimt meets Egon Schiele. Klimt's work is to have a great influence on Schiele for a long period of time. From July 13 to September 8, he once again summers with the Flöge family in Litzlberg.

On October 19, Peter Altenberg's play *Masks*, with costumes designed by Klimt, is performed at the opening of the Cabaret Fledermaus.

Klimt visits Berlin from November 8–11.

Farm Garden with Sunflowers, *c.* 1907 (ND 145)

The Sunflower, 1907 (ND 146)
Poppy Field, 1907 (ND 149)
Garden Landscape, 1907 (ND 164)

1908

On the plot of land where the Viennese Konzerthaus will later be constructed, the "Klimt Group," which had split from the Secession, receives the opportunity to present their first "Kunstschau" in an improvised exhibition hall designed by Josef Hoffmann. In volume twenty-three of *Deutsche Kunst und Dekoration*, Josef Lux describes it as "a ceremonial garment for Klimt," with

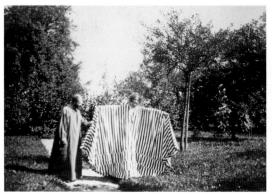
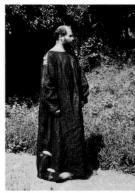

Gustav Klimt and Emilie Flöge, in a dress presumably designed by Koloman Moser, in the garden at Villa Oleander, Kammerl am Attersee, 1908

Gustav Klimt in his painter's robe and Emilie Flöge in a Chinese dress in the garden at Villa Oleander, Kammerl am Attersee, 1910. Details from lumière autochrome plates by Friedrich Walker

Austrian artists exclusively rallying around the master. In the most representative hall, Klimt exhibits sixteen paintings—in the center, revealed for adoration, *The Kiss.* In his report on the "Kunstschau," Peter Altenberg calls the room "the Gustav Klimt church of modern art." The visitor is shown that all the necessities for life and culture are intertwined with each other, the borders between lay art and professional artists' art are erased—painting themes are seen as a pretext for decoration.

Through Klimt's intervention, without jury approval, Oskar Kokoschka is allowed to exhibit. The expected protest does not materialise. As a sign of his gratitude, Oskar Kokoschka dedi-

cates his book *Die träumenden Knaben* (The Dreaming Youths) (1908) to Klimt. The "Kunstschau" is violently attacked in Karl Kraus's *Fackel,* where Klimt is compared to Makart.

The Ministry of Education procures the main work shown at the exhibition—*The Kiss* (see p. 68)—for the Moderne Galerie. At the beginning of July, the Historical Museum of the City of Vienna purchases the *Portrait of Emilie Flöge.* Klimt exhibits *Jurisprudence* and a number of other paintings in Prague.

With Klimt supervising, the Miethke Gallery starts publication of *Das Werk Gustav Klimts.* He designs a different signet for each sheet. Up to sixteen separations are required for each print.

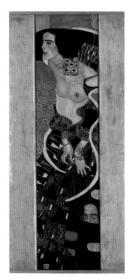

Gustav Klimt, *Judith II,* 1909
Galleria Internazionale d'Arte
Moderna
(Cà Pesaro), Venice

Postcard sent by Gustav Klimt from his *Sommerfrische,* showing Schloss Kammer in Kammer am Attersee to Julius Zimpel in Vienna, dated August 1910; front: "Sincere thanks for your kind regards. Feel very well here—it's more beautiful in Litzlberg—even Kammer is much prettier than on this somewhat unflattering card. With best wishes, Gustav." Private collection

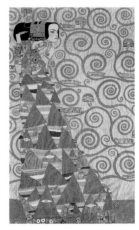

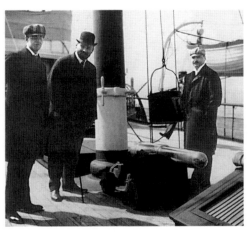

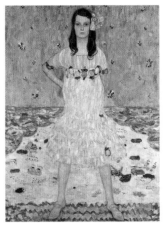

Gustav Klimt, *Expectation*,
cartoon for the *Stoclet Frieze* (detail),
c. 1905–09, Österreichisches Museum
für Angewandte Kunst, Vienna

Crossing the English Channel on a trip to London, 1906 or 1911
(*left to right*: Carl Otto Czeschka, Gustav Klimt, and Fritz Waern-
dorfer), photographed by Josef Hoffmann

Gustav Klimt, *Portrait of Mäda Primavesi*,
c. 1912, The Metropolitan Museum of Art,
New York

Klimt visits Munich from July 9–10, then travels to Attersee,
where he and the Flöges spend their first summer in Villa
Oleander in Kammerl on Attersee, from July 13 to September 11.

Schloss Kammer on the Attersee I, 1908 (ND 159)

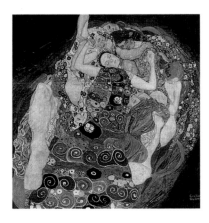

Gustav Klimt,
The Maiden, 1913,
Národní Galerie
v Praze, Prague

1909

In July, the second "Kunstschau" provides an overview of mod-
ern European painting, with works by van Gogh, Matisse,
Corinth, Munch, Toorop, Valloton, Vuillard, and Bonnard
going on display; Klimt's *Hope I* and *Hope II* are shown publicly
for the first time. Like Oskar Kokoschka, Egon Schiele is given
an exhibition room and shows five portraits, leading to his
artistic breakthrough.

Klimt spends the period from July 12 until at least September
11 with the Flöge family in Villa Oleander in Kammerl.

He takes part in the 10th International Art Exhibition in
Munich, in the 18th Exhibition of the Berlin Secession, and visits
Paris from October 16–24, where he admires Manet's *Olympia*
and visits the Musée Guimet. From October 25–31, he travels to
Spain, where he studies the work of Velázquez and El Greco.

In November, the Miethke Gallery organizes an exhibition
with works by Toulouse-Lautrec.

Park, 1909 (ND 165)

Schloss Kammer on the Attersee II, 1909 (ND 166)

Pond at Schloss Kammer on the Attersee, 1909 (ND 167)

1910

From April 23 to October 31, Klimt takes part in the 9th Venice
Biennale; the Galleria Internazionale d'Arte Moderna purchases
Judith II. In addition, he is represented at the Exhibition of the
Deutscher Künstlerbund in Prague and at the exhibition *Zeich-
nende Künste* in the Berlin Secession. The Miethke Gallery displays
drawings by Klimt.

The National Gallery in Prague purchases *Farm Garden* and
Schloss Kammer on the Attersee I.

Klimt summers with the Flöge family in Villa Oleander in
Kammerl from July 16, at the latest, until at least August 29.

Schloss Kammer on the Attersee III, 1910 (ND 171)

Schloss Kammer on the Attersee IV, 1910 (ND 172)

Litzlberg on the Attersee, c. 1910–12 (ND 192)

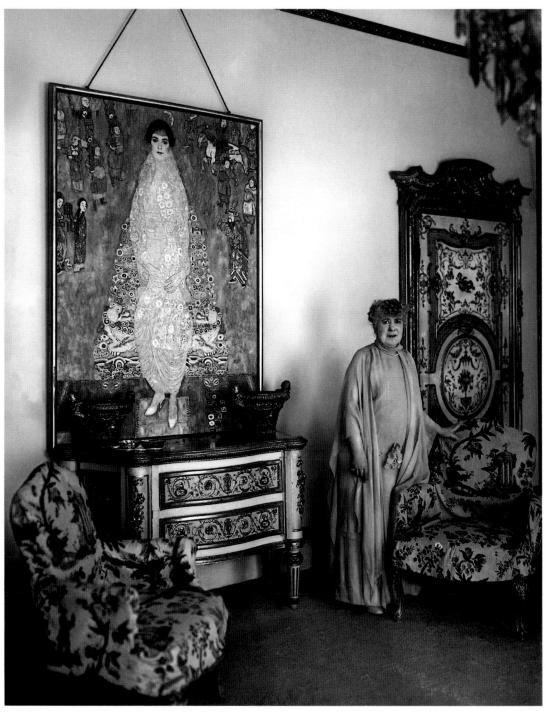

Serena Lederer in her Vienna apartment in Bartensteingasse 8, Vienna I, in front of Klimt's *Portrait of Baroness Elisabeth Bachofen-Echt* (her daughter), *c.* 1914, photographed by Martin Gerlach Jr. *c.* 1930

1911

The *Stoclet Frieze* is completed in Brussels. Klimt visits the International Art Exhibition in Rome from March 27–30, where he receives the first prize for his *Death and Life*.

Accompanied by Fritz Waerndorfer, he visits Brussels and London. He spends the period from August 3 (at the latest) until at least August 13 with the Flöge family in Villa Oleander in Kammerl on Attersee.

Farmhouse in Upper Austria, 1910 (ND 173)

1912

Klimt takes part in the Great Art Exhibition in Dresden. The Moderne Galerie in Dresden purchases *Beech Forest I*.

Egon Schiele paints *The Hermits*—a picture depicting himself and Klimt.

Klimt becomes president of the "Österreichischer Künstlerbund."

On July 11, he meets Emilie Flöge in Bad Gastein. Following this they summer in Villa Oleander in Kammerl on Attersee from July 12 until at least September 11. They both visit Bad Gastein every summer up until Klimt's death.

Farm Garden with Crucifix, 1912 (ND 174*)
Orchard with Roses, 1912 (ND 175)
Apple Tree I, c. 1912 (ND 180)
Avenue in Schloss Kammer Park, 1912 (ND 181)
Litzlbergkeller on the Attersee, 1912–16 (ND 193)

1913

Klimt exhibits ten paintings and ten drawings at the Exhibition of the Society of Austrian Artists, in the Hungarian capital, Budapest.

He takes part in the 9th International Art Exhibition in Munich and in the 3rd Exhibition of the Deutscher Künstlerbund in Mannheim.

From June 27 until at least July 10, Klimt is in Bad Gastein. From July 31 until August 18, he visits Lake Garda, where he stays with the Flöge family in Porto di Tremosine. In September, he spends a few days in Seewalchen on Attersee in Villa Paulick, which belongs to Emilie's brother, Hermann, and his wife (née Paulick).

Along with Rudolf Jung, Josef Hoffmann, and Carl Reininghaus, Klimt is a member of the jury for the "Reininghaus Competition" which is won by Anton Faistauer.

Church in Cassone, 1913 (ND 185)
Malcesine on Lake Garda, 1913 (ND 186*)
Italian Garden Landscape, 1913 (ND 214)

From Gustav Klimt's collection of African wood sculptures

1914

Klimt moves to a studio in Feldmühlgasse 11 (13th district).

He shows works at the Exhibition of the Deutscher Künstlerbund in Prague—the National Gallery in Prague purchases *The Maiden*. The *Portrait of Mäda Primavesi* is exhibited at the 2nd Secession in Rome from February to June.

In March, after having been declared bankrupt, the Wiener Werkstätte is restructured, with the Primavesi family becoming the main shareholders.

Klimt stays in Brussels from May 14–22, where he visits the Musée du Congo Belge in Tervuren and is enthusiastic about the statues displayed.

On June 27, he is in Bad Gastein with Emilie Flöge and her mother. Later—from July 19 until September 11 he visits Weissenbach on Attersee, where he stays in the forester's house.

Forester's House in Weissenbach on the Attersee, 1914 (ND 182)
Villa on the Attersee, 1914 (ND 189)

1915

Klimt's mother dies on February 2.

From August 20 until at least September 12 he stays with the Flöges in Weissenbach. Three paintings and twenty-two draw-

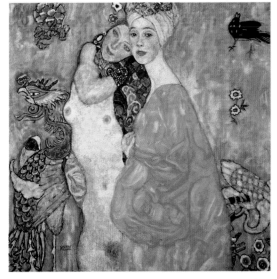

Gustav Klimt, *The Women Friends*, 1916/17, lost in a fire at Schloss Immendorf, Lower Austria, in 1945

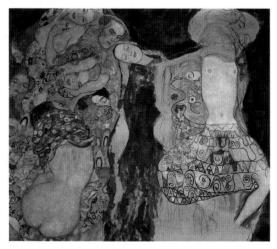

Gustav Klimt, *The Bride*, 1917/18, Österreichische Galerie Belvedere, Vienna,
on permanent loan from a private collection

ings are shown at *Viennese Artists* in the Kunsthaus Zürich from
August 4–22. With Schiele, Kokoschka, and Faistauer, he takes
part in the "Society of Austrian Artists" show in the Berlin
Secession.

On December 10, he visits the country house — designed by
Josef Hoffmann — belonging Otto and Eugenia Primavesi in
Winkelsdorf in Moravia.

1916

On May 25, Klimt is named a member of the Saxon Academy of
Fine Arts in Dresden.

From July 11 (at the latest) until at least September 11, he
stays with Emilie Flöge and her mother in Weissenbach on
Attersee.

Schönbrunn Park, 1916 (ND 194)

Apple Tree II, 1916 (ND 195)

Church at Unterach on the Attersee, 1916 (ND 198)

Houses at Unterach on the Attersee, c. 1916 (ND 199)

Garden Path with Chickens, 1916 (ND 215*)

Garden Landscape with Hilltop, 1916 (ND 216)

Farmhouse in Weissenbach with the Schoberstein, 1916 (ND 217)

Forest Slope in Unterach on the Attersee, 1916 (ND 218)

View of Gustav Klimt's studio in Feldmühlgasse 11, Vienna XIII,
photographed shortly after his death. Still on their easels are the
unfinished paintings: *The Bride*, 1917/18, and *Lady with Fan*, 1917/18

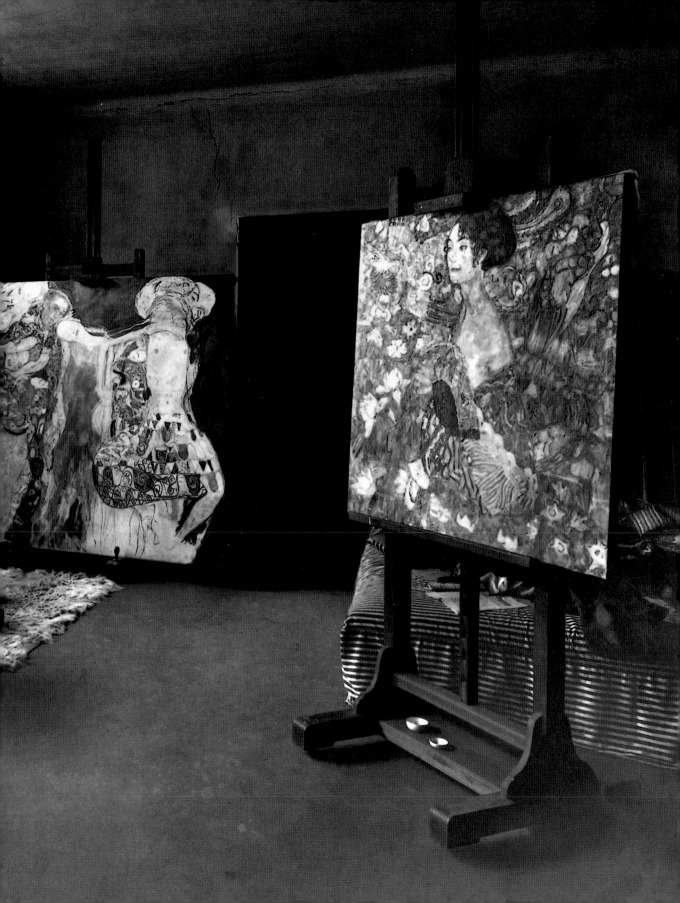

1917

Klimt visits the Primavesi family in Winkelsdorf before January 6, returning to Vienna on January 11.

For years, Klimt used to walk from his apartment in Westbahnstrasse 36 to his studio in Feldmühlgasse past the Tivoli dairy in Schönbrunn, where he had breakfast. In his reminiscences, *Zwanzig Jahre nach Klimts Tod* (Twenty Years after Klimt's Death) published in 1938, Wilhelm Dessauer reported that, before this walk, Klimt exercised with dumbbells and that his breakfast consisted of *gugelhupf* and a large portion of cream.

On March 2, Schiele lists Klimt as one of the founders of the "Kunsthalle," an exhibiting and working group made up of painters, writers, and musicians including Arnold Schönberg, Josef Hoffmann, and Peter Altenberg.

In a letter dated May 22, 1917, Klimt discusses the price for a landscape with a possible client. "Unfortunately, I cannot let *Schönbrunn Park* go for 6,000 crowns—I must insist on 8,000. I could imagine a ten percent 'cash discount' with two, or maybe three, drawings thrown in."

In July, Klimt writes the following lines:
A water lily grows by the lake / It is in full bloom
But a handsome man has / Wounded its soul.

He visits Bad Gastein from July 30 to August 8, returning to Vienna on August 10 to make a selection of thirteen paintings and twenty drawings for the "Österrikiska Konstutställingen" in Stockholm. On August 16, he meets up with Emilie Flöge in Mayrhofen in Tyrol, and stays at the Badhotel Kirchler in Hintertux.

On October 26, he is appointed an honorary member of the Academy of Fine Arts in Vienna.

Gastein, 1918 (ND 219*)

1918

On January 11, Klimt suffers a stroke in his apartment in Westbahnstrasse and is semi-paralyzed. He dies in the General Hospital on February 6 and is buried, three days later, in the Hietzing Cemetery.

Maps of Attersee (Lake Atter) and Lake Garda

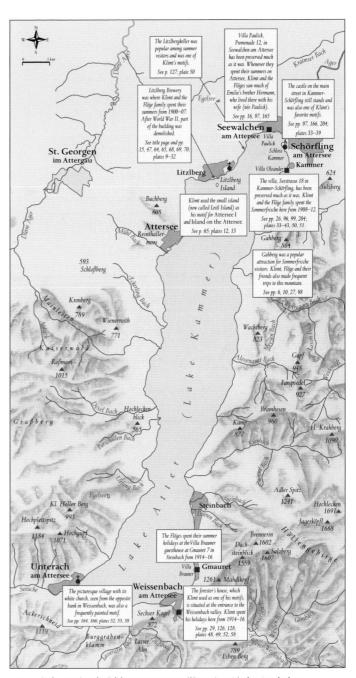

Attersee (Lake Atter) in the Salzkammergut region (Upper Austria), showing the houses and villages where Klimt and the Flöge family spent their *Sommerfrische*.

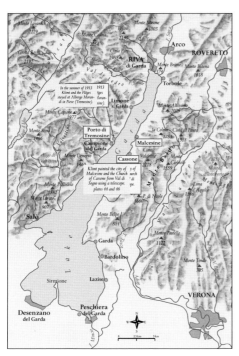

Lake Garda in northern Italy, where Klimt spent the summer in 1913.

Selected Bibliography

Peter ALTENBERG, "Gustav Klimt," in *Kunst,* December 3, 1903, vol. 7, p. 20ff.

—, "Kunstschau 1908," in ibid., *Bilderbögen des kleinen Lebens,* Berlin 1909

Exh. cat. HANOVER, *Gustav Klimt. Zeichnungen,* Hanover 1984

Hermann BAHR, *Secession,* Vienna 1900 (2nd edition)

—, *Rede über Klimt,* Vienna 1901

—, *Gegen Klimt,* Vienna/Leipzig 1903

— (ed.), *Gustav Klimt. 50 Handzeichnungen,* Leipzig/Vienna 1922

Colin B. BAILEY (ed.), *Gustav Klimt: Modernism in the Making,* exh. cat., National Gallery of Canada, Ottawa 2001

Josef BAYER, *Das neue k.k. Hofburgtheater als Bauwerk mit seinem Sculpturen- und Bilderschmuck,* Vienna 1894

Angelika BÄUMER, *Gustav Klimt. Frauen,* Salzburg 1985

Hans BISANZ, "Ornament und Askese," in: Alfred Pfabigan (ed.), *Ornament und Askese im Zeitgeist des Wien der Jahrhundertwende,* Vienna 1985, pp. 130–41

Marian BISANZ-PRAKKEN, "Jan Toorop en Gustav Klimt. Een analyse van de betekenis van Jan Toorop voor Gustav Klimt" in *Nederlands Kunsthistorisch Jaarboek,* 1976, pp. 175–209

—, *Gustav Klimt. Der Beethovenfries. Geschichte, Funktion und Bedeutung,* Salzburg 1977, revised edition, Munich 1980

—, "Gustav Klimt und die Stilkunst Jan Tooraps," in *Klimt-Studien. Mitteilungen der Österreichischen Galerie* 22/23, 1978–79, issue 66/67, pp. 146–214

—, "Das Quadrat in der Flächenkunst der Wiener Secession," in *Alte und Moderne Kunst,* issue 180/181, 1982, pp. 40–46

—, "Im Antlitz des Todes. Gustav Klimts 'Alter Mann auf dem Totenbett,' ein Portrait Hermann Flöges?" *Belvedere. Zeitschrift für bildende Kunst* 2, 1996, issue I, pp. 20–39

—, *Heiliger Frühling. Gustav Klimt und die Anfänge der Wiener Secession 1895–1900,* exh. cat. Graphische Sammlung Albertina, Vienna 1998

—, *Gustav Klimt e le origine della Secessione Viennese,* exh. cat. Fondazione Antonio Mazzotta, trans. by Carlo Mainoldi, Milan 1999

—, "Die fernliegenden Sphären des Allweiblichen. Jan Toorop und Gustav Klimt," in *Belvedere. Zeitschrift für bildende Kunst* 7, 2001, issue I, pp. 34–47

Jean-Paul BOUILLON, *Klimt: Beethoven,* Geneva 1986

—, *Klimt: Beethoven: The Frieze for the Ninth Symphony,* Geneva/New York 1987

Christian BRANDSTÄTTER, *Klimt und die Mode,* Vienna 1998

Otto BREICHA (ed.), *Gustav Klimt. Die Goldene Pforte. Werk–Wesen–Wirkung. Bilder und Schriften zu Leben und Werk,* Salzburg 1978

Markus BRÜDERLIN, "Die Geburt der Abstraktion aus dem Geiste des Ornaments," in: Markus Brüderlin, Ornament und Abstraktion. Kunst der Kulturen, Moderne und Gegenwart im Dialog, exh. cat. Fondation Beyeler, Basel 2001, pp. 118–131

—, *Gustav Klimt. Die Bilder und Zeichnungen der Sammlung Leopold,* Salzburg 1990

Jean CLAIR (ed.), *Vienne, 1880–1938: l'apocalypse joyeuse,* exh. cat. Centre Pompidou, Paris 1986

Alessandra COMINI, *Gustav Klimt. Eros und Ethos,* Salzburg 1975

Ettore COZZANI, "Gustav Klimt: l'orchidea," in *Vita d'Arte* 5, January–June 1910, pp. 248–50

Gino DAMERINI, "Gustav Klimt," in *Il Gazzettino di Venezia,* April 23, 1910

Wilhelm DESSAUER, "Eine Winterreise mit Klimt (Nach Erinnerungen des Malers Maximilian Lenz)," in *Österreichische Kunst, Monatsschrift für bildende und darstellende Kunst. Architektur und Kunsthandwerk* 4, 1933, issue 3

Johannes DOBAI, "Das neuerworbene Landschaftsbild von Gustav Klimt: 'Mohnwiese,'" in *Mitteilungen der Österreichischen Galerie* 1, 1957, issue 8/9, pp. 1–6

—, *Das Frühwerk Gustav Klimts,* dissertation, Vienna 1958

—, "Zu Gustav Klimts Gemälde 'Der Kuss,'" in *Mitteilungen der Österreichischen Galerie* 12, 1968, issue 56, pp. 83–142

—, "Gustav Klimt's 'Hope I,'" in: *Bulletin. National Gallery of Canada,* 1971, issue 17, pp. 2–15

—, *L'opera completa di Klimt,* Milan 1978

—, "Die Landschaft in der Sicht von Gustav Klimt," in: *Klimt-Studien, Mitteilungen der Österreichischen Galerie* 22/23, 1978–79, issue 66/67, p. 250

—, *Gustav Klimt. Die Landschaften,* Salzburg 1981

—, *Gustav Klimt: Landscapes,* trans. by Ewald Osers, Boston 1988

Max EISLER, *Gustav Klimt,* Vienna 1920 (English edition 1921)

—, *Gustav Klimt. Eine Nachlese,* Vienna 1931, new edition 1946

—, *Gustav Klimt: An Aftermath,* trans. by B. W. Tucker, Vienna 1931

Monika FABER, *Madame d'Ora. Wien–Paris. Portraits aus Kunst und Gesellschaft 1907–1957,* Vienna 1983

Anton FAISTAUER, *Neue Malerei aus Österreich. Betrachtungen eines Malers,* Zürich/Leipzig/Vienna 1923

Wolfgang Georg FISCHER, *Gustav Klimt and Emilie Flöge: An Artist and His Muse,* Woodstock, N. Y., 1992

—, "Gustav Klimt und Emilie Flöge, Aspekte des neu entdeckten Nachlasses," in *Alte und Moderne Kunst* 28, Vienna 1983, "Liebe Emilie," issue 186/187, p. 8ff.; "Aus Emilies Welt," issue 188, p. 28ff.; "Erinnerungen an Emilie Flöge," issue 190/191, p. 54ff.

—, *Gustav Klimt und Emilie Flöge. Genie und Talent, Freundschaft und Besessenheit,* Vienna 1987

Gottfried FLIEDL, *Gustav Klimt 1862–1918. Die Welt in weiblicher Gestalt,* Cologne 1989

Lisa FLORMAN, "Gustav Klimt and the Precedent of Ancient Greece," in *The Art Bulletin* 72, June 1990, issue 2, pp. 310–326

Gerbert FRODL, *Klimt,* Cologne 1992; English ed. trans. by Alexandra Campbell, New York 1992

—, *Gustav Klimt in der Österreichischen Galerie Belvedere in Wien,* Salzburg 1992, 2nd edition 1995

The GALERIE ST. ETIENNE, *Gustav Klimt,* exh. cat., New York, April 1959

—, *Gustav Klimt 1862–1918. Drawings,* exh. cat. New York, March/April 1970

—, *Gustav Klimt/Egon Schiele,* exh. cat. New York 1980

Martin GERLACH (ed.), *Allegorien und Embleme. Originalentwürfe von den hervorragendsten modernen Künstlern, sowie Nachbildungen alter Zunftzeichen und moderne Entwürfe von Zunftwappen im Charakter der Renaissance,* Vienna 1882–85

— (ed.), *Allegorien. Neue Folge. Originalentwürfe von namhaften modernen Künstlern,* with explanatory text, Vienna 1896[–1900?]

Herbert GIESE, "Matsch und die Brüder Klimt. Regesten zum Frühwerk Gustav Klimts," in *Klimt-Studien. Mitteilungen der Österreichischen Galerie* 22/23, 1978–79, issue 66/67, pp. 48–68

GUGGENHEIM MUSEUM, *Gustav Klimt – Egon Schiele,* exh. cat. New York 1965

Albert Paris GÜTERSLOH, "Grabrede für Gustav Klimt," in: ibid., *Zur Situation der modernen Kunst. Aufsätze und Reden,* Vienna/Hanover/Bern 1963

—, "Klimt. Ein Bild in Worten," in *Gustav Klimt/Egon Schiele. Zum Gedächtnis ihres Todes vor 50 Jahren,* exh. cat. Graphische Sammlung Albertina, Vienna 1968

Hugo HABERFELD, "Gustav Klimt," in *Kunst für Alle* 27, January 15, 1912, issue 8,

Ingomar HATLE, *Gustav Klimt, ein Wiener Maler des Jugendstils,* dissertation, Graz 1955

Christian HECK, "De L'École du Danube' à la Vienne de la Secession. Klimt et Altdorfer," in *Cahiers du Musée national d'art moderne,* Spring 1988, issue 23, pp. 75–81

Ludwig HEVESI, *Österreichische Kunst im 19. Jahrhundert,* Leipzig 1903

—, *Acht Jahre Sezession (März 1897–Juni 1905). Kritik – Polemik – Chronik,* Vienna 1906 (new edition Klagenfurt 1984)

—, *Altkunst–Neukunst: Wien 1894–1908,* Vienna 1909 (new edition Klagenfurt 1986)

—, "Internationale Kunstschau Wien 1909," in *Zeitschrift für Bildende Kunst,* 1909, issue 20, pp. 221–26

HISTORISCHES MUSEUM DER STADT WIEN, *Gustav Klimt. Zeichnungen aus amerikanischem Privatbesitz und aus den Beständen des Historischen Museums der Stadt Wien,* exh. cat., Vienna 1984

—, *Traum und Wirklichkeit, Wien 1870–1930,* exh. cat. Vienna 1984

—, *Emilie Flöge und Gustav Klimt. Doppelporträt in Ideallandschaft,* exh. cat. no. 112, Hermesvilla/Lainz, Vienna 1988

Werner HOFMANN, "Gustav Klimt und die Wiener Jahrhundertwende," from the series *Österreicher des 20. Jahrhunderts,* Salzburg 1970 (new edition 1977)

—, *Gustav Klimt,* Milan 1967, trans. by Inge Goodwin, New York 1971

—, *Gustav Klimt,* London 1972

— (ed.), *Experiment Weltuntergang, Wien um 1900,* exh. cat. Hamburger Kunsthalle, Munich 1981

H.H. HOFSTÄTTER, *Gustav Klimt: Erotische Zeichnungen,* Cologne 1979

Christoph HÖLZ (ed.), *Gegenwelten. Gustav Klimt – Künstlerleben im Fin de Siècle,* Munich 1996

Jane KALLIR, *Gustav Klimt: 25 Meisterwerke*, New York/ Salzburg 1985

Enno KAUFHOLD, *Heinrich Kühn. Die Kunstfotografie um 1900. Stationen der Fotografie IV*, Berlin 1988

Karl KILINSKI, "Classical Klimtomania: Gustav Klimt and Archaic Greek Art," in *Arts Magazine* 53, April 1979, issue 8, pp. 96–99

Karl KILINSKI, "Classical Klimtomania: An Update," in *Arts Magazine* 56, March 1982, issue 7, pp. 106–107

Gustav KLIMT, Foreword to exh. cat., Kunstschau 1908, Vienna 1908

—, *Das Werk von Gustav Klimt*, Vienna 1914–18, introductory remarks by Hermann Bahr and Peter Altenberg

—, "Zehn Photographien von Emilie Flöge in Reformkleidern," in *Deutsche Kunst und Dekoration*, 1906/07, issue 19, pp. 65–73

Gustav Klimt, 25 Handzeichnungen, facsimile edition, Vienna 1919

Gustav Klimt, 50 Handzeichnungen, foreword by Hermann Bahr, Vienna 1922

Stephan KOJA, *De Waldmüller à Klimt: Chefs d'oeuvre de la peinture autrichienne*, exh. cat. Musée Marmottan, Lausanne/Paris 1994

—, *Klimt–Kokoschka–Schiele. Un sueño vienés (1898–1918)*, exh. cat. Fundación Juan March, Madrid 1995

—, "Ewige Suche nach dem 'Richtigen'. Impressionistisches im Werk von Theodor von Hörmann als Folge seines künstlerischen Wahrheitsanspruchs," in: Elisabeth Hülmbauer/Stephan Koja (eds.), *Impressionistische Naturschilderung in der Österreichischen Landschaftsmalerei von 1870 bis zur frühen Moderne*, exh. cat. Tokyo 1996, pp. 186–90

—, "Von hier und 'anderswo'. *Beobachtungen zur Topographie von Gustav Klimts Attersee-Landschaften*, in *Belvedere. Zeitschrift für bildende Kunst* 2/2003, pp. 60–79 and 105–112

Ulrich KNAPP, *Heinrich Kühn. Photographien*, Salzburg 1988

Hans KOPPEL, "Wiener Neuigkeiten. Bei Gustav Klimt," in *Die Zeit* 406, November 15, 1903, pp. 4–5

Horst-Herbert KOSSATZ, "Der Austritt der Klimt-Gruppe – Eine Pressenachschau," in *Alte und Moderne Kunst* 20, 1975, issue 141, pp. 23–26

Udo KULTERMANN, "Gustav Klimt, Emilie Flöge und die Modereform in Wien um 1900," in *Alte und Moderne Kunst* 23, 1978, p. 157

Friedrich KURRENT/Alice STROBL, *Das Palais Stoclet in Brüssel*, Salzburg 1991

Karl M. KUZMANY, "Kunstschau Wien 1908," in *Die Kunst*, September 1908, issue 18, p. 513ff.

—, "Die 'Kunstschau' Wien 1909," in *Die Kunst*, October 1909, issue 21, pp. 20–22

Edwin LACHNIT, "Neuentdeckte Dokumente zum Professorenstreit um Klimts 'Philosophie,'" in *Wiener Jahrbuch für Kunstgeschichte*, 1986, vol. 39, pp. 205–20

Terence LANE, "The Gallia Collection," in *Apollo*, September 1983, issue 259, pp. 233–38

Jaroslav LESHKO, "Klimt, Kokoschka und die Mykenischen Funde," in *Mitteilungen der Österreichischen Galerie* 13, 1969, issue 57, pp. 16–40

Alfred LICHTWARK, *Die Bedeutung der Amateurphotographie*, Halle an der Saale 1894

—, *Reisebilder*, Hamburg 1924

Marie-José LIECHTENSTEIN, "Gustav Klimt und seine Oberösterreichischen Salzkammergutlandschaften," in *Oberösterreichische Heimatblätter* 5, 1951, issue 3/4, pp. 297–317

Josef A. LUX, "XVI. Ausstellung der Vereinigung bildender Künstler Österreichs – Secession 1902. Klingers Beethoven und die moderne Raumkunst," in *Deutsche Kunst und Dekoration* 10, 1902, issue I, p. 475ff.

—, "Kunstschau Wien 1908," in *Deutsche Kunst und Dekoration* October 23, 1908–March 1909, issue I, pp. 33–61

Alma MAHLER-WERFEL, *Mein Leben*, Frankfurt/ Main 1960

—, *Tagebuch-Suiten. 1898–1902*, Frankfurt/Main 1997

—, *Diaries 1898–1902*, trans. by Antony Beaumont, Ithaca 1999

Lucian O. MEYSELS, *In meinem Salon ist Österreich, Berta Zuckerkandl und ihre Zeit*, Vienna/Munich 1984

Manu von MILLER, "Symphonie in Rosa. Das Bildnis Sonja Knips," in *Belvedere. Zeitschrift für bildende Kunst* 7, 2001, issue I, pp. 48–59

Carl MOLL, "Meine Erinnerungen an Gustav Klimt. Aus dem Leben und Schaffen des Meisters der Secession," in *Neues Wiener Tagblatt* 24, 24.1.1943

Wilhelm MRAZEK, "Die 'Allegorie der Skulptur' vom Jahre 1889, Ein neuentdecktes Frühwerk von Gustav Klimt," in *Klimt-Studien. Mitteilungen der Österreichischen Galerie* 22/23, 1978–79, issue 66/67, pp. 37–47

MUSEEN DER STADT WIEN, *Ver Sacrum. Die Zeitschrift der Wiener Secession 1898–1903*, exh. cat., no. 77, Vienna 1982–83

MUSEUM FÜR KUNST UND GEWERBE HAMBURG, *Kunstphotographie um 1900. Die Sammlung Ernst Juhl, Dokumente der Photographie 3*, Hamburg 1989

Richard MUTHER, *Studien und Kritiken*, 2 vols., Vienna 1900–01

Tobias G. NATTER/Gerbert FRODL (eds.), *Klimt und die Frauen*, exh. cat. Österreichische Galerie Belvedere, Vienna 2000, English edition *Klimt's Women*, Vienna 2000

Christian M. NEBEHAY, *Gustav Klimt Dokumentation*, Vienna 1969

—, *Ver Sacrum 1898–1903*, Vienna 1975

—, *Ver Sacrum*, Munich 1976

—, *Gustav Klimt. Sein Leben nach zeitgenössischen Berichten und Quellen*, Munich 1976

—, "Gustav Klimt schreibt an eine Liebe," in *Klimt-Studien. Mitteilungen der Österreichischen Galerie*, Vienna 22/23, 1978–79, issue 66/67, p. 101ff.

—, *Gustav Klimt. Das Skizzenbuch aus dem Besitz von Sonja Knips*, Vienna 1987

—, *Gustav Klimt, Egon Schiele und die Familie Lederer*, Bern 1987

—, *Gustav Klimt. Von der Zeichnung zum Bild*, Vienna 1992

—, *Gustav Klimt: From Drawing to Painting*, New York 1994

NEUE GALERIE AM LANDESMUSEUM JOANNEUM GRAZ, *Gedächtnisausstellung aus Anlass des 100. Geburtstages von Gustav Klimt, 14. Juli 1862–6. Feb-

ruar 1918. Mit Werken aus privatem und öffentlichem Besitz in der Steiermark*, exh. cat. Graz 1962

Walter Maria NEUWIRTH, "Die sieben heroischen Jahre der Wiener Moderne," in *Alte und Moderne Kunst* 9, May–June 1964, issue 74, pp. 28–31

Fritz NOVOTNY, "Zu Gustav Klimts 'Schubert am Klavier,'" in *Mitteilungen der Österreichischen Galerie* 7, 1963, issue 51, p. 90ff.

Fritz NOVOTNY/Johannes DOBAI, *Gustav Klimt: With a Catalogue Raisonné of His Paintings*, London/New York 1968

ÖSTERREICHISCHE GALERIE, *Gustav Klimt. 29 Gemälde, ausgestellt im Oberen Belvedere aus Anlass der 100. Wiederkehr seines Geburtstages*, exh. cat. Vienna 1962

Susanna PARTSCH, *Klimt: Life and Work*, London 1989

—, *Gustav Klimt. Leben und Werk*, Munich 1990

—, *Gustav Klimt. Maler der Frauen*, Munich 1994

Sonja PASCHEN, *Die Bedeutung der britischen Kunst des 19. Jahrhunderts für das Werk Gustav Klimts. Eine Spurensuche*, diploma thesis, Vienna 1995

Oskar PAUSCH (ed.), "Nuda Veritas Rediviva. Ein Bild Gustav Klimts und seine Geschichte," in *Mimundus 8*, Wissenschaftliche Reihe des Österreichischen Theatermuseums, Vienna 1997

Emil PIRCHAN, *Gustav Klimt. Ein Künstler aus Wien*, Vienna/Leipzig 1942

—, *Gustav Klimt*, revised edition Vienna 1956

Arthur ROESSLER, *Erinnerungen an Egon Schiele*, Vienna/Leipzig 1922

—, *In Memoriam Gustav Klimt*, Vienna 1926

—, "Klimt und seine Modelle" in *Arbeiterzeitung*, Vienna, 15.8.1953

Serge SABARSKY (ed.), *Gustav Klimt: Drawings*, Milan 1983, English edition, London 1984

Felix SALTEN, *Gustav Klimt. Gelegentliche Anmerkungen*, Vienna/Leipzig 1903

—, "Gustav Klimt," in *Geister der Zeit-Erlebnisse*, Vienna 1924

Ilona SÁRMANY-PARSONS, *Gustav Klimt*, Munich/ New York 1987

Egon SCHIELE, "Nachruf auf Klimt," in *Der Anbruch*, Vienna 1918, issue 3

L. SCHMIDT, *Gustav Klimt*, Kirchdorf am Inn 1989

Carl E. SCHORSKE, *Fin-de-Siècle Vienna. Politics and Culture*, New York 1980

—, "Mahler and Klimt: Social Experience and Artistic Evolution," in *Daedalus* 3, Summer 1982, issue 3, pp. 29–49

—, *Wien – Geist und Gesellschaft im Fin-de-Siècle*, Frankfurt/Main 1984

Sabine SCHULZE (ed.), *Sehnsucht nach Glück. Wiens Aufbruch in die Moderne. Klimt, Kokoschka, Schiele*, exh. cat. Schirn Kunsthalle, Frankfurt/Ostfildern 1995

Franz SERVAES, "Ein Streifzug durch die Wiener Malerei," in *Kunst und Künstler*, issue 8, 1909–10, pp. 587–98

SOTHEBY'S, *Gustav Klimt and Emilie Flöge: Artist and Muse. Property from the Estate of Emilie Flöge*, auction cat., London, October 6, 1999

Kristian SOTRIFFER, "Vincent van Gogh und sein Einfluß in Wien," in *Alte und Moderne Kunst* 9, May–June 1964, issue 74, pp. 26–27

Hermann SPEER, "Die Wiener Schule: Hugo Henneberg. Heinrich Kühn. Hans Watzek," in: *Kunst-

fotografie um 1900, exh. cat. Museum Folkwang, Essen 1964

—, Heinrich Kühn 1866–1944, Innsbruck 1976

Christa STEINLE/Gudrun DANZER (eds.), Unter freiem Himmel. Die Schule von Barbizon und ihre Wirkung auf die österreichische Landschaftsmalerei, exh. cat. Neue Galerie Graz am Landesmuseum Joanneum, Graz 2000

Toni STOOSS/Christoph DOSWALD (eds.), Gustav Klimt, exh. cat. Kunsthaus Zürich, Zurich 1992

Erhard STÖBE, "Die Farbe als das Kernproblem der Malerei. Pierre Bonnards Malmethode aus dem Blickwinkel eines Malers," in Belvedere. Zeitschrift für bildende Kunst 3, 1997, issue 2, pp. 30–41

Alice STROBL, Gustav Klimt. Zeichnungen und Gemälde, Salzburg 1962, 2nd edition 1965, 3rd edition 1968

—, "Zu den Fakultätsbildern von Gustav Klimt," in Albertina Studien 4, 1964, pp. 138–69

—, "Gustav Klimt in der Kritik seiner Zeit," in Weltkunst 46, 1976, 9, pp. 845–55

—, "Klimts 'Irrlichter.' Phantombild eines verschollenen Gemäldes," in Klimt-Studien. Mitteilungen der Österreichischen Galerie 22/23, 1978–79, issue 66/67, pp. 119–45

—, Gustav Klimt. Die Zeichnungen 1878–1918, 4 vols., Salzburg 1980–89, vol. 1 (1878–1903), Salzburg 1980; vol. 2 (1904–12), Salzburg 1982; vol. 3 (1913–18); vol. 4 (supplementary volume), Salzburg 1984f.

—, "'Hanswurst auf der Stehgreifbühne zu Rotheburg.' Das Burgtheater- und das Staffeleibild – Aufklärung eines Mißverständnisses der Klimtliteratur," in: C. Beutler (ed.) Kunst um 1800 und die Folgen. Werner Hofmann zu Ehren, Munich 1988, pp. 336–345

—, "Vom Begriff des 'Malerischen', Gustav Klimts

Zeichenstil und Zeichenweise," in Parnass 20, 2000, special issue 17, p. 44–55

Hans TIETZE, "Wiens Heiliger Frühling war Klimts Werk," in Kunstchronik 19, 1917/18, no. 21, I. 3. 1918

—, "Gustav Klimts Persönlichkeit nach Mitteilung seiner Freunde," in Wiener Jahrbuch für Bildende Künste 2, 1919, issue 1–10

—, Gustav Klimt. Neue Österreichische Biographie, Vienna 1926

Kirk VARNEDOE (ed.), Vienna 1900: Art, Architecture and Design, exh. cat. The Museum of Modern Art, New York, Boston/New York 1986

VEREINIGUNG "JUNGE AUSSTELLUNG–SECESSION LXXXVIII" (ed.), Inselräume. Teschner, Klimt & Flöge am Attersee, exh. cat. Villa Paulick, Seewalchen am Attersee 1988

Peter VERGO, "Gustav Klimts Beethoven Frieze," in The Burlington Magazine, 1973, issue 115, pp. 109–13

—, Art in Vienna 1898–1918. Klimt, Kokoschka, Schiele and Their Contemporaries, London 1975, 3rd edition 1993

—, "Gustav Klimts 'Philosophie' und das Programm der Universitätsgemälde," in Klimt-Studien. Mitteilungen der Österreichischen Galerie 22/23, 1978–79, issue 66/67, pp. 69–100

M. E. WARLICK, "Mythic Rebirth in Gustav Klimt's Stoclet Frieze: New Considerations of Its Egyptianizing Form and Content," in The Art Bulletin 74, March 1992, issue I, pp. 115–34

Alfred WEIDINGER, Neues zu den Landschaften Gustav Klimts, thesis, Salzburg 1992

—, "Natursehen am Attersee: Aspekte der Landschaftsmalerei Gustav Klimts," in Parnass 20, 2000, special issue 17, pp. 56–69

Peter WEIERMAIR, "Von der Kunstfotografie zur Neuen Sachlichkeit," in Geschichte der Foto-

grafie in Österreich, Verein zur Erarbeitung der Geschichte der Fotografie in Österreich (ed.), Bad Ischl 1983

Arpad WEIXLGÄRTNER, "Gustav Klimt," in Die graphischen Künste 35, 1912, pp. 49–66

Alfred WERNER, Gustav Klimt. 100 Zeichnungen, New York 1972

Patrick WERKNER, "Hermann Bahr und seine Rezeption Gustav Klimts: Österreichertum, 'sinnliches Chaos' und Monismus," in: M. Dietrich (ed.) Hermann Bahr Symposium (1984), report, Linz 1987, pp. 65–76

WIENER SECESSION, Klimt Gedächtnisausstellung. XCIX. Ausstellung der Vereinigung Bildender Künstler Wiener Secession, exh. cat. Vienna 1928

Claire A. P. WILLSDON, "Klimt's Beethoven Frieze: Goethe, 'Tempelkunst' and the fulfilment of wishes," in Art History 19, March 1996, issue 1, pp. 44–73

Thomas ZAUNSCHIRM, Gustav Klimt — Margarethe Stonborough-Wittgenstein. Ein österreichisches Schicksal. Frankfurt/Main 1987

Berta ZUCKERKANDL, "Wiener Situationsbild," in Die Kunst, 1905, issue II, pp. 185–87

—, Zeitkunst Wien 1901–1907, Vienna/Leipzig 1908

—, "Die Hoffnung," in Wiener Allgemeine Zeitung, 26. 4. 1909, p. 2

—, "Der Klimt Fries," in Wiener Allgemeine Zeitung, 10. 3. 1911, pp. 2–3

—, "Als die Klimtgruppe sich selbstständig machte," in Neues Wiener Journal, 10. 4. 1927

Berta ZUCKERKANDL-SZEPS, "Gustav Klimt," in Neues Wiener Journal, 5. 2. 1931

—, "Einiges über Klimt," in Volkszeitung, 6. 2. 1936

—, My Life and History, trans. by John Sommerfield, New York 1939

Klimt leaving Seewalchen station for Attnang-Puchheim. In the background Seewalchen church can be seen. September 14, 1913

Index of Plates

22 *Life, A Struggle*
 (Knight; The Golden Knight)
 Das Leben ein Kampf (Ritter; Der goldene
 Ritter), 1903
 Oil on canvas, 100 × 100 cm
 Aichi Prefectural Museum of Art, Nagoya
 ND 132

23 *Golden Apple Tree*
 Goldener Apfelbaum (Apfelbaum (?)),
 1903
 Oil on canvas, 100 × 100 cm
 Lost in a fire at Schloss Immendorf,
 Lower Austria, in 1945
 ND 133

24 *Tall Poplars II (Approaching Thunderstorm)*
 Die Große Pappel II (Aufsteigendes
 Gewitter; Gewitter), 1902
 Oil on canvas, 100.8 × 100.7 cm
 Leopold Museum – Privatstiftung, Vienna
 ND 135

25 *Pear Tree*
 Birnbaum (Birnbäume), 1903 (later
 reworked)
 Oil and casein on canvas, 101 × 101 cm
 Busch-Reisinger Museum, Harvard
 University Art Museum, Cambridge,
 Massachusetts, gift of Otto Kallir
 ND 134

26 *Roses Under Trees*
 Rosen unter Bäumen (Rosen;
 Rosengarten (?)), c. 1905
 Oil on canvas, 110 × 110 cm
 Signed bottom left: GUSTAV KLIMT
 Musée d'Orsay, Paris
 ND 147

27 *Garden Landscape (Blooming Meadow)*
 Gartenlandschaft (Blühende Wiese),
 c. 1905/06
 Oil on canvas, 110 × 110 cm
 Signed bottom right: GUSTAV KLIMT
 Private collection
 ND 148

28 *Garden Landscape*
 Gartenlandschaft, 1907
 Oil on canvas, 98.7 × 99.4 cm
 Signed bottom left: GUSTAV KLIMT
 Carnegie Museum of Art, Pittsburgh
 ND 164

29 *Poppy Field*
 Mohnwiese (Blühender Mohn), 1907
 Oil on canvas, 110 × 110 cm
 Signed bottom right: GUSTAV KLIMT
 Österreichische Galerie Belvedere, Vienna
 ND 149

30 *Farm Garden*
 Bauerngarten (Blumengarten),
 c. 1905/06
 Oil on canvas, 110 × 110 cm
 Signed bottom right: GUSTAV KLIMT
 Private collection
 ND 144

31 *The Sunflower*
 Die Sonnenblume, 1907
 Oil on canvas, 110 × 110 cm
 Signed bottom right: GUSTAV KLIMT
 Private collection
 ND 146

32 *Farm Garden with Sunflowers*
 *(The Sunflowers; Garden of the Brauhaus
 in Litzlberg on the Attersee)*
 Bauerngarten mit Sonnenblumen
 (Bauerngarten; Die Sonnenblumen;
 Brauhausgarten in Litzlberg am Attersee),
 c. 1907
 Oil on canvas, 110 × 110 cm
 Signed bottom left: GUSTAV KLIMT
 Österreichische Galerie Belvedere, Vienna
 ND 145

33 *Schloss Kammer on the Attersee I*
 (Schloss on a Lake)
 Schloß Kammer am Attersee I
 (Wasserschloß), 1908
 Oil on canvas, 110 × 110 cm
 Národní Galerie v Praze, Prague
 ND 159

34 *Schloss Kammer on the Attersee II*
 Schloß Kammer am Attersee II, 1909
 Oil on canvas, 110 × 110 cm
 Signed bottom right: GUSTAV KLIMT
 Private collection
 ND 166

35 *Park*
 Park, 1909
 Oil on canvas, 110 × 110 cm
 Signed bottom left: (on left tree trunk):
 GUSTAV KLIMT

The Museum of Modern Art, New York,
Gertrud A. Mellon Fund
ND 165

36 *Schloss Kammer on the Attersee III*
 Schloß Kammer am Attersee III, 1910
 Oil on canvas, 110 × 110 cm
 Signed on right (on bank):
 GUSTAV KLIMT
 Österreichische Galerie Belvedere, Vienna
 ND 171

37 *Pond at Schloss Kammer on the Attersee*
 Schloßteich in Kammer am Attersee
 (Schloßteich), 1909
 Oil on canvas, 110 × 110 cm
 Private collection
 ND 167

38 *Schloss Kammer on the Attersee IV*
 Schloß Kammer am Attersee IV, 1910
 Oil on canvas, 110 × 110 cm
 Signed bottom right: GUSTAV KLIMT
 Private collection
 ND 172

39 *Avenue in Schloss Kammer Park*
 Allee im Park von Schloß Kammer
 (Schloßallee), 1912
 Oil on canvas, 110 × 110 cm
 Signed bottom left: GUSTAV KLIMT
 Österreichische Galerie Belvedere, Vienna
 ND 181

40 *Farmhouse in Upper Austria*
 (Farmstead)
 Oberösterreichisches Bauernhaus
 (Bauerngehöft), 1911
 Oil on canvas, 110 × 110 cm
 Signed bottom right: GUSTAV KLIMT
 Österreichische Galerie Belvedere, Vienna
 ND 173

41 *Apple Tree I*
 Apfelbaum I, c. 1912
 Oil on canvas, 110 × 110 cm
 Signed bottom right: GUSTAV KLIMT
 Private collection
 ND 180

42 *Farm Garden with Crucifix*
 Bauerngarten mit Kruzifix
 (Kreuz in einem Bauerngarten), 1912
 Oil on canvas, 110 × 110 cm

Lost in a fire at Schloss Immendorf,
Lower Austria, in 1945
ND 174

43 *Orchard with Roses*
Obstgarten mit Rosen (Rosengarten), 1912
Oil on canvas, 110 × 110 cm
Signed bottom left: GUSTAV KLIMT
Private collection
ND 175

44 *Church in Cassone (Landscape with
Cypresses)*
Kirche in Cassone (Landschaft mit
Zypressen), 1913
Oil on canvas, 110 × 110 cm
Signed bottom left (on bank):
GUSTAV KLIMT
Private collection
ND 185

45 *Italian Garden Landscape*
Italienische Gartenlandschaft, 1913
Oil on canvas, 110 × 110 cm
Signed bottom right: GUSTAV KLIMT
Kunsthaus Zug, deposit of Foundation
Collection Kamm
ND 214

46 *Malcesine on Lake Garda*
Malcesine am Gardasee, 1913
Oil on canvas, 110 × 110 cm
Signed bottom right: GUSTAV KLIMT
Lost in a fire at Schloss Immendorf,
Lower Austria, in 1945
ND 186

47 *Schönbrunn Park*
Schönbrunner Park
(Schönbrunner Landschaft), 1916
Oil on canvas, 110 × 110 cm
Signed bottom left: GUSTAV KLIMT
Private collection
ND 194

48 *Forester's House in Weissenbach on
the Attersee*
Forsthaus in Weißenbach am Attersee
(Forsthaus; Forsthaus am Attersee; Haus
im Garten; Hausgarten; Landhaus), 1914
Oil on canvas, 110 × 110 cm
Signed bottom left: GUSTAV KLIMT
Neue Galerie New York
ND 182

49 *Villa on the Attersee*
Landhaus am Attersee (Litzlberg), 1914
Oil on canvas, 110 × 110 cm
Signed bottom left: GUSTAV KLIMT
Private collection
ND 189

50 *The Litzlbergkeller on the Attersee*
Litzlbergkeller am Attersee (Litzlberg),
1912–16
Oil on canvas, 110 × 110 cm
Signed bottom left: GUSTAV KLIMT
Private collection
ND 193

51 *Litzlberg on the Attersee*
Litzlberg am Attersee
(Häuser am Attersee,
Unterach am Attersee), 1910–12
Oil on canvas, 110 × 110 cm
Signed bottom right: GUSTAV KLIMT
Rupertinum, Museum für moderne
und zeitgenössische Kunst Salzburg
ND 192

52 *Houses at Unterach on the Attersee*
Häuser in Unterach am Attersee
(Häuser in Unterach), *c.* 1916
Oil on canvas, 110 × 110 cm
Private collection
ND 199

53 *Church at Unterach on the Attersee*
Kirche in Unterach am Attersee
(Kirche in Unterach), 1916
Oil on canvas, 110 × 110 cm
Signed bottom right: GUSTAV KLIMT
Private collection
ND 198

54 *Apple Tree* II
Apfelbaum II, 1916
Oil on canvas, 80 × 80 cm
Private collection
ND 195

55 *Garden Path with Chickens*
Gartenweg mit Hühnern
(Bauerngarten), 1916
Oil on canvas, 110 × 110 cm
Signed bottom left (on edge of path):
GUSTAV KLIMT
Lost in a fire at Schloss Immendorf,
Lower Austria, in 1945
ND 215

56 *Garden Landscape with Hilltop*
Gartenlandschaft mit Bergkuppe
(Gartenlandschaft), 1916
Oil on canvas, 110 × 110 cm
Signed bottom right: GUSTAV KLIMT
Kunsthaus Zug, deposit of Foundation
Collection Kamm
ND 216

57 *Farmhouse in Weissenbach with the
Schoberstein*
Preßhaus am Attersee (Preßhaus), 1916
Oil on canvas, 110 × 110 cm
Signed bottom left: GUSTAV KLIMT
Private collection
ND 217

58 *Forest Slope in Unterach on the Attersee*
Waldabhang in Unterach am Attersee
(Unterach am Attersee), 1916
Oil on canvas, 110 × 110 cm
Signed bottom right: GUSTAV KLIMT
Private collection
ND 218

59 *Gastein*
Gastein, 1917
Oil on canvas, 70 × 70 cm
Lost in a fire at Schloss Immendorf,
Lower Austria, in 1945
ND 219

Hans Tietze noted that Klimt did not
place any value on the titles of his paint-
ings, instead praising those who looked
at his works "purely as paintings." (Hans
Tietze, "Gustav Klimts Persönlichkeit
nach Mitteilung seiner Freunde," in
Die Bildenden Künste, 1919, vols. 1–2, 2). For
this reason the quest for the "original"
title should not be taken too seriously.

In most cases, the titles of the works have
been taken from the *Index of Works*, com-
piled by Johannes Dobai (Fritz Novotny
and Johannes Dobai, *Gustav Klimt*, Salzburg,
1967). Numbers referring to this work are
prefaced by ND. In some fewer cases, the
titles listed by Dobai have been corrected,
other dates suggested, and titles changed
in line with those used during Klimt's life-
time in catalogues, reviews, or letters
written by the artist.

The biography lists all of Klimt's landscape
paintings.